Martial Arts
as Embodied Knowledge

Martial Arts
as Embodied Knowledge

Asian Traditions in a Transnational World

Edited by

D. S. Farrer

and

John Whalen-Bridge

"Chin Woo Fighting Form" cover photograph courtesy of Sifu Ng Gim Han, and Sifu Chow Tong

Published by State University of New York Press, Albany

For information, contact State University of New York Press, Albany, NY
www.sunypress.edu

Production by Diane Ganeles
Marketing by Michael Campochiaro

Library of Congress Cataloging-in-Publication Data

Martial arts as embodied knowledge : Asian traditions in a transnational world /
 edited by D. S. Farrer and John Whalen-Bridge.
 p. cm.
 Includes bibliographical references and index.
 ISBN 978-1-4384-3967-9 (hardcover : alk. paper)
 ISBN 978-1-4384-3966-2 (pbk.: alk. paper)
 1. Martial arts. 2. Martial arts—Social aspects. I. Farrer, D. S.
II. Whalen-Bridge, John.

 GV1101.M283 2011
 796.8—dc22 2011009301

10 9 8 7 6 5 4 3 2 1

D. S. Farrer dedicates his work on this volume to
Master Huo Yuanjia.

John Whalen-Bridge dedicates his work on this volume to
Takamiyagi Shigeru and Charles Johnson.

Contents

Part III: Transnational Self-Construction

Illustrations

Acknowledgments

D. S. Farrer wishes to thank the Yan Chin Martial Arts Association, Singapore, for their assistance during his research. Sifu Ng Gim Han, Sifu Chow Tong, and Sifu Tan Mon Joo deserve special recognition. Mr. Yong Feng acted as my translator in several countries where we experienced some difficult, even dangerous, situations. Thanks also to Master Tan of Northern Praying Mantis, Melaka, and the masters and students of the Chin Woo Athletic Federation in Kuala Lumpur, Malaysia, and the Chin Woo Athletic Federation in Foshan and Guangzhou, China. Master Chia of Hong Shen Choi Lai Fut, Singapore, provided invaluable lessons. Many thanks go to Sifu Paul Whitrod, of Southern Praying Mantis, who adopted me into the kung fu fraternity two decades ago. The College of Liberal Arts and Social Sciences at the University of Guam provided a seed grant toward this research. Bryan Turner encouraged this project from the outset. Many thanks to John, for sharing some of his no-holds-barred publishing techniques.

John Whalen-Bridge thanks the National University of Singapore for sabbatical leave in 2009 that helped him finish several projects including this book. Thank you Robbie Goh for working out a way for me to spend a whole year writing and not grading a single paper. I also thank the Faculty of Arts and Social Sciences for a grant in 2010 that allowed for some help from excellent research assistants such as Rodney Sebastian and Nirmala Iswari. I would especially like to thank my martial arts teachers from Okinawa who made my five years there (1993–1998) time well spent: Shigeru Takamiyagi, Toshio Higa, Katsuyoshi Higa, Sokei and Hatsuko Machida, and Hirokuni Yamashiro. *Domo arigato gozaimasu.* Thank you to my various sparring partners—whether on the mat or across laptop computers—who have helped define life over the last twenty-five years. And thank you Douglas for convincing me this project could be done.

1

Introduction

Martial Arts, Transnationalism, and Embodied Knowledge

D. S. Farrer and John Whalen-Bridge

The outlines of a newly emerging field—martial arts studies—appear in the essays collected here in *Martial Arts as Embodied Knowledge: Asian Traditions in a Transnational World*. Considering knowledge as "embodied," where "embodiment is an existential condition in which the body is the subjective source or intersubjective ground of experience," means understanding martial arts through cultural and historical experience; these are forms of knowledge characterized as "being-in-the-world" as opposed to abstract conceptions that are somehow supposedly transcendental (Csordas 1999: 143). Embodiment is understood both as an ineluctable fact of martial training, and as a methodological cue. Assuming at all times that embodied practices are forms of knowledge, the writers of the essays presented in this volume approach diverse cultures through practices that may appear in the West to be esoteric and marginal, if not even dubious and dangerous expressions of those cultures. The body is a chief starting point for each of the enquiries collected in this volume, but embodiment, connecting as it does to imaginative fantasy, psychological patterning, and social organization, extends "far beyond the skin of the practicing individual" (Turner and Yangwen 2009). The discourse of martial arts, which is composed of the sum total of all the ways in which we can register, record, and otherwise signify the *experience* of martial arts mind-

1

and-body training, is the topic *par excellence* through which to understand the challenges of embodied knowledge, fantasy, and the body.[1]

The subject of martial arts studies may cause some readers to pause as it invokes a series of disturbing dialectical linkages between philosophy, religion and violence, self-defense and aggression, Buddhism and brutality, and points toward an Asian war machine supposedly usurped by the "evolution" of sophisticated modern (read Western) methods of remote disembodied technological warfare. The valorizing words that tether experience of various sorts to "knowledge" appear to be greased in the places where martial artists are most likely to attempt to catch hold. In Western academe, precisely because martial arts seem like an awkward pretender to "knowledge," the problems associated with embodied knowledge and scholarly resistance to it are apparent. However, studies of the body and embodiment have resisted becoming the materialistic fall guy to "mind" or "spirit." The growth of martial arts studies has almost certainly been stunted by one of the paradoxes of postcolonialism: the conceptual apparatus of embodied thinking, in its reflexive effort to liberate the body from its role as mind's subordinate other, too often goes too far in the direction of what Spivak (1996: 214) has called "strategic essentialism." The term "martial arts" signifies "Eastern" and can be accessed to champion, as a counterdiscourse to effeminizing Orientalist clichés, the contemporary paradigmatic image of the Asian-yet-masculine martial arts icon (think of Bruce Lee). To the degree that this reactionary response is highly predictable, so does the cumulative effect of Asian martial arts discourse serve, in spite of its advocates' best intentions, to reify and falsely unify the notion of a centered, stable, objective Asian culture.

Martial arts, meaning the things done to make the study of fighting appear refined enough to survive elite social prohibitions, has never been exclusively an Asian matter, but martial arts *discourse*, meaning the expectations that help order the texts and images of martial bodily training and its entourage of cultural side effects, remains predominantly projected onto the Asian body. In Western representation martial arts are powerfully associated with specifically Asian traditions and practices. The association of particular physical skills with particular kinds of socialization gathers even more complexity when we figure in the role of Orientalist fantasy. According to Edward Said (1979), we (especially the empowered "we" of the West as opposed to Asia) construct a fantasy self, and this fantasy self uses a distorted version of an Other to brace

itself. One casts oneself into a primary role and casts the other—the fantasized Other—into an often unflattering role, thus producing a foil for the fantasized self. The very act of imagining other civilizations is its own form of war, according to extreme extensions of this model, and so we must approach martial arts as a vehicle of intercultural transmission and communication with caution and care.

Martial arts considered as embodied knowledge offers a rapidly changing, ambiguous, contradictory, and paradoxical quarry. *Martial Arts as Embodied Knowledge: Asian Traditions in a Transnational World* approaches the study of Asian martial arts with such built-in conceptual problems firmly in hand. Whereas martial arts discourse often produces "positive" images of the Asian body, a positive image, if it is a stereotype, can be demeaning even as it apparently flatters in terms of its semiotic content. Therefore, we must figure into our corrective reconsiderations that the celebration of achievement in a purely physical sphere also offers a compliment in a manner that may ultimately be a put down. The language and intellectual habits of "globalization" have begun to unsettle the illusory and not especially productive fantasies of an enduring Asian identity that is articulated within and often defended by heroic practitioners.[2] Martial arts as a discourse finds ways to discuss the consequences of bodies crisscrossing the modern world in globalized networks of transnational cultural exchange: the erotic appeal of the martial arts body is inseparable from its Otherness, and this otherness is hardly the sort of radical alterity that would produce the oriental/occidental oppositions about which so many martial artists are taught to fantasize.

For certain, Asian countries have evidenced a long-standing and lively intellectual engagement with traditional martial arts. Japanese martial arts have long benefited from university faculty interest, government support, and state investment where martial arts are utilized as "technologies of self" to build national character, bolster perceived masculinity, and to enhance feelings of self-worth, especially in the postwar miasma of defeat (Foucault 1988; Nippon Budokan 2009: 277–286). In China martial arts have long been employed as nation-building devices promoting the health and fitness of the population, especially against colonial interlopers (Brownell 1995; Farrer, this volume). Nevertheless, traditional martial arts seem to have once again entered a period of relative decline, where traditional martial art schools now compete against mixed martial arts for audience, participation and credibility.

Mixed martial arts (MMA), a concoction of Brazilian *jiu-jitsu* (deriving from the Samurai art *jujutsu*), Western boxing, wrestling, and Thai boxing, currently enjoys unprecedented media popularity in Japan, America, and worldwide. From a street fighter's perspective, MMA is more practical, realistic, and combat effective than "martial sports" such as karate, judo, wushu, and taekwondo, and more grisly, bloody, spectacular, and violent than either boxing or wrestling. Founded in 1993, the Ultimate Fighting Championship (UFC) is already estimated to be worth a billion dollars, and looks well set to overtake boxing and wrestling in terms of revenue generation through television viewing (Plyler and Siebert 2009: 26). However, it is too early to claim that the rise of MMA, dominated as it now is by American Caucasian wrestler/boxers, inevitably rings the death knell of traditional Asian martial arts. Once the initial public excitement over the simple and effective MMA techniques applied in the ring wears off they may in turn be rendered prosaic. Fighters, promoters, and mixed martial artists should continue to dip into the well of traditional martial arts so as to more fully reveal their profound embodied potential; just as so-called traditional martial artists must engage with MMA within or outside of the ring, an approach perhaps best exemplified by Donnie Yen in the Hong Kong film *Flashpoint* (2007), in a superb introduction of MMA to the Chinese martial arts action genre.

The Asian martial arts featured in this volume incorporate a global diffusion of ideas, images, and consumer goods, and present the diasporic, transnational, and organizational crossing of national, political, social, and cultural boundaries in ways that collapse the simple dualisms of traditional and modern, east and west, and of us and them. Although the regular essentialist reinscriptions of martial arts as some kind of racially specific behavior appear with dreadful predictability, the practitioners who actually produce and extend this form of embodied knowledge are properly impatient with such accounts. It is not incidental that all but one of the scholars contributing to this volume are themselves dedicated martial arts practitioners. Just as the medieval Japanese scholar-monk Dogen recommended that we study the self precisely so that we may forget the self, so too do the most traditional scholar-practitioners of martial arts disciplines know that one may immerse oneself in regionally specific traditions in ways that wear out the narrative threads that bind martial arts to an imaginary Japan, China, or Malaya. Alternately, the pursuit of Asian martial arts provides a lifelong vehicle to engage in studies of language and culture,

philosophy and morality, traditional medicine and healing, a practice to temporarily forget the self, in order to polish the self.

Establishing the Contemporary Meaning of Martial Arts

During the previous decade the available martial arts literature has exploded, emerging upon the groundbreaking contributions of such pioneers as Donn F. Draeger (1972), Robert W. Smith ([1974] 1990), Oscar Ratti (Ratti and Westbrook 1973), and Adele Westbrook (Westbrook and Ratti 1970). Several decades later at the cusp of the new century the edited volumes of Green and Svinth (2003), *Martial Arts in the Modern World*, and Jones (2002), *Combat, Ritual and Performance: Anthropology of the Martial Arts*, have attempted to bring the study of martial arts into the "respectable" fold of contemporary scholarship (see also Green and Svinth [2010] *Martial Arts of the World: An Encyclopedia of History and Innovation*). However, except for the work of Alter (1992, 2000), Farrer (2009), Ots (1994), and Zarrilli (1998), the themes of embodied knowledge and the interdependence of embodiment and fantasy in the martial arts have by and large been neglected. The themes of embodiment, fantasy, and the body are scattered across the martial arts scholarship emerging from action film studies (Hunt 2003); dramas of resistance (Amos 1997); aesthetics (Cox 2003); religion and cults (Dumézil 1970; Elliot 1998; Shahar 2008); mysticism, spirituality, and the supernatural (Farrer 2006, 2008, 2009; Maliszewski 1987, 1996; Payne 1981); theater and combat (Holcombe 2002; Pauka 1998, 2002); violence and riots (Horowitz 2001); Japanese swordsmanship (Hurst 1998); fiction (Johnson 1987); discourses of deception (Lowell Lewis 1992); racial self-construction (Prashad 2001); emotions and violence (Rashid 1990); travel narratives (Salzman 1986; Twigger 1997); and traditional medicine (Schmieg 2005).

Associations with the body and popular culture complicate the subaltern status of the newly emergent martial arts studies. Nevertheless, efforts to launch the "discourse" (as we say on campus) about martial arts have steadily gained ground. "Discourse" can mean many things, but let us consider "martial arts discourse" to be ways of describing and interpreting the practices that are more than mere supports to the practices themselves. To draw the circle "martial arts discourse" is to select those serious discussions that not only affirm the contributions of the specific practices to an evolving way of life but also, at best, participate

in the creative extension of these practices. To say "discourse" rather than "practice" here facilitates an elasticity that encompasses more than a professionally circumscribed, highly specialized field (although such writing and teaching certainly bolsters such a discourse).

The elasticity of martial arts discourse is important because the phenomenon in question concerns the nature of class and status. Supposedly people go to martial arts studios to fend off attackers in the street, but practitioners know that this is an inadequate explanation of the phenomena. However important self-defense is, *social* self-defense—defense against the slights and larger injuries associated with social class—is also very important, and becoming proficient in a martial art can offer sanctuary unavailable to those who cannot access other modes of social advancement such as a university education. Cases vary from art to art and culture to culture, but in crafting identity, moral and psychic self-defense must be considered in the analysis of martial arts traditions. To avoid closing down avenues of inquiry before they have even been noticed properly, it is necessary to examine the ways in which a *discourse* must, as much as an individual person, operate with a sometimes invisible nexus of class relations. There is already a great deal of writing about the martial arts, but the status of the media in which these writings appear is low, just as the presumable stature of a martial arts studio is typically much lower than the presumed stature of a ballet studio. Magazine writing (*Black Belt*, *Inside Kung Fu*, among others) speaks to one segment of this community of interpreters, and a there is a lone academic journal as well, the *Journal of Asian Martial Arts* (from 1991 through the present).[3] Critical anthologies such as Thomas Green and Joseph Svinth's *Martial Arts of the World* demonstrate that martial arts discourse is slowly garnering respect in the academy, a small flame increasingly fanned by the University of Hawai'i Press, well placed at the margins of North America and the Asia-Pacific (see, for example, Schmieg 2005; Shahar 2008).

A hostile interpretation might have it that serious accounts of Asian martial arts are crowded out by amateur efforts in trade magazines such as *Black Belt* and *Inside Kung Fu*, but this is not the case with other discourses that have successfully elevated themselves. For example, "popular cultural studies" and "media studies" are terms for university-certified forms of enquiry that had to distinguish themselves from fandom, but it is significant that these academic disciplines managed to do so in ways that preserved gradations of discourse. There is a kind of "class mobility" between fandom, movie reviews, "more thoughtful" movie reviews,

and the highbrow cultural criticism of academic journal articles, each with its own awe-inspiring bibliography. Martial arts vanity publications and self-promotional materials abound. Mythical histories brace national identities—the scholar will often present her own work against such a foil in ways that contrastively present the "knowledge" of the one against the popular fantasy construction of the Other.

Essays in this volume by and large do not disown fantasy construction. Perhaps because most of the writing is done by scholar-practitioners, the work is shot through with embodied, existential commitment and so (we may speculate) there is less anxiety about authenticity. Simply put, the work in this volume stems from cross-training in the library and on the mat, and one result of this fruitful combination of theory and practice is liberation from defensiveness. This middle way must avoid two main kinds of partiality, which each stultify the discourse. Many martial artists may dismiss "theorists" who do not have the *embodied* authority of a martial arts master who has put in thousands of hours of practice. Or, a cultural historian who would not endanger intellectual credibility by being a participant-observer in what so many peers would mistake for *fighting* might need to certify himself or herself by disparaging the actual embodied pleasures and experiences that are inescapable elements of martial arts practice. At its best, martial arts discourse is a training ground in which mind and body do not pull rank on one another, mainly because they have not been artificially separated.

Essays in this volume are more concerned with the practices themselves than with criticism of the available martial literature. Nevertheless, in the last decade more work has begun to appear in the form of non-academic publications, which can provide intense and highly informative accounts of the journeys of curious martial artists who have spent decades exploring Asian martial arts. These non-academic yet scholarly practitioners have, as an addition to their intensive training, used representational media such as historical description, photography, and documentary film to salvage or preserve endangered forms of knowledge and to publicize those practices that have been overshadowed (see, for example, Frantzis 1998; Hsu 1997; Furuya 1996; Normandeau 2004; Tedeschi 2000; Wiley 1997). Despite the advent of the *Journal of Asian Martial Arts* and subsequent edited spin-off volumes, the boundaries between scholarly, journalistic, and private efforts in martial arts studies have become increasingly blurred (Jones 2001, 2002).[4]

A similar mixed bag of scholarly and amateur materials appear throughout the titles emerging from the booming martial arts publishers

such as Frog, Shambhala, and Tuttle. Harking back to Sir Richard Burton's (1884) *The Book of the Sword*, in an early attempt to launch martial arts studies, renowned martial arts scholar Donn Draeger borrowed the moniker of "hoplology," to refer to the evolutionary study of weapons and armor, in a drive toward academic professionalism in the study of martial arts.[5] While hoplologists have made useful distinctions between civil and military fighting arts, the accounts of the International Hoplological Society remain fundamentally technical, functional, and behavioral, and are largely concerned with "how to" perform martial arts techniques, albeit located in environmental circumstance, history, and myth. While recognizing the value of such contributions, the concept of martial arts studies that we propose de-essentializes the "how to" approach in favor of a more theoretically informed strategy grounded in serious contemporary scholarship that questions the practice of martial arts in their social, cultural, aesthetic, ideological, and transnational embodiment.

What is martial arts studies, then? A murkily fluid set of characteristics flows over terms such as "martial art," "martial sports," "martial traditions," and "martial ways" (Jones 2002: xi–xiv). The object of study is called "martial arts" in everyday parlance, and by this phrase most people mean to indicate a primarily Asian combative practice that may or may not have a grand genealogy. Two exceptions to the "Asia rule" would be *capoeira* and Brazilian *jiu-jitsu*, the latter seeming to come from Japan but owing at least as much to Greco-Roman wrestling. Most martial arts, apart from the two exceptions and other explicitly modern forms such as judo, claim extensive lineages going back even to Bodhidharma or beyond. Judo is clearly a modern invention in which the martial element is somewhat displaced by athleticism and fitness; practices such as taekwondo and hapkido are sometimes given questionable family trees that do not credit any Japanese influence whatsoever. This is not to say, in the manner of the voguish academic reflex, that everything in the world was invented in the nineteenth century. Perhaps it is best to say that we have to consider the relationship between martial arts and history in two ways: there is the question of historically accurate information, but we also see the ways in which a historical narrative is a semiotic form of martial prowess—the rhetorical magnification of historical imperturbability is an action against rival martial arts communities and a defense against their attacks on credibility.

Martial arts historiography poses formidable challenges, but it is widely accepted that many martial arts traditions have survived centu-

ries of transmission. Martial arts are microcosms of culture *par excellence* for the way in which the practices and communities interact with and sometimes organize other ways of knowing and being, including what we tend to call philosophy, religion, magic, medicine, and theater. For some, "martial arts" may be little more than a set of combat skills developed to defend one's self, friends, and family—this is the predominant Western paradigm. In Asian cultures, as essays in this volume show again and again, the "self" that is defended extends beyond the nuclear family and often tends to involve community, religion, nation, and state. A martial arts school invariably signifies something more than a fighting school, and cutting-edge work in what we are calling martial arts studies investigates discourses of power, body, self, and identity (Zarrilli 1998); gender, sexuality, health, colonialism, and nationalism (Alter 1992, 2000; Schmieg 2005); combat, ritual, and performance (Jones 2002); violence and the emotions (Rashid 1990); cults, war magic, and warrior religion (Elliot 1998; Farrer 2009; Shahar 2008).

The word "martial" is relatively clear, but the notion of a martial "art" generates a bit more resistance. Similar to the work of a high-level craftsperson, martial arts demands high levels of self-control, but martial arts discourse tends to also include moral and psychological training that modernist trends have marked as "old-fashioned" or Victorian. The practitioner supposedly learns, according to the conception that prevails in Asia, Europe, and in the Americas, that even the greatest warrior has to overcome or *craft* his or her self (Kondo 1990; Zarrilli 1998).

The importance of martial arts for the study of embodiment, fantasy, and the body becomes immediately apparent to anyone who attends one of the actor's training workshops run by the martial artist, performance theorist, and theater director Phillip Zarrilli, which involve training in the Indian martial art *kalarippayattu* (see also Zarrilli 2002). Here, actors, from a standing position, swing their heads back and forth between their outstretched legs, in an exercise that causes the participants to experience the peculiar sensation that their heads are somehow passing through the floor. Strange and profound bodily or psychosomatic experiences are a characteristic of martial arts training, where specific *techniques du corps* raise questions pertaining to the boundaries of the bodymind, the peculiarities of the senses and of the horizons of perception (Blacking 1977; Mauss 1979). In the terms of Spinoza, echoed by Deleuze and Guattari (2002; see also May 2005), the question becomes "of what is a body capable?"

Farrer's research on the Malaysian martial art *silat gayong* led him to observe people putting their hands into cauldrons of boiling oil without being burned (Farrer 2009). While physicists such as Jearl Walker (1997) have attempted to debunk such ritual ordeals as phenomena explainable in secular terms operating outside the realms of magic, religion, or mysticism, clearly, under the correct conditions and given the proper training, the body is capable of realizing the embodied fantasy of invulnerability and of withstanding an assault of boiling oil. The boiling oil bath is not merely an exotic isolated instance, but one example of a multitude of martial discursive knowledge formations that inform the traditions of Asian martial arts, often blended with heroic tales, myths, and legends. In the past martial discursive knowledge formations have typically been bound to secret societies and tied to secret rituals; yet as these discursive practices have spread to all regions of the globe, former social and religious ties have frequently been attenuated, giving rise to new forms of transnational social organization. The essays collected here set out to investigate martial knowledge as it exists in the contemporary world through a discussion of embodied fantasy, of how the social body trains martial arts, and of self-construction in an era characterized by transnational diasporic identity formation.

Research Methods and Martial Arts Studies

Research methods used in the study of martial arts include methods derived from a diverse array of disciplines including history, hagiography, archaeology, biological anthropology, physics, and kinesics. This volume demonstrates methodologies derived from interdisciplinary social sciences and the humanities including literary and filmic analysis, sociological autoethnography, and practitioner and performance ethnography. Of course, ethnographic methods may not be possible or feasible for historical, filmic, or literary studies, where the researcher may instead gain access to the field through vicarious experience.

For martial arts studies, ethnography and autoethnography, augmented by interviews, film, and photography are so far the predominant ways to transmute martial arts practice into "knowledge." These methods best serve to help us approach martial arts *experience* as opposed to discursive forms that may often displace the most experientially direct ways of knowing. With Zarrilli's (1998) groundbreaking book on the South

Indian martial art *kalarippayattu*, the method of "performance ethnography" made its debut for studies in martial arts. Performance ethnography is understood to refer to a method of participant observation where the observer joins in and learns the performance genre. The difference between "performance ethnography" and "practitioner ethnography" is largely theoretical. *Performance ethnography* links to the performance theory pioneered by Victor Turner (1988) in *The Anthropology of Performance*, which has subsequently spun off into social anthropology, performance studies, and theater studies, whereas *practitioner ethnography* connects to a long-established body of sociological literature, particularly to works in deviance, health, and education.

The writings of Phillip Zarrilli, Bryan Turner, Thomas Csordas, and Victor Turner, among others, have raised the intellectual bar for studies in performance, embodiment, the body, and martial arts, to the point where martial arts studies has become a viable academic pursuit, one that should incorporate the relevant findings of the "how to" approach, but not be reduced to it. To some extent, for martial arts studies, the gated community of "academic knowledge" remains locked in an ivory tower, but for the most part the gate is wrought of only one idea: that martial arts cannot really be an art since the practices involve more *repetition* rather than *individual expression* or *stylistic innovation*.

Martial arts, whether familial, sect, temple, clan, caste, class, civil, university, police, or military exist in competitive environments, and have emerged from collective or community responses to violent, adverse, agonistic, and repressive conditions, only to be incorporated in their turn into the war machine and the state in its effort to monopolize the means of violence. Commandos, police, and other state functionaries and military personnel have long appreciated and appropriated the relatively straightforward and easily taught techniques of the martial arts, redefined as "unarmed combat" to provide both a last-ditch line of defense, and a means of harnessing precise levels of force geared toward elimination, or the capture, control, and manipulation of bodies. Alongside the rise in combatives, numerous modern martial arts have emerged as a response to colonialism, oppression, and defeat. After World War II the Japanese martial arts of karate and judo were explicitly constructed as "self" engines tied to moral and national reconstruction, just as the Chin Woo Athletic Association emerged as a response to Japanese colonial aggression in Shanghai earlier in the twentieth century. This is not to say that such ultra-traditional, nationalistic, consciousness-raising, and deliberately

moral endeavors necessarily produce martial arts that are ineffective in combat, only that the primary rationale and mission of the martial art, whether for performance, theater, nation building, military, or civil defense or gambling, organized crime, or street fighting must be accounted for. Continuous practice, combined with reflective awareness, and ruthless analysis unlocks the paradox of embodied tradition, where the pivotal experiential structures of martial embodiment, including the underlying philosophy, moral, medical, spiritual, and kinesic principles are revealed as the foundations of embodied knowledge upon which the martial arts are based. In short, whether practiced, devised, or employed for the purposes of rebellion and resistance, or utilized in order to maintain or ameliorate the status quo, or harnessed toward oppression and domination, at a highly advanced level of practice all genuine martial arts are inherently geared toward some form of ongoing transformation and reconstruction.

The Essays

The essays collected here are located under the rubric of three broad categories: part 1 details "embodied fantasy," part 2 presents findings from research concerning "how the social body trains" in martial arts, and part 3 engages "transnational self-construction." These categories overlap and interlock; essay placement is not absolute because considered individually the essays each interrogate most if not all of these central themes and their placement is essentially a matter of degree rather than of difference. Although emerging from a wide variety of academic fields all the essays are descriptive and explanatory. Several essays discuss Chinese and Japanese martial arts in China and Japan, as well as in Southeast Asia, Africa, and Europe; one essay concerns indigenous martial arts in Southeast Asia (*silat*); and one concerns the United Kingdom and India (*kalarippayattu*). It appears that a global "recentering" of Asian martial arts has occurred, where *kali*, *kalarippayattu*, *silat*, and others have pulled the "center" south down from the Far East (see also Jones 2002; Green and Svinth 2003). However, the essays presented here demonstrate that diasporic and transnational networks of social and cultural exchanges displace the embodied fantasy of some imagined historical or geographical Mecca for Asian martial arts.

As any filmgoer knows, the idea of abilities "stranger than fiction" has always taken pride of place in martial arts discourse; and martial arts

biography, autobiography, and ethnography all contain rich elaborations on the same basic story: that by training the body properly one may enter an alternative space, one not characterized by disenchantment. Individual re-enchantment can also be an embodied, lived allegory of social re-enchantment. The empowerment of the individual body becomes, with the national and transnational mappings that are constant features of martial arts discourse, not only a figuration but also an embodiment of the empowerment and even enchantment of larger, communal selves. The social body also undergoes martial arts training, and such training combined with the embodied fantasies of myth, legend, travel, and tourism culminate in processes of diasporic identity construction and reconstruction with national and global consequences for the ways in which martial "traditions" are transmitted and received, in addition to being represented and understood.

Embodied Fantasy

The metanarrative of individualistic martial arts self-regeneration has several key stages. First, a martial arts hero undergoes grave insult or even intense physical abasement. Most martial arts "fight to the death" movies have this plotline; for example, see *Blood Sport* (1989) starring Jean-Claude Van Damme. Ralph Macchio's character had to overcome just this sort of humiliation in *Karate Kid* (1984), which he could not have done without the help of Mr. Kesuke Miyagi, the Okinawan-in-exile with a permanently romantic soul played by actor Pat Morita. Perhaps a bad person intentionally cripples the hero's brother, or perhaps the hero's sister faced with rapists instead chooses, honorably, to kill herself, as did Su Lin (played by Angela Mao) the sister of Lee (played by Bruce Lee) in *Enter the Dragon* (1973), the first kung fu movie produced by a major Hollywood studio. Sometimes the CIA can be involved as well, such as in Steven Seagal's revenge fantasy, *Hard to Kill* (1990). The audience member, so the theory goes, supposedly feels weak and can thus identify with the weak almost-murdered hero, who will later be recognized as strong. Consumers of martial arts fantasy, it could be said, harbor a wish to become "the most unstoppable son-of-a-bitch" people ever knew. The cinematic fantasies are the publically shared cultural texts in which the wounded hero gathers the pieces of his or her life together through the redemptive, if vicious, aid of an Asian master, exemplified by Pai Mei

(played by Chia Hui Lui), ripped unceremoniously from his own historical time into modern times for Quentin Tarantino's 2004 film, *Kill Bill 2*, so that he may teach Beatrix Kiddo (played by Uma Thurman) the fabled one-inch punch, which comes in handy for her to blast her way out of a coffin while buried alive.[6]

Our arrangement here begins with "embodied fantasy" at the individual level, but the individual triumph allegorizes national anxieties as well, and the essays in Embodied Fantasy examine the correlations between the individual, national, and international levels of interpretation. In "Some Versions of the Samurai: The Budō Core of DeLillo's *Running Dog*," John Whalen-Bridge discusses the ways in which the American novelist Don DeLillo pursues the dislocation and subsequent rearticulation of transnational martial arts conventions. DeLillo takes a series of utterly conventional plotlines—CIA conspiracy thriller, martial arts fantasy, and an investigative journalist on the hunt for an expose—individually conventional devices, that become surreal when combined, probably because the assemblage violates the ideologically effective convention of asserting the individuality of the quest. DeLillo points out the ways in which the embodied knowledge of martial training, Samurai ethical norms, and American sexual freedom alter meanings and conventions as they migrate from dojos to popular media to highbrow fiction.

Essays in this section demonstrate the ways in which martial arts, both as a practice and the subject around which a field of representations is organized, bridges the divide between body and mind that have prevailed in Western forms of self-understanding. In the novel discussed by Whalen-Bridge, we see martial arts as a figural activity that can tell us about the interrelated reasoning and physical practices of characters while at the same time presenting, swathed in irony, an ideal form of embodied mind against which to measure various more compromised ways of life.

Paul Bowman's "The Fantasy Corpus of Martial Arts, or, The 'Communication' of Bruce Lee" crosses the divide in another way. Bowman's article primarily wishes to reveal the deconstruction of the "fantasy versus embodied reality" binary that is a reoccurring theme of martial arts discourse. Drawing on Derrida, and biographical considerations of Bruce Lee, and popularizers of Zen Buddhism such as Alan Watts, Bowman illuminates a continuous process of mutual development between body and imagination. If Bowman examines the transnational deployment of martial arts discourse as way to encounter fractious divides productively *from the Western* side, examining Bruce Lee's films alongside popular songs

and movies such as Jarman's *Ghost Dog*, Jie Lu's "Body, Masculinity, and Representation in Chinese Martial Art Films" approaches similar matters via a consideration of Chinese cinema in relation to Chinese attitudes toward gender and the body. There can be no simplistic division between East and West in a discussion of martial arts discourse, and Jie carefully situates Ang Lee's films within a cultural buffer zone between East and West, one in which a transnational cultural product has been "made possible by Hollywood capital, a pan-Asian star cast, and a well-known international team."

While it is often said that Western philosophical traditions programmatically present spirit as superior to body in ways that Far Eastern cultures would not, Jie's carefully nuanced discussion shows how Asian philosophical traditions are, at distinct historical moments, more or less of the same mind, as it were, about the body, and, in a dialectical manner, in direct opposition to Western attitudes: "Mao Zedong tempered his body in physical education. A strong body became a precondition for making a modern (male) subject and building a strong nation" (101). The Maoist body had to be yet constrained, lest eroticism divert the body-energies that were meant to be organized, and so we cannot, even for a moment, rest in lazy binaries. Jie's historically rich approach makes alignments between the imagined body and the embodied political stakes and outcomes with admirable clarity: "[d]e-erotized, both the proletarian body of Mao's China and Lee's self-displayed body were used to symbolize the political power and national strength and/or to redefine Chinese masculinity and reconstruct the image of cultural China" (102).

How the Social Body Trains

Findings derived from anthropological fieldwork concerning how the social body trains are presented here by de Grave for the Indonesian martial art (*pencak silat*) and by Rennesson for Thai boxing. Before commencing with an outline of the individual chapters, taken together it may be noted that each implicitly or explicitly engages the notion of rationalization. Max Weber's typology of action, including rational action (formal and substantive), affective action, and traditional action, also includes another type of action linked to the body that has rarely been developed. The essays in this section offer different ways to approach bodily action: de Grave explains the distinct sensory or body rationality of Javanese

martial arts that employ a far broader conception than the basic five senses commonly accepted in the West; Rennesson probes the interconnected network of bodies that become locked in a "polymorphous clinch" through participation in Thai boxing matches in the local, national, and international arena.

Regarding the individual essays, in "The Training of Perception in Javanese Martial Arts," French anthropologist Jean-Marc de Grave presents remarkable findings from his research into the Javanese martial art *pencak silat*. In Java, where up to ten senses are described, the understanding and classification of the senses is broader than it is in the West. De Grave considers the Merpati Putih style of *pencak silat*, originating from Yogyakarta, Central Java, in order to document the training of tactile and proprioceptive senses that are said to detect subtle vibratory frequencies (see also de Grave 2001). A dramatic test for such abilities is stopping a ball kicked toward a goal while wearing a blindfold, or negotiating a field of standing obstacles while blindfolded.

Merpati Putih, one of the principal schools of *tanaga dalam* (inner power), is renowned in Indonesia for its breathing exercises and for the training of elaborate skills such as the ability to sense *getaran* (waves, vibrations). This secularized training is rationalized through collaboration with medical, military, and sports professionals. According to de Grave, on the basis of breathing exercises and special concentration techniques, practitioners develop "true inner feeling" (*rasa sejati*) and develop particularly sensitive perceptual abilities allowing them to perceive the immediate environment without the need to see it. The development of peculiar sensory awareness is also harnessed to other applications such as the breakage of hard objects, including metal files, tempered steel targets, concrete slabs, and ice blocks.

De Grave illustrates a process where practitioners "may develop abilities that resemble a touch intensified to the extreme" (135) and where through "remote blind detection" blind people become able to negotiate obstacles in the outer environment as if they could see them, thus allowing them to "move around practically like seeing people" (134). Far from attempting to debunk such phenomena, de Grave notes the convergence of indigenous empirical methods with recent findings in the neurosciences, and discusses the links between "actual perception" and the "active imagination" (137). He concludes with the question of whether modern people would prefer to relate to "external media cognitive objects"—cars, computers, and so forth—or develop their inner potencies (140).

The next essay on training the social body articulates the aesthetic, pragmatic, national, and international aspects of the social definition of the fighter's body. In "Thai Boxing: Networking of a Polymorphous Clinch," Stéphane Rennesson reveals the relational, hierarchical, and competitive networks of Thai boxers in the Kingdom of Thailand. According to Rennesson, professional Thai boxing (Muay Thai) was originally a form of martial tradition that rapidly began to grow into a sporting form of prize fighting in the late nineteenth century.

To avoid essentializing the individual fighter's body, Rennesson takes a "dynamic heuristic perspective" that focuses upon the "polymorphous clinch," a multivalent notion that articulates the dyad of two boxers from different stables or "fighting exogamies" as they are framed in any particular boxing contest (156). For dramatic purposes, and to a lesser extent for training, Thai boxers are understood to be naturally "artists" or "attackers," where attackers typify a stereotype of the darker skinned, more stocky Isan fighters from the northeast of Thailand, compared to their lighter skinned compatriots to the south. Predominantly tall and slender "artists" emphasize skill and technique over the strength and tenacity of stocky "attackers," however, these categories are not absolute, fixed, and immutable, but fluid, relational, and open to negotiation and amalgamation depending on the way promoters, managers, and journalists frame any two boxers who are to fight. Hence, Rennesson states that "[p]ugilists' bodies can't be taken for granted but must be regarded as temporary states, results of small adjustments that are modified following the stakes they embody in each and every fight" (156). The endless fights involving the co-relational defining and redefining of the boxers' bodies serve to manifest competitive local identities at the regional or national level, only to fuse in combination to define "Thai" national identity as *both artist and attacker* in international competitions whether against foreign contestants in Thailand, or where Thai nationals fight overseas.

Transnational Self-Construction

Welton, Chan, and Farrer consider issues of self-construction as they relate to transnational martial arts training. Welton evaluates authenticity, travel, and tourism for *kalarippayattu* in India and the United Kingdom, Chan contemplates Japanese martial arts in Zambia and Zimbabwe, and

Farrer illustrates social memory and the maintenance of Chinese diasporic forms of cultural capital in contemporary Singapore.

Martin Welton in "From Floor to Stage: *Kalarippayattu* Travels" discusses training in the Indian martial art *kalarippayattu* from the standpoint of actors training for the British theater. Welton proceeds from the perspective of his own "field-research training in *kalarippayattu* as a performer traveling between the United Kingdom and India," predominantly in Northern style *kalarippayattu* "at the CVN Kalari in East Fort Thiruvananthapuram between 2000 and 2004" (168). He says that "the significance of 'travel' to the chapter is that it not only draws attention to the fact of movement—that culture/s as well as people travel—but that it identifies movement as the meeting point of body and culture (Rojek and Urry 1997: 10; Welton 162).

For Dean MacCannell (1976) tourism drives the search for authentic encounters, and Welton questions to what extent *kalarippayattu* may offer access to the authentic. Welton notes that in the transfer from floor to stage, *kalarippayattu* has moved from India to Britain and from Malayali to non-Malayali bodies. The key issue concerns the processes of embodiment for *kalarippayattu* as a transnational practice, and whether learning *kalarippayattu* for the stage constitutes an authentic embodiment of the martial tradition. Welton's response to the challenge of inauthenticity and "fears over the diminution of *kalarippayattu* as a necessarily *martial* art" is to say that *kalarippayattu* has not been engaged purely as theater by the traveling practitioners, but that it has become a daily practice that has "subverted" their existing embodiment (175; Alter 2004). Actors have developed a means of paying attention with their bodies, a "somatic mode of attention," that informs their work (Csordas 1993). Hence the issue of authenticity is resolved in quotidian engagement with the movements of *kalarippayattu*.

Stephen Chan, from the standpoint of comparative sociology combined with personal reflection, continues the theme of martial arts travel and self-construction in a transnational world. Chan is the inheritor of a private family system of Japanese martial arts and bases this highly personal account upon more than thirty years of experience in learning and teaching martial arts in Asia, Europe, and Africa. Like a riddle, the essence of Chan's account is located in the title of his essay, "The Oriental Martial Arts as Hybrid Totems, Together with Orientalized Avatars."[7] Here insights drawn from severe self-reflection reveal themselves through a hybrid of confessional autobiography blended with sociological critique.

By situating the oriental martial arts as "hybrid," Chan reflects not upon the combination of supposedly once "pure" martial traditions, but upon the recreation, reconstruction, and repackaging of Japanese martial arts (originating from Southern China via Okinawa) according to various national and international cultural demands, and upon his own dissemination of a "heretical" karate syllabus to Zambia and Zimbabwe, derived from lessons in New Zealand and from "dojo-hopping all over London" (191). Via "totems," Chan conveys how *traditional culture, whether martial or otherwise, is never how it seems,*" and shows that in Africa, with the commercialization of schools that arose from his own free-of-charge teaching he was "reduced finally to the substance of celluloid and video" (197). Chan as "oriental avatar" was displaced for "a hybrid of oriental appearance (vocabulary, costume, rituals) and African autonomy within African customary hierarchies. . . . The amalgam was held up as a totem that could not be defiled" (197). Chan makes a wry self-reference with his notion of "orientalized avatar" (200). He refers to his initial reception in Africa, where to be a Chinese man in the 1970s meant that he could feel safe in even the roughest areas due to the embodied fantasy of oriental invulnerability made transnational by the films of Bruce Lee. However, the avatar status is no longer relevant today, because, in Chan's words "democracy and neoliberalism have crowded out the idyll of the avatar," where Chinese identity may now merely convey the status of a racist immigrant storekeeper (196). Chan continues that "[t]here is nothing oriental any more. It is everything to do with a debate between internationalism and nationalism. . . . Whether orientalized or internationalized, [karate] is a form of paternalized control" (198).

D. S. Farrer's "Coffee-Shop Gods: Kung Fu in the Singapore Diaspora" resumes the themes of self-construction and transnational martial arts training through an ethnographic analysis of social memory in the maintenance of overseas Chinese identity among kung fu masters in the Southeast Asia. Farrer's essay is drawn from a thirty-month-long "performance ethnography" of Chinese kung fu in Singapore, augmented by visits to China, Malaysia, and Thailand in the company of Singaporean kung fu experts, and focuses primarily on Chin Woo (Jingwu) supplemented with findings from Hong Sheng Choi Lai Fut. The inquiry into social memory was prompted initially by people who asked how the kung fu masters could remember all the moves in the long routines they perform. Considering the role of embodied social memory in relation to practice and performance led Farrer to inquire not solely what the moves

represent or symbolically encode, but what it means to remember them. Such embodied remembering relates to a rich cultural tradition, one in which myth, legend, and story are maintained and transmitted through performance genres including Chinese opera, lion dance, and kung fu.

In order to learn Singaporean kung fu and come to an understanding of "the dagger society" (the Singaporean kung fu masters) the researcher must be prepared to "enter the coffee shop" (210). Considered as an external kitchen, and the primary social space outside of work and the home, the coffee shop is an important vehicle of the Chinese diaspora. Learning kung fu in Southeast Asia involves participating in the lives of the fictive kinship group, where the *sifu* takes on a fatherly or avuncular role. After each kung fu session kung fu practitioners would gather in their coffee shop, where the *sifus* would often debate the origin and meaning of the kung fu forms.

The stylized movements of kung fu contained within the set routines provide a rich vein of symbolic representation based upon the movements of animals, heroes, assassins, immortals, and deities, that often refers to the heroes of *The Outlaws of the Marsh* and *The Romance of the Three Kingdoms*. The most prevalent deity to appear in Singaporean coffee shops is Guan Gong, the God of War, claimed to be the founder of *ying jow* (Eagle Claw) kung fu and of *baguazhang* (Eight Trigrams). Guan Gong is normally depicted carrying a halberd, and kung fu practitioners learn to use this heavy weapon as part of their daily practice. However, the myths are of secondary importance to the ability to practice or teach kung fu, where the "coffee shop gods" are the human and not merely the symbolic patrons of the establishment.

According to Singaporean kung fu masters, much of the kung fu they teach was lost in China due to the Cultural Revolution and the promotion of modern *wushu*, regarded as martial dance. This led Farrer to conclude that "[t]he martial arts culture at its richest is produced through an active remembering, simultaneously enacted and immanent. . . . an external memory, the overseas Chinese martial arts exist as a vast reservoir of Chinese cultural capital, one that has the potential to be reinvested back into China" (203). To relegate martial practices to simply the performance of cultural or national identity merely demotes such activity to passive "pretence." In discussing the social significance of kung fu in Singapore with masters of the art in the coffee shops, where martial arts discourse is truly at home, Farrer reveals indigenous hostility and suspicion to such external, academic depictions.

Martial arts provide a lens into society that has led to a newly emergent field, that of martial arts studies. The essays in this volume clearly demonstrate that the martial arts and the way we talk about them are much more socially complex and intricate, subtle, multi-modal, and transnational than could be registered with conventional descriptors. The discipline of martial arts studies suggests and invites research upon such varied topics as social and cultural forms of violence, dance, and theater, social memory, political critique, nationalist reconstruction, cultural preservation, religious spirituality, psychological reframing, and a host of other richly varied forms of social activity. The phrase "martial arts discourse," more than anything else, provides a way to refer to the embodied practices that does *not* semantically divide muscular action from intellectual evaluation and appreciation *in limine*. As we have shown, martial artists throughout history have worked against this kind of semiotic apartheid. To phrase the matter in this way is certainly somewhat hyperbolic, but scholars attempting to write about martial arts within a university face an implicit Western bias against the body; the body becomes a subaltern object of inquiry. Within this context, there is an implicit and largely unchallenged pressure to disembody, to render abstract and general what is fleshy and alive. Martial arts studies, it is hoped, will approach martial arts training in relation to historically specific cultural contexts (that are themselves both magnified and threatened by transnational flows and globalization) in terms cognizant of the embodied cultural contributions offered by these unique forms of bodily, psychological, and spiritual training.

Notes

1. We would like to thank E. Teo, Kelvin Tze-how Tan, Angela Faye Oon, Loh Wai Yee, Chin Chun-yi, Heidi Virshup, Nirmala Iswari, and especially Rodney Sebastian for providing invaluable support as research assistants.

2. See Christina Klein (2004), "*Crouching Tiger, Hidden Dragon*: A Diasporic Reading" (*Cinema Journal* 43 [4]: 18–42) for a discussion of the ways in which martial arts practices such as "pushing hands" exercises become symbols of "Chineseness" in films such as *Pushing Hands* and *Crouching Tiger, Hidden Dragon*.

3. *JAMA* can be considered a kind of "beach head" publication, one in which the *forms* of high-class intellectual behavior (footnotes, professional style

guides, anonymous referee systems) interact with a content that has more often than not been deemed sub-intellectual.

4. One can present the mixture of materials in a dystopian manner (in which bad money drives out the good), or one can describe a ladder effect in which a proliferation of popular writing signifies a broad cultural significance warranting rather specialized investigations. We favor an upbeat approach, but one should be careful to avoid euphemism: as our non-practitioner colleagues have repeatedly pointed out to us when we mention "martial arts discourse," much of the writing has been the work of practitioners partial to a given system and perhaps even bound by allegiances to a particular teacher. Representations of this sort will fail to earn the credibility that (among university researchers) depends upon peer review and methodological premeditation modeled after the laboratory scientist. At its worst, such amateur work suffers from historicist, ethnocentric, and Orientalist overtones.

5. See http://www.hoplology.com/about.htm.

6. Or her life in *The Next Karate Kid* (1994), in which Hilary Swank would begin the series of gender-crossing roles that would later culminate in *Million Dollar Baby*, in which Western masculinity as symbolized by the flinty face of Clint Eastwood provides the missing magic.

7. The term "oriental" has different connotations in London than in New York. In New York "oriental" may generally be regarded as a derogatory term, but in the United Kingdom its use may simply be as a descriptive noun.

References

Alter, Joseph S. 1992. *The Wrestler's Body: Identity and Ideology in North India.* Berkeley: University of California Press.

———. 2000. "Subaltern Bodies and Nationalist Physiques: Gama the Great and the Heroics of Indian Wrestling." *Body and Society* 6 (2): 45–72.

———. 2004. *Yoga in Modern India: The Body between Science and Philosophy.* Princeton, NJ, and Oxford: Princeton University Press.

Amos, Daniel M. 1997. "A Hong Kong Southern Praying Mantis Cult. *Journal of Asian Martial Arts* 6 (4): 31–61.

Bennet, Alexander, trans. 2009. *Budō: The Martial Ways of Japan.* Tokyo: Nippon Budokan Foundation.

Blacking, John, ed. 1977. *The Anthropology of the Body.* London: Academic Press.

Brownell, Susan. 1995. *Training the Body for China: Sports in the Moral Order of the People's Republic.* Chicago: University of Chicago Press.

Cox, Rupert A. 2003. *The Zen Arts: An Anthropological Study of the Culture of Aesthetic Form in Japan.* Richmond: RoutledgeCurzon.

Csordas, Thomas J. 1993. "Somatic Modes of Attention." *Cultural Anthropology* 8 (2): 135–156.

———. 1999. "Embodiment and Cultural Phenomenology." Pp. 143–164 in Gail Weiss and Honi Fern Haber, eds., *Perspectives on Embodiment: The Intersections of Nature and Culture.* New York: Routledge.

de Grave, Jean-Marc. 2001. *Initiation rituelle et arts martiaux: trois ecoles de kanuragan Javanis.* Paris: Association Archipel.

Deleuze, Giles, and Félix Guattari. 2002. *A Thousand Plateaus: Capitalism and Schizophrenia.* Trans. Brian Massumi. Reprint. London: Continuum. Original edition *Mille Plateax,* Vol. 2 of *Capitalisme et Schizophréne,* Les Editions de Minuit, Paris, 1980.

Draeger, Donn F. 1972. *Weapons and Fighting Arts of Indonesia.* Boston: Tuttle.

Dumézil, Georges. 1970. *The Destiny of the Warrior.* Trans. Alf Hiltebeitel. Chicago: University of Chicago Press.

Elliot, Paul. 1998. *Warrior Cults: A History of Magical, Mystical and Murderous Organizations.* London: Blandford.

Farrer, Douglas. 2006. "Deathscapes of the Malay Martial Artist." *Social Analysis: The International Journal of Cultural and Social Practice,* Special edition on Noble Death, 50 (1): 25–50.

———. 2008. "The Healing Arts of the Malay Mystic." *Visual Anthropological Review* 24 (1): 29–46.

———. 2009. *Shadows of the Prophet: Martial Arts and Sufi Mysticism.* Muslims in Global Societies Series. Netherlands: Springer.

Foucault, Michel. 1988. "Technologies of the Self." Pp. 16–49 in Luther H. Martin et al., eds., *Technologies of the Self: A Seminar with Michel Foucault.* Amherst: University of Massachusetts Press.

Frantzis, Bruce Kumar. 1998. *The Power of Internal Martial Arts: Combat Secrets of Ba Gua, Tai Chi and Hsing-I.* Berkeley, CA: North Atlantic Books and Energy Arts.

Furuya, Kensho. 1996. *Kodo: Ancient Ways.* Ohara: n.p.

Green, Thomas A., and Joseph R. Svinth, eds. 2003. *Martial Arts in the Modern World.* Westport: Praeger.

———. 2010. *Martial Arts of the World: An Encyclopedia of History and Innovation.* Santa Barbara, California: ABC-CLIO.

Holcombe, Charles. 2002. "Theater of Combat: A Critical Look at Chinese Martial Arts." Pp. 153–174 in David E. Jones, ed., *Combat, Ritual and Performance: Anthropology of the Martial Arts.* Westport: Praeger.

Horowitz, Donald L. 2001. *The Deadly Ethnic Riot.* Berkeley: University of California Press.

Hsu, Adam. 1997. *The Sword Polisher's Record: The Way of Kung Fu.* Boston: Tuttle.

Hunt, Leon. 2003. *Kung Fu Cult Masters: From Bruce Lee to Crouching Tiger.* London and New York: Wallflower.

Hurst, G. Cameron. 1998. *Armed Martial Arts of Japan: Swordsmanship and Archery.* New Haven and London: Yale University Press.

Johnson, Charles. 1987. "China." Pp. 61–95 in *The Sorcerer's Apprentice: Tales and Conjurations.* New York: Penguin.

Jones, David E. 2001. *Martial Arts Training in Japan: A Guide for Westerners.* Boston: Tuttle.

———, ed. 2002. *Combat, Ritual and Performance: Anthropology of the Martial Arts.* Westport: Praeger.

Klein, Christina. 2004. "*Crouching Tiger, Hidden Dragon*: A Diasporic Reading." *Cinema Journal* 43 (4): 18–42.

Kondo, Dianne K. 1990. *Crafting Selves: Power, Gender and Discourses of Identity in a Japanese Workplace.* Chicago and London: University of Chicago Press.

Lowell Lewis, James. 1992. *Ring of Liberation: Deceptive Discourse in Brazilian Capoeira.* Chicago: University of Chicago Press.

Maliszewski, Michael. 1987. "Martial Arts." Pp. 224–229 in Mircea Eliade, ed., *Encyclopedia of Religion*, Vol. 9. New York: Macmillan and Free Press.

———. 1996. *Spiritual Dimensions of the Martial Arts.* Rutland: Tuttle.

MacCannell, Dean. 1976. *The Tourist: A New Theory of the Leisure Class.* New York: Schocken Books.

Mauss, Marcel. 1979. *Sociology and Psychology: Essays.* Trans. Ben Brewster. London: Routledge and Kegan Paul.

May, Todd. 2005. *Giles Deleuze: An Introduction.* Cambridge: Cambridge University Press.

Normandeau, Josette D. 2004. *À la rencontre des grands maîtres.* Québec: Les éditions de l'homme.

Ots, Thomas. 1994. "The Silenced Body-The Expressive *Lieb*: On the Dialectic of Mind and Life in Chinese Cathartic Healing." Pp. 116–138 in Thomas Csordas, ed., *Embodiment and Experience: The Existential Ground of Culture and Self.* Cambridge: Cambridge University Press.

Pauka, Kirstin. 1998. *Theatre and Martial Arts in West Sumatra: Randai and Silek of the Minangkabau.* Athens: Ohio University Center for International Studies.

———. 2002. *Randai: Folk Theatre, Dance, and Martial Arts of West Sumatra.* CD-ROM. N.p.: University of Michigan Press.

Payne, Peter. 1981. *Martial Arts: The Spiritual Dimension.* London: Thames and Hudson.

Plyler, Danny, and Chad Siebert. 2009. *The Ultimate Mixed Martial Arts Training Guide: Techniques for Fitness, Self Defense, and Competition.* Cincinnati, Ohio: Betterway Sports.

Prashad, Vijay. 2001. *Everybody Was Kung Fu Fighting: Afro-Asian Connections and the Myth of Cultural Purity.* Boston: Beacon Press.

Rashid, Razha. 1990. "Martial Arts and the Malay Superman." Pp. 64–95 in
 Wazir Jahan Karim, ed., *Emotions of Culture, a Malay Perspective*. Singapore:
 Oxford University Press.

Ratti, Oscar, and Adele Westbrook. 1973. *Secrets of the Samurai: The Martial Arts
 of Feudal Japan*. Boston: Tuttle.

Rojek, John, and Chris Urry. 1997. *Touring Cultures: Transformations of Travel
 and Theory*. London: Routledge.

Said, Edward. 1979. *Orientalism*. Random House: New York.

Salzman, Mark. 1986. *Iron and Silk*. Random House: New York.

Schmeig, Anthony L. 2005. *Watching Your Back: Chinese Martial Arts and Tradi-
 tional Medicine*. Honolulu: University of Hawai'i Press.

Shahar, Meir. 2008. *The Shaolin Monastery: History, Religion and the Chinese Martial
 Arts*. Honolulu: University of Hawai'i Press.

Smith, Robert W. [1974] 1990. *Chinese Boxing: Masters and Methods*. Berkeley,
 CA: North Atlantic Books.

Sudnow, D. 2001. *Ways of the Hand: A Rewritten Account*. Cambridge, Massa-
 chusetts: MIT Press.

Spivak, Gayatri. 1996. *The Spivak Reader*. Ed. Donna Landry and Gerald MacLean.
 New York and London: Routledge.

Tedeschi, Marc. 2000. *Hapkido: Traditions, Philosophy, Technique*. N.p.: Shambhala.

Turner, Bryan S., and Zheng Yangwen. *The Body in Asia*. New York: Berghahn
 Books.

Turner, Victor Witter. 1988. *The Anthropology of Performance*. New York: PAJ Pub.

Twigger, Robert. 1997. *Angry White Pyjamas: A Scrawny Oxford Poet Takes Lessons
 from the Tokyo Riot Police*. New York: HarperCollins.

Walker, Jearl. 1997. "Boiling and the Leidenfrost Technique." Pp. 533–536 in
 David Halliday, Robert Resnick, and Jearl Walker, eds., *Fundamentals of
 Physics*, 5th ed. New York: John Wiley.

Westbrook, Adele, and Oscar Ratti. 1970. *Aikido and the Dynamic Sphere: An
 Illustrated Introduction*. Boston: Tuttle.

Wiley, Mark V. 1997. *Filipino Martial Culture*. Rutland: Tuttle.

Zarrilli, Phillip B. 1998. *When the Body Becomes All Eyes: Paradigms, Discourses
 and Practices of Power in Kalarippayattu, a South Indian Martial Art*. New
 Delhi: Oxford University Press.

———. 2002. *Acting (Re)considered: A Theoretical and Practical Guide*. New York:
 Routledge.

Part I

Embodied Fantasy

2

Some Versions of the *Samurai*

The *Budō* Core of DeLillo's *Running Dog*

John Whalen-Bridge

"Dying is an art in the East."
"Yes, heroic, a spiritual victory."

—Don DeLillo, *Running Dog*

Yukio Mishima, the *budō* code, the Japanese guide for killer courtiers known as the *Hagakure*—these would not appear to be the important elements from a novel by Don DeLillo, arguably America's finest living novelist, but they are. *Running Dog* is his fifth novel and was published in 1978, in the wake of the Watergate scandal and the conclusion of America's military involvement in Southeast Asia. There have been many novels and films about America's failed involvement in Vietnam, and there have been innumerable reflections in film and other media forming American popular culture concerning America's fascination with Asia. *Running Dog* involves Vietnam tangentially and fears of rising criminality in American intelligence agencies centrally.[1] Seventies popular culture (e.g., films like *Three Days of the Condor* and *The Parallax View*) reflects popular fears about government secrecy and criminality, while Orientalist fantasies were in that decade more often kept in their own generic ghetto,

but DeLillo fuses these genres fruitfully. *Running Dog,* in the manner of postmodern parody, is a novelistic imitation of a crowd-pleasing, only vaguely political, spy thriller, but the novel contains within this apparently consumerist framework a much more searching critical reflection on what President Jimmy Carter termed the American "malaise." By presenting the *budō* path as the hero's alternative to an uncritical acceptance of this malaise, DeLillo connects the political crises of the late seventies to the increasing fascination—the seventies was the decade when everybody was kung-fu fighting—with various manner of Orientalist phenomena.[2] What is especially surprising to post-Saidian readers is the way in which DeLillo gives his Orientalist fantasia an anti-imperialist spin.

Joke and Pastiche: *Running Dog* as Spy Thriller and Postmodern Romance

If we were discussing the literature of the 1930s as Daniel Aaron does in his 1961 study *Writers on the Left,* we would identify the political affiliation of the writer by making connections between the books themselves and the authors' memberships, signed petitions, and participation in public political actions. According to such criteria, DeLillo would barely count at all as a "political writer," but the term now is used to draw attention to the symbolic action of the texts produced by such writers. Novels "hail" readers in ways that not only publicize but also construct political identities. Edward Said's study *Orientalism*—published in the same year as *Running Dog*—has arguably been the single most persuasive statement in the post-Vietnam era regarding the political significance of literary texts, and this text and others in its wake have realigned many critical judgments regarding what it means to be a politically progressive text.

A "politically progressive text" will, more often than not, fight a two-front war. When attacked from the Right, DeLillo is the "bad citizen" who makes it attractive to hate America. From the Left he has been discussed as a "Cold War" novelist, a "white male" writer, and a creator of "imperial romance" fantasies.[3] Defenders such as Frank Lentricchia have attempted to protect both flanks simultaneously by embracing the "bad citizen" label while asserting that the mainstream, as opposed to the margins, of American literature has been "bad" in DeLillo's way. Lentricchia then creates a canonical coalition of Leftist/progressive writers that intentionally disrupt the purifying strategies of the politically cor-

rect: besides DeLillo, the pantheon includes Morrison, Melville, Mailer, Didion, Doctorow (Lentricchia 1991: 3). Many critics would just as well jettison the notion of "political fiction" on the grounds that writers are powerful magicians in the realm of private imagination but utterly powerless as shapers of law or public values, but DeLillo, like the other writers Lentricchia mentions, will not entirely give up that ghost.[4] Even though he knows in advance that political fiction is completely harmless to those who usurp the powers of government to benefit antidemocratic profiteers, DeLillo, accepting in advance the "death of the novel," can be read as a samurai writer who is free to proceed in his attack precisely because he has fully accepted the notion that he must fail. Just because this battle cannot be won, it does not follow, for DeLillo, that such a battle is not worth losing. To train for his impossible mission, a samurai would enter a very specific form of apprenticeship, and a CIA agent would, as any consumer of Hollywood action films knows, spend some time at "Langley." DeLillo trained for this aspect of his career as a writer, I hope to suggest, by writing *Running Dog*.

DeLillo's novel brings together elements from several kinds of stories, and a short summary will show how DeLillo weaves together the martial arts and the political thriller fantasy. The characters in the novel come together around a MacGuffin in the form of a secret film of Hitler's final days in the Fuhrer's bunker, a film in which Hitler's own transgressive sexual practices will be revealed. A journalist named Moll Robbins investigates this possibility as part of her research for an article about the growing sex industry (porn films, mafia distribution networks, and so forth) for *Running Dog*, a magazine clearly modeled on *Rolling Stone*. To find out more about this film, she meets with Alan Lightborne at his gallery Cosmic Erotics. Lightborne is a dealer in erotica who hopes to come into possession of the film. At the gallery, Moll notices an attractive man who seems both bored by and knowledgeable about the subject of erotic art, Glen Selvy. He is actually an intelligence agent who has been planted in the office of Senator Lloyd Percival, a collector of erotica who is also investigating "PAC/ORD," a funding mechanism originally meant to support clandestine activities but which has become so successful that it threatens to make the CIA-like organizations it supports financially independent. Selvy is in Percival's office to obtain material to blackmail Percival at a later time. Selvy and Robbins become involved, which leads Selvy's superiors (Mudger and Lomax) to conclude erroneously that he has betrayed his mission, and Mudger insists on having Selvy killed. The

plot fails, and the middle section of the novel, "Radial Matrix," follows Moll's investigations of Percival and Mudger, while Selvy avoids assassination and Lightborne (and others, including representatives of the Mafia and pornographer entrepreneurs) attempt to secure control of the film. In the final section of the novel, "Marathon Mines," Selvy flees but in a way that guarantees his pursuers and he will meet at the Marathon Mines, where Selvy was trained to be an intelligence agent, and Robbins eventually gets to see the Hitler film with Lightborne, though she has no idea what has happened to Selvy. Selvy chooses to fight his pursuers with a machete of sorts rather than with guns; he makes a misstep and is killed and beheaded. His spiritual guru Levi Blackwater administers a specifically Asian form of Last Rights, one that is associated with the Tibetan process of "sky burial" in which the corpse is offered to scavengers for consumption.

The work presents readers with two kinds of failure, either of which might be recuperated as "spiritual victory." The investigative journalist Moll Robbins is working on an article for the magazine *Running Dog*, which, she explains, was intended as an ironic nod to Mao's condemnation of the running dogs and lackeys who support the American empire.[5] Like the magazine title *Rolling Stone*, the name "*Running Dog*" is a preemptive gesture of sorts, a check against taking oneself too seriously.[6] The ironic title strongly signifies that market capitalism has completely commodified resistance, though that is ultimately one moral of Don DeLillo's novel: Moll's editor is blackmailed by intelligence agents who in this way are able to block publication of her story. The idea that such institutions as *Running Dog* and *Rolling Stone* are relatively powerless responses to political and moral corruption is the central problem of the novel.

Moll's failure to get her story published figures more widespread feelings of political impotence about which DeLillo has often spoken. In post-Watergate America, the investigative journalist often stands for the possibility of speaking truth to power, of the pen being mightier than the sword, but *Running Dog* expresses grave doubts about this power of the pen, and it presents the reward of ironic laughter as a dubious compensation for such relative powerlessness. Moll's pen fails, and the novel becomes the story of Selvy's romantic, fatal attraction to the way of the sword.

The political implications of this turn are not simple. Moll's primary obstacle will turn out to be the military-industrial complex itself, as personified by ex-CIA agent Earl Mudger, who has set up essentially private companies to fund CIA activities the U.S. government declines to

support. Mudger's business arrangements are an extension of his activities in Vietnam. The suspicion that his company has become a for-profit entity rather than an extra-legal means to political ends erases the distinction between an intelligence mission and a Mafia operation. The attempts to check Mudger and Radial Matrix on the part of Senator Percival and Moll both fail. Though he shows great integrity while Moll's efforts seem comparatively impotent, Selvy's self-sacrifice might also seem utterly pointless, since his romantic martial path results in his being hunted down and beheaded by two former ARVN Rangers who now work for Mudger in the United States. If we are to interpret the paths of Robbins and Selvy allegorically, we have a choice between ironic impotence and futile self-assertion that is not even rebellion. In presenting the challenge to democracy represented by groups such as Radial Matrix, which largely stand for the unchecked power of market conditions over everyday life, the novel asks what one would have to do to not be a "running dog," a comprador who works happily with immoral forces or one whose resistance is so ineffectual as to amount to the same thing.

Killed and beheaded by Vietnamese assassins, Selvy dies a samurai death, though the word "samurai" is never mentioned in the novel. Selvy's life, shaped by ideals that correspond closely to the Japanese martial code known as budō, is a stark alternative to the corrupted paths elsewhere described in the novel and reveal Selvy's choice—to follow "the Way of the Samurai" that is "found in death" (Tsunetomo 1979: 17)—as heroic as it is bizarre. His quasi-suicidal question can be taken as a moment of Orientalist sensationalism, or we might choose to see it as that allegory of America's faltering self-image known as the "Vietnam syndrome"—the ARVN assassins are chickens coming home to roost. A third possibility exists as well: perhaps the Orientalist martial ideals described within the narrative represent the possibility of maintaining dignity in late 1970s America. If this is so, Selvy's anachronistic martial path suggests that we can be more than running dogs.

The novel gives fictional form to a widely understood ethos that is often called budō, which is frequently translated as "warrior code" but which really refers to a more complete value system. While the novel does not cite any of the samurai literature directly, the 1979 English translation of Hagakure: The Book of the Samurai—which clearly appeared too late to have been any kind of direct influence—consolidates in one text the essential elements of this code. William Scott Wilson, the translator of the 1979 text, closes his introduction with the following caveat:

it is perhaps best to state first what it is not: that is, a well-thought-out philosophy, either in the sense of containing a closely reasoned or logical argument, or in terms of subject matter. On the contrary, it contains an anti-intellectual or anti-scholastic bent throughout . . . (1979: 15)

As Wilson explains, attempts to discuss martial arts as a "philosophy," as more than a set of bodily exercises, often fail miserably, but *budō* designates much more than learning to fight. More than fighting but less than philosophy, *Hagakure* adamantly warns against efforts not contributing directly to the performance of one's specific role. Still, Wilson uses "philosophy" in his foreword to allow this qualified sense:

The philosophy of *Hagakure* represents an attitude far removed from our modern pragmatism and materialism. Its appeal is intuitive rather than rational, and one of its prime suppositions is that a person can go anywhere he likes by means of a simple cerebration. Intuition based on sincerity and moral guidance leads one back to the bedrock. (Wilson 1979: 7)

If we consider philosophy as a "way of life," as Pierre Hadot has recommended, then our presuppositions shift and it is possible to discuss "martial arts philosophy" more fruitfully. As opposed to just learning how to fight, which carries no particular political meaning, *budō* can signify both the means to effect change and the values justifying or delimiting such means.

In referring to *Hagakure* I may be guilty of overspecifying the path DeLillo imaginatively develops in his novel *Running Dog*, so I should say specifically at the outset that the novel borrows elements from a broad range of Orientalist discourses. The sword death and many moments throughout the text recall Yamamoto's classic descriptions and recommendations about samurai conduct, but Selvy actually dies with a Filipino guerrilla bolo in his hand. The bolo is a machete used by resistance fighters during the Philippine-American War that is popular in Filipino martial arts. In addition to references to Japanese martial arts and philosophy and to weapons from various systems, there are a number of references to Buddhism in the text, especially regarding practices related to death. Selvy's mentor Blackwater wishes to give him a Tibetan "sky burial" after he succumbs to his enemies. Before his death, Selvy asserts the legitimacy

of his choices to Blackwater, saying, "Dying is an art in the East," and it is this notion of an Orientalist association that is not merely a conceit or a representation but rather a set of values measured in terms of bodily price that especially interests DeLillo.[7]

Mixing Japanese, Philippine, and Tibetan traditions in this way may strike some readers as a careless totalization of Asian culture, but it seems much more likely, given the way characters in the story glibly acknowledge this mixture, that DeLillo is acknowledging the ways in which a pan-Asian identity is *constructed* for the purposes of affirming an embattled self. That the construction he produces is a fantasy composed of images and ideas from various historically distinct moments and traditions is perfectly obvious:

"What's that you got there?"

"Filipino guerrilla bolo."

"Where's your jungle?"

"I bought it for the name."

"You didn't get your money's worth unless a jungle came with it."

"I like the name," he told the old man. "It's romantic." (191)

In this highly self-reflexive moment, Selvy shows himself to be perfectly aware that 1) his romantic construction is a pastiche of fantasy elements, 2) purely practical elements are secondary at this time to his self-construction, and 3) he is consciously choosing what will turn out to be a "way of death." One could say the fantasy is "orientalist," but it is also "turning into a Western" at the same time. Most importantly, Selvy comes to realize that his life is a quasi-fictional construction, but this does not mean it is merely inauthentic or based on a deception. When Selvy's companion Nadine makes the suggestion that their journey is "turning into a Western," he says "What was it before?" (186), not merely making the postmodern joke in which characters discuss what kind of fiction they are in, but also bringing together the strange opposition at the center of Selvy's character: he is simultaneously a true believer and a thorough agnostic.

True Believer: The Samurai Way as
Alternative to Bankrupt Modernity

The various themes of *Running Dog* come into focus around Selvy's pursuit of a kind of martial purity of spirit, but DeLillo discloses Selvy's quest gradually after presenting several alternative notions about the relationship between body, society, and war. These alternatives in some ways conform to the binary division of "Eastern" and "Western" experience described by Said in *Orientalism*, though the "Western" bodily practices hardly come across as superior in DeLillo's account.[8] In addition to Selvy's samurai narrative, readers encounter three ways of relating to the body that are alternatives to Selvy's own quest. These are: 1) Western eroticism—the "god of the body" filling the contemporary void in belief; 2) absurdly commodified forms of Orientalist body practices, for example, "naked karate"; and 3) Eastern martial arts practices such as *t'ai chi* that subordinate individualism to a communal group ego. It needs to be stressed that, while DeLillo was not writing to an audience saturated with the language of postcolonial critique, he was nonetheless ironizing many of the Orientalist clichés that he appropriated for his text. By exploring three ways of looking at the body developed within the novel, we can see that an East-West binary was certainly a key imaginative device, but it would be incorrect to say that DeLillo naturalized such distinctions.

Of the three body "avatars" that the text offers to the reader, the first is "the god of the body."[9] The novel's opening moments are Western, sexy, and jarring, confusingly associating Western history with a shift from masculine warriorship to feminine enticement. The reader begins, to use Heidegger's word, in a state of thrown-ness, uncertain in the novel's first sentences where the words are coming from or where they are going: "You won't find ordinary people here. Not after dark, on these streets, under the ancient warehouse canopies. Of course you know this. That's the point. It's why you're here, obviously" (DeLillo 1978: 3). There is a guilty raciness to the scene, an exhilaration born of danger, and the scene is populated by homeless people and men "smoking in the dimness, waiting for the homosexuals to make their way down from the bars above Canal Street. You lengthen your stride, although not to hurry out of the cold. You like the stiffening wind" (3). "Stiffening wind" and the river's "musky tang" on this evening add to the atmosphere of illicit sexuality, but then "you" see strange graffiti spray-painted on a wall: "Mongrel scrawl. ANGW. But familiar somehow, burning a hole in time" (3). The reader does not know

yet that "you" are a minor character named Christof Ludecke, a cross-dressing German who is about to be murdered. The "mongrel scrawl," Ludecke understands, refers to a motto engraved on a ceremonial halberd: "Alles nach Gottes Willen" (4). Ludecke thinks, "Weapons have become godless since then. Weapons have lost their religion" (4). If weapons have become godless, what power will fill this void? For Ludecke, eroticism fills the void: "All according to God's will. The God of the Body. The God of Lipstick and Silk. The God of Nylon, Scent, and Shadow" (4). In this way, DeLillo introduces the erotic theme of the novel, suggesting that eroticism has replaced "God" as a source of motivation.

Several characters in the novel are driven by erotic hunger, and it seems likely that Ludecke is murdered because of his connection to a much-sought-after pornographic film of Hitler's final revels in the bunker. The pattern of associations—God with eroticism rather than righteous weaponry; eroticism with movement and a chase after ultimate kinds of degradation and scandal—resonates with descriptions of American por-notopia, the normal world of our increasingly sexualized culture.

At the same time this "God of the Body," insofar as it is con-nected with a sexualized *Gotterdammerung* in Hitler's bunker, indicates an apocalypse at the end of these culturally amplified desires. Western eroticism, once we have done the math, becomes a kind of death drive. Weapons, now godless, have been replaced not just by eroticism but by modes of eroticism characterized by unrestrained acceleration. Eros and capitalist growth each figure out the other, and so Moll, who is "plan-ning a series of articles on sex as big business" (14), seeks to uncover the links between intelligence agents, professional pornographers, high-level politicians, media gatekeepers, Mafia functionaries, and even Adolph Hitler.[10] In DeLillo's novel these entities circle and sometimes morph into each other with dreamlike ease. Erotic power, the "God of Nylon, Scent, and Shadow," appears initially as if it were merely a sign of New York decadence, but it then reveals itself as the displacement of phallic weaponry by commodified feminine objects of desire. In dressing like a woman, Ludecke—the man who possesses the lost Hitler film—is in obvious ways a marginal character, but he is also a disturbing sign of the times. This purportedly Western graduation from "godless" weapons to an empowerment of lipstick and stockings is presented in the novel as a decline in dignity, such as when the detective who discovers the body says that the blood is "royal" because it is that of a "queen" (8). Ludecke's body as it is perceived and understood by the worldly New York cops

who discover it, represents the erosion of codes connecting God, honor, and masculinity. If this "god of the body" is markedly Western, it is not obviously superior to some "Eastern" kind of body.

The next body-avatar in the series of three can be called "naked karate." Midway through the novel there is a scene in which Selvy, aware that someone may be pursuing him, sits in a bar to relax and perhaps to hide from danger. The man next to him asks, "You a TV type?" and Selvy says he is not, but the man continues his surreal and apparently random pitch just the same:

> What I'm doing is a contest to the death. Man versus polar bear. Combat supreme. Polar bear is vicious. Polar bear can decimate a herd of reindeer in a matter of minutes. I'm lining up this guy Shunko Hakoda. A sumo wrestler. He goes three-fifty, easy. His agent's hedging right now but I think we got the numbers. Meanwhile I'm negotiating with the president of Malawi to hold the fight there. I'm envisioning a large cage in the middle of a soccer stadium. You're asking yourself where we'll find a polar bear in Malawi. (116)

This passage must have seemed more surreal in the time before "reality television," but DeLillo's talent for capturing social absurdity gives the passage an edge over the culture's tendency to outflank the best efforts of satirists.[11] DeLillo sets this satirical gem within a setting of actual danger: "Selvy eased off the bar stool and walked out. He headed back toward Times Square, taking the same route. Naked karate. Pagan baths. A battle-scarred Cadillac moved slowly down Broadway" (116). Martial arts, DeLillo knows, can be a commodity like anything else, and events such as "naked karate" and the sumo-versus-bear television show satirically represent the modern equivalent of bearbaiting and other gory, gladiatorial spectacles. The fighting is stripped of any art or rules until there is only a raw vision of power, which results in a kind of pornography.[12] Selvy, alternatively, leaves the bar precisely when he does because he is being hunted, and he hides out in a striptease club that specializes in "nude storytelling" (118). DeLillo suggestively links "naked karate" and "nude storytelling" to show how either practice is rendered ridiculous when taken to its commodifiable extreme, but DeLillo offers more than surrealism in his conjunctions; "naked karate" and "nude storytelling" are two kinds of sex show, one showing the copulation of eros and aggression,

the other that of eros and narration itself. We note that Selvy is in no way ensnared by this world. Moll notices when she first meets him in the Cosmic Erotics gallery that he is uninterested in the materials about which he appears to have expertise.

Finally, the "corporate *t'ai chi* body" offers a form of transcendence, insofar as the martial discipline relieves one of the stress and pain of the individual, embodied self. In comparison with body practices that are associated with furtive eroticism or tasteless commodification, an insistently Orientalist body practice comes across in a way that shows, at the very least, technical admiration. Before we learn anything about Selvy's odd appropriation of the *budō* path, DeLillo presents readers with Selvy's momentary perception of a group of "Orientals" practicing a martial art in an open space. This paragraph sets the stage for the martial arts theme that the novel will develop. In this evocative passage the primary aesthetic effect is one of compression, drawing from the way cinematic sequences about martial arts movements use slow motion to express heightened power, and the primary shaping idea is that there is a kind of empowerment that comes from the subordination of the individual ego, an idea popularized in the United States through martial arts disciplines and Buddhist meditation practices. Here is what Selvy sees from his car window:

> Off the road a creek meandered east into the distance. In a park a group of young Orientals practiced the stylized movements of *t'ai chi*, a set of exercises that seemed to some degree martial in nature. The tempo was unchanging and fluid, and although there were eight of them involved it was hard to detect an individual dissonance in their routine. Almost in slow motion each man thrust one arm out while moving the other back, this second arm bent at the elbow, both hands extended, fingers together, as though the arms were hinged weapons. Moves and countermoves. Front leg bending, rear leg stretching. Active, passive. Thrust and drag. A breeze came up, the lighter branches on the trees rising slightly as their leaves tossed in the agitated air. Eight bodies slowly moving in a revolving lotus kick. The creek disappeared at the end of a stretch of elms, swifter here, running in the sun. (27–28)[13]

This passage does not seem to be ambivalent, but it is. Selvy's momentary view of martial artists practicing outdoors sets the stage for

DeLillo's more developed martial arts theme, but it is important to note that the prose-poem just quoted stylistically replicates the martial arts gestures that it describes. The "way" that is embodied in the group's orchestrated movements that are, like DeLillo's own harmonic paragraphs, fluid, balanced, subtle, and beautiful. All of this sounds quite positive, but the repression of individual personality in the group performance is linked specifically to Asian bodies, and the bodies themselves are coordinated and, at least temporarily, governed by a specifically Asian cultural practice. This subordination creates the conditions for artistic grace but this subordination is clearly a threat to personal integrity, insofar as one's integrity is defined (as it often is in American literature) by one's ability to resist demands to conform. DeLillo sometimes writes about this subordination of self with admiration (such as in the *t'ai chi* description just quoted, in which the balletic discipline is lovingly reproduced) and sometimes with revulsion (such as when the Moonies have a group wedding in the first pages of *Mao II*).

At the level of representation and at the level of style, Orientalist transcendence presents itself as lustrous and empowering. While the "tempo was unchanging and fluid," our perception of the action is slowed down considerably, and this alteration of perception is one of the special powers a martial arts practitioners seeks—the super-training of muscle and reaction that alters one's embodied relation to temporal experience. That Asians have a greater capacity for self-subordination (or are the victims of a kind of group mind) is the next detail unpacked from Selvy's drive-by perception: "although there were eight of them involved it was hard to detect an individual dissonance in their routine. Almost in slow motion each man thrust one arm out while moving the other back, this second arm bent at the elbow." As a spiritual or philosophical option, the martial arts path envisioned in this drive-by moment is attractive to Selvy, but the attraction seems as improper to him as it does to the post-Said reader, albeit for entirely different reasons.[14] When he sees a group of Japanese tourists all falling asleep at exactly the same time, he thinks, "This apartness he'd always found interesting in Asians" (187).

The three avatars mark an evolutionary path. The Western, masculine, God-blessed, and weaponized body has gone away, and a feminized erotic body takes its place. God is gone, but pleasure (including also the danger of predatory pursuit, sexual slumming, and so forth) remains. The absurd extreme of this commodification removes the direct risks of

predatory sexual relations, replacing this danger with the hyperkinetic, accelerating simulacra that DeLillo captures in the image of "naked karate," and which we can map to current trends in "reality culture." Compared to these choices, the Orientalist submission of self looks relatively better than it would if presented alone. If we pluck out the Orientalist theme in *Running Dog* and do not see its evolutionary position, we misconstrue it entirely.

After momentarily viewing the *t'ai chi* practitioners, in which the ego and body coexist without conflict, Selvy returns to his conversation with his immediate superior, Lomax, and this conversation illustrates the difficulties of living in a hyper-individualist culture: you are assumed to attempt rebellion even when you have no such aim. The novel's plot-lines become visible as Selvy and Lomax discuss the impure work that concerns them, namely, gathering information with which to blackmail Senator Percival, who has been investigating secret operations such as Radial Matrix:

> "We've got more than enough leverage to use against the Senator."
>
> "I don't make policy," Lomax said.
>
> "We've got the smut collection to use against him. His interest in this movie is just an added twist of the knife."
>
> "I execute policy, I don't make it. I do fact-gathering."
>
> "We know he's got pieces that once belonged to Goering."
>
> "People ask me questions. I frame a reply in terms of giving an answer." (28)

Lomax is always associated with his dogs (though we do not see him running them; he often rides with them in his limo as if to demonstrate that spies, too, enjoy the comfortable life. He has all the accoutrements of conventional success, and he dissociates himself from the results of his actions, explaining to Selvy that he is merely following orders. His name sounds like "low max" or "low maximum," signaling extreme banality; it is against this backdrop of lowness and crudity that we perceive Selvy. Lomax fully recognizes Selvy's superior commitment, such as when he

says to the novel's diabolical personification of business as murder, Earl Mudger: "Selvy's more serious than any of us. He believes. You ought to see where he lives. . . . Buried in some rat-shit part of the city. Isolated from contact. He'd do it for nothing, Selvy. The son of a bitch believes" (141).[15] Though Lomax gently suggests to Mudger that Selvy may not be guilty of any disloyalty, Lomax of course "does not make policy," and so he does not endanger himself by offering significant resistance to the "adjustment"—meaning the assassination—Mudger demands. Presenting Selvy in contrast to Mudger and Lomax in this manner underscores Selvy's romantic qualities.[16] Selvy's spy craft within the novel is limited to attempts to purchase erotic art for Senator Percival and attempts to defend his own life, but he has no real interest in pornography, no personal motives that present as character flaws. Presumably he was trained to commit acts that most DeLillo readers would find politically and morally objectionable, but these kinds of actions are only hinted at in the novel. Within the realm of spying and intelligence work, Selvy is a true believer dedicated to spy craft, and he will follow the logic of his role "to its final unraveling" (56). He is a thoroughly dedicated romantic artist. Perhaps we could say that Selvy is a "formalist," like the poet who disdains the notion that poetry carries particular meanings and wishes, instead, that the poet be judged by how the content is expressed rather than by truth or utility of any particular message.

"Unraveling" indicates failure, but Selvy's path—his discovery that it is his fate to be an American samurai—is at once a failure and a success. It is important to understand that *budō* means more than "martial arts practice," as it specifically refers to martial arts discipline *as a spiritual path*, a definition that makes an implicit claim upon our respect that will very likely arouse readers' skeptical resistance.[17] Such a quest seems ridiculous in contemporary times, as Yukio Mishima pointed out in his own introduction to the *Hagakure*, and Moll, the character whom DeLillo describes in an interview as the novel's moral "weathervane" (DePietro 2005: 7), represents the feet-on-the-ground secularity that many readers of the novel will share: "Moll was suspicious of quests. At the bottom of most long and obsessive searches, in her view, was some vital deficiency on the part of the individual in pursuit, a meagerness of spirit" (224). Moll's position on Mishima's own botched *seppuku* ceremony is not hard to imagine, and it is easy to see why Mishima was wary that *Hagakure* could be read by the wrong kind of reader.[18] To the right reader, to a

"samurai reader," the text would be a spiritual path, but to readers such as Moll, the spectacle of men cutting their stomachs open to win honor would only be a symptom of "some vital deficiency."[19]

A samurai is characterized by an ethos that exceeds technical skill, though the acquisition of such skills remains essential. Selvy's skills are revealed when he literally comes under fire. Until the attempt on his life, Selvy comes across as handsome, assured, and detached from the processes around him in ways that befit our expectations for a "spy" or "secret agent," but the attempt on his life forces him to reveal his highly impressive martial training. When "the first three-round burst took out the bartender and sent glass flying everywhere," Selvy throws Moll to the floor until "she was aware of Selvy's hand leaving his hip with a gun in it" (65). Showing an almost superhuman focus,

> Selvy took a head-on position, prone, to avoid presenting too wide a target. He noted muzzle flash. Gun bedded in his hand, he moved his fingertip to the trigger and applied pressure, straight back and unhurriedly, letting out his breath but not completely, just to a point, holding it now as the gun fired, only then exhaling fully. (65)

The repetitive movements described in the *t'ai chi* passage are linked vaguely to weapons and to the creation of mature reactions to attacks that will not require pause for thought, and the repetitive training that makes possible the repose Selvy demonstrates during the assassination attempt in Frankie's Bar is described later in the novel: "At the range he worked on stance, breath control, eye focus. The idea was to build up a second self. Someone smarter and more detached. Do this perfectly and you've developed a new standard for times of danger and stress" (83). Weapons are often described in almost religious terms in this novel, and Selvy "found it reassuring to handle their parts, to know their names and understand their functions. Attention to detail is a form of vigilance" (83). The agent's relationship to training and weapons involves technology and technique, but very clearly the relationship between the warrior, his weapons, and the practices of self-making far exceed the technical requirements of a CIA agent in Selvy's position: "There were no shadings in his willingness to use the stopping force at his disposal. This was very clear, this resolve. It affirmed his bond to the weapon itself" (83). The

gun is not just something to *use*, it is something to which one must be true. It is unusual for a *gun* to signify codes of discipline and honor in this way; usually, in Orientalist cinema and other media through which ideas about *budō* are popularized, a sword carries this burden. Eventually Selvy will switch from gun to sword, and an examination of the samurai way helps understand why.[20]

To use terms like "samurai" or *budō* is to indicate something more than a fighter or a warrior, and this difference amounts in large part to the code of discipline that governs such a life. Martial arts scholar William Scott Wilson explains the idealist potential implicit in both *budō* and samurai by looking at their derivations:

> I would say that the code developed when the leaders of the warrior class began to reflect on their position in society and what it meant to be a warrior. They first began to write these thoughts down as *yuigon*, last words to their descendents, or as *kabegaki*, literally "wall writings," maxims posted to all their samurai. Samurai itself is an interesting word, coming from the classical *saburau*, "to serve." So when we understand that a samurai is "one who serves," we see that the implications go much farther than simply being a soldier or fighter. (Wilson 2007)

The samurai is not the Luciferian rebel whose powers allow revolt, but rather, one whose martial mastery bespeaks a life of self-overcoming. Idealistic associations of this sort have been essential to the popularization of Asian martial arts practices in non-Asian countries. The idealistic distinction implied by this sort of code rationalizes and moralizes martial arts training within those spheres of modern life in which a person is almost never supposed to fight. Parents are encouraged to take their children to karate and other kinds of martial arts schools so the story goes so that they will learn to fight because they have learned how. For a fighting school to be called a "*dojō*" instead of merely a gym, it is understood that a spiritual dimension, rather than just a technical one, hence the phrase "affirmed his bond to the weapon itself" (83). There are martial arts that focus intensively on just the drawing of the sword (e.g., *Iaido*), but an art of "gun-do" sounds ludicrous. Selvy's "bond with his weapon" is not a typical trademark of his training but is rather the sort of detail that distinguishes him from those who have undergone the same training.

Selvy as DeLillo:
Death as a Spiritual Discipline, Writing as a Martial Art

Selvy's path is anything but *budō*, despite some apparent similarities; we find *budō* values in the non-accidental deficiencies of his intelligence training. His formal training as an agent takes place at a location called Marathon Mines, the fateful location to which he returns for the novel's final fight. In order to become part of what is supposedly the most elite intelligence unit in the country,

> he attended classes in coding and electronic monitoring. There was extensive weapons training. He took part in small-scale military exercises. He studied foreign currencies, international banking procedures, essentials of tradecraft. For the first time he heard the term "funding mechanism." (153)

The technical training does not involve codes of honor but rather modes of fighting that exist outside of legal frameworks or agreements such as the Geneva Conventions: "A great deal of time was spent studying and discussing the paramilitary structure of rebel groups elsewhere in the world" (153), which strikes Selvy as especially odd. He finds it "curious that intelligence officers of a huge industrial power were ready to adopt the techniques of ill-equipped revolutionaries whose actions . . . were contrary to U.S. interests. The enemy" (153). At the mines Selvy studies the *tieu to dac cong*, "the special duty unit considered the most danger-ous single element in the VC system" (153) and learns fighting skills of the highest order. The contradictions between the primal authenticity of raw fighting techniques and the parallel lessons in paper-shuffling and Orwellian redescription do not disturb Selvy especially at this point in the novel; if these contradictions cause Selvy to seek out Blackwater, that possibility is not presented in any direct manner, though it is clearly part of his training to learn how to continue to function in the pres-ence of what should be overwhelming disturbances or contradictions. His response to the attempt on his life in Frankie's Bar reveals the "sec-ond self" under fire, both literally and then figuratively. As the *t'ai chi* practitioners subordinated self to "routine" (27), Selvy's learned method of coping with the most intense pressure imaginable is to sink into his "routine" (82). Directly after the attack this subordination of conventional self involves an absolutely technical perception of events, which shocks

Moll. Selvy-the-Formalist explains matters to Moll precisely, but Moll is perturbed by his detachment: "'He had his right elbow at the wrong angle. He had it pointed way down. Your elbow should be straight out, parallel to the ground, firing that particular weapon.' 'Jesus, will you stop?' she said. 'Will you tell me what happened?'" (66)

The point is not that Moll is shocked by the events whereas Selvy is magically unperturbed, as we expect of the Hollywood martial arts superman. In a three-page subsection about Selvy's response to the shooting, we see him sitting alone in a room, at once holding himself together and falling apart. DeLillo allows the idea of "routine" to exfoliate in ways that bring out the specific disciplines involved and also the inner workings of such a routine: "He hadn't shaved in two and a half days, the first time this had happened since his counterinsurgency stint at Marathon Mines in southwest Texas, a training base for paramilitary elements of various intelligence units and for secret police of friendly foreign governments" (81). The routine taught him to do certain things automatically, including shaving every day, maintain combat gear properly, choose appropriate seats in a plane or on a train, and only have sex with married women. "These were personal quirks mostly, aspects of his psychic guide to survival" (81). Breaking the "sex with married women" rule, however, costs him his life, in that his association with the frizzy-haired journalist who has no motive to keep secrets dovetails with one or two other facts in ways that allow for the mistaken impression that Selvy is a traitor and so directly lead to his "adjustment."

He tells himself that the failure to shave and inappropriate sex are "minor lapses." This passage describes what might be Selvy's most impressive martial capacity:

> [T]he routine still applied. That's what mattered most. The routine applied to the extent where he didn't actively speculate on who that might have been who was standing in the doorway of that run-down bar directing automatic fire across the room, or what the reasoning behind it was, or who was supposed to get hit. (83)

The passage ends with a tough-guy punch line to underscore the fact that the routine saves Selvy from consuming himself with dread, even though it seems likely that someone is trying to kill him. "He didn't build models of theoretical events surrounding a criminal act. Nor did he con-

cern himself with policy" (82). In this respect, Selvy's training resonates strongly with the essentials of *budō*: *Hagakure* insists on the "substance of the Way of the Samurai. If by setting one's heart right every morning and evening, one is able to live as though his body were already dead, he gains freedom in the Way. His whole life will be without blame, and he will succeed in his calling" (Tsunetomo 1979: 17–18).

Spiritual training is not a top priority at the mines, though Selvy does meet Levi Blackwater there, and it is Blackwater who teaches Selvy about meditation and other Asia-associated practices. Significantly, DeLillo withholds details of Selvy's training until the climax of the novel. Before we learn about Blackwater and Selvy's specific intelligence training, readers learn that Selvy believes codes of conduct are important. Early in the novel, during a scene in Frankie's Bar that occurs prior to the assassination attempt, the novel gives its first signal that Selvy has chosen to live by martial codes and disciplines of the sort that other characters around him would find impractical, strange, or even appalling. In response to a barfly's claim that it was the "code" of "Frankie's Tropical Bar" that drunks such as himself be helped home, Selvy says "I believe in codes" and then helps the drunk (33). The context is anything but dignified, and so the reader won't know what to make of "I believe in codes" just yet. In this ludic moment, Selvy's belief in codes comes wrapped in parodic self-awareness. In and around the drunken stumblers, "the routine still applied."

After the botched attack in Frankie's Bar, Mudger and Lomax reconnoiter at Mudger's home to discuss the fact that Selvy successfully defended himself. Odd props hint at Mudger's history: there is a Buddhist shrine on the wall, perhaps put there by his wife Tran Le who is Vietnamese (93).[21] When Mudger asks why "the subject" was carrying a gun and why he wasn't alone in the bar, Lomax confesses he doesn't know (95). Talking shop about assassination (95), they laughingly agree that the job should not have been given to someone called "Augie the Mouse" (94). Lomax even takes considerable pride in Selvy's abilities:

> "That's not your average man in the street they'll be dealing with," Lomax said. "I have to tell you I felt a little surge of pride or satisfaction or what-have-you when I got word he walked out of the bar without a mark on him. Plus putting a bullet in the Mouse. I felt gratified, Earl, truth be known. Certain amount of my own time and effort invested there.

This is the best penetration I've run, frankly. I don't think your adjusters will find this just another day's work." (95)

As Selvy immerses himself in one kind of routine, Lomax and Mudger wrap themselves in another, in a shop-talk language that displaces through its jokey banter, the murderous heart of their topic, namely, the plusses and minuses of assassinating a member of one's own group. DeLillo is an accomplished black humorist, and this passage, in which Lomax takes great pride in the development of a person even as he tarries over the details of the person's assassination, is one among the most darkly funny moments in DeLillo's *oeuvre*. The "adjustment," it is understood all around, is not personal. As if to show proper respect for the person being killed, it should be handled by a technically proficient *professional*, not someone called "Augie the Mouse."

Mudger decides to assign Selvy's adjustment to the former Vietnamese Rangers Van and Cao, who form a *tieu to dac cong* unit. As a result of this pursuit, Selvy is forced to strip down his life in ways that clarify its meaning; he comes to a realization about his own path, about the fascination it has held for him over the years. "It was all becoming clear. He was starting to understand what it meant. All that testing. The polygraphs. The rigorous physicals. The semisecrecy. All those weeks at the Mines. Electronic Code-breaking. Currencies. Weapons. Survival" (183). Selvy comes to understand in this moment what it is about these particular disciplines that have given them the power to hold his world together: "What it meant. The full-fledged secrecy. The reading. The guns. His regard for precautions. How your mind works. The narrowing of choices. What you are. It was clear, finally. The whole point. Everything" (183). Then, capping this suggestive list of lessons finally absorbed and fully understood in an instant, the meaning of Selvy's life fits cleanly into one sentence: "All this time he'd been preparing to die" (183). Selvy's realization resonates powerfully with the most famous sentence from the classic samurai manual known as *Hagakure*, "the Way of the Samurai is found in death" (17).

Reading Don DeLillo's *Running Dog* alongside *Hagakure* leaves the powerful impression that DeLillo's novel, published in 1978, received a great deal of inspiration from the collection of parables and stories that is well known mainly to martial arts practitioners, but the Yamamoto text was not translated into English until 1979 when William Scott Wilson's Kodansha translation was published. Perhaps Kathryn Sparling's 1977

translation of Mishima's 1967 commentary *Hagakure Nyūmon: The Way of the Samurai: Yukio Mishima on Hagakure in Modern Life* could have been a direct source for DeLillo, but the timing makes direct influence seem rather unlikely. Perhaps the narrative traveled as an angry ghost without textual embodiment. After the Japanese novelist's extraordinary suicide in 1970, which was certainly a world event among literary people, the *Hagakure* became, as Mishima would have liked, a bestseller in Japan: perhaps a writer like DeLillo learned a great deal about this enigmatic Japanese text even before it was translated into English. It is not necessary to prove that DeLillo had access to any particular book to show that the *budō* ideals of some sort haunt DeLillo's novel, especially since filmic representations of Asian-specific honor codes were becoming increasingly common in the 1970s, but *Hagakure* resonates more clearly than any other text.[22]

That Selvy likes codes and that his story has affinities with the samurai ethos as propounded by *Hagakure* would seem to suggest that we are dealing with one stable codified set of values when we discuss "the samurai code," but we cannot assume so much. In his highly enthusiastic appraisal of the text, Mishima discounts the possibility that *Hagakure* could be read properly or authentically by modern readers, and Mishima's anxiety underscores the exclusivity of the text's force and appeal, at least as Mishima understood it: "At present, if *Hagakure* is read at all, I do not know from what point of view it is approached. If there is still a reason for reading it, I can only guess that it is for considerations completely opposite to those during the war" (Sparling 89). To make sense of the text, we must at least consider it within the absolutist terms in which it presents itself. For Mishima, the proper reader of the text is one who has, himself, embraced death in advance: "in evaluating the impact of *Hagakure*, it becomes an important question whether or not the *readers* are samurai. If one is able to read *Hagakure* transcending the fundamental difference in premise between [Yamamoto's] . . . era and our own, one will find there an astonishing understanding of human nature" (33). My supposition in reading *Running Dog* in the light of *Hagakure* is not that DeLillo had anything like a death wish—as Mishima clearly did, as becomes evident when he complains of "our enormous frustration at not being able to die" (89)—but rather that DeLillo's novel reenvisions the warrior's death-fidelity against the modernist or the postmodernist grain as a source of self-respect rather than a symptom of pathology. When Mishima insists that embracing death in advance is a path toward

greater self-respect, he celebrates the samurai's heroism at the expense of ordinary life, which Mishima found undignified. "The philosophy of *Hagakure* represents an attitude far removed from our modern pragmatism and materialism" (Sparling 17), aspects of modernity that Mishima found corrupting.

Speaking in an interview about the failings of American life during this period, DeLillo comments on Moll's awareness of avarice and political maneuverings: "The evil, or whatever we call it, is there. We can't position these acts and attitudes around a nineteenth-century heroine. They float in a particular social and cultural medium. A modern American medium. Half-heartedness and indifference are very much to the point" (DePietro 2005: 7). Whatever we might say about Selvy's ultimately self-destructive adamancy, it is not "half-hearted."

At several junctures the samurai classic illuminates DeLillo's novel. If we look at two passages side-by-side, one from the *Hagakure* and one from *Running Dog*, we see that both texts proceed from a common paradox that we might call "empowerment through submission," a phrase that might apply to religious disciplines more generally. The most famous passage from *Hagakure* explains that the voluntary renunciation of survival as one's top priority is the gateway to freedom:

> Negligence is an extreme thing. The Way of the Samurai is found in death. When it comes to either/or, there is only the quick choice of death. It is not particularly difficult. Be determined and advance. To say that dying without reaching one's aim is to die a dog's death is the frivolous way of sophisticates. When pressed with the choice of life or death, it is not necessary to gain one's aim. (Tsunetomo 1979: 17)

The samurai must be aware in advance that "conscience doth make cowards of us all" (*Hamlet* III.1.83), and he must understand *in advance* that "either/or" will spoil the quality of his action if he fails to make the proper advance preparations. Like the ideal retainer who knows that "negligence is an extreme thing," Selvy realizes, especially when he returns to the mines to face his pursuers, what was most essential about his martial training: "All that incoherence. Selection, election, option, alternative. All behind him now. Codes and formats. Courses of action. Values, bias, predilection." "Choice," Selvy realizes, "is a subtle form of disease" (192). The samurai code depends primarily upon acquiescence

to the demands of one's mission even at the cost of death, and Selvy exemplifies this sort of acquiescence whether the matter at hand is large or small. Early in the novel, Lomax reminds Selvy about their respective roles, and Selvy presents his different view without pressing the point:

> Both men knew this wasn't a complaint. It was an indirect
> form of acquiescence, a statement of Selvy's willingness to blend
> with the pattern, to travel an event to its final unraveling.
> All the way back, Lomax remained slumped in his jump
> seat, talking to the dogs. (56)

Lomax's affinity with dogs (as opposed to birds of prey, to which Selvy is drawn) shows him to be one of the novel's clear examples of a "running dog" in Mao's sense. Selvy's commitment, though described as "acquiescence," is also an indictment of Lomax's more conventional acquiescence. Even when Selvy is just following orders, he does so with what might be called a purity of heart. This wholeheartedness is a striking alternate to the manner of other characters in the novel.

The novel was written and published in the years following the American withdrawal from Vietnam and measures a shift in consciousness among Americans that occurs as a result not only of America's failure in Vietnam but also events such as the JFK assassination. "I think that what has been missing for the past twenty-five years is a sense of the coherent reality most Americans share" (DePietro 2005: 28). DeLillo links this shared consciousness to conspiratorial gaps or repressions in American history: "Documents are lost or concealed. Official records are sealed for fifty or seventy-five years. A curious number of suspicious murders and suicides. And I think this current runs from November of 1963 right through Viet Nam and Watergate, and into Iran Contra" (DePietro 2005: 28). The feeling of blockage and loss and the fear that historical memory has been manipulated so as to forestall democratic accountability are very much at the heart of *Running Dog*, especially if we think of Moll's failure to publish her work and her editor Grace's compliant submission to blackmail. The repression is forced in the novel, but DeLillo also worries that writers censor themselves, that they are "too ready to be neutralized" (97) and are therefore "one beat away from becoming elevator music" (97).

Moll's story illustrates the social forces that blunt the writer's edge. In the final counterpoint of the novel, Moll finally gets to see the Hitler film, and she feels that Hitler has been able to mock us from beyond the

grave when, instead of indulging in some kind of paraphilia as expected, he imitates Charlie Chaplin at a children's party. "I expected something hard-edged. Something dark and potent. . . . The perversions, the sex. Look, he's twirling a cane," Lightborne says (237). "A disaster." "Hitler humanized" is Moll's wry summary, though she confirms with Lightborne that all the children were killed with cyanide. The cynical image of Hitler looking into the camera and getting a last laugh is balanced against Levi Blackwater's somewhat frustrated attempt to provide Tibetan Buddhist last rights for Selvy.

Hitler is "humanized," Lomax and Mudger block the exposé, and Selvy is beheaded by his enemy so that Blackwater cannot perfectly complete his "*lama* function" (245)—and yet these final, finely orchestrated expressions of despair are belied by the fact of the novel itself. The author of *Running Dog* knows all the reasons why it is futile to attack the Mudgers of the world, and yet DeLillo wrote the book. What must the writer do if he chooses to take on the doomed mission of identifying the hidden work of the Mudgers of this world? While DeLillo has steadily denied that he has a "political program" (DePietro 5005: 38), he has also affirmed that "we need the writer in opposition, the novelist who writes against power, who writes against the corporation or the state or the whole apparatus of assimilation" (97).[23] During the Iran-Contra hearings, DeLillo reports with pride to an interviewer "that to find the roots of the Iran-Contra [scandal] all you had to do was look at *Running Dog*," a novel in which a CIA company, initially a "conduit for espionage," becomes "a vast profit-making apparatus on its own" (28). For DeLillo, secret intelligence networks have been able to empower themselves by pretending to be part of an ideological struggle rather than a way of doing business.

Hope of attaining one's aim, Yamamoto warns in *Hagakure*, is an inadequate approach to life: "When pressed with the choice of life or death, it is not necessary to gain one's aim." While DeLillo does not claim that he seeks ideas worth dying for or anything of that sort, the qualities that make Selvy most interesting are the qualities DeLillo asserts are most essential to the novelist:

> Obsession is interesting to writers because it involves a centering and a narrowing down, an intense convergence. . . . When it comes to writers being obsessed, I have one notion. Obsession as a state seems so close to the natural condition of a novelists at work on a book that there may be nothing else to say about it. (DePietro 2005: 13)

Selvy may very well be an ironic, self-deprecatory revelation of what a novelist must become, a mordant self-image expressing the novelist's dark knowledge of political futility, but Selvy does not get the final word in *Running Dog*. The strangely mystical CIA agent Levi Blackwater has the role of putting the pieces together when the most important pieces are missing. His Tibetan sky burial is a tantric ritual, and perhaps Blackwater, rather than Selvy, is the figure that best stands for the novelist's potential and responsibility.

Doomed Selvy hones his Filipino guerrilla bolo with a whetstone, but DeLillo survives to do more than passively extract ideas and images from pulp fiction, formulaic popular cinema, and the discourse of Orientalism, and he is not limited to ironic impotence. A *tantric* artist works with energies and images (of anger, of desire) that other Buddhist teachers, for example, those in the Theravada tradition would repress or scorn. Just as a student practitioner of Vajrayana (Tantric) Buddhism cultivates enlightenment by working with defilements (anger, lust, and envy) in ways which other Buddhist traditions rigorously abstain, DeLillo as a tantric artist takes dangerous and questionable cultural practices (Orientalist fantasy, in this case) as a means to clarify confusion muddying the stream of American culture. Selvy is a fantasy, a fake and outrageous construction, but from such materials DeLillo has constructed not only *Running Dog* but an extraordinary *oeuvre* of novels that offer resistance to the cultural conditions that made them possible.

Notes

1. I would like to thank Heidi Virshup, D. S. Farrer, Ross G. Forman, Barbara Ryan, and Helena Whalen-Bridge for helpful criticisms of this essay.

2. One need not accept uncritically the mythos of a prior, prealienated golden age within Japanese *budō* in order to show how writers like DeLillo use such notions. See Shun (198) for a critique of uncritical acceptance of the antiquity of *budō*.

3. McClure associates DeLillo's novel with Reagan's reframing of American foreign policy in the wake of the Iran hostage crisis, arguing that "DeLillo both disputes the new crusade romance" (in which American freedom would increasingly be set against Islamic terrorism) "and offers a revised romance that resembles it in problematic ways" (1994: 121). For McClure, "late imperial romance" is a form in which "the locus of quest and redemption has simply been shifted . . . away from the collective and the political to the individual and the spiritual," a relocation which DeLillo ironizes (57).

4. Nardin and Sherman's *Terror, Culture, Politics* includes no mention of the statements by writers such as Sontag, DeLillo, Didion, Mailer, among others. Films and comic books displace novels not just as objects of consumption but also as places of imaginative refuge. For example, there is only passing reference to one living writer in the Nardin/Sherman collection of essays—Tony Kushner, mentioned because he contributed to a volume put out by Marvel comics. A famous literary scholar, Elaine Scarry, contributed two essays, but neither is about literature. The essay that mentions Kushner is entitled "Captain America Sheds His Mighty Tears: Comics and September 11," and it concerns the progressive, antiwar discourse of Marvel's *411* series, to which Kushner contributed.

5. "People of the world, unite and defeat the U.S. aggressors and all their running dogs! People of the world, be courageous, dare to fight, defy difficulties and advance wave upon wave" (Mao 1967).

6. Anthony DeCurtis notes that the fictional magazine "that gives DeLillo's novel *Running Dog* its title bears some resemblance to *Rolling Stone*" (DePietro 2005: 53).

7. We observe with disapproval the Orientalist appropriation in which, in films such as *The Last Samurai*, the white hero acquires powers from the Asian Other, reifies differences between the Oriental and Occidental mind, and in various ways aids and abets the colonial domination of Asia in ways that prop up a Western communal identity. This kind of Orientalist appropriation is alive and well, but it would be an extremely superficial reading of *Running Dog* that failed to see the ways in which DeLillo's novel doubles back on the cultural materials of which it has been composed. See Tierney's "Themes of Whiteness in *Bulletproof Monk, Kill Bill*, and *The Last Samurai*" on the persistence of Hollywood Orientalism.

8. Said famously defines Orientalism as "a style of thought based upon an ontological and epistemological distinction made between 'the Orient' and (most of the time) 'the Occident.' Thus a very large mass of writers, among whom are poets, novelists, philosophers, political theorists, economists, and imperial administrators, have accepted the basic distinction between East and West as the starting point for elaborate theories, epics, novels, social descriptions, and political accounts concerning the Orient, its people, customs, 'mind,' destiny, and so on. *This* Orientalism can accommodate Aeschylus, say, and Victor Hugo, Dante and Karl Marx" (1979: 2–3).

9. Video game enthusiasts and networks of online gaming and cyber-socialization use the term "avatar" to designate a fictive identity or role. The bodies that present themselves to the readers as "embodying" lived responses to the problems of modernity are clearly stylized fictional choices. They are avatars: fantasy bodies through which we may enter into a socially organized embodied fantasy. The compensatory nature of this fantasy is an essential plot mechanism in the 2009 movie *Avatar*, in which person who is paralyzed in the real world becomes super-agile when his consciousness is transposed into an avatar body.

10. This business comes to involve representatives from various walks of life such as a seedy merchant (Alan Lightborne), a U.S. senator (Everett Percival), several Mafia characters, and a series of secret intelligence operatives. The erotica chased by various agents is a source of danger and shame. It would be a great embarrassment for the senator, who has a massive collection of erotica, to be found out. Lightborne attempts to sell crude items by claiming they are art.

11. See Murray and Ouellette (2004).

12. A number of versions of no-holds-barred "cage fighting" currently exist, though media commodification will always bring with it insurance policies, basic safety measures, advertising contracts, and so forth. Mixed martial arts competitions are generally run through large organizations such as UFC (Ultimate Fighting Championship) and Pride FC (Pride Fighting Championship). MMA can be classified as an "extreme sport" with rules against techniques such as biting and eye-gouging, which one would find in a hand-to-hand combat training course. While the polar bear match or naked karate tournaments are clearly absurd, the public appetite for spectacles of raw aggression, including both martial arts and choreographed expressions such as WWF (World Wrestling Federation) professional wrestling is huge. The man in the bar who speaks to Selvy may seem ridiculous, but his entrepreneurial instincts, looking back after three decades, appear to have been quite sound.

13. While it is hard to be sure how old *t'ai chi* is as a distinct tradition, one study traces currently practiced forms back to the mid-1500s (Wile 1996: 34). Da Liu, whose *T'ai Chi Ch'uan and I Ching* was published in 1972, began teaching it at the United Nations in 1955 (Komjathy 2004.). A general history of postwar American religion states that t'ai chi centers were common in the United States by the mid-1970s (Allitt 2003: 141).

14. While there has been less attention given to spirituality in *Running Dog*, there have been several articles that approach DeLillo as a spiritually engaged artist, often reclaiming him from those who, assigning him to the category "postmodern" and defining all items in that category as antireligious, simplify DeLillo's expression. McClure begins "Postmodern/Postsecular: Contemporary Fiction and Spirituality" by squaring off against Jameson's claim that "spirituality virtually by definition no longer exists: the definition in question is in fact that of postmodernism itself" (1995: 141). Also see Little (1999), Packer (2005), Born (1999), Glover (2004), and Hungerford (2006).

15. Mudger is often seen, Vulcan-like, hammering hot steel or fashioning knives.

16. Longmuir traces the connections between the difficult-to-define thriller genre and the ideological celebration of masculine individualism in "Genre and Gender in Don DeLillo's *Players* and *Running Dog*": "an ideology of extreme individualism underpins this genre" (2007: 130). Longmuir argues convincingly that the thriller is a constant resource in DeLillo's *oeuvre*: "DeLillo's fiction has displayed a consistent interest in the power relationship between individuals and

the society or culture that they inhabit. The thriller, with its characteristic opposition of the single figure against a conspiring group, offers DeLillo a ready-made vehicle with which to explore one of the questions that dominates his fiction" (131–132), namely, the question of whether this autonomous, self-sufficient self can really exist. While I would endorse most of Longmuir's arguments, we have alternate readings of the novel's conclusion. For Longmuir, DeLillo acknowledges that "the masculine ideology" is "fundamentally flawed" and so he "demonstrates instead that it is only feminine subjects, who acknowledge the impossibility of wholeness, who achieve any kind of agency" (144). Longmuir is correct that Moll acknowledges the shortcomings of the masculine project of self-completion, but Moll is clearly frustrated by her role as gangster's moll, as a "mafia girlfriend" who gets to know about the worst secrets of the society but cannot reveal them. For Longmuir, "Selvy is able only to conform slavishly to existing cultural narratives," whereas "Moll and Nadine are able to script themselves by subverting generic conventions. Moll and Nadine's critical and self-conscious employment of cultural narratives allow them to make and re-make themselves, in a fashion that results in some kind of self-expression, after the genres of thriller and the Western have proven inadequate to the task" (144).

17. Buddhism is often taken to be the antithesis of "martial." This commonplace assumption presents itself as paradox in TV shows like *Kung Fu*, in which the phrase "I don't want to fight" by the peaceful wandering monk almost always precedes his masterly martial response to someone else's aggression. The paradox of the peaceful Zen warrior is parodied in the film *A Fish Called Wanda*, in which the macho fop played by Kevin Kline comically confuses Buddha and Nietzsche's *Übermensch*.

18. To my knowledge, DeLillo has not commented directly on Mishima's suicide, but, like Gary Harkness commenting on a piece of Scotch Tape on a wall in *End Zone*—he assumes that the tape must have held up a poster of Wittgenstein, and that the owner of the poster, Taft Robinson, must have been more interested in the Wittgenstein work that was unsayable—I suppose that DeLillo responded to Mishima's death in much the same way as he responded (through the creation of Gary Harkness) to Wittgenstein's language. When asked by an interviewer about the Wittgenstein references in his work, DeLillo said that he found the language fascinating because it was at once so bizarre and yet so confident; he called it "Martian language." See Stuart Johnson's (1985) discussion of DeLillo's use of Wittgenstein in *End Zone*.

19. If Selvy has a deficiency, DeLillo presents him almost entirely in terms of mastery and skill; Moll may be right about Selvy, or the comment may indicate more about her own subject-position: perhaps she protects herself by seeing those who are on a "quest" in terms of weakness rather than drive.

20. See Goh (2006) for a discussion of the anachronistic sword in recent cinema such as the *Highlander* and *Kill Bill* films. For Goh the anachronistic

sword carries a regular "double-edged" quality. The sword at once expresses "the incessantly and brutally competitive nature of capitalist society" (85), but at the same time the sword's anachronistic placement in contemporary contexts: "the wider cultural practice of the sword suggests that it is invested with quasi-spiritual essences of entrepreneurial power, charismatic leadership, romantic independence, or a combination of these and other similar connotations" (73).

21. Tran Le is the name of the First Lady of the failed South Vietnamese regime supported by the United States. "Madame Nhu, also known as Madame Ngô Đình Nhu and born Trần Lệ Xuân, was considered the First Lady of South Vietnam from 1955 to 1963; (born 1924 in Hanoi, Vietnam)." http://www.123exp-biographies.com/t/00034160614/, accessed 2 July 2008.

22. The code at once requires that one defend one's personal integrity and also transcend the self. Bruce Lee's cinematic revenge fantasies of the early 1970s were accompanied by his own articulation of martial arts as a path beyond attachment to the self, *The Tao of Jeet Kune Do*. Films such as *Seven Samurai* (1954) and television shows such as *Kung Fu* (1973–1975) demonstrate that the Asian martial code was freely circulating through cinema audiences. Sydney Pollack's film *Yakuza*, starring Robert Mitchum, is a perfect example of an anachronistic sword film.

23. Writers often deny a "political program," but a number of readers have found in DeLillo a literary-political hero. According to Frank Lentricchia, DeLillo "represents a rare achievement in American literature—the perfect weave of novelistic imagination and cultural criticism" (1991: 83).

References

Aaron, Daniel. 1961. *Writers on the Left: Episodes in American Literary Communism.* New York: Harcourt, Brace and World.

Allitt, Patrick. 2003. *Religion in America since 1945.* New York: Columbia University Press.

Castro, Erwin de, B. J. Oropeza, and Ron Rhodes. 2007. *Enter the Dragon? Wrestling with Martial Arts Phenomenon Part One: the Historical-Philosophical Backdrop.* http://home.earthlink.net/~ronrhodes/Martial1.html, accessed 5 September 2007.

Born, Daniel. 1999. "Sacred Noise in Don DeLillo's Fiction." *Literature and Theology: An International Journal of Theory, Criticism and Culture* 13 (3) (September): 211–121.

Chan, Stephen. 2003. "The Performativity of Death: Yukio Mishima and a Fusion for International Relations," *Borderlands* 2 (2): 1–13.

DeLillo, Don. [1972] 1986. *End Zone.* New York: Penguin.

———. 1989. *Running Dog.* New York: Vintage Books.

DePietro, Thomas. 2005. *Conversations with Don DeLillo*. Jackson: University Press of Mississippi.

Dewey, John. 1980. *Art as Experience*. New York: Perigee.

Fields, Rick. 1991. *The Code of the Warrior*. New York: HarperCollins Publishers.

Fu, Poshek, and David Desser, eds. 2000. *The Cinema of Hong Kong: History, Arts, Identity*. New York and Oakleigh, Melbourne: Cambridge University Press.

"Girl, Reignited." 2002. *The Guardian*. http://film.guardian.co.uk/features/featurepages/0,,835359,00.html, accessed 20 July 2007.

Glover, Christopher S. 2004. "The End of DeLillo's Plot: Death, Fear, and Religion in White Noise." *Americana*. http://www.americanpopularculture.com/archive/bestsellers/delillos_white_noise.htm, accessed 20 December 2007.

Goh, Robbie B. H. 2006. "Sword Play: The Cultural Semiotics of Violent Scapegoating and Sexual and Racial Othering." *Semiotica* 160 (¼): 69–94.

Hadot, Pierre. 1995. *Philosophy as a Way of Life*. Trans. Michael Chase. Cambridge, MA: Blackwell Publishers.

Heimert, Alan. 1963. "*Moby-Dick* and American Political Symbolism." *American Quarterly* 15 (4): 498–534.

Hungerford, Amy. 2006. "Don DeLillo's Latin Mass." *Contemporary Literature* 47 (3) (Fall): 343–380.

Hutchinson, Stuart. 2000. "'What happened to Normal? Where is Normal?' DeLillo's *Americana* and *Running Dog*," *Cambridge Quarterly* 29 (2): 117–132.

Johnson, Stuart. 1985. "Extraphilosophical Instigations in Don DeLillo's *Running Dog*." *Contemporary Literature* 26 (1) (Spring): 74–90.

Keesey, Douglas. 1993. *Don DeLillo*. New York: Twayne Publishers.

Komjathy, Louis. 2004. "Tracing the Contours of Daoism in North America." *Nova Religio* 8 (2)(November): 5–27.

Lentricchia, Frank.1991. *New Essays on White Noise*. Cambridge, UK: Cambridge University Press.

———, and Jody McAuliffe. 2003. *Crimes of Art and Terror*. Chicago: University of Chicago Press.

Little, Jonathan. 1999. "Ironic Mysticism in Don DeLillo's *Ratner's Star*." *Papers on Language and Literature* 35 (3): 301–332.

Longmuir, Anne. 2007. "Genre and Gender in Don DeLillo's *Players* and *Running Dog*." *Journal of Narrative Theory* 37 (1) (Winter): 128–145.

Ludlum, Robert. 1984. *The Bourne Identity*. New York: Bantam.

Lyotard, Jean-Francois. 1984. *The Postmodern Condition*. Trans. Geoff Bennington and Brian Massumi. Minneapolis: University of Minnesota Press.

Mao, Tse-tung. 1967. People of the World Unite and Defeat the U.S Aggressors and All Their Lackeys. http://www.marx2mao.com/Mao/PWU67.html, accessed 13 July 2007.

Maltby, Paul. 1996. *Mysticism: Experience, Response and Empowerment*. University Park: Pennsylvania State University Press.

McClure, John A. 1994. *Late Imperial Romance*. London: Verso.

———. 1995. *Modern Fiction Studies* 41 (1) (Spring): 141–163.

Mishima, Yukio. 1979. *Yukio Mishima on 'Hagakure': The Samurai Ethic and Modern Japan*. Harmondsworth, Middlesex: Penguin Books.

Mullen, Bill. 1996. "No There There: Cultural Criticism as Lost Object in Don DeLillo's *Players* and *Running Dog*." Pp. 113–139 in Ricardo Miguel Alfonso, ed., *Powerless Fiction?* Amsterdam and Atlanta: Rodopi.

Murray, Susan, and Laurie Ouellette, eds. 2004. *Reality TV: Remaking Television Culture*. New York: New York University Press.

Nardin, Terry, and Daniel J. Sherman, eds. 2006. *Terror, Culture, Politics: Rethinking 9/11*. Bloomington: Indiana University Press.

O'Donnell, Patrick. 1992. "Engendering Paranoia in Contemporary Narrative." *Boundary 2* 19 (1) (Spring) New Americanists 2: National Identities and Postnational Narratives: 181–204.

Packer, Matthew J. 2005. "'At the Dead Center of Things' in Don DeLillo's *White Noise*: Mimesis, Violence, and Religious Awe." *Modern Fiction Studies* 51 (3): 648–666.

Prashad, Vijay. 2000. *The Karma of Brown Folk*. Minneapolis: University of Minnesota Press.

———. 2001. *Everybody Was Kung Fu Fighting*. Boston: Beacon Press.

Prete, Laura Di. 2005. "Don DeLillo's *The Body Artist*: Performing the Body, Narrating Trauma." *Contemporary Literature* 46 (3): 483–510.

Rowe, John Carlos, and Rick Berg, eds. 1991. *The Vietnam War and American Culture*. New York: Columbia University Press.

Said, Edward. 1978. *Orientalism*. New York: Pantheon.

Shakespeare, William. 2001. *Hamlet*. Ed. A. R. Braunmuller. New York: Penguin Books.

Shun, Inoue. 1998. "'Budo': Invented Tradition in the Martial Arts." Pp. 83–94 in Sepp Linhart and Sabine Fruhstuck, eds., *The Culture of Japan as Seen through Its Leisure*. Albany, NY: State University of New York Press.

Sun-Tze. 1993. *The Art of War*. Trans. Roger T. Ames. New York: Ballantine Books.

Tierney, Sean M. 2006. "Themes of Whiteness in *Bulletproof Monk*, *Kill Bill*, and *The Last Samurai*." *Journal of Communication* 56 (3) (September): 607–624.

Tsunetomo, Yamamoto. 1979. *Hagakure: The Book of the Samurai*. Trans. William Scott William. New York: Kodansha International.

"Vietnam Syndrome." N.d. *Wikipedia*. http://en.wikipedia.org/wiki/Vietnam_Syndrome, accessed 19 June 2007.

Wile, Douglas. 1996. *Lost T'ai-chi Classics from the Late Ch'ing Dynasty*. Albany: State University of New York Press.

Wilson, William Scott. 2007. "An Interview with William Scott Wilson." http://www.kodansha-intl.com/books/html/en/9784770029423.html, accessed 14 July 2007.

Film

A Fish Called Wanda. 1988. Dir. Charles Crichton. MGM.

Avatar. 2009. Dir. James Cameron. Twentieth Century Fox.

Bourne Identity. 2002. Dir. Doug Limon. Universal Studios.

The Parallax View. 1974. Dir. Alan J. Pakula. Doubleday Productions.

The Yakuza. 1975. Dir. Sydney Pollack. Warner Bros. Pictures.

Three Days of the Condor. 1975. Dir. Sydney Pollack. Paramount.

The Fantasy Corpus of Martial Arts, or, The "Communication" of Bruce Lee

Paul Bowman

. . . embodiment is itself a mode of interpretation, not always con-
scious . . .

—Judith Butler, "Competing Universalities"

Ten Things You Need to Know about Bruce Lee

One day in 1973, in America, a young writer-to-be, Davis Miller, went
to the cinema, as he often did, to see a movie, as he often did—any
old movie, just a movie—because that's what he liked to do. He writes:

> The picture that night was *Enter the Dragon*. The house
> lights dimmed, flickered, went out. The red Warner Brothers
> logo flashed.
>
> And there he stood. There was a silence around him.
> The air crackled as the camera moved towards him and he
> grew in the centre of the screen, luminous.
>
> This man. My man. The Dragon.

One minute into the movie, Bruce Lee threw his first punch. With it, a power came rolling up from Lee's belly, affecting itself in blistering waves not only upon his onscreen opponent, but on the cinema audience.

A wind blew through me. My hands shook; I quivered electrically from head to toe. And then Bruce Lee launched the first real kick I had ever seen. My jaw fell open like the business end of a refuse lorry. This man could fly. Not like Superman—better—his hands and his feet flew whistling through the sky. Yes, better: this wasn't simply a movie, a shadow-box fantasy; there was a seed of reality in Lee's every movement. Yet the experience of watching him felt just like a dream.

Bruce Lee was unlike anyone I (or any of us) had seen. (Miller 2000: 4)

This encounter changes Miller's life. In his account of this moment, Miller eloquently conveys an experience—his experience—singular, intimate, personal. But it is also an experience that has been shared in common by innumerable people in innumerable situations, all "alone," yet all sharing something in common. We can see this same process, this same experience, in many accounts, in the most diverse places: pervading popular culture; in many forms of literature from many countries; and even in all sorts of academic work. All of these accounts describe this same moment: once, I was one way; then I saw Bruce Lee, and that was the day everything changed.

But, I can almost hear the complaint: hang on a minute—isn't Bruce Lee just that 1970s chop-socky martial arts star? Of course. Yet, anyone interested in the relations between popular culture and cultural politics needs to know a few things before deciding whether to dismiss Bruce Lee as just a seventies celluloid flash in the pan. Ten things, in fact.

First, Bruce Lee was the first Asian male lead in what the movie posters for *Enter the Dragon* proudly declared "the first American produced martial arts spectacular," in 1973.

Second, Bruce Lee was the first Asian male to (co)star on American TV. First, in *The Green Hornet* in 1966 and then in *Longstreet*. (He nearly starred in his own brainchild, an idea that became the TV series *Kung Fu*; but the producers thought that an Asian lead was too risky,

even though the lead character, Caine, was meant to be half Chinese. So instead, the entirely white David Carradine was orientalized for the role.)

Third, in the words of Davis Miller: "in the three years immediately preceding his death Bruce Lee revolutionized the martial arts and forever changed action movie-making. He became the first truly international film luminary (popular not only in the United States, Great Britain and Europe, but in Asia, the Soviet Union, the Middle East and on the Indian subcontinent—in those pre-Spielberg days [when, it must be remembered] people in most nations were not particularly worshipful of the Hollywood hegemony)" (Miller 2000: 96).

Fourth, Bruce Lee was born in America, raised in Hong Kong, a child star in dozens of Hong Kong films, catapulted to fame in Asia thanks to his role as Kato in *The Green Hornet*; the breaker of all box office records with, first, his Hong Kong martial arts films *The Big Boss* and *Fists of Fury* and then the Hollywood and Golden Harvest co-produced *Enter the Dragon*—a film that was "global" to a hitherto unprecedented extent.

Fifth, Bruce Lee almost single-handedly introduced kung fu into Western popular consciousness and discourse. If everybody was kung fu fighting, this owed almost everything to Lee.

Sixth, along with this introduction of kung fu into global popular culture, a whole lot more was introduced or amplified besides: Western interests in China, Taoism, Buddhism . . .

Seventh, in the mid to late 1960s Bruce Lee was experimenting with interdisciplinarity in martial arts practice and preaching both an antidisciplinary and an egalitarian philosophy. He was training according to any method or approach that "worked" and training anyone who would "work," regardless of age, gender, or ethnicity.

Eighth, the impact and effects of Bruce Lee on cinematography and fight chorcography is still being felt the world over (although rarely acknowledged), in filmic contexts as diverse as Disney and Pixar animations, Manga, action dramas of all orders, from *Raiders of the Lost Ark*, to *Buffy the Vampire Slayer*, to *Fight Club*, to *The Matrix*, and way beyond, up to and including the many elements of Bruce Lee choreography, camera angles, editing, and orchestration that are palpably stamped all over such recent martial arts films as the 2008 American produced *Forbidden Kingdom* or the 2008 Hong Kong produced *Ip Man*.

Ninth, the impact of Bruce Lee on martial arts practice, the world over, is still being felt.

Tenth, the cultural and perhaps even "political" status and signifi-cance of all of this remains unresolved.

Bruce Lee has always been construed as a figure who existed at various crossroads—a kind of chiasmatic figure, into which much was condensed, and displaced. His films, even though in an obvious sense being relatively juvenile action flicks, have also been regarded as spanning the borders and bridging the gaps not only between East and West, but also between "trivial" popular culture and "politicized" cultural movements (Brown 1997; Morris 2001; Prashad 2001; Kato 2007). For, although on the one hand, they are all little more than fantastic choreographies of aestheticized masculinist violence; on the other, they worked to produce politicized identifications and modes of subjectivation that supplemented many popular-cultural-political movements: his striking(ly) nonwhite face and unquestionable physical supremacy in the face of often white, always colonialist and imperialist bad guys became a symbol of and for multiple ethnic, diasporic, civil rights, antiracist, and postcolonial cultural move-ments across the globe (Prashad 2001; Kato 2007).

Both within and "around" his films—that is, both in terms of their internal textual features and in terms of the "effects" of his texts on certain viewing constituencies—it is possible to trace a movement from ethnonationalism to a postnational, decolonizing, multicultural imaginary (Hunt 2003). This is why his films have been considered in terms of the interfaces and interplays of popular culture, postcolonial, postmodern, and multiculturalist issues that they have been deemed to "reflect," engage, dramatize, explore, or develop (Abbas 1997; Hunt 2003; Teo 2008). Lee has been credited with transforming intra- and inter-ethnic identification, cultural capital, and cultural fantasies in global popular culture, and in particular as having been central to revising the discursive constitutions and hierarchies of Eastern and Western models of masculinity (Thomas 1994; Chan 2000; Miller 2000; Hunt 2003; Preston 2007).

In the wake of such well-worn approaches to Lee, I want to add a couple of dimensions. The first is to suggest that Bruce Lee's celluloid cinematic interventions—no matter how fantastic and fabulous—ought to be approached as texts and contexts of cultural translation (Chow 1995). This is not simply to refer to translation in a linguistic or hermeneutic sense. It is rather to be understood as something less "literal" (or logo-centric); as what Rey Chow calls "an activity, a transportation between two "media," two kinds of already-mediated data" (Chow 1995: 193).[1] Thus, the notion of "cultural translation" demands that we extend our

attention beyond the scripts and into the matter of the very medium of film itself, the relations between films, between film and other media, and lived bodily practices, and so on.[2] Second, I want to suggest that cultural translation here amounts to an "event," perhaps precisely in Alain Badiou's sense. Moreover, what Chow's approach to cultural translation allows us to see very clearly is that even the supposedly pure Badiouian or Pauline event is predicated on some rather messy and impure conditions of possibility, such as the material media supervening the debased realms of transnational popular culture within which we live, think, and act.[3] Chow's point is:

> the translation between cultures is never West translating East or East translating West in terms of verbal languages alone but rather a process that encompasses an entire range of activities, including the change from tradition to modernity, from literature to visuality, from elite scholastic culture to mass culture, from the native to the foreign and back, and so forth. (192)

It is here that Bruce Lee should be placed. However, given the complexity of this "place"—this relation or these relations—it seems likely that any translation or indeed any knowledge we hope might be attained cannot henceforth be understood as simple unity-to-unity transport. This is not least because the relations and connections between Bruce Lee and—well—anything else, will now come to seem always shifting, immanent, virtual, open-ended, ongoing, and uncertain. This is so much so that the very notions of completeness, totality, or completion are what become unclear or incomplete in the wake of "cultural translation." In other words, this realization of the complexity of cultural relations, articulations, and encounters jeopardizes traditional, established notions of translation and knowledge-establishment. Yet, it does not "reject" them or "retreat" from them. Rather, it transforms them.[4]

There is a lot more that could be said about this theoretical perspective. But I will spare you further elaboration, for now.[5] Not least because it might be observed that to bring such a complicated theoretical apparatus to bear on Bruce Lee films seems quite excessive anyway. It seems this way because most dubbed and subtitled martial arts films from Hong Kong, China, or Japan have traditionally been approached not with cultural theories to hand but rather with buckets of popcorn and crates of beer.

For, as Kwai Cheung Lo argues, they have overwhelmingly been treated as a source of cheap laughs for Westerners (Lo 2005: 48–54). Moreover, as Leon Hunt has noted, what kung fu film fans "loved" in these films, what their "Asiaphilia" was all about, seems mainly to have been their "mindlessness"—the mindless violence of martial arts. Like Lo, Hunt suggests that therefore even the Asiaphilia of Westerners interested in Eastern martial arts "subtly" amounts to yet another kind of Orientalist "encounter marked by conquest and appropriation" (Hunt 2003: 12).

Nevertheless, the appeal of Bruce Lee and putatively mindless chop-socky kung fu films has never really been simple. As Bill Brown observes, it actually took scholarship a rather long time to make any sense of the massive popularity in the West of Eastern martial arts. Some journalists in the early seventies, however, did touch on something important when they suggested, usually in rather un-PC ways, that it all seemed to have something to do with ethnicity: martial arts in the United States exploded first within black and Hispanic communities. Some white commentators seemed to worry about this. However, the film industry cottoned on quite quickly that the black audience was a serious dollar: so, the first entirely U.S. and "U.S.-lensed" martial arts film was *Black Belt Jones* (1974). And, yes, the Jones with the black belt was himself, of course, black.

Retrospect has allowed both scholarly and popular discourse to agree that the historical moment of the entrance of Bruce Lee (basically: 1973) can be drawn as a historical conjuncture characterized as overwhelmingly organized by two interrelated forces. The first was America's grieving attempts to come to terms with the traumas of Vietnam. Thus, in Hollywood films we see various codes for "Vietnam" throughout the seventies, eighties, and even nineties: China, Okinawa, Japan, Korea, and indeed anything to do with the "yellow" East in general all often clearly stand for "Vietnam." The second was the familiarization and normalization—the wholesale commodification and domestication—of countercultural motifs (the exotic, the other) of sixties radicalism. This is indexed by the installation of these motifs right at the heart of mainstream popular culture. There is perhaps no better example of this than *Enter the Dragon*.

But Bruce Lee does not simply amount to commodification in the entirely negative sense that Marxist criticism often gives to the term. T. M. Kato (2007), for instance, offers an argument about the way in which this commodification generates an excess that is not comprehended by the commodifying system itself. So, even though produced by and operating at the very heart and pinnacle of the consumer industry and even

though being the very essence of the spectacle (as pure simulation), the image, the simulacrum, carried a political charge and had progressive cultural-political effects.

Indeed, Kato suggests a connection between Bruce Lee and what is termed "popular cultural revolution." This connection, says Kato, is "expressed in two narrative modes: symbolic articulation and kinetic articulation" (Kato 2007: 41). By this, Kato refers to the way in which the narrative and choreographic styles, techniques, and formulas employed by Bruce Lee's films tapped into ongoing struggles in ways that appealed to certain constituencies at a particular historical political moment—a moment Kato characterizes as dominated by "decolonization struggles." Thus, for Kato, in Lee, it's not just that the underdog wins, but who the underdog is, the way the underdog wins, and who he beats. This suggests that the "reality" of Lee's relation to wider struggles is a visibility produced by the combination of two factors: first, the encoding of historical and ongoing cultural struggles, dramas, and conflicts within the semiotic structure of the text, combined with a context of reception in which the interpretive tendencies of the audience are more or less attuned or inclined toward seeing such connections. This is why, although many films and dramas employ the same sorts of familiar devices as those that are found in Bruce Lee films—devices that are little more than dramatic and semiotic clichés—in a certain time and place, these can become politically affective. Thus, asserts Kato, "only through rigorous historical and social contextualization can this symbolic narrative become legible, thereby unfolding the means by which it liberated the unconscious of the Asian people faced with the image of colonization by the neo-imperialist cultural industry" (40). As such, for both Kato and many other thinkers (including Vijay Prashad), the decisive factor about Lee that "connects" him with other contexts and scenes relates to the convergence of his films' dramatization in condensed form of ongoing tensions, resentments, and ethnically inflected power imbalances. Bruce Lee films offer the possibility of politicizing consciousness—of producing what Foucault or Deleuze might term a visibility.

Seeing an Event

The movement from superlative physical violence to supreme calm is reiterated regularly throughout *Enter the Dragon* (1973), and this central

image shapes everything else we can say about the film. Repeatedly, Bruce Lee fights, wins, stops; is utterly calm. He bests hordes of opponents; then sits down in the lotus position. He kills a man, waits; walks away. Amid the mayhem of a mass battle, he sees his enemy, stops, ignores all else, walks toward him. My basic claim is that this reiterated rhythmic cycle encapsulates the fundamentals of the *event* of Bruce Lee. My overall proposal is that Bruce Lee was indeed an "event"—a *cultural event*—and not merely a moment confined only to the realms of cinema. Rather, this rhythmic motif, reiterated by Bruce Lee, enabled (or completed) a profound transformation in Western *discourses* and in Western *bodies*. What "happened" when Bruce Lee "happened" signals a displacement, a transformation, in many registers and realms: public, private, discursive, psychological, and corporeal, in transnational popular culture. Finally, my aim in this chapter is to argue that, in the words of Jacques Derrida, "what happens in this case, what is transmitted or communicated, are not just phenomena of meaning or signification," for "we are dealing neither with a semantic or conceptual content, nor with a semiotic operation, and even less with a linguistic exchange" (Derrida 1982: 309). We are dealing with an *event*.

The philosopher Alain Badiou argues that events are *encounters* that cannot be communicated as such—at least not in any conventional sense of the term "communication." As Badiou puts it:

> Communication is suited only to opinions. . . . In all that concerns truths, there must be an *encounter*. The Immortal that I am capable of being cannot be spurred in me by the effects of communicative sociality, it must be *directly* seized by fidelity. That is to say: broken . . . with or without knowing it, by the eventual supplement. To enter into the composition of a subject of truth can only be something that *happens to you*. (Badiou 2001: 51)

In its simplest form, the event of Bruce Lee boils down to this: in viewing Bruce Lee, something happened to many people. But what was it that happened? And how? If there is a "change" as a result of an encounter with the cinematic text, then, in the words of Rey Chow, what is clear is "the visual encounter and the change, but not *how* the visual encounter caused the change." Thus, Chow suggests: "The central question in all visual encounters boils down to this simple *how* . . . how do we go about explaining the changes it causes in us?" (Chow 1995: 7)

Bruce Lee Changing the Subject

This event or emergence first took place, as we have seen, at a certain historical moment, post-sixties radicalism and in the shadow of Vietnam. But, of course, the entrance of the dragon was primarily a cinematic event on the order of what postmodernists called the "simulacrum," namely, of the fake or entirely constructed representation; or what psychoanalytical cultural theory calls fantasy (or "phantasy"). Nevertheless, fantasy and physical reality cannot really be divorced. Instead, explains John Mowitt, from a psychoanalytical perspective, even "in what makes reality seem original to us, fantasy is at work" (Mowitt 2002: 143). In other words, fantasy ought to be understood in a way that frustrates the possibility of a simple or sharp distinction between objective and subjective, and indeed between the inside and the outside of the subject.

In the language of cultural theory, fantasies can be said to *supplement* the subject. That is: there is no getting away from them. Everyone has them. They are part of our "ingredients"—part of what produces and influences us. They are an element from *outside* (society) that is taken into the heart of the *inside* (of our subjectivities, our selves) (Derrida 1981; 1998). Moreover, according to Judith Butler, fantasies are dynamically linked with what she calls "social norms"—values and practices that "are variously lived as psychic reality" (2000: 154). As Butler argues, identity is always *performative*: one is not *born* a subject, one *becomes* one, and there is no essential "being" behind this doing and becoming. What we "are" is merely what we have become or what we are becoming—a process that is steered by a dynamic relationship between social norms, social/subjective fantasies, and modes of interpretation, performance, and embodiment. As Butler couches it: "Norms are not static entities, but [are] incorporated and interpreted features of existence that are sustained by the idealizations furnished by fantasy" (152). Reciprocally, then: "Norms are not only embodied . . . , but embodiment is itself a mode of interpretation, not always conscious, which subjects normativity itself to an iterable temporality" (Butler 2000: 152).

In one respect, the fantasy offered by Bruce Lee was *perfectly normal*: as a point of identification, the heroic subjectivity that Lee offers is straightforwardly patriarchal or heteronormative. In the terms of Jacques Lacan, the image of Bruce Lee is a phallic image: an image of power, completeness, and plenitude, which we may fantasize about becoming. Yet, in another respect, this particular fantasy is a *reinterpretation* of certain norms; a reiteration that did not simply *repeat*, but at a particular histori-

cal moment actually *transformed* norms, fantasies, and discourses (Derrida 1982: 318; Butler 2000: 152). This is central to my argument: that Bruce Lee intervened into the fantasy life, discourses, and lived practices of international culture in a particularly remarkable way.

In arguing this, I am not alone. Any number of recent works have offered one or another version of this sort of argument (see, for instance: Abbas 1997; Brown 1997; Chan 2000; Hunt 2003; Kato 2007; Marchetti 2001; Morris 2001; Prashad 2001; Teo 2008). However, in making my argument, I also—if not primarily—want to draw attention to the way that so many studies implicitly or explicitly adopt and follow a certain line of thinking; one that is associated with cultural theory, especially poststructuralism in general and deconstruction in particular. This is important to note because, on the one hand, poststructuralist deconstruction and psychoanalysis has clearly been enormously productive in thinking about identities and bodily and cultural practices. But on the other hand, such "theory" is very widely dismissed or derided as being of little or no use for conceptualizing, engaging with, or understanding lived practices, embodied knowledges, or putatively "real" culture and everyday life as such. Poststructuralism has been dismissively characterized as a discourse that reduces everything to language, and hence ultimately reduces "culture" to "communication."

I would like to challenge this widespread assumption. I will do so by pointing to some of the ways that "the case of Bruce Lee" complicates facile understandings of "culture"—whether culture is understood as being a "thing" that "groups" "have" (in an anthropological, positivistic, or essentialist sense) or whether culture is understood as a matter of linguistic (or logocentric) "communication." My discussion will consider the connections between several realms: the technical and technological processes of signification as materialized (if not "embodied") in cinema; moments and processes of meaning-making, such as take place in the "cinematic encounter"; and the relationships between identifying with such images, the channeling of our desires and fantasies into particular bodily practices; and the relationships between this and the wider movements and forces of history. In doing this, I hope to clarify the extent to which perspectives offered by poststructuralist deconstructive and psychoanalytic cultural theory enable us to grasp the sense in which it is possible to "place the body-in-cultivation in a specific historical context" and to see how "the individual, physical body both registers and reveals the . . . sociopolitical landscape" (Xu 1999: 961).

Historic Lee

The historical moment of the "entrance" of Bruce Lee can be regarded as the tail end of the first generation of a counterculture whose seeds had been sown in World War II, which had emerged in the 1950s and proliferated in the 1960s (Brown 1997; Heath and Potter 2005). The proliferation of popular cultural encounters with "Oriental" martial arts constituted an explosion in the early 1970s. Many critics isolate the date of 1973 as decisive, both in terms of the highpoint of kung fu cinema, the "kung fu craze," and in terms of the wider transition to the age of "postmodernity" as such. But before this there were some earlier "inter-cultural" or "East-West" encounters, of a rather different order: namely, the American war with Japan in WWII and the wars in Korea and Vietnam (Brown 1997; Krug 2001). Much has been said about the fact that the Second World War in Asia culminated in the atomic bombing of Hiroshima and Nagasaki (Krug 2001; Chow 2006; Prashad 2001), just as there was much outcry about carpet-bombing and napalming in Vietnam. The significance of these wars as *mediatized spectacles* (the images of the mushroom clouds, the images of burned Vietnamese villagers, and so forth) and the effect that such imagery had on the popular countercultural psyche should not be overlooked.

Writing in the 1950s, at the cutting edge of the emerging counter-culture, the first words of the Preface of Alan Watts' enormously influential book, *The Way of Zen* (1957), remark on the "extraordinary growth of interest in Zen Buddhism" and in East Asian culture and thought in the West: "this interest has increased so much that it seems to be becoming a considerable force in the intellectual and artistic world of the West," he proposes. Watts suggests that this interest is a consequence "no doubt, [of] the prevalent enthusiasm for Japanese culture which is one of the constructive results of the late war" (Watts 1957: 9). In other words, one might say, because what the counterculture (of beatniks, peaceniks, hippies, and New Agers) was *counter to* was the society that went to war with the East (via such terribly "photogenic" means as atomic bombs and napalm), therefore it was largely overdetermined that one of the things the *counterculture* chose to adore was the East—*the Other*.[7] The post–Second World War and then the Vietnam War countercultural turns away from faith in Western institutions (and away from *institutions* and *the West* per se) and toward the "mystical" and the Oriental Other was doubtless bolstered by the sense (as Watts discusses at the very beginning of chapter

1) that "Zen Buddhism is a way and a view of life which does not belong to any of the formal categories of modern Western thought." This, Watts continues, is particularly because it "is not a religion or philosophy; it is not a psychology or a type of science," but rather "an example of what is known in India and China as a 'way of liberation,' and is similar in this respect to Taoism, Vedanta, and Yoga" (Watts 1957: 23).

Bruce Lee entered Western consciousness at the tail end of the emergence of the counterculture, in 1973. The "mechanics" of this entrance—or rather of the transformations that it precipitated—can be approached most concisely in terms of "interpellation" (Althusser 1971; Mowitt 2002).[8] For what the Bruce Lee simulation of physical prowess did was to "call out" to viewers: *"Hey, you! This could be you! All you need to do is train in kung fu, and you too could become (closer to) invincible!"* This is precisely the mechanism that Louis Althusser proposes in his model of interpellation: the "call to us" that—if we recognize ourselves in it—puts us in a certain place or relation, in and through which we "find" ourselves—whether that call be from a parent (interpellating us as a child, subject to their authority), a teacher (interpellating us as a student), a policeman (in Althusser's famous example, interpellating us as a subject of—and subject to—the law), or an image or position with which we identify or desire to be/come. It is in terms of such a process of interpellation that the event of Bruce Lee ought first to be understood.

Specifically, of course, what Lee-the-cinematic-simulation explicitly called out for was a very physical encounter with the bizarre new/ancient Oriental thing called kung fu. Many Westerners' first encounter with martial arts as such was through seeing Bruce Lee films. In itself, this new "lifestyle option" can be viewed as culturally significant. As one biographer of Bruce Lee reflects, it was entirely due to Bruce Lee films that he, "an Englishman . . . was able to begin learning a Chinese martial art from a Welshman" (Thomas 2002: xii). Such a quotidian practice may seem very little—almost nothing. But it is both subjectively and socioculturally significant. This is not least because training in martial arts leads to the "transformation of the novice, the change of his or her muscles, attention patterns, motor control, neurological systems, emotional reactions, interaction patterns, top-down self-management techniques, and other anatomical changes" (Downey 2006: unpublished manuscript). Moreover, Lee's biographer argues, Bruce Lee's intervention was one that also apparently "bridged cultures, revolutionized the martial arts, taught

a fierce philosophy of individualism . . . and remade the image of the Asian man in the West" (xi).

We ought to hesitate before accepting at face value utopian-sounding claims about "culture bridging," as if it were a straightforward matter. This is so even though quite a few studies of Bruce Lee *are* organized by the belief in Lee's emancipator status as an icon who united different ethnic and cultural groups, particularly blacks, Hispanics, and Asians in inner-city U.S. contexts (Prashad 2001; Kato 2007). Nevertheless, there does seem to be something undoubtedly significant in terms of what Bill Brown calls the "interethnic bond" that has been identified in the appeal of Asian martial arts to black Americans. Some have connected this appeal to a wider "countercultural investment in Taoism and Buddhism" (Brown 1997: 32); others to slick targeted trailers for the films themselves; as the director of many Hong Kong martial arts films, Raymond Chow himself, "pointed to Nixon's visit to China in 1972, and the subsequent U.S. interest in Chinese culture" (Brown 1997: 33; Hunt 2003). But, for Brown, the reason for a strong connection between urban black American culture and martial arts "is less the ethnic specificity of Bruce Lee than what we might call his generic ethnicity": this, he says, is what "seems to have inspired the enthusiasm of the U.S. black inner-city audience" (33). For there were not many nonwhite movie stars at the time, to say the least; fewer still who habitually fought and defeated white Westerners.

As well as appealing to black and Hispanic audiences in the United States in particular, Brown suggests that a further aspect of this "generic ethnicity" was the way that it was accompanied by "an implicit invitation to translate the ethnonationalism conflicts staged within the kung fu film into the conflict of class" (33). Many Hong Kong kung fu films, including Lee's, are clearly strongly organized by class antagonisms. Indeed, says Brown, "if we're to believe the accounts of this international *mass* spectatorship, we might imagine a (failed) moment of international *class* longing" (33). Whether we are in a position to accept this or not, Brown notes that although there was (and may still be) a lag in scholarly knowledge about martial arts culture and its connections with ethnic groups globally ("commentators groped for a rationale to explain the particular attraction of kung fu for black audiences" throughout the 1970s, Brown observes), market mechanisms in the form of marketing strategies informed by data about the audience were quick to respond: "the industry's report on the primary audience for the twenty-one kung fu films that

appeared in the United States in 1973 made it clear to producers that a new market had emerged." As such, notes Brown, "Not unpredictably, *Black Belt Jones* (1974), in which black martial arts students battle white gangsters, became the 'first U.S.-lensed martial arts practitioner'" (33). Thus: "While 'invisibility' had come to be understood, by some, as the provocation of the city riots of the 1960s, in the early 1970s the black population had become visible to the film industry as a potent consumer constituency" (33). The interethnic bond, then, or the "culture bridging," could be said to be structured by the visual contours of a common process of ethnicization shared by black and Asian subjects and organized by cinematic texts, with Bruce Lee, who instantly "became synonymous with kung fu" (31), at the forefront.

We see here the workings of a complex relation between visibility and invisibility around martial arts, popular culture, and cultural politics. Invisibility, exclusion, subordination, and marginalization in social, cultural, and political contexts helped add an affective interpretive charge to moments of visibility. Thus, even texts that are semiotically speaking simplistic, clichéd, or hackneyed—such as all of Bruce Lee's films—may nevertheless be seen to be dynamically related to wider social issues. As Brown puts it, "the slippage between race, nationality, and class—not in oppositional thought but in urban culture—is precisely what seems to underlie the attraction to kung fu in 1973" (36).

Brown's own analysis considers the case of a story by Charles Johnson ("China") in which the lead character, a middle-aged black working-class man called Rudolph, becomes hooked on martial arts. Brown argues that what Rudolph sought was *remasculinization*—as is often the case in discourses about masculinity—or the attainment of a sense (or sensuous experience) of self-worth and potency. The manner in which this becomes possible to him is via martial arts. This route is determined by what is available to him within his historical and cultural moment. This moment is the cultural milieu of 1970s America, and Rudolph's choice, as it were, is led by his becoming enthralled with cinematic representations of kung fu. After viewing, he joins a kwoon and trains relentlessly, at every given opportunity. Over time, his middle-aged body is transformed. As such, Brown reminds us, the fruits of his labors, his dramatic "new body is predicated on a globalizing media-distribution network" (24). In this familiar (albeit fictional) case, what nevertheless becomes visible is the way that the effects of a global media network condense in a certain encounter with a "simple," "mere," or indeed "corny" cinematic text.

This is an encounter that transforms a subject. As such, the encounter transforms the status of the filmic text itself (no matter how corny or simplistic it may "objectively" be). Moreover, because of the role that this textual encounter plays in the lives of those whose experiences and existential struggles involve the problems of ethnic and class prejudice and exclusion that are dramatized within it, the cultural-political significance of such an evental process ought to be recognized.

So, the films enable new forms of identification and practice to emerge. However, this is not the end of the story. The process has neither been "simple" nor simply emancipatory. Rather, there has been what Brown calls a "double movement," which suggests why we should hesitate before rushing to the conclusion that the interethnic bond activated in the process of cinematic identification is either straightforward or necessarily emancipatory. For, first of all, it is not simply "blacks" and "Asians" who are somehow "united" or "hybridized." Rather, any "postnational political affiliation" opened up or promised by the encounter is clearly predicated first on "the affiliation between Hong Kong and Hollywood." This affiliation is easy to specify. Its nature is financial. It "worked" to the extent that it was, in Brown's words, "affectively subsidized by the longing of the urban masses" (36–37).

Thus, as well as seeing a progressive interethnic cultural movement, we also need "to understand the attraction to kung fu films as taking the place of, as displacing, any sustained attraction to the radical post-nationalizing imagination" (36). As one "commentator dismissively put it," notes Brown, the problem is that the films offer a "dream where politics are resolved by a boxing match'" (36). Thus, the one problematic or complicating dimension to martial arts films relates to the fact that the "kung fu craze thus seems explicable within the cultural logic of urban history as explained by David Harvey, intensifying his sense of 1973 as the pivotal year in the transition to what he calls postmodernity." What this means is that the "urban spectacle of mass opposition that violently disorganized the space of American cities in the 1960s was finally transformed into the organized spectacle of consumption." In this, the "countercultural scene resurfaces as the commodification of subculture." And it is within such a movement that, in films that all include "the local display of local ethnicity and multiethnic harmony, Golden Harvest, the Shaw Brothers, and Cathay Studios displayed interethnic and interclass violence that marked and managed the otherwise suppressed conflicts of the inner city" (37).

This process of capitalizing on socioeconomic conflicts by commodifying martial arts (as "cool") traveled in tandem with and testified to the shifting discursive status of martial arts over time (Brown 1997: 37). From being subcultural activities on the interethnic working-class margins of society, whose proliferation testified to various antagonisms of class, gender, and race, they gradually move to the forefront of the "postmodern" (depoliticizing) movements of "self-actualization." In Slavoj Žižek's words:

> when, three decades ago, Kung Fu films were popular (Bruce Lee, etc.), was it not obvious that we were dealing with a genuine working class ideology of youngsters whose only means of success was the disciplinary training of their only possession, their bodies? Spontaneity and the "let it go" attitude of indulging in excessive freedoms belong to those who have the means to afford it—those who have nothing have only their discipline. The "bad" bodily discipline, if there is one, is not collective training, but, rather, jogging and body-building as part of the New Age myth of the realization of the Self's inner potentials—no wonder that the obsession with one's body is an almost obligatory part of the passage of ex-Leftist radicals into the "maturity" of pragmatic politics: from Jane Fonda to Joschka Fischer, the "period of latency" between the two phases was marked by the focus on one's own body. (Žižek 2004: 78–79)

Žižek's discussion overlooks issues of interethnic bonds, of course, but his tidy account is very suggestive. Bill Brown's analysis shares similar contours to Žižek's but it adds extra dimensions. For instance, Brown identifies that:

> if the reception of [Bruce] Lee's films seems to displace an overtly political and explicitly postnational affiliation with interethnic identification, then Johnson's story, while metonymically recording that reception, exhibits a double displacement: violence has been evacuated from the martial arts aesthetic, and, characteristic of the growing appreciation of kung fu in the 1980s, a class-coded mode of revenge (harking back to the Boxer Rebellion) has been transcoded into a search for self. By 1980, one could learn in the pages of the

Atlantic Monthly that the "real value lies in what the martial arts tell us about ourselves: that we can be much more than we are now." Existentialist struggle replaces both class and ethnic conflict in a classic case of the embourgeoisement of mass-cultural and cross-cultural novelty. (1997: 37)

Thus, the shift seems to involve a distinct displacement away from cultural politics as such. Indeed, Brown's essay is an analysis of "how the political resistance of the 1960s transforms into the consumer pleasure of the seventies and eighties and, further, how collective radicality becomes transcoded into a privatizing politics of consumption" (25–26). However, unlike cultural critics who bemoan this familiar movement of cultural appropriation and domestication, what Brown seeks to emphasize is the way that "the conditions of postnational possibility—the structural costs of what we might call *outward mobility*—are inscribed within the everyday" (26). This is why Brown is keen to point out that, sometimes, at least: "postnationality finally exists neither as the work of 'internationalists,' nor as the local instantiation of an interethnic and international bond, but as a physical feat consumed as an image in the register of mass culture" (42).

Such formations clearly "matter"—at least, if culture "matters." In any eventuality, it seems important to emphasize the extent to which such formations have been constituted, called into being or organized around or through a cinematic spectacle. As Meaghan Morris puts it:

A "popular" cultural genre is one in which people take up aesthetic materials from the media and elaborate them in other aspects of their lives, whether in dreams and fantasies, in ethical formulations of values and ideals, or in social and sometimes political activities. (Morris 2005: 1)

Martial Arts, Cinema and, "Cultural Hybridity"

Whether a moment of "radicalization" or of "privatization," the "mechanisms" involved in all of this require an active link between the cinematic simulation, fantasy, and bodily practice. If bodily practices are what "literally" make us, it is important to perceive the ways that subjects identify with, fantasize through, appropriate, and live social and publicly available fantasies. Fantasy intervenes into and influences psychic life, subjectivity,

and bodily practice. To see this process at work, we would be hard pressed to find a better publicly available example to consider than Bruce Lee. For the fantasy offered by Bruce Lee touched millions. Of course, this was not a *physical* touch. Rather, to borrow a poetic expression from the controversial philosopher Martin Heidegger, writing about cinema, this is a touch "in which there is concentrated a contact that remains infinitely remote from any touch . . . suffused and borne by a call calling from afar and calling still farther onward" (Heidegger 1971: 16). In other words, although not "physical" in the limited sense, this cinematic contact is nevertheless a call that "touches" the body.

Of course, there is a huge gulf between call and response, between *fantasizing* and *doing*, *imagining* and *becoming*. What the fantasy proposed by Bruce Lee demands is physical training: kung fu. This is why the cinematic event of Bruce Lee overwhelmingly precipitated a transnational popular engagement with Chinese and Japanese martial arts. This encounter was real and palpable, but it was (and is) still primarily an encounter *with a fantasy*—what one might call *the fantasy of kung fu*. This is not just a fantasy about the ancient, the mystical, and the distant. It also operates in the very constitution of the real and present. This can be shown in a consideration of the double-pronged dimension to Bruce Lee's martial arts.

As is well known, the "Shaolin kung fu" of *Enter the Dragon* bears little if any relation to the actual "kung fu" that may have been practiced in any of the Shaolin monasteries or elsewhere. Indeed, even the term "kung fu" itself is acknowledged to be a chiefly *Western imposition*, being as it is the synecdochic transformation of a general term for "effort" or "discipline" into the name for "all Chinese martial practices." In response to the accusation of the lack of "reality" or "authenticity" of Lee's cinematic kung fu, his students, friends, and disciples always made plain that what is seen in Bruce Lee films is *knowingly* spectacular and *deliberately* hyperbolic choreography. What Bruce Lee "really practiced," they continue, was *his own brand* of innovative and trailblazing fighting: *jeet kune do* (Inosanto 1980). It is the "real practice" of Jeet Kune Do that is considered by fans and disciples as offering the proof of Lee's *real* combative genius, and as his evidence of his having *surpassed* "traditional" martial arts by inventing a superior "interdisciplinary" hybrid. However, this hybrid has been regarded by other martial artists as merely reflecting the fact that Lee never actually *completed* any formal training syllabus in any one martial art, so he could not actually "know" what may or may not be lacking or in need of improvement or alteration in any martial system (Smith 1999).

This is the crux of debates about Bruce Lee's martial arts (and indeed, the debates about the relative merits of "traditional" martial arts versus contemporary "mixed martial arts"). In this often febrile debate about the status of the hybrid martial art of Jeet Kune Do, a lot of familiar issues about *cultural hybridity* more widely can be seen. Is the hybrid an inferior bastardization and dilution of something(s), or is it a superior work of alchemy? Or is hybridization just something that happens? My aim here is not to adjudicate on the status of Jeet Kune Do as a martial art vis-à-vis other martial arts. Rather, it is simply to reiterate that in any and every eventuality, what Bruce Lee offered was *a fantasy* of kung fu. With the films, the fantasy on offer is that of an *ancient, mystical, mysterious* kung fu. With Jeet Kune Do, the fantasy on offer is that of a *rational, efficient, interdisciplinary* martial "science."[9]

Of course, Bruce Lee is certainly not responsible for *the* fantasies of kung fu. Rather, the Shaolin warrior monk that he plays in *Enter the Dragon* is a mythical figure (of dubious historical status), which antedates Lee. But, in terms of offering a fantasy that fuels physical practice, *nothing about this distance from or proximity to "historical reality" really matters.* The transnational encounter with kung fu precipitated by the films was a cinematically mediated fantasy that called primarily to the imagination, in ways leading to new practices and new transformations of mind and body. Martial arts films cannot simply be dismissed as fantasy. Rather they should be regarded as generative and productive conditions of possibility for certain kinds of ensuing intercultural encounters, of different orders.

Much as it offends the sensibilities of those who are intimately engaged with particular geographical, ethnic, and nationalist issues and knowledges, many of the subjects called, hailed, or interpellated into position by "Asian" martial arts did not (and do not) necessarily know about, care about, or feel any need to distinguish or discriminate between, say (*Chinese*) "kung fu" and (*Japanese*) "Samurai." Historical truth is by-the-by here. What *matters* is a fantasy about physicality. As the lyrics to one song ("Strange Eyes") on the soundtrack to the film *Ghost Dog: The Way of the Samurai* run:

> Let's go steal a coup
> and practice kung fu on the roof next to the pigeon coup
> and keep the stack like the big boy Cadillac
> Forty-eight tracks, got my voice on the DAT
> Samurai style for them niggas actin' wild . . .

Of course, (Japanese) "Samurai" did not practice (Chinese) "kung fu." Kung fu and Samurai style would "really" be very different. But this need not matter in the hybrid spaces of popular cultural practice. The fantasy here happily connects elements, ideas, and practices that hitherto have been geographically, culturally, politically, and otherwise distinct but that *can* be appropriated as if they are emotionally, semiotically, or affectively intimate, connected, or identical. It evidently does not matter to the Wu Tang Clan, Sunz of Man, or others who have been "inspired" by Shaolin and Samurai myths. Indeed, it cuts both ways: for nor does "historical reality" necessarily even register to the millions "worldwide who practice [certain] martial arts and believe that these arts have antique and spiritual values beyond what passes for history and cultural value in the constructions of their own cultures" (Chan 2000: 69).[10]

What this attests to can be clarified by a further consideration of *Ghost Dog: The Way of the Samurai* (1999). In this film, the life of a black youth (Forrest Whittaker) is saved by a mafia gangster who shoots two white teenagers who were beating him apparently to death. The youth subsequently devotes his life to the "Samurai code" and hence to martial arts training. As an adult, he becomes "Ghost Dog," an enigmatic assassin, who works exclusively, invisibly, and anonymously for his gangster savior. Yet, despite this, he has attained a paradoxical and improbable status within the local ghetto community: Ghost Dog is both *well known* (well respected) in the community (moreover, by gangs and rappers of all colors—a surely impossible fantasy), and yet he remains secretive, *unknown* and often effectively *invisible*. Throughout the film, Ghost Dog regularly refers to the book *Hagakure: The Way of the Samurai* (Tsunetomo 1979), and quotations from this book intersperse the film and the movie soundtrack. These enlighten viewers and listeners as to precisely what the "Samurai code" may be or entail.

Thus, the film directly proposes that, in certain conditions, through an encounter with a translated Japanese text, and through identification with a fantasy social position (one *cannot be* a Samurai outside of feudal Japanese social relations) and the practical discipline of martial arts, a black youth from violent ghetto streets can become, to all intents and purposes, a ninja. The ninja were a legendary/mythological clan of Samurai forced into hiding and turned assassin. This is precisely what Ghost Dog has become.

This story, as such, dramatizes a rather idiosyncratic—or perhaps merely "un-PC" and hyperbolic—version of what is entailed by theories

of the "performativity" of identity, as developed by thinkers such as Judith Butler. Butler's theory has often been reductively understood as a theory of "personal" identity construction, which has no wider ramifications for the understanding of culture—other than the suggestion that it is only in more liberal "postmodern" contexts that identities can be freely performatively constructed. However, in *Ghost Dog*—and in Butler—it seems rather to be the case that there is more at issue in identity-performativity than one person's "self-invention." In fact, the premise—and thematic "point"—of both the film and Butlerian theory is well illustrated in a scene in which Ghost Dog encounters two redneck hunters who have illegally killed a black bear and who seem more than prepared to do exactly the same thing to the very palpably black man who is questioning them about their actions:

> *Hunter*: You see, there aren't too many of these big black fuckers left around here, so when you get a good, clear shot at it, you sure as hell take it.
>
> *Ghost Dog*: That's why you shoot them, 'cause there's not that many left?
>
> *Hunter*: There ain't all that many coloured people round here, neither.
>
> *Ghost Dog*: In ancient cultures, bears were considered equal with men.
>
> *Hunter*: This ain't no ancient culture, mister.
>
> [Hunter reaches for a gun. Ghost Dog shoots both hunters]
>
> *Ghost Dog*: Sometimes it is.

In this scene, Ghost Dog verbalizes a very strong thesis about the reciprocal interaction and inter-implication of "personal" identity and "cultural" identity. This boils down to a complex relation between the subject of lived bodily practice and historical-cultural "reality." Primary within it is an inability to disentangle "reality" from "fantasy." But there remain some fairly hefty questions about *what is going on* in such apparent "encounters"

and "hybridizations" as these. For, the proposition of *Ghost Dog* is this: sometimes this culture can be or could become another culture—and even when the only "direct access" to or "contact with" that other culture is translated, mediated, packaged, and reliant upon an identification with a fantasy. The question to ask here is, simply: Can it?

Ghost Dog is particularly interesting because it deals with and dramatizes the kind of change precipitated in certain viewers and viewerships by martial arts myths and fantasies. In one way, the film itself constitutes a cinematic reflection on the relation between oriental martial arts and urban black communities, which plays self-consciously with intertextual references from Hong Kong and Japanese martial arts movies, 1970s Hollywood mafia movies, and mid-1990s hip hop aesthetics (Wu Tang Clan member, the RZA, has a prominent cameo role). *Ghost Dog* explores a change from ghetto kid to samurai- or ninja-like assassin; a change precipitated by an encounter with the *Hagakure, Rashomon,* and oriental martial arts. But is this a *cross-cultural* encounter? Ghost Dog is a loner, whose only contact with "culture" as such appears to be his long bouts of reading and rereading translated Samurai literature. In this, of course, it could be said to be an *intercultural* encounter, perhaps, if not an *interpersonal* one. Unlike many other American martial arts films, *Ghost Dog* refrains from showing an Oriental-master–Western-student relationship. The question of the "authority" or "authenticity" of Ghost Dog's "credentials" remains obscure throughout. Which makes the film infinitely more thought provoking: for, what the hell is going on here?

Martial Arts, Events, and Cultural Encounters

It is possible to construct what J. J. Clarke calls a long list of "the West's intellectual encounters with Eastern thought." However, Clarke observes, it remains equally valid and necessary to "ask philosophical questions about the very possibility of crossing linguistic and cultural boundaries, and about the adequacy of inter-cultural communication, and [to] reflect on the nature of the hermeneutical process which . . . is at the heart of these encounters" (Clarke 1997: 181). Accordingly, before celebrating or denying the possibility of cross-cultural "encounters," what needs to be established is the very "possibility of crossing linguistic and cultural boundaries" and the nature of any possible "inter-cultural communication" as such (Clarke 1997: 181).

Clarke sees it this way: *if* there can be *any* form of interpersonal encounter *anywhere*, then there can of course be intercultural encounters. As he puts it, "arguments which apply to [the impossibility of] communication between Europe and China apply with equal force, not only between modern and mediaeval Europe, but also between any two individuals attempting to communicate with one another" (1997: 182). So, if two individuals can have an encounter, there can be intercultural encounters. Nevertheless, he asserts, it remains important to "reflect on the nature of the hermeneutical process which . . . is at the heart of these encounters" (181).

However, it seems important to interject: it is equally necessary to reflect on whether it *is* actually a "hermeneutical process" that is "at the heart" of intercultural encounters, or indeed at the heart of culture as such. For, is "culture" simply a matter of (linguistic) communication and (conscious) interpretation? "Culture" has, as is well known, increasingly become theorized *as* "communication." Yet is culture not rather to be approached in terms of an *event* that may be, as Badiou suggests, *not* reducible to "communication," or, as Derrida suggests, *not* reducible to linguistic, semantic, or semiotic understandings of the term "communication"? (It is important to mention Derrida here because what is too often lost in criticisms of deconstruction is the extent to which Derrida himself offers a sustained critique of "logocentrism," or, in other words, the idea that "everything is language.")

According to the implications of this argument, both *Enter the Dragon* and *Ghost Dog* could feasibly be added to a list of East-West "encounters." This is so *even though such encounters are obviously not "authentic" in any sense.* Such films are certainly "American produced." The first movie poster for *Enter the Dragon* proudly declared that it was "the first American produced martial arts spectacular." Obviously then, this begs the question of how they could possibly be said to have "bridged cultures" or to constitute any kind of real encounter.

To broach this, let us return to our opening motif: Bruce Lee fights; Bruce Lee is still. What is there here? This encounter is not an "authentic" encounter, of course. But nor is it "hermeneutic" in the dry linguistic (logocentric) sense. Rather, the encounter is with the image of a body and what it can do. At its heart is not an intellectual "hermeneutical process." And even though all that is "there" is obviously a semiotic simulacrum that may be deemed anything from patriarchal to Orientalist to fetishistic to commodifying, the *spectacle* of Bruce Lee *calls*

to the body directly, in precisely the same way music calls to the body directly (Gilbert and Pearson 1999: 44–47; Mowitt 2002). When music starts playing, it is not a "hermeneutical process" that makes your feet start tapping and your body start moving. In exactly the same way, Bruce Lee is *music to the eyes*.[11]

We see all of this and more at the end of one of the most spectacular fight sequences of *Enter the Dragon*: Bruce Lee's prolonged battle with hordes of the evil Han's guards. During this frenetic and protracted fight, Lee systematically and artfully bests wave after wave of assailants with bare hands and a range of traditional martial arts weapons. The fight ends abruptly when Lee runs into a vault and thick steel doors slam down all around him, preventing his exit. Instantly realizing there is nowhere to go, the sweating and bleeding Bruce Lee simply sits straight down, crosses his legs, hangs his nunchakus around his neck, and pulls his heels onto his thighs, adopting the classic meditative lotus position. *This* is what "enters" with *Enter the Dragon*. In the instant switch from amazing fighting to meditative calm sitting, a clear and unequivocal connection is made between "mystical," "spiritual" alterity and the disciplined body. And *this* is a *rearticulation*—a rewiring, a rearrangement—of the usual connections made in Western discourses, in which the spiritual is (or was) *opposed* to the physical, or the body. In *Enter the Dragon*, audiences are repeatedly shown an entirely novel transformation of this traditional relation.[13]

Of course, this rearticulation is not at first entirely intelligible. Indeed, the film needs to (re)introduce it several times, in different ways. In fact, before introducing plot, before any characterization, and in fact, before anything else, the beginning of *Enter the Dragon* aims at delivering the lesson of this new equation. The first scene of the film is Bruce Lee's rite of passage ceremonial fight in the Shaolin Temple. The second scene is Lee's conversation with his teacher. The third scene involves Lee teaching a lesson to his own student, Lau. This scene actually begins with Lee meeting the British agent, Mr. Braithwaite, in a garden. They are served tea. "This is very pleasant," observes Mr. Braithwaite. But before they can get down to the business of discussing the mission that Braithwaite has for Lee (the mission that will drive the plot), they are interrupted. A young boy turns up. Seeing him, Lee says:

Lee: It's Lau's time.

Braithwaite [slightly confused]: . . . Yes, of course . . .

[Lee walks over to Lau. They bow to each other]

Lee: Kick me. . . . Kick me. [*Lau throws a kick*] What was that? An exhibition? We need [*pointing to his head*] emotional content. Try again. . . . [*Lau kicks again*] I said emotional content. Not anger! Now try again! With *me*! [*Lau throws two more kicks, causing Lee to respond, moving and blocking*] That's it! How did it feel to you?

Lau: Let me think.

Lee: [*slaps Lau's head*] Don't think! *Feel*! It is like a finger pointing away to the moon. [*slaps Lau's head*] Don't concentrate on the finger or you will miss all that heavenly glory. Do you understand?

Lau: [smiles, nods, bows]

Lee: [*Slaps the back of Lau's head*] Never take your eyes off your opponent, even when you bow. . . . [*Lau bows again, very cautiously*] That's it.

The camera cuts back to Braithwaite, who is smiling and nodding (*our*) approval. For, even though this lesson has delayed his delivery of the plot, all is forgiven: this peculiar lesson *feels* much more important. But what has been learned? Certainly nothing *logocentric*, or to do with words, statements, or meanings. So what is "it"? In fact, in the preceding scenes, we have already been shown what Lee "knows." Immediately before this pedagogical scene, for instance, we have seen Lee with his own teacher. This is the second scene of the film. The first scene saw Lee winning a ceremonial—apparently graduation-like—fight in the Shaolin Temple. After passing that physical test, Lee goes to his own teacher (as if for the *viva voce*):

[Lee approaches an elderly monk on a path]

Lee: [bowing] Teacher?

Teacher: Hmm. I see your talents have gone beyond the mere physical level. Your skills are now at the point of spiritual

insight. I have several questions. What is the highest technique you hope to achieve?

Lee: To have no technique.

Teacher: Very good. What are your thoughts when facing an opponent?

Lee: There is no opponent.

Teacher: And why is that?

Lee: Because the word "I" does not exist.

Teacher: So. Continue.

Lee: A good fight should be like a small play, but played seriously. A good martial artist does not become tense, but ready. Not thinking, yet not dreaming: ready for whatever may come. When the opponent expands, I contract; when he contracts, I expand; and when there is an opportunity, I do not hit: [he raises his fist, but does not look at it] it hits all by itself.

So, in the opening scenes of *Enter the Dragon* we have seen: a rite-of-passage ceremonial fight; Lee with his teacher; Lee with his student. The second and third scenes are lessons, *showing* (but not *explaining*) what Lee "knows," "is," "represents," or "stands for" for us. And what this "is" has just been called "spiritual." However, what *produced* this "spiritual insight" was immense *bodily discipline*. In the terms of Foucauldian analysis, what subtends all of this going "beyond the mere physical level" is *not* disembodied "spirituality" but *physical discipline*. Lee amounts to the highest production of Shaolin discipline—indeed, the most perfect example of what Foucault called a "plastic" or "docile body."

What this strange pedagogy is actually at pains to emphasize (to *show*, to *perform*) is an entirely unequivocal yet difficult-to-articulate equation between subject, body, and "spirituality." This is a difficult lesson to "show" let alone to "speak." For, as Smith and Novak point out:

> Because meditation is commonly linked to the vague term "spirituality," it is sometimes tarred with that term's negative

connotations toward the body. Those who have not under-
taken Buddhist meditative training, therefore, can hardly
be expected to guess how intimately connected it is to an
awareness of one's own body. The body may be the site of
our bondage, but it is also the means of our extrication. Thus,
it is not surprising to find the Buddha suggesting that having
been born into a human body is one of the three things for
which we should give thanks daily.

Indeed, it barely exaggerates the matter to regard Bud-
dhist meditation as a lifelong training in right body awareness.
(Smith and Novak 2003: 80)

Enter the Dragon constructs and conveys this particular connection and
introduces the key indices of this "new mystical eastern" discursive constel-
lation extremely efficiently. Indeed, what it proposes, through the model
of Lee, is an inversion and displacement of Freud's Enlightenment motto
"Wo Es war, soll Ich werden" ("where the id was, there ego shall be"): in
other words, let the light of conscious knowledge replace the darkness of
ignorance. Instead, in Lee's physical spirituality, the path to insight that
is proposed follows almost the opposite maxim: *where ego was, let "it" be.*
But *"it"* is no longer the barbaric primary impulses of a wild id that must
be repressed (as "it" has overwhelmingly been theorized in the Freudian
West). Rather *it* is fundamental harmony and enlightenment achieved
through a non-egotistical but disciplined physical mastery of the mind
and body. In other words, while meditation per se may not be much of a
spectator sport, nor make for very exciting viewing, Hollywood nevertheless
managed to represent a strong trait of the sixties countercultural interest
in oriental alterity through the mystical and spiritual "way of liberation"
and "enlightenment" produced by the "training in right body awareness"
embodied in the spectacular character of Lee's mythical Shaolin Temple
warrior monk.

There is thus the potential of a "communication" between physical
bodies induced by an interpellation that is mediated or disseminated by
the cinematic apparatus. This involves a simulation that engages fan-
tasy that precipitates in practice that leads to subjective, physical, and
discursive transformation. Such practice may well be or become Zen or
Buddhist meditation, Taoist *qigong*, or any number of other practices.
But the point is that even an entirely "Western" cinematic simulacrum
may well offer an "entrée into Chinese philosophy, medicine, meditation,
and even language" (Wile 1996: xv). It may of course—and inevitably

also does—produce chimeras, fictions, fantasies, and absurdities, such as the wonderfully ridiculous invented "martial art" of "Rex Kwon Do" in *Napoleon Dynamite* (2004), for instance.[13] But such, perhaps, is the nature of the fallout of any *event*—and hence, perhaps, the nature of "culture," as such. As Thomas Docherty puts it:

> Culture, I contend, is something that "happens," something in the nature of an "event." It is episodic and rare; but it is recognised in terms of its capacity for edification, growth, *Bildung*. Insofar as it is concerned with growth or develop-ment, especially improving development, it involves not the identity of the self, but its transformation and thus its differ-ence from itself. . . .
>
> [A]n "event," in these terms, is the something that happens when happening itself is entirely unpreprogrammed and unpredictable. An event, we might say, is what happens when we know that something is happening but we do not know what it is that is happening. The "outcome" of the event is entirely unforeseeable, unpredictable. (Docherty 2003: 222–223)

Cultural "Communication"

What is there to be learned from this? This is just another way of asking: What is there? To think about the lesson, let's rewind to the touching pedagogical scene in which Lee points Lau to the physically graspable, metaphorically evocable but linguistically unsayable "it." As you will recall, Lee tests Lau by gesturing and saying, "It is like a finger pointing away to the moon." Then he slaps Lau and says: "Don't concentrate on the finger or you will miss all that heavenly glory." Lesson learned. But, what is it? As we are not simply Lee's Shaolin disciples, let's allow ourselves the luxury of one last quick furtive look at Lau looking at the pointing finger, for which he was so sternly reprimanded.

In his essay "What is there?" Maurizio Ferraris proposes that *any* response to the ontological question of "what is there?" always boils down to the work of "A finger, generally the index, [which] gives a sign towards something, and indicates it as *this*." And this, he points out, "is *presence*, ontology in the simple and hyperbolic sense" (2001: 96). Then

Ferraris goes on to consider what he calls that "obstinate superstition that holds [that children are] incapable of abstraction [because they] look at the finger . . . instead of what the index is pointing to" (100). He notes that the conventional interpretation of the classic child's mistake is that it shows children are *incapable* of abstraction. (Similar statements have been made about the so-called Chinese Mind, of course.) But Ferraris suggests that surely children who look at the finger and not at what it points to "are if anything *more* abstract [than adults], since they produce an inflation of presences" (100). For what they are staring at (if not "seeing") is *the agency which designates—the act of designation*—rather than that which is intended. Thus the over-attention of the naïve, captive, and attentive disciple inadvertently and unintentionally points to the fact that we are always guided, led, directed, pointed to something, by some guide or guiding act of designation. Designation is determined by a designator. Disciples are taught what to look at and what to see and what not to see. What disciples *see* is what they are in a sense *shown* (or trained) *how to see*. Thus, as Ferraris puts it: "the presence of the index is no less problematic than everything it points to" (Ferraris 2001: 98).[15]

Alan Watts once asked: "What happens to my fist (noun-object) when I open my hand?" (1957: 25). The question seeks to suggest that ways of thinking determine what can be seen, understood, or communicated. Thus, what may seem like an *object* may perhaps be better construed as an *event* or a *process*. In a similar sense, the concept-metaphors used to think about "culture" have themselves shifted from conceiving of it as a fixed or essential *thing* toward thinking of it as a *process*, or—overwhelmingly nowadays—as *communication*. But, what is communication? And how is "it" communicated? As Jacques Derrida once asked: what does the word *communication* communicate? We tend to "anticipate the meaning of the word *communication*" and to "predetermine communication as the vehicle, transport, or site of passage of a meaning, and of a meaning that is *one*" (1982: 309). But, he observes:

> To the semantic field of the word *communication* belongs the fact that it also designates nonsemantic movements. . . . [O]ne may, for example, *communicate a movement*, or . . . a tremor, a shock, a displacement of *force* can be communicated—that is, propagated, transmitted. . . . What happens in this case, what is transmitted or communicated, are not just phenomena of meaning or signification. In these cases we are dealing neither

with a semantic or conceptual content, nor with a semiotic operation, and even less with a linguistic exchange. (1982: 309)

Such is the communication of the fantasy corpus of martial arts: it cannot be reduced to a hermeneutical or logocentric communication of meaning, nor even the direct transmission of a "real" tradition. It is always the performative reiteration of "material" from heterogeneous realms or registers: myths, specters, symbols, and simulacra being as operative in—and as organizing of—bodily practice as any positive or empirically specifiable "real." Of course, such communications, events, exchanges, or encounters can be placed in historical contexts, and can be historicized. But they should not be regarded as "therefore" being simple epiphenomenal "expressions" of larger or "more real") historical processes. Rather, such events as "Bruce Lee" are equally *productive* of their historical contexts. Such events are rearticulations that "rewire" and transform discourses, ideologies, fantasies, and bodies.

Notes

1. Furthermore, cultural translation would also be understood as a range of processes which mean that, for academics, "the "translation" is often what we must work with because, for one reason or another, the "original" as such is unavailable—lost, cryptic, already heavily mediated, already heavily translated" (193). This is not a particularly unusual situation, of course. It is, rather, everyday. Such translated, mediated, commodified, technologized exchanges between cultures happen every day. This is also the situation we are in when encountering film, especially films that are dubbed or subtitled, of course, as in the case of Bruce Lee's Hong Kong–produced films. Such films are translated, dubbed, and subtitled. But, this is not the start or end of translation.

2. This is important to emphasize because, despite its everydayness, despite its reality, and despite the arguable primacy of the situation of cultural translation between "translations" with no (access to any) original, this situation of cultural translation is not often accorded the status it could be said to deserve. It is rather more likely to be disparaged by scholars, insofar as it occurs predominantly in the so-called realms of popular culture and does not conform to a model of translation organized by the binary of "primary/original" and "derived/copy" (Chow 1995: 182).

3. Accordingly, as Chow emphasizes, "the problems of cross-cultural exchange—especially in regard to the commodified, technologized image—in the

postcolonial, postmodern age" (182) demand an unorthodox approach. For, as she points out, as well as the "literal" matters of translation that arise within film, "there are at least two [other] types of translation at work in cinema" (182). A first involves translation understood "as inscription": any film is a kind of writing into existence of something that was not there as such or in anything like that way before its constitution in film. A second type of translation associated with film, proposes Chow, involves understanding translation "as transformation of tradition and change between media" (182). In this second sense, film is translation insofar as a putative entity (she suggests, "a generation, a nation, [or] a culture") are "translated or permuted into the medium of film." So, film as such can be regarded as a kind of epochal translation, in the sense that cultures "oriented around the written text" were and continue to be "in the process of transition and of being translated into one dominated by the image" (182).

4. For a related discussion of the implications of this and of the discussion of Foucault in the paragraph that follows, see also Weber (1987: xii).

5. To elucidate this transformation, Chow retraces Foucault's analyses and argument in *The Order of Things* (1970) to argue that both translation and knowledge per se must henceforth be understood as "a matter of tracking the broken lines, shapes, and patterns that may have become occluded, gone underground, or taken flight" (Chow 2006: 81). Referring to Foucault's genealogical work on the history of knowledge epistemes in *The Order of Things*, Chow notes Foucault's contention that "the premodern ways of knowledge production, with their key mechanism of cumulative (and inexhaustible) inclusion, came to an end in modern times." The consequence of this has been that "the spatial logic of the grid" has given way "to an archaeological network wherein the once assumed clear continuities (and unities) among differentiated knowledge items are displaced onto fissures, mutations, and subterranean genealogies, the totality of which can never again be mapped out in taxonomic certitude and coherence" (81). As such, any "comparison" must henceforth become "an act that, because it is inseparable from history, would have to remain speculative rather than conclusive, and ready to subject itself periodically to revamped semiotic relations." This is so because "the violent yoking together of disparate things has become inevitable in modern and postmodern times." As such, even an act of "comparison would also be an unfinalizable event because its meanings have to be repeatedly negotiated." This situation arises "not merely on the basis of the constantly increasing quantity of materials involved but more importantly on the basis of the partialities, anachronisms, and disappearances that have been inscribed over time on such materials' seemingly positivistic existences" (81).

6. Moreover, in the face of studying Bruce Lee, and despite the apparently trivial status of this long departed Hong Kong American celebrity martial artist, it is of more than "academic" interest to note, right at the start, the extent to which "China" or "Chineseness" is inscribed (indeed, *hegemonic*) within the current theoretical and political discourses of cultural studies, post-structuralism, ethnicity

and feminism. As Rey Chow makes plain, this is so in at least three ways. First, the Chinese "other" played a constitutive (haunting) role in the deconstructive critique of logocentrism and phonocentrism, in ways that far exceed the general "turn East" (in the search for alternatives) characteristic of "French" theory and much more besides of the 1960s and 1970s. Second, the feminism of the 1960s and 1970s actively admired and championed the Chinese encouragement of women to "speak bitterness" against patriarchy. And third, the enduring interest in the "subaltern" among politicized projects in the West has always found an exemplary example in the case of the Chinese peasantry. Indeed, says Chow, in these ways and more, "'modern China' is, whether we know it or not, the foundation of contemporary cultural studies" (Chow 1993: 18).

7. Of course, this Althusserian notion has a rather a bad name; first because it apparently remains bound to an unfashionable Marxism (although, according to Mowitt, the "Marxist" dimension of interpellation is not at all certain. For, interpellation "has also played a constitutive role in the emergence of what is now, somewhat reluctantly, referred to as post-Marxism. To this extent, interpellation participates in a 'properly' dialectical elaboration of the very theoretical tradition which it might otherwise be said to have sublated" [Mowitt 2002: 43]). But mainly because it apparently simplistically implies that *what* interpellates individuals as subjects must always be determinate "Ideological State Apparatuses" (Althusser 1971). The problem here would be that subjects must be "entirely the effects of the state apparatus" (Mowitt 2002: 49), and this would suggest that agency, let alone "resistance . . . all but foreclosed" (49). However, as Mowitt has argued, given the plurality and complexity of addresses, hails, commands, suggestions, sources of identification, and the contingency of response, interpretation and performance, a "conflict of interpellations" easily and often arises (Mowitt 2002: 49). So the subject is not merely a passive reflection of structure. Rather, subjectivity is an ongoing performative process amid conflicting interpellations. In the postmodern, polyvocal, and media-saturated world, the interpellations that tend to prevail are, one might say, *those calls that answer a call.*

8. I have discussed the interplay and interconnection of these two apparently distinct but actually overlapping fantasies—mystical and rational—in Bowman 2006.

9. Historians have always cast doubt both on the origin myth of Shaolin Kung Fu, in which wandering monk Bodhidharma introduced Zen meditation to the unfit monks of the Shaolin Temple and, as a result of the physical discipline required for Zen meditation, also inadvertently invented kung fu. Historians also consistently challenge the subsequent myths of the improbable physical abilities of Shaolin monks. For instance, Kennedy and Guo suggest that the myths of Shaolin were "largely created in two books:" a popular turn of the century novel, *Travels of Lao Can* (Liu 2005), and an apparently totally fabricated and instantly debunked 1915 training manual entitled the *Secrets of Shaolin Boxing* (unknown 1971; Kennedy and Guo 2005: 70–71). Henning points out that the

origins of the Shaolin myth "cannot be traced back earlier than its appearance in the popular novel, *Travels of Lao Can*, written between 1904 and 1907, and there is no indication that it was ever part of an earlier oral tradition" (Quoted in Kennedy and Guo 2005: 70). *Secrets of Shaolin Boxing* contained accounts of improbable/impossible processes and end results of Shaolin training. It was instantly debunked by the leading contemporary martial arts historians of the time (Tang Hao and Xu Je Dong). Yet this book in particular had a significant impact. For, even though quickly exposed, "unfortunately [it] became popularly accepted as a key source for Chinese martial arts history enthusiasts, and its pernicious influence has permeated literature on the subject to this day" (Henning, quoted in Kennedy and Guo 2005: 70–71).

10. However, Chan's argument is slightly different. For him, myths of "ancientness" *do* matter. But they still need not be related to any "truth." Of course, this is a controversial view. As he explains, "a UNESCO survey of the world's martial arts" that he was involved with had to be abandoned "because the various authors could not agree on the nature of the project" (Chan 2000: 69). They could not agree on a workable definition or delimitation of their shared object of study, "the martial arts." In other words, this putatively obvious and stable identity ("martial arts") itself immediately turned out to be a rather deceptive signifier, something that can be drastically differently construed depending on one's standpoint. The UNESCO group was unable to agree on *how* to conceive of the martial arts: how to contextualize them, how to establish and assess their limits, their "essence," and indeed how to ascertain what constitutes their "reality." They were especially unable to agree on whether the "reality" of martial arts should include or exclude the myths, fictions, fantasies, and fabrications that constantly blur the edges and muddy the waters of this subject.

11. Gilbert and Pearson (1999) enquire into the nature of music's effects and note the "non-verbal aspect of music's effectivity which has given rise to its strange status in western thought" (1999: 39). The dangerous hedonistic bodily effects of music led Socrates to want only simply, functional, militaristic music (in Plato's *Republic*); many others still try to tie music down to "meanings" (40); Kant hated "*Tafelmusik*"—table music, music that is not designed for *contemplation* (41); and so forth. Gilbert and Pearson argue: "this tradition tends to demand of music that it—as far as possible—*be meaningful*, that even where it does not have words, it should offer itself up as an object of intellectual contemplation" (42). However, music is felt by the body. They propose, "music—like all sound—is registered on a fundamentally different level to language or modes of visual communication" (44); and "music can be said to, as Robert Walser suggests, 'hail the body directly'" (46). I am simply saying, so does Bruce Lee.

12. For a full account of the theoretical concept of "articulation" (and rearticulation), see Laclau and Mouffe (1985). For the most recent study of the significance of "articulation" as the key term of contemporary cultural theory, see Bowman 2007.

13. The magnificent "Rex Kwon Do" scene from *Napoleon Dynamite* can be seen on www.youtube.com at http://www.youtube.com/watch?v=PKmUsVeKp1o.

14. Of course, Lee's character is seeking to dissolve the "Western" problematic in which, behind the index (the finger pointing us to what *is*), "there is first of all a *cogito* with respect to which [things] are present" (Ferraris 2001: 98). As Lee has already told us, "the word 'I' does not exist."

References

Abbas, Ackbar. 1997. *Hong Kong: Culture and the Politics of Disappearance.* Minneapolis and London: University of Minnesota Press.

Althusser, Louis. 1971. *Lenin and Philosophy.* New York: Monthly Review Press.

Badiou, Alain. 2001. *Ethics: An Essay on the Understanding of Evil.* Trans. Peter Hallward. London: Verso.

Bowman, Paul. 2006. "Enter the Žižekian: Bruce Lee, Martial Arts and the Problem of Knowledge." *Entertext* 6 (1) (Autumn).

———. 2007. *Post-Marxism Versus Cultural Studies: Theory, Politics and Intervention.* Edinburgh: Edinburgh University Press.

Brown, Bill. 1997. "Global Bodies/Postnationalities: Charles Johnson's Consumer Culture." *Representations* 58 (Spring): 24–48.

Butler, Judith. 2000. "Competing Universalities." Pp. 136–180 in Judith Butler, Ernesto Laclau, Slavoj Žižek, *Contingency, Hegemony, Universality: Contemporary Dialogues on the Left.* London: Verso.

Clarke, J. J. 1997. *Oriental Enlightenment: The Encounter Between Asian and Western Thought.* London: Routledge.

Chan, Stephen. 2000. "The Construction and Export of Culture as Artefact: The Case of Japanese Martial Arts." *Body and Society* 1: 69.

Chow, Rey. 1993. *Writing Diaspora: Tactics of Intervention in Contemporary Cultural Studies.* Bloomington: Indiana University Press.

———. 1995. *Primitive Passions.* New York: Columbia University Press.

———. 2006. *The Age of the World Target.* Durham and London: Duke University Press.

Derrida, Jacques. 1981. *Dissemination.* Trans. Barbara Johnson. Chicago and London: University of Chicago Press.

———. 1982. *Margins of Philosophy.* London: Harvester Wheatsheaf.

———. 1998. *Resistances of Psychoanalysis.* Stanford: Stanford University Press.

Docherty, Thomas. 2003. "Responses." Pp. 221–230 in Paul Bowman, ed., *Interrogating Cultural Studies: Theory, Politics and Practice.* Pluto: London.

Downey, Greg. 2006. " 'Practice without Theory': The Imitation Bottleneck and the Nature of Embodied Knowledge." Unpublished manuscript.

Ferraris, Maurizio. 2001. "What is there?" Pp. 93–158 in Jacques Derrida and Maurizio Ferraris, *A Taste for the Secret.* Cambridge: Polity.

Gilbert, Jeremy, and Ewan Pearson. 1999. *Discographies: Dance Music, Culture and the Politics of Sound*. Routledge, London.

Heath, Joseph, and Andrew Potter. 2005. *The Rebel Sell: Why the Culture Can't Be Jammed*. Chichester: Capstone.

Heidegger, Martin. 1971. "A Dialogue on Language: Between a Japanese and an Inquirer." Pp. 1–55 in *On the Way to Language*. New York: Harper Collins.

Hunt, Leon. 2003. *Kung Fu Cult Masters: From Bruce Lee to Crouching Tiger*. London: Wallflower.

Inosanto, Dan. 1980. *Jeet Kune Do: The Art and Philosophy of Bruce Lee*. Los Angeles: Know How Publishing.

Kato, T. M. 2007. *From Kung Fu to Hip Hop: Revolution, Globalization and Popular Culture*. Albany: State University of New York Press.

Kennedy, Bob, and Elizabeth Guo. 2005. *Chinese Martial Arts Training Manuals: A Historical Survey*. Berkeley: North Atlantic Books.

Krug, Gary J. 2001. "At the Feet of the Master: Three Stages in the Appropriation of Okinawan Karate into Anglo-American Culture." *Cultural Studies: Critical Methodologies* 1 (4): 395–410.

Laclau, E., and Chantal Mouffe. 1985. *Hegemony and Socialist Strategy: Towards a Radical Democratic Politics*. London: Verso.

Liu, Elizabeth. 2005. *The Travels of Lao Ts'an*. Yi Lin: Chu Ban She.

Lo, Kwai-Cheung. 2005. *Chinese Face/Off: The Transnational Popular Culture of Hong Kong*. Chicago: University of Illinois Press.

Marchetti, Gina. 2001. "Jackie Chan and the Black Connection." Pp. 137–158 in Matthew Tinkcom and Amy Villarejo, eds., *Keyframes: Popular Cinema and Cultural Studies*. London: Routledge.

Miller, Davis. 2000. *The Tao of Bruce Lee*. London: Vintage.

Morris, Meaghan. 2001. "Learning from Bruce Lee." Pp. 171–184 in ed. Matthew Tinkcom and Amy Villarejo, *Keyframes: Popular cinema and cultural studies*. London: Routledge.

———. 2005. "Introduction: Hong Kong Connections." Pp. 1–30 in Meaghan Morris, Siu Leung Li, and Stephen Chan Ching-kiu, eds., *Hong Kong Connections: Transnational Imagination in Action Cinema*. Durham and London: Duke University Press.

Mowitt, John. 2002. *Percussion: Drumming, Beating, Striking*. Durham and London: Duke University Press.

Prashad, Vijay. 2001. *Everybody Was Kung Fu Fighting: Afro-Asian Connections and the Myth of Cultural Purity*. Boston: Beacon Press.

Preston, Brian. 2007. *Bruce Lee and Me: A Martial Arts Adventure*. London: Penguin.

Smith, Huston, and Philip Novak. 2003. *Buddhism*. London: Harper Collins.

Smith, Robert. W. 1999. *Martial Musings: A Portrayal of Martial Arts in the 20th Century*. Erie, PA: Via Media.

Teo, Stephen. 2008. *Chinese Martial Arts Cinema: The Wuxia Tradition*. Edinburgh: Edinburgh University Press.

Thomas, Bruce. 1994. *Bruce Lee: Fighting Spirit*. Basingstoke and Oxford: Sidgwick and Jackson.

Tsunetomo, Yamamoto. 1979. *Hagakure: The Book of the Samurai*. Trans. William Scott Wilson. New York: Kondansha International.

Unknown. 1971. *Secrets of Shaolin Boxing*. Taipei: Zhonghuawushu Press.

Watts, Alan. 1957. *The Way of Zen*. London: Penguin.

Weber, Sam. 1987. *Institution and Interpretation*. Minneapolis: University of Minnesota Press.

Wile, Douglas. 1996. *Lost T'ai-chi Classics from the Late Ch'ing Dynasty*. Albany: State University of New York Press.

Xu, Jian. 1999. "Body, Discourse, and the Cultural Politics of Contemporary Chinese Qigong." *Journal of Asian Studies* 58 (4) (November): 961–991.

Žižek, Slavoj. 2004. "The Lesson of Rancière." Afterword to Jacques Rancière's *The Politics of Aesthetics*. London: Continuum.

Film

Black Belt Jones. 1974. Dir. Robert Clouse. United States. Warner Brothers.

Enter the Dragon. 1973. Dir. Robert Clouse. HK/United States. Warner Brothers.

Ghost Dog: The Way of the Samurai. 1999. Dir. Jim Jarmusch. United States. Warner Brothers.

Napoleon Dynamite. 2004. Dir. Jared Hess. United States. Warner Brothers.

Rashomon. 1950. Dir. Akira Kurosawa. Japan.

4

Body, Masculinity, and Representation in Chinese Martial Arts Films

Jie Lu

This essay seeks to study alternative representations of masculinity in the globalized Chinese martial art film. This is exemplified by *Crouching Tiger, Hidden Dragon*, a *wuxia* film (sword-fighting martial arts genre) directed by Ang Lee in 2000. This film typifies a focus on the body as a cultural site for representing nonhegemonic Chinese masculinities. It is also a locale for cultural crossover, transgression, and contention. The study of this film will be situated within two contexts: the traditional Chinese conception of the body in constructing masculinities and its modern transformation as represented in Chinese martial arts films. As a discursive site, the body is inscribed by sociocultural changes, global influences, and traditional cultural sediments, and registers cultural/moral ambiguities/anxieties and even nationalist contentions. In a broader sense, the trajectory of the body from traditional invisibility to postmodern spectacular presentations is an integral part of the historical transformation of China to a modern state.

Crouching Tiger, Hidden Dragon is a transitional and "flexible production" made possible by Hollywood capital, a pan-Asian star cast, and a well-known international team. A spectacular and exquisite epic, the film has both legitimized and globalized the *wuxia* genre of martial arts film as bona fide cinema. Its representation of the mythic past, locating imperial China and its cultural imagery within unspecified temporal and spatial configurations of China's last dynasty, constitutes a deterritorialized

pan-Chinese identity with broad appeal to the Chinese diaspora. Its breathtaking scenery, "cyber Beijing," and cultural references recreate the long-lost glory of ancient China as well as a fantastic and imaginary world of martial arts (Lo 2005: 181).

However, there is a profound incongruity between the spectacular epic story genre and *Crouching Tiger, Hidden Dragon's* nonheroic heroes. The general critical view has been that the film, utilizing the *wuxia* genre as a form of "mythic remembrance" for the diaspora and an imaginary expression of Chinese culture together with the grand scenery and cultural settings, generates an idealized Chinese cultural identification (Lo 2005: 181). On the other hand, its character portrayals reflect cultural ambiguities toward the body. This ambivalent representation of the body opens up new masculine imaginings and possibilities. An outline of Chinese conceptual changes regarding the body and their relations to cultural/filmic representation is a necessary prelude to a fresh reading of this film that takes male gender roles seriously.

From Hidden to Revealed: Body and Masculinity in Chinese Sociohistorical and Cultural Contexts

Masculinity in the Chinese sociocultural context necessarily raises issues of body and gender. As others have recently argued, the male/female bodily distinction that has formed the fundamental principle in Western symbolic systems does not explain Chinese gender construction and symbolism. Viewed from traditional Chinese cosmology, gender constructs sex, instead of the other way around (Brownell and Wasserstrom 2002: 26). The representation of "woman" as defined by inborn biological functions did not exist in premodern China and has been borrowed from the West (Rosenlee 2006: 45). The body is absent from traditional Chinese thinking as well as gender construction.

The significance of the body in social and cultural life in general has emerged recently as a result of the rise of medical science, intellectual paradigm shifts, and social and political changes. Yet, viewed historically, the body has been, according to Bryan Turner (1984: 8), "the most elusive, illusory . . . metaphorical and ever distant thing." In traditional Western thought, several traditions contribute to the ubiquitous yet elusive status of the body. The Greek negative view was grounded in the inferiority of the body to the soul. Christianity identified the body as the locale of sin.

Cartesian dualism distinguished between mind and body and, privileging the former over the latter, favored a disembodied rational subject. The Enlightenment tradition devalued the body and desire as the foundation for action while the "Protestant ethic" subjected bodily pleasure to work ethics in order to inculcate discipline and high achievement in the individual. These Western dualist paradigms all view the body and soul/mind as discrete entities and result in a conception of the body as underdetermined, devalued, and denigrated. Western feminists argue that this dualism also forms the foundation for gender inequality by relegating women to the domain of nature—the lower part of this hierarchy. Femininity is associated with body and nature and the female body is perceived as a social difference upon which is built sexual domination and suppression. Marginalizing the significance of the body results in the suppression of women and gender inequality (Rosenlee 2006: 49).

If the body is suppressed in the West, Confucian thinking, the dominant thought system in premodern China, relegates it to insignificant status. Its insignificance can be demonstrated in the definition of gender in the Confucian tradition. In a philosophical study of gender in Confucianism, Li-Hsiang Lisa Rosenlee traces the genealogy of various meanings of yin-yang interplay and points out that sexual differences alone were not used to define man-woman gender relations. Sexual differences were employed only to describe the animal world while human males and females were defined by gender roles and social obligations. Gender in the Chinese tradition was not dictated by biological differences; the innate physical attributes of sexed bodies as implied in yin and yang was not the ontological basis for gender difference. In fact, the fluidity of yin-yang complementarity and traditional Chinese medical theory contrasts sharply with the rigidity of gender roles in the Chinese gender system (Rosenlee 2006: 45–48).

Tani Barlow locates the ontological foundation for the traditional Chinese gender system in the patrilinear family (Zito and Barlow 1994: 253–261), while Rosenlee employs the broader concept of *nei-wai* (inside-outside/private and public) to anchor gender roles. The bipolar of *nei-wai* encompasses both physical space and moral/social space: the *loci* of public virtues resides both in the bounded private space of the family and the public realm of the state. However, the social pattern implicit in *nei-wai* is complicated; unlike the distinct spheres of public and private in the West, *nei-wai* is a continuum. This sense of spatial continuum is demonstrated by the Chinese word for "country," formed by two characters

meaning family and state, and by the traditional view that the familial virtue of filial piety is the foundation for public virtue in a moral gentleman (Rosenlee 2006: 85). *Nei-wai*, while inscribing and defining Chinese gender roles, does not directly relate to a theory of body; studies of the traditional Chinese female have repeatedly noted the "absent" body in Chinese gender conception and formation.

Although the sexed body is not central to gender construction in premodern China, the body itself remains a key site for shaping both femininity and masculinity in the culture. In Confucian thought, the body is seen as insignificant: its erasure works to produce both femininity and masculinity socially. As studies on the notorious foot-binding in premodern China demonstrate, foot-binding is a way of moving away from body/ nature. Reshaping the feet is part of gender/female sexuality formation (Zito and Barlow 1994: 30), and is equivalent to men's literary learning as part of Confucian self-cultivation and a mark of civility (Rosenlee 2006: 141). As pure sexual differences only mark the natural world, woman's natural body symbolizes an untamed animal. So only through mutilation and concealment of the female body can women achieve femininity and the feminine ideal and enter the realm of culture (Rosenlee 2006: 143).

While traditional femininity was achieved through bodily inscription, cultural patterns on the (female) body, Chinese masculinity was obtained through suppression of bodily/physical desires. In the process of constructing masculinity, the body was under erasure in several different ways. Kam Louie discusses the construction of Chinese masculinity using the dyad of *wen-wu* (literary attainment–martial virtues) as a theoretic paradigm to understand its constituents. Representing the dominant forms of masculinity, this model is based on the traditional figures of the official-scholar and the military soldier, each of which embodies different virtues. The *wen* type is based on Confucian ideals of what constitutes a gentleman: literary learning, artistic pursuits, moral cultivation, and good personal governance; while the *wu* type is represented by martial skills, martial power, loyalty, and righteousness. Despite remaining in the shadow in this paradigm, the body in fact constitutes a crucial site for producing masculinity.[1]

Despite a weak and effeminate body, the *wen* type is no less masculine than the *wu* type. In fact, because elite scholar officials, the embodiment of the *wen* type, held the reins of political power, the *wen* type was more highly regarded than the *wu* type. The crucial similarity of both types was self-discipline and personal governance in controlling

sexual desire, although this self-restraint was manifested in different ways in each type. The *wu* hero shows strength and maleness by totally eschewing feminine charm; while the *wen* scholar, always associated with women, demonstrates masculinity by giving up erotic desires in order to fulfill ethical obligations.[2] In both cases, the body exists in terms of erotic desires and masculinity is constructed through negation of these desires/ the body. The male body is never revealed; it is literally, in Chris Berry's words, "lost in billowing robes." The male body parallels the female bound feet: the bound feet conceal the female body; self-control/billowing robes conceal the male body. Chris Berry further points out that the invisibility of the male body is part of a general absence of the revealed body in premodern Chinese art (2006: 224).[3] In the Confucian social and moral system, the (male) body never existed visibly. Its existence can only be pointed to through its cultural and social negation. The absent body in gender construction in premodern Chinese society means that the body is the very foundation and the last stronghold of Confucian moral and cultural thinking. Thus the body only begins to appear when Confucian social and moral systems have collapsed.

The emergence of the body parallels China's transformation into a modern nation in the late nineteenth century. This emergence was initiated by crises of the body caused by Western colonizers labeling the Chinese as the "Sick Men of East Asia." Later, in the context of modernization, the body gained political and social significance: it became equated with national resurgence, national power, and national well-being. Thus the health of China as a nation was equated with the state of the male body. As the locus of national weakness, it needed to be transformed, just as weak imperial China needed to be modernized through the building up of military power and industrialization. Lu Xun, pioneer modern writer of the early twentieth century, initially went to medical school in order to help make Chinese people strong; Mao Zedong tempered his body with physical education. A strong body became a precondition for making a modern (male) subject and building a strong nation. It was during this time that the *wuxia* film genre came into being to an enthusiastic popular reception. The flying body became the site of mass attraction and identification. *Wuxia* films, as a body-related genre, possessed an empowering effect upon the people labeled as the sick men of East Asia (Lu 1997: 56–57). The eroticized body as well appeared at this time in popular cultural productions—not as the object of suppression, but as a site with varying significance and as a symbol of romantic love and freedom.

The communist modernization during Mao's period (1949–1976) redefined the body away from the erotic and toward the heroic and politicized. It contradictorily highlighted (male) muscular bodily strength (symbolized by the strong arms of men as well as women in the Cultural Revolution posters) to stand for proletarian power and revolutionary will and worked to erase sexuality and eroticism by marginalizing femininity through making the female gender masculine. Kam Louie (2002: 19) observes a movement away from the *wen* hero to *wu* hero type in literary representations at this time. It was the people—factory workers, peasants, and soldiers who worked with their bodies—who occupied a dominant social position and constituted masculinity.[4] *Wen* people could not express the power/strength of the nation envisioned by Mao's revolutionary idealism. The intellectuals/the educated with their emasculated bodies were demoted to a dubious class to be reeducated and reformed, if not eradicated.

Paradoxically the politicizing of the male body in Mao's China occurred at the same time as martial arts films produced in Hong Kong or jointly produced by Hong Kong and Hollywood film studios were turning the body into spectacle. Martial arts films celebrate power and invincibility based on the body's strength, hard training, and martial skills. The universally recognized symbol of this new conception is Bruce Lee's half-clothed muscular body. De-erotized, both the proletarian body of Mao's China and Lee's self-displayed body were used to symbolize political power and national strength and to redefine Chinese masculinity and reconstruct the cultural image of China. Since the proletarian body spectacularized by Cultural Revolution posters only aimed to symbolize political power, it was Lee's muscular and martial body that opened up new possibilities for representations of Chinese masculinity.

A second wave of interest in *wuxai*/action genres was witnessed in Hong Kong (and the Chinese diaspora) in the mid-1960s. This occurred with the death of the romantic hero—symbol of the subordinate status of a colonized and dominated culture—and the emergence of the *wuxia*/ action hero at the time when China asserted its new power and Hong Kong became an Asian tiger.[5]

Since the mid-1980s, Chinese films, especially those of the Fifth Generation directors, have moved away from traditional aesthetics and images of masculinity through the portrayal of the "tough guy." In these films the body figures prominently as a mark of masculinity. Zhang Yimou's *Red Sorghum* (1988) portrays tough masculinity through provocative images

of the half-naked male body, blatant sexuality, and male potency. Although emphasizing virility and vitality in native Chinese sociocultural types of bandits and outlaws, the use of the male body and macho attitudes to highlight male essence was influenced by the Western conception of masculinity and a global culture of body aesthetics. Thus both Zhang Yimou's male heroes and Bruce Lee's neo-*wu* masculinity are, to use Chris Berry's word, a hybridized version that incorporates both Chinese and Western masculine constituents (2006: 226). Bruce Lee's tough masculine characters were intentionally conceived as a representation to counter the Western image of effeminate Chinese men in the global context.[6] However, Zhang's and Bruce Lee's characters also bear a strong contrast: the body of Zhang's hero is given freedom to express sexuality and virility, while Lee's body is always in control and self-disciplined. Interestingly, the new muscular masculinities, whether represented by Bruce Lee or Fifth Generation cinematic heroes, are prototypes drawn from the so-called low social classes. Bruce Lee's modern social underdog, Zhang Yimou's traditional outlaws, and Chen Kaige's socially marginalized people all fit this categorization. In the broadest sense, the embodied masculinity in recent Chinese cultural productions is associated with nonhegemonic masculinity.

In Bruce Lee's films, for instance, a nationalist and anticolonial interpretation reads the embodied masculinity constructed by his screen persona as asserting Chinese/Asian/third-world re-empowerment. Here the ascendance of *wu* masculinity over traditionally favored *wen* masculinity reworks the global image of Chinese men. Lee's body expands the traditional construction of Chinese masculinity based on the suppression of the body.[7] However, his masculine characters, framed within the narratives of "triumph of the underdog," portray hegemonic masculinity only in the world of cinema and media. In reality, such characters can hardly assert hegemonic masculinity. The dominant screen masculinity does include many masculine ideals (and carries as well political and cultural implications), yet its association with nondominant social classes suggests the inconsequential nature of its social power and efficacy. Thus the real significance of the dominant screen masculinity lies more on a symbolic than a social level. A masculinity based on the dominant rising middle class, such as those constructed by TV dramas, may thus have more social significance and a greater ability to affect societal change.

Another modern film—although not of the martial arts variety—presents the human body as an embodiment of the lack of human

dignity as well as masculinity. The documentary film, *West of the Tracks* (dir. Wang Bing, 2003), represents the animal-like life lived by formerly socialist workers in Northeast China's declining industrial infrastructure. In Mao's China, these state-owned factories constituted the country's heavy industrial base but have devolved in the process of capitalist privatization into sites of desolation and misery. As Ban Wang (2008) points out, the film tells a tragic story of the uneven development of global capitalism that leaves in its wake human casualties and ruined landscapes. Showing the completely naked bodies of the factory workers underscores the film's criticism of the cruelty and inhumanity of contemporary China's capitalist development. The animal-like bodies of the workers form a darkly ironic contrast to their former representation as heroic members of a valued class. China's transition from socialism to capitalism is also symbolized by the demotion of these bodies from symbolic to actual reality. While poster images of strong proletarian arms/bodies symbolized political power during Mao's Cultural Revolution, real proletarian bodies in their naked-ness demonstrate the "gross animalism" of their actual lives. Here the body has become a powerful discursive site to expose and critique social reality. The traditional disdain for the body itself, however, still remains in the deep structure of neo-masculinity behind the spectacle of Lee's muscular body and the withered bodies of factory workers.

The filmic spectacularization of the body has intensified cultural anxieties about the body. As the body is revealed in films and media, more "body incidents" have occurred, revealing concerns and uneasiness about the body. *Memoirs of a Geisha* (dir. Rob Marshall, 2005), a Hollywood movie about the life and experiences of a geisha in prewar and postwar Japan, is such a case. Zhang Ziyi, a Chinese actress and an international film star, plays the female lead. An intense love scene involving the semi-clad geisha and a Japanese man caused widespread outrage in Mainland China not because of Zhang Ziyi's role as a geisha, often mistaken to be equivalent to a prostitute, but because of the use of her physical body. Even though it was eventually revealed that the body in the scene was not Zhang Ziyi's but that of a Japanese actress, the physical body of Zhang Ziyi was interpreted as a Chinese body penetrated by imperial/colonial Japan; this body became the site of a memory inscribed with the atroci-ties surrounding the invasion of China (1937–1945), Rape of Nanjing (1937), and Comfort Women during WWII (Chen 2006). The film was eventually banned in Mainland China, further politicizing the issues surrounding the film's use of the body. The condensation of two identi-

ties—the real Chinese actress and the fictive Japanese geisha—inscribed
into one body demonstrates the discursive nature of the body. The body
can yield meanings well beyond the imagination of the director depending
on the circumstances of its representation and reception.

Despite the spectacular emergence of the body in contemporary Chi-
nese cultural productions, traditional disdain remains, provoking cultural
ambivalence and intensifying anxieties regarding national identity and
dignity. However, in this age of globalization, transnational understand-
ings of the body efface national and racial boundaries. *Crouching Tiger,
Hidden Dragon* with its alternative masculine imaginings, as we will see,
fully exemplifies the social and cultural complexities of the body alive
in today's society.

Embodied and Disembodied Masculinities
in *Crouching Tiger, Hidden Dragon*

Crouching Tiger, Hidden Dragon was adapted from the intricate storyline
of a multivolume novel by Chinese writer Wang Dulu (1909–1977). The
film starts with the theft of a sword, the Green Destiny, and the ensu-
ing attempt to retrieve it. The Green Destiny is what Hitchcock called
a MacGuffin: the object that kick-starts an adventure. The theft not
only puts everyone into frantic, purposeful motion, but also spins out
two tragic love stories. Li Mu Bai is a legendary swordsman of Wudang
School in the world of rivers and lakes (an imagined world of martial
arts) who pursues Yu Shu Lien, also a skillful female kung fu master. Jen
Yu (Yu Jiao Long in pinyin, meaning Jade Dragon), is the daughter of a
Manchurian governor. Her secret lover is a desert bandit, Lo (Luo Xiao
Hu in pinyin, equivalent to Little Tiger). Weary of the heroic life of the
rivers and lakes, Li Mu Bai resigns and asks Yu Shu Lien to deliver the
Green Destiny, the sword he had carried for many years, to Sir Te, an
aristocrat of the Qing dynasty, for safekeeping in Beijing. As soon as Yu
Shu Lien delivers the sword to Sir Te, it is stolen by Jen, who dreads an
imminent arranged marriage and yearns for the adventure she has read
about in books. The process of retrieving the sword engages another woman
warrior, Jade Fox, who, under the cover of Jen's maid, has taught Jen the
martial skills of Wudang School. While fighting with Jen to retrieve the
sword and with Jade Fox to avenge the death of his master by her hand,
Li Mu Bai sees Jen's potential and wants to bring her back to the right

path of Wudang School. Both Li Mu Bai and Jade Fox hope to claim Jen as their student. Jen must choose at the crossroads: to live a court life, to live as an outlaw with Jade Fox, or to follow the path of Wudang School of martial arts as Li Mu Bai's disciple. Rebellious, she has refused all. In the end, in order to save Jen from Jade Fox who wants to kill her for hiding the knowledge of the secret Wudang journals, Li Mu Bai falls into Jade Fox's trap. Though he kills Jade Fox, he is poisoned by her needles, and dies in the arms of Yu Shu Lien. The film ends when Jen, after meeting her lover Lo for one night in the Wudang Mountains (that were also the home of Li Mu Bai), jumps from a high mountain and flies into the sea of clouds. The grand finale is ambiguous: it is obvious that she jumps in order to fulfill a belief based on a legend she heard from Lo, that a faithful heart makes wishes come true. But does she jump because she feels guilty that her action that caused Li Mu Bai's death, or because she wishes to bring Li Mu Bai back to life, or because she wants to transcend the earthly world?

Overlaid by a string of meanings, this enigmatic finale is richly polyvalent, pointing out the ambiguity implicit in all generic conventions and characterizations. This ambiguous ending, because it informs all dimensions of the film, creates a broad representational space for exploring alternative cultural forms including those associated with masculinity. While challenging the dominant screen masculinity, it also allegorizes the indeterminate nature of masculinity.

As an artistic culmination and synopsis of the hundred-year-long *wuxia* genre, *Crouching Tiger, Hidden Dragon's* achievement lies first of all in its transformation of the generic conventions of *wuxia* film. *Wuxia* film is a hybrid. Originating from premodern practices in literature, opera, oral narrative tradition, and genres of popular history, it incorporates elements of period costume and fantasy movies, medieval European romance, Hollywood swashbucklers and westerns. Its contemporary form has absorbed elements from Japanese *chambara*, James Bond spy thrillers, and action movies (Lu 1997: 56–57; Teo 1997: 191–221). Although hybrid in form and open to innovations, this film still contains elements of the traditional *wuxia* genre, depicting a closed structure based on imageries of the world of rivers and lakes, codes of conduct, and traditional mores such as honor, loyalty, justice, and righteousness. The world of rivers and lakes—a site outside our "official" world, a near-utopian realm—is simultaneously coherent/self-contained and mythic/fantastic (Chen 2002: 73–74). It features larger-than-life heroic warriors of great virtue and supreme martial skill

who demonstrate chivalric behavior by fighting for justice and revenge but at the same time defying general society. Thus, the film privileges story/plot over the characters. Gaudy costumes, implausible events, and special effects highlight the fantastic dimension of the *wuxia* film that typically is enjoyed more as entertainment than taken seriously. However, *Crouching Tiger, Hidden Dragon* is not typical. It accepts the *wuxia* form only so far—toning down the fantastic dimensions and expanding realistic ones, to create a nuanced balance between engaging the audience emotionally and sparking the imagination (Williams 2001a: 72).[8] This allows director Ang Lee to move the film away from being merely plot driven toward a character-focused drama. The typical *wuxia* events—sword-theft, desert romance, and revenge—exciting by themselves, also bring out psychological concerns and hidden desires (Williams 2001a: 72). Each fight is laden with symbolism. The incorporation of nonmartial art elements such as film noir and the growth story create a larger opportunity for character development (Lo 2005: 189–196). With its character focus, the film transforms *wuxia*'s black-white pattern of characterization into a portrayal of ambiguous and ambivalent characters. It is through the medium of ambivalent characters that the film presents alternative masculinities.

Ang Lee, reversing the macho tradition of the martial arts film, uses two martial women as the anchors of the movie, Yu Shu Lien and Jen (William 2001a: 69). The dominance of female protagonists has "feminized" the film. Critical readings tend to focus on Jen and Yu Shu Lien (as well as Jade Fox), and treat the two male protagonists as foils for the female stories (Lo 2005 and Chan 2004). Indeed, the high status of Li Mu Bai, the legendary martial master, is considerably outshined by the two woman warriors. His legendary status is further demoted by the denial of a heroic death: he is killed by Jade Fox, a woman, and "by a very small needle for a very small ambiguous cause" (Teo 1997: 202). His first screen appearance already establishes him as a pensive, serene, and inward-looking martial master with "hero-fatigue" (Teo 1997: 202). Operating within the larger signifying framework of the martial arts film, Li is devoid of many traits associated with the dominant type of screen masculinity. His masculine persona represents a variation of the paradigm of masculinity, one that rests less on the physical body and more on psychological prowess. In short, Li Mu Bai's role transcends those adopted by recent Chinese martial arts films.

Ang Lee's accomplishment can be appreciated more fully in the context of contemporary action films. John Woo's *A Better Tomorrow*

(1986), a stylistic and modern transformation of sword-play (martial art) and fistfight (kung fu) has opened up possibilities of masculinity and laid a foundation for Chinese filmic masculine politics. The film tells the story of two delivery boys in the world of Hong Kong gangsters, Mark and Ho, who work for a syndicate dealing in counterfeit notes. When they try to smuggle notes into Taiwan, Ho is betrayed, captured, and sentenced to jail, leaving Mark alone to square up with his betrayers. Although he kills his enemy, Mark is shot and crippled for life. For three years he lives as a bum, humiliated by the new boss of the syndicate, Shing, who was behind the betrayal. In the final showdown between the traitors and the protagonists, who are bound by a code of loyalty, Mark, instead of fleeing, joins the fight with Ho and his police brother. They win, but Mark dies heroically.

As indicated by the original Chinese title, *True Color of the Hero*, the film portrays a new brand of masculine hero to which the spectacle of the body, male bonding, and the traditional value system of honor, justice, righteousness, and personal loyalty are crucial. The construction of this new masculine hero is within the traditional *wu* masculine paradigm delineated by Kam Louie and stresses the homosocial environment and Confucian moral ethics. However, both of these elements are reexamined in the context of a different time and place, namely, contemporary Hong Kong.

The foregrounding of the body, influenced by the Western concept of masculinity as represented by Bruce Lee's subjectivity, marked an important point of departure from the traditional *wu* construction of masculinity. However, the body imageries in Woo's film are different from the self-display of Bruce Lee and the Hollywood bodybuilders. The Hollywood action film, in particular, emphasizes the power and aesthetic of the male body as the anchor of an ideal masculinity. In Woo's film, the body is not imaged according to the visual/syntactical paradigm of half-naked musculature. Instead it emphasizes stylized clothes and accessories such as food, gum, cigarettes, sunglasses, and matches. Rather than nudity, facial expressions and gestures abound. In hiding the physical/naked body, these trappings and gestures foreground the expressive, cultural, and communicative dimensions of the body within the homosocial environment; body gestures become expressions of homosociality. The structure of chivalry and sentimentality are reinforced but lightly so, by the rare heterosexual romance. Nevertheless, although hidden within clothes, the physicality of the body does not disappear; rather it is represented

through the bruised body—the body damaged by violence. Bloodstains on the clothes, scars, and the crippled leg of Mark metonymically stand for the body, thus drawing attention to the significance of the body hidden beneath the clothes.

Mark's screen body as a spectacle of pain and suffering registers multiple meanings. Psychologically, it stands for the character "whose sense of individuality is always premised upon subjecting his body to excessive pain and violence."[9] Generically, the film combines the female "suffering genre" and male "doing genre" in order to create an unstable masculine subjectivity who—in a political reading—shows a sense of powerlessness in the ability to respond to the impending historical change on the eve of Hong Kong's return to China (Stringer 1997: 29). The bruised body, not the revealed one, together with the traditional *wu* masculine features, constitutes the dominant screen masculinity here. The significance of the (bruised) body to this portrayal of masculinity is reinforced by squeezing out the romantic relationship between man and woman, thus allowing the film to emphasize not just the male bond but also different dimensions of the body—physical strength and endurance, the experience of agency, and the heroism of dying for loyalty and righteousness. The bruised body hinges on violence and offers men a performative basis on which to construct masculine identity. In other words, violence dramatizes the body and constitutes the body as a symbolic terrain for representing masculinity.

In *Body Work*, Peter Brooks sees the body as a "vehicle of mortality," inescapably inscribing and being inscribed upon by narrative (Brooks 1993: 1). Storytelling and the meaning of narratives, Brooks maintains, are sustained by the presence of the body (Brooks 1993: 1). In *A Better Tomorrow* the body visually inscribes the narrative. It is the locale where Woo's stylized fighting and hyperkinetic choreography are performed. Within the simulacrum of a violent world, the body constitutes the *mise-en-scéne*.

A Better Tomorrow is not without emotionalism. According to Robert Hanke (1999: 39), Mark represents a new kind of male protagonist, one who demonstrates both physical violence and emotional intensity, as distinct from the one-dimensional hero in classic Hollywood action movies. Yet, the *mise-en-scéne* of extreme violence and the teleological narrative of fight and solution valorize the bruised body primarily as the film's central dynamic of proving masculine identity and realizing loyalty and righteousness. The process of being subjected to bodily brutalization and destruction does not produce a transformation in the realm of

consciousness, but only shapes the male body culturally and ethically and moves the hero toward his complete incorporation into homosociality and its values. Adding an emotional dimension to his identity, the soft side of Mark (and of Woo's other action protagonists) does not modify and complicate masculine subjectivity.[10] The teleological narrative and cinematic excess of violence allow little space for the hero's inner world; his focus remains on actions in the "public" domain. Coherent masculinity is thus primarily located on the (bruised) surface of the body.

Li Mu Bai's character in *Crouching Tiger, Hidden Dragon* considerably complicates the dominant masculinity in martial arts films and challenges notions of coherence, constancy, and closure in the mediation of masculine identity beyond that typified by Woo's heroes. To begin with, the film decenters the identity politics of the male hero through an environmental dislocation. Instead of being in a homosocial world, Li Mu Bai is surrounded mostly by female characters, including his arch enemy, Jade Fox (who killed his master). If masculinity is understood as "a subjectivity that is organized within the structure of control and authority," then the homosocial environment or patriarchal domination is crucial to this structure (Chapman and Rutherford 1988: 11). But in this film, the feminine environment has replaced the homosocial context of Li Mu Bai as the martial hero. Here the female environment does not so much shape Li Mu Bai's masculinity as it provides a context for a different structure of male control—the control of hidden/romantic desires. His love for Yu Shu Lien is prohibited by traditional moral propriety and the code of honor. Because Yu's betrothed, who died in a battle, was Li Mu Bai's "brother in oath," Li Mu Bai and Yu Shu Lien must suppress their desires for each other and thus transform this denial into an aspect of warrior discipline and the moral code of the world of lakes and rivers. Ang Lee, explaining the title of the film, captures the essence of Li Mu Bai's type of masculinity in terms of the conflict between desire and duty: "The true meaning of the film lies with the "Hidden Dragon." *Crouching Tiger, Hidden Dragon* is a story about passions, emotions, desires—the dragons hidden inside all of us. . . . So as Li Mu Bai and Shu Lien pursue Jen, they are chasing their own dragons. Jen's youth and energy remind them of the romance and freedom that neither of them has experienced. Having chosen a life of duty, Li Mu Bai and Shu Lien must suppress their passions and their mutual love. Their desire is always close to the surface, but they would be abandoning the code of honor that shaped their lives if they gave in to their true feelings" (quoted in Chan 2004:

8–9). Li Mu Bai's repressed desire can be seen to stand metonymically for his physical body, which is always represented completely clothed. Thus it is the denial of the body/desires that largely confirms his masculinity.

The displacement of the homosocial environment evokes masculine features not usually found in the pure *wu* type or in the embodied masculinity of Woo's action movies. For the (neo) *wu* hero, homosocial space is a precondition: it reinforces ideologies of brotherhood and loyalty, and precludes female temptation through abstinence. Typically this stoic hero cannot afford to waste his energy by pursuing amorous affairs. Masculinity can only be achieved in the absence of women. For the *wen* hero, on the other hand, the man-woman relationship is part of his social landscape. The mind-body dichotomy broadly informs the representation of *wen* masculinity: overcoming temptation, especially sexual temptation, is a precondition for the success or attainment of Confucian gentlemanhood. Li Mu Bai is by no means from the elite social echelon that models *wen* masculinity, but he embodies its mind-body conflict in his efforts of suppressing his romantic passions. [11] Li can be seen to cross-pollinate *wen* and *wu* conceptions of masculinity in combination. He is a composite figure that combines the *wu* identity of martial master and *wen* conflict of mind-body. His Taoist meditation and pondering on the truth of the world of rivers and lakes have further added *wen* dimension to his martial identity. Fighting in this film dramatizes the story and shows the hero's martial artist status; however, it also proves Li Mu Bai's self-control as demonstrated by his supreme poise and balance in the fight with Jen on the bamboo treetops. In the world of martial arts/action films, Li Mu Bai represents the unfamiliar figure of a weak and inward-turning martial hero. His hybrid masculinity challenges the notion of an essential masculine subjectivity located in the heroic/bruised body, creating a strong contrast to the masculinity embodied in Woo's *A Better Tomorrow*. Moreover, this hero also betrays the traditional distain of the body: the hidden body/ denial of desires is the mark of the dominant/elite masculine rationality.

Li Mu Bai's disembodied masculinity contrasts with a second image of masculinity embedded within *Crouching Tiger, Hidden Dragon*. Lo, who has an illicit liaison with Jen, is a desert outlaw known as Dark Cloud. He represents, in Kenneth Chan's (2004: 9) words, "the antithesis of Mu Bai and Shu Lien"—the former being distinguished heroes of the world of rivers and lakes and the latter head of the security agency hired by the rich to protect themselves and their wealth from criminals like Lo. If Jen and Li Mu Bai/Yu Shu Lien represent the official world of the

Manchu rulers and the world of rivers and lakes, then Lo represents the barbarian world of the non-Han Chinese. His outfit, loose hair style, and the Gobi Desert all identify him as a member of a minority in Chinese Turkestan. His body further defines his "barbarian" status, representing a type of "masculinity" beyond the dominant *wen-wu* paradigm. The paradigm of masculinity clearly does not apply to non-Han Chinese because non-Chinese are perceived to represent a sexualized masculinity that reveals their animal barbarism (Louie 2002: 12). The perception of the body and physical power as barbaric became dominant after the Chinese were conquered and ruled by the non-Han Chinese or Manchu, significantly changing the Chinese conception of masculinity.[12] To a large extent the aesthetic disdain for the (male) body came to be based on its association with barbarians as well as with others of low social class such as entertainers, boxers, and acrobats. The *wen-wu* paradigm of masculinity is defined against a series of "others"—namely, minority/non-Han Chinese, women, and others of low social class.

In the film, Lo's "other" masculinity is enacted through two indexes: the Gobi Desert and his body/irrationality. Although the Gobi Desert, far away from suffocating social restrictions imposed by Confucian morality and the warrior's codes of conducts, is a locale of freedom where the romantic love between Lo and Jen can flourish, it is also presented as a place of moral dubiousness: an uncivilized place where bandits freely roam and illicit love affairs occur. The representation of Lo reveals stereotypical traits associated with minorities through his body and his irrational acts. His exotic clothes, his half-revealed chest, his "wild" body gestures and facial expression underscore his "otherness." Even though the love scene between Lo and Jen does not reveal much of their bodies, the scene itself—the illicit love between a minority man and woman (Jen being a Manchu)—unconventional in martial arts movies, eroticizes the body of the "others." Lo's reckless attempt to take Jen away as she is on her way to her wedding—without any consideration of the serious consequences for her—further demonstrates his "barbarian" irrationality and impulsiveness. Cast as a romantic hero, Lo serves as an "antithesis" to Li Mu Bai (and Yu Shu Lien) in terms of moral propriety and self-control. He represents the sexualized notion of "other" masculinity based on the uncivilized body. In addition to the political implication in the depiction of the marginal status of China's ethnic minorities within the framework of Han centrality and Lee's Chinese national imagery (Chan 2004: 19),

the representation of Lo's embodied masculinity clearly associates his body with minority status.

If Lo is posed as an "antithesis" to Li Mu Bai to represent an alternative masculinity, then Jen can also be seen to represent another form of embodied masculinity, although in more complicated ways. As discussed earlier, ambiguity constitutes the structure of representation and characterization of the film. Jen's ambivalent character is built on a series of transgressions. To foreground the woman as the lead of the action and narrative in the masculine genre of a *wuxia* movie is already a (generic) transgression. Jen's intrusion into the traditionally masculine territory of violence is a further transgression of gender boundaries. Perhaps the most ambivalent transgression is Jen's masculine identity. To read Jen as representing masculinity might sound farfetched; yet among her multiple identities—the daughter of an aristocratic Manchu family, the secret lover of a desert bandit in the Chinese Turkestan area, and a swordsman in disguise—the last one most represents her aspiration and forms the dynamic of her story as well as the film's plot.

Jen's masculine desire is initially played out in her theft of Li Mu Bai's Green Destiny. The sword is laden with the history of Wudang School and the social and political power of Li Mu Bai. As a phallic symbol, it represents the masculinity of the martial world. Its mythic power is reified by Yu Shu Lien when she exclaims to Jen, "Don't touch it! That's Li Mu Bai's sword. . . . Without the Green Destiny, you are nothing." Interestingly, Jen's desire to obtain the sword constitutes a reversal of Li Mu Bai's decision to give up the sword. Jen's masculine aspiration therefore strongly contrasts Li Mu Bai's hero-weariness. The ensuing fighting between Jen and Shu Lien over the sword further reveals Jen's "other" identity as a martial "man." The clothes of a knight-errant Jen wears when she is engaged in fighting are only part of her masculine identity; it is her "masculinized body" shaped by martial arts that forms the core of her masculinity. In discussing Jen (Jiaolong) in Wang Dulu's novel, *Crouching Tiger, Hidden Dragon* (serialized 1941–1942; from which Ang Lee adapted his film), Tze-lan Sang sees martial arts as a body-altering technology. Although this technology does not change the body physically (as does twenty-first-century sex-reassignment technologies), they have equipped Jen with a set of martial skills and qualities such as strength, speed, explosive power, valor, ambition, and even cruelty (Martin and Heinrich 2006: 104). These qualities mark her difference from other women in

her time and conflict with her identity of an aristocratic woman (Martin and Heinrich 2006: 104). But most of all, Jen's bodily transformation—from feminine frailty to masculine athletic prowess—produces a form of embodied masculinity based not on the anatomical sex/biologically male body, but on the bodily performance. Her masculine "otherness" allegorizes masculinity as an empty signifier, and, in a way, represents the "end of masculinity" forecasted by MacInnes (1998: 77)—the demise of the belief in masculinity as an identity specific to men.

As an ultimate transgression, Jen's embodied masculinity forms the deep structure of her ambiguity. She is neither white nor black. Her dynamic energy challenges the rules of the traditional social order, the paralyzing effects of which her gender transgression is a symptom. Jen has learned martial arts from Jade Fox, the arch villain of the film, who represents the subversive force that disrupts the patriarchal tradition and moral categories of the world of the *jian hu* realm, also known as "the world of rivers and lakes" (Chan 2004: 9–11). Influenced by Jade Fox's corrupted force, Jen is not interested in the totalizing narrative of good versus evil that governs the minds of Li Mu Bai and Yu Shu Lien; she aspires to freedom—an imagined freedom in the world of rivers and lakes that she has learned about from reading fiction (Lo 2005: 190). Her attempts to live out this imagined freedom turns her masculine body into a dangerous power with frightening consequences. She indirectly causes Li Mu Bai's death: he is poisoned in his attempt to save her but she fails to return in time to provide the antidote to save him. Lacking a noble cause, her embodied masculinity cannot be located in the heroic tradition of the woman warrior as exemplified by the Mulan myth, an Amazonian type of woman who assumes male garb and identity in order to address disorder or injustice in society. [13] Ang Lee even says that Jen "is in some ways the villain in the movie, but a most likable one" (Lo 2005: 191).

Jen's ambiguity is perhaps best understood in terms of her inability to live within any traditional order. The world of *Crouching Tiger, Hidden Dragon* is framed by three spaces in a structure of descending concentric circles. The aristocratic home of Jen depicted in the micro spatiality of intimate and minute domestic details and the harmonious architectural layout of Sir Te's compound represent the space of Confucian social order. The walls and gates are both physical and symbolic/cultural boundaries that set it apart as the center of Chinese civilization, a world of rigid hierarchy, rituals, and decorum. Outside this center is the world of rivers and lakes of Li Mu Bai and Yu Shu Lien consisting of locations at the

geographical margins of society: a complex of inns, forests, highways, and caves. In contrast to Confucian order, this world is characterized by a sense of autonomy and a utopian ethos. Yet it is not an anarchic world of absolute freedom; it has its own hierarchic structure and codes of conduct. It is also a dystopian world filled with evil and murders/assassinations, controlled by base desires and greed. Lying beyond the world of rivers and lakes is the uncivilized space of barbarians represented by the Gobi Desert/Chinese Turkestan area inhabited by Lo and his bandits.

To Jen, none of these worlds can provide her identity: she is not satisfied with the life of an aristocratic lady—she escapes from an arranged marriage to an ugly man. Yet her Confucian conscience does not allow her to live the life of a desert bandit with ease. Nor does she want to live the life of knight-errantry heroism in the world of rivers and lakes. Her rejection of Li Mu Bai's effort to accept her as his student is also her refusal to accept his moral ideology. She belongs to none of these worlds because none of them is able contain her vision of an authentic life of freedom. Jen's dive from the mountains is symbolic of her desire to transcend the limitations of these worlds.

Jen desires transcendence because the traditional social order is oppressive; it will not tolerate the alterity of embodied masculinity. Jen's masculine performance is an act of transgression—not the transgression of heroic knight-errantry or a fake male body—but a bodily transgression that underwrites all her transgressions, including the discursive transgression of the *wu* masculine paradigm. Her performance of masculinity demonstrates the limitation of *wu* masculinist discourse and as the main protagonist, her departure from the heroic status "contaminates" the heroic genre of the *wuxia* movie itself.

The embodied masculinities of Jen and Lo both alienate them from and threaten to subvert the Confucian world order. This threat of subversion to the nominal orders of the Confucian world is represented in terms of bodily force—whether Lo's minority body or Jen's altered body. The film's ending betrays a profound distrust of the body as a disruptive force to the dominant sociocultural orders.

Conclusion

Situated within the globalized Chinese masculine imaginings represented by Bruce Lee and John Woo's action heroes such as Mark in *A Better*

Tomorrow, Crouching Tiger, Hidden Dragon, nevertheless, presents alterna-
tive masculine possibilities that negotiate between traditional Chinese
masculine ideals and contemporary cultural reimaginings. At the core
of their different configurations lie the different body imaginings: the
body imaged as an index of heroic masculinity (Bruce Lee and Mark),
or as a mark of otherness or alterity (Lo and Jen), or as an absent pres-
ence (Li Mu Bai). Action films have elevated the body to be part of
the dominant screen masculinity while Ang Lee's film problematizes the
body in constructing masculinity. Ironically however, the differences in
their masculine imaginings—whether embodied or disembodied—have
all invoked the traditional distrust of the body as a disruptive social
force and a prejudice toward its association with minorities, persons of
low social class and women. The embodied and disembodied forms of
masculinity in *Crouching Tiger, Hidden Dragon*, viewed in both contexts
of the sociocultural conceptions of the body in Chinese history and the
Chinese martial arts filmic tradition have demonstrated the importance
of the body as a site for cultural contentions and representations. From
its traditional invisibility to its postmodern spectacularization, the body
has inscribed and has been inscribed upon by sociocultural changes over
time and has registered contemporary cultural anxieties and ambivalence.
The ascendancy of the body in cultural representation, especially in the
construction of masculinity, reflects global cultural influence, contemporary
body politics, and the traditional Chinese view of the body. The cultural
and discursive complexities of the body are played out in Chinese martial
arts films (of both *wuxia* and action genres). Indeed, the body in film, or
the filmic body with its tangible and intangible iconicity, constitutes, more
than other narratives, a symbolic terrain for probing and interrogating
fluid concepts such as masculinity.

Notes

 I wish to thank Bob Benedetti for his critical comments and careful editing,
and D. S. Farrer and John Whalen-Bridge, the editors of this volume, for their
valuable suggestions and great efforts in bringing this collection to publication.
I also wish to thank the anonymous readers for their comments and suggestions.
 1. Yao Souchou, in his review of Louie's book, points out that the body
remains "a mere shadow, an apparition without form or substance." See Yao's
(2002) review of Kam Louie's *Theorising Chinese Masculinity*.

2. This is certainly an ideal masculinity. It is never the case in literary presentation, as *qing* (romantic feelings) is a major topic in classic Chinese literature. See Haiyan Lee (2007: chapter 1).

3. For detailed studies on the representation of the body in traditional Chinese art, see John Hay's "The Body Invisible in Chinese Art?" (1994: 42–77).

4. For body culture under Mao, see Ann Anagnost's essay on "The Politicized Body" that addresses the continuities and discontinuities in the conceptions of the social body (Martin and Heinrich 2006: 116).

5. See also Stephen Teo (1997: 97–109) for the difference between *wuxia* and kung fu genres.

6. For the political and cultural implications in Bruce Lee's masculinity, see Stephen Teo's (1997: 110–221) "Bruce Lee: Narcissus and the Little Dragon" and Jachinson Chan's (2001: 73–96) "Bruce Lee: A Sexualized Object of Desire."

7. For more detailed studies on complicities in Bruce Lee's body in representing neo-*wu* masculinity, see Chris Berry's (2006) "Stellar Transit."

8. In fact, as Zhang Zhen points out, the term *wuxia*, when first used in the late 1920s, is a compound phrase—*wuxia shenguai pian*—the "martial arts-magic spirit" film (Lu 1997: 53).

9. Jillian Sandell quoted in (Hanke 1999: 45).

10. Another typical example of John Woo's action hero who is both martial and sentimental is from his film *The Killer* (1989). For detailed studies on the film, see Jinsoo An (1997) and Ciecko (1997).

11. On the other hand, as critics all have noticed, there is latent romantic desire in Li Mu Bai for Jen. See Lo (2005) and Chan (2004).

12. Van Gulik quoted in Louie (2007: 7).

13. Zhen (2005) points out that the *wuxia* genre also has a subgenre with martial heroines. The basic narrative confirms the tradition of woman warriors, and it invariably ends with the happy ending of family reunion—to confirm family values and the woman's position at home.

References

An, Jinsoo. 2001. "*The Killer*: Cult Film and Transnational (Mis)Reading." Pp. 95–113 in Esther C. Yau, ed., *At Full Speed: Hone Kong Cinema in a Borderless World*. Minneapolis and London: University of Minnesota Press.

Berry, Chris. 2006. "Stellar Transit." Pp. 218–234 in Fran Martin and Larissa Heinrich, eds., *Embodied Modernities: Corporeality, Representation, and Chinese Cultures*. Honolulu: University of Hawai'i Press.

Beynon, John. 2002. *Masculinities and Culture*. Buckingham and Philadelphia: Open University Press.

Brooks, Peter. 1993. *Body Work: Objects of Desire in Modern Narrative.* Cambridge and London: Harvard University Press.

Brownell, Susan, and Jeffrey N. Wasserstrom, eds. 2002. *Chinese Femininities, Chinese Masculinities.* Berkeley: University of California Press.

Chan, Jachinson. 2001. *Chinese American Masculinities: From Fu Manchu to Bruce Lee.* New York and London: Routledge.

Chan, Kenneth. 2004. "The Global Return of the Wu Xia Pian (Chinese Sword-Fighting Movie): Ang Lee's *Crouching Tiger, Hidden Dragon.*" *Cinema Journal* 43 (4): 3–17.

Chapman, Rowena, and Jonathan Rutherford, eds. 1988. *Male Order: Unwrapping Masculinity.* London: Lawrence and Wishart.

Chen, Pingyuan. 2002. *The Literati's Dreams of Wuxia* [*qiangu wenren xiagemeng*]. Beijing: New World Publishing House.

Chen, Xiaoyun. 2006. "The Representation and Anxiety of Body in the Recent Chinese Films." *Contemporary Chinese Film* [*Dangdai dianying*] 6: 94–98.

Ciecko, Anne. 1997. "Transnational Action: John Woo, Hong Kong, and Hollywood." Pp. 221–237 in Sheldon Hsian-peng Lu, ed., *Transnational Chinese Cinema.* Honolulu: University of Hawai'i Press.

Hanke, Robert. 1999. "John Woo's Cinema of Hyperkinetic Violence: From *A Better Tomorrow* to *Face/Off.*" *Film Criticism* 24 (1): 39–57.

Hay, John. 1994. "The Body Invisible in Chinese Art?" Pp. 42–77 in Angela Zito and Tani E. Barlow, eds., *Body, Subject and Power in China.* Chicago: University of Chicago Press.

Klein, Christina. 2004. "*Crouching Tiger, Hidden Dragon*: A Diasporic Reading." *Cinema Journal* 43 (40): 18–42.

Lee, Haiyan. 2007. *Revolution of the Heart: A Genealogy of Love in China, 1900–1950.* Stanford: Stanford University Press.

Lo, Kwai-cheung. 2005. *Chinese Face/Off: The Transnational Popular Culture of Hong Kong.* Urbana and Chicago: University of Illinois Press.

Louie, Kam. 2002. *Theorising Chinese Masculinity: Society and Gender in China.* Cambridge: Cambridge University Press.

Lu, Sheldon Hsian-peng. 1997. *Transnational Chinese Cinema.* Honolulu: University of Hawai'i Press.

———. 2005. *Chinese-Language Film: Historiography, Poetics, Politic.* Honolulu: University of Hawai'i Press.

MacInnes, John. 1998. *The End of Masculinity.* Buckingham: Open University Press.

Martin, Fran, and Larissa Heinrich, eds. 2006. *Embodied Modernities: Corporeality, Representation, and Chinese Cultures.* Honolulu: University of Hawai'i Press.

Morris, Meaghan, Siu Leung Li, and Stephen Chang Ching-kiu, eds. 2005. *Hong Kong Connections: Transnational Imagination in Action Cinema.* Durham and London: Duke University Press, Hong Kong: Hong Kong University Press.

Rosenlee, Li-Hsiang Lisa. 2006. *Confucianism and Women*. Albany: State University of New York Press.

Schamus, James. 2004. "Aesthetic Identities: A Response to Kenneth Chan and Christina Klein." *Cinema Journal* 43 (4): 42–52.

Stringer, Julian. 1997. "'Your Tender Smiles Give Me Strength': Paradigms of Masculinity in John Woo's *A Better Tomorrow* and *The Killer*." *Screen* 38 (1).

Sunshine, Linda, ed. 2002. *Crouching Tiger, Hidden Dragon: A Portrait of the Ang Lee Film*. New York: Newmarket Press.

Teo, Stephen. 1997. *Hong Kong Cinema: The Extra Dimensions*. London: British Film Institute.

Turner, Bryan S. 1984. *The Body and Society*. Oxford: Blackwell Publishing.

Wang, Ban. 2008. "In Search of Real-Life Images in China: Realism in the Age of Spectacle." Special issue edited by Jie Lu, *Journal of Contemporary China* 17 (56): 497–512.

Williams, David E. 2001a. "Enter the Dragon." *American Cinematographer* 82 (1): 68–77.

Williams, David E. 2001b. "High-Flying Adventure." *American Cinematographer* 82 (1): 54–67.

Yau, Esther C. 2001. *At Full Speed: Hong Kong Cinema in a Borderless World*. Minneapolis and London: University of Minnesota Press.

Yao Souchou. 2002. Review of Kam Louie's *Theorising Chinese Masculinity: Society and Gender in China*, in *Australian Humanities Review* http://www.australianhumanitiesreview.org/archive/Issue-September-2002/souchou.html

Zhen, Zhang. 2005. "Bodies in the Air." Pp. 64–68 in Sheldon Hsian-peng Lu, ed., *Transnational Chinese Cinema*. Honolulu: University of Hawai'i Press.

Zito, Angela, and Tani E. Barlow. 1994. *Body, Subject and Power in China*. Chicago: University of Chicago Press.

Film

Crouching Tiger, Hidden Dragon. 2000. Dir. Ang Lee. Sony Pictures Home Entertainment.

Red Sorghum. 1988. Dir. Zhang Yimou. Xi'an Film Studio.

West of the Tracks. 2003. Dir. Wang Bin. European DVD release, Mk2.

Memoirs of a Geisha. 2005. Dir. Rob Marshall. Columbia Pictures Dreamworks.

A Better Tomorrow. 1986. Dir. John Woo. Cinema City Company Limited.

Part II

How the Social Body Trains

5

The Training of Perception in Javanese Martial Arts

Jean-Marc de Grave

To what extent can the classification of the senses be considered objective or universal? Can touch be considered a simple capacity or sense or an elaborate one? Answers to such questions depend on the way the hierarchy of senses is shaped in a given sociocultural context and how in this context the senses are educated. This chapter examines a training of the senses that refines the conventional notion of "touch" away from ordinary "touching" and closer to what was called "tact" in eighteenth-century Europe.

Javanese martial arts draw their roots from an esoteric context where the refinement of perception does not represent an end in itself but a passage toward self-control with an implied relationship to the divine. However, the practice of Javanese *pencak silat* in its modern version tends to be emancipated from any spiritual reference. The training focuses on implied touch, tact, and proprioception in a very active way.[1] After discussing the Javanese traditional context, I will present an ethnography of the techniques used in Javanese martial arts to refine the notion of sensitive perception. I will then show how modern scientific research on cognition echoes the concepts and the Javanese empirical models described, draw a comparison with the European context, and conclude by discussing the educability of the senses within a cultural context.

Classical Javanese Conceptions of the Senses

Java is one of the principal islands of Indonesia. The Javanese occupy the central and eastern parts of the island. On the basis of oral traditions,

123

certain concepts and practices from India were adopted starting in the first centuries CE. The specific classification of the senses dating from this time still marks Javanese culture and habits today, surviving both Islamization at the beginning of the fifteenth century and Dutch colonization from the sixteenth century onward.

This categorization of the senses is aligned with a broader system of classification that stands on a hierarchical basis of four peripheral terms and one central term. Space, for example, is conceived according to the four cardinal directions and one center point. For the senses, the four peripheral elements or "external senses" are: smell, hearing, sight, and taste. The central sense is "inner feeling" (*rasa*). *Rasa* includes all that can be perceived and felt within the body: combining sensations of the skin and proprioception as well as the "emotions and feelings" (*rasa-pangrasa*) especially tied to the liver. The sensations of the skin and proprioception induce a sense of touch: for example, one can sense heat and cold without direct contact with the skin. Therefore, in Javanese, "touch" (*dumuk*) strictly speaking simply indicates what one touches; while the verbal form *ngrasaké* (from *rasa*) is used for feeling what one touches.

Inside *rasa*, "the true inner feeling" (*rasa sejati*) can be activated by a special state of concentration that is obtained by balancing the external senses and the internal sense. This balance is tied to balanced social behavior and—for those who want it—is achieved through meditation and asceticism. *Rasa sejati* is the most subtle form of feeling that lies in the body; it corresponds to the "true essence" of being and is supposed to be of divine origin (fig. 5.1).

The general traditional formative systems that we find in *pencak silat* thus consist in harmonizing between them each peripheral sense in order to activate the "inner feeling" so that it expresses—through suitable training and practices—feelings of compassion and empathy. At a sociorelational level, the transmission of this kind of knowledge coincides with the coming of age in adulthood, a crucial period of the human life cycle notably described in anthropological works.[2] In Java, entering into adulthood marks the need to follow the teaching of a master with the aim of becoming a "true human being" through lifelong learning.[3]

The creation of a modern Indonesian State in 1945, however, initiated the spectacular development of secularized and even laicized practices, in which any relationship to the spiritual dimension is sometimes excluded. Such an exclusion may be illustrated through an example from within the framework of martial arts training, where the senses of touch

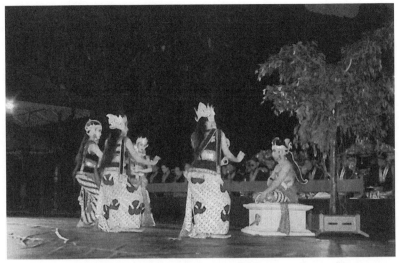

Figure 5.1. The highest exercise of *rasa*, figured by the meditation of Arjuna.

and feeling are strongly involved through breathing and concentration exercises. Concrete applications of such exercises involve training remote sensitive blind detection and developing the ability to break hard objects.

Tenaga Dalam: Techniques to Reenforce Body Contact

Merpati Putih (MP) is one of the principal Indonesian schools of *tenaga dalam* (inner power). Such schools have undergone a large-scale development beginning at the end of the 1980s. The biggest schools can count several hundred thousand members. Their sponsors—often practitioners themselves—are influential religious, political, or military personalities. This phenomenon has become so extensive that it tends toward institutionalization. In 1997, for example, I could visit an experimental state hospital comprising a *tenaga dalam* section in Surabaya, East Java. This development corresponds to an adaptation to modernity, where the notion of internal sense is still maintained but transposed, as we shall see.[4]

The school of Merpati Putih originated in the town of Yogyakarta, Central Java. Subsequently, when the founders started training the presidential guards in the school's breathing and "inner power" techniques, the

administrative center moved in 1976 to the Indonesian capital city, Jakarta (Western Java). Since the formal creation of the organization in 1963, the persons in charge of Merpati Putih worked hard to rationalize their techniques by collaborating with military, medical, and sport specialists. Their leitmotif consists of saying that one can acquire good health with Merpati Putih and increase one's energetic capacities without the use of mystical practices such as fasting or the use of formulas of invocation/protection. This manner of approach is regarded as a positive and modern approach by certain "progressives" and young people.

The school, while internationally famous for its self-defense techniques of *pencak silat*—the martial arts of the Malayan peoples—it is known above all for its breathing techniques. Believed to be inherited from ancient Indian tantra, these practices make it possible to sharpen the capacities related to body perception, especially skin perception and proprioception. The first series of breathing exercises comprises four different postures. Transmitted after two months of training at the first level, it continues to be practiced regularly thereafter because it allows the practitioner to maintain the accumulated *tenaga dalam*. Immediately after this series, the students learn another series that includes fourteen different postures (see one of them in fig. 5.2) and aims at developing the acquired potential of *tenaga dalam*. The way of breathing consists of: inspiration, retention and

Figure 5.2. A breathing posture of the Merpati Putih (school).

Figure 5.3. A pair of metal targets broken by a fourth-level student.

muscular tension, expiry and muscular relaxation. The second series is complementary to the first and aims to reinforce various parts of the body: lower limbs and the pelvis, the abdominal muscles and all the muscles of the body, upper limbs and the chest. The exercises are carried out with the eyes closed and by turning one's attention to internal feelings. As the student becomes more adept at these practices, the order of the positions of the breathing series is reversed, then combined. Then the type of breathing that is practiced at first as hissing becomes subtle, weights are used to reinforce the desired effects, the exercises are practiced in water, and three types of breathing techniques are alternated, centered either on the chest, stomach, or solar plexus.

The basic practice to test the use of the vital force is the "breakage of hard objects" (*pemecahan benda keras*). The most common targets used for different levels of attainment are made of concrete (fig. 5.3). The composition and sometimes the size will differ according to the level and the gender of the practitioner: the higher the level, the less sand is used in order to make the target harder to break. The second type of target,

used by second-level students and beyond, is an ice block. The third type, also used by second-level students and above, is a target of metal files in tempered steel (fig. 5.3). The practitioner must break through a number of these targets at one time, with the quantity increasing according to the level of the student. The fourth type, made of cast iron, is used starting at the third level; it generally consists of water pump handles. The fifth type, probably the hardest target to break, is a pumice tuff block: it is used starting with the fourth level.

Practitioners explain that well-developed *tenaga dalam* and the control of gesture make it possible to break an object by reducing the impact on the body when the target is struck. Because not all students have attained the requisite development and control, physical contact frequently compensates for the effect of the *tenaga dalam* on the object that is used as a target. To prepare the body to encounter hard contact with the target, exercises aiming at hardening the points of bodily impact directly on the ground (or on a faggot of cut rods of bamboo placed on the ground) are practiced during training. For the breaking of hard objects beyond the first level of practice, one also uses the foot, the hand, the elbow, the arm, the calf, the head, and so forth, in addition to the external edge of the hand.

The technique of breakage thus implies adequate knowledge of the points of impact, for to strike a target anywhere other than in a favorable (in general, fleshy) zone can prove to be dangerous. It implies also the ability to employ an appropriate amount of striking power for the type of target used: a target made out of concrete or pumice tuff requires, for example, that one stresses the power of the blow, while a target made out of tempered steel or from cast iron requires that one stresses the speed of the strike, and a target made out of ice blocks requires that one combines both power and speed.

Practices that require breaking boards or bricks train perception at various levels. The student must be acutely aware, on the one hand, of the intrinsic characteristics of the materials used (all of them more or less breakable, although very dense in certain cases), and, on the other hand, of the capacities and the physiological reactions of the human body in its interaction with the material environment. The student must have control of displacements, rapid movements, and the inevitable counter-shocks that accompany such exercises.[5] This very developed sense of observation and experimentation is closely tied to *rasa* as an "internal touch"—where pain possibly intervenes in case of failure—and as "emotional sensitivity." On

Figure 5.4. A second-level student breaks through concrete during an examination.

this subject, instructors systematically insist that simultaneously with the technical aspect, it is essential to have complete self-confidence to succeed. Ultimately, if the practitioner doesn't control all these parameters—is not concentrated or has not trained assiduously—he or she can be hurt.

Therapeutic techniques specific to the school are put in practice in case of injuries or wounds. In the case of simple contusions, the practitioner can treat himself by the means of special exercises in which postures, movements, and adapted breathing forms are used. If there are bruises or tendonitis, a qualified member of the school—the master (*guru*) or a coach—can do massage to detect the damaged zones and help regenerate them or position them back into place. This qualified member may also apply *tenaga dalam* to the therapy—which is parented to what we call magnetism in Europe—carried out while placing hands a few centimeters above the zone to be treated. It is then a question of interpreting the feelings registered on the palm. Those feelings give indices (heat, cold, pins and needles, and so forth) on the nature and the precise location of the pain, and attest to the energy exchange that occurs between the specialist and the patient. This type of technique is called *getaran*. Before describing how the *getaran* training is applied to perception, I will discuss its philosophical background as expressed by MP's master.

Philosophical Aspects of the Teaching

After a certain level of mastering breakage techniques, the students of the school deepen their understanding of the philosophical teaching that parallels the breathing techniques described later on. The master of the Merpati Putih school thus considers the entire set of "inner force" (*tenaga dalam*) breathing techniques and sensitive action that seeks to feel "subtle waves" (*getaran*) within the broader philosophical background to which the Javanese *Mersudi patitising tindak pusakané titising hening* notably refers.

For the Indonesian non-Javanese members, this statement translates in Indonesian to *Mencari sampai mendapatkan tindakan yang benar dalam ketenangan*, which means: "To look for, until obtained, balanced behavior thanks to a peaceful mind and heart." The two Indonesian terms that compose the school's name, Merpati Putih, form the acronym of this statement and establish a way to develop a multilevel interpretation. At the external level we have Merpati Putih, at the internal level *Mersudi patitising tindak pusakane titising hening*, and this in turn is subdivided into further levels. This method of procedure is tied to the Javanese cosmological tradition that insists on the interdependence of beings, objects, and the relations that unite them. School founder Mas Pung interprets this statement as follows: *Mersudi* means "to look for" in the most active way, with all one's forces and investing oneself fully until the goal is found and obtained. The reasons and true goals that motivate this investigation must be "felt and lived." Every movement must be carried out and accompanied with a true "introspection" (*mawas diri*) because "introspection forms the basis of courage" (*Mulat sarira hangrasa wani*).

Patitising confers a sense of "precision, correct goal, being in agreement (with the system of social values)." One must remember that what is good for oneself is not necessarily good for others. It is necessary to remain humble and not flaunt one's knowledge and capacities.

Tindak means the "attitude, behavior" that reflects one's empirical action. Everyone must strive to become an example for one's friends or younger fellows in order to build a bridge over which new generations can pass. It is essential to adopt a manner of behavior that is "humble" (*andhap asor*), "honest" (*jujur*), full of "compassion" (*welas asih*) and "wisdom" (*arif wijaksana*).

Pusakané here does not designate a *pusaka* as a physical object (a regalia) but as a "principle" that forms a pillar of truth, a deep truth that represents the banner of the school that protects all of its members.

Titising hening means that one must start with something "pure" (*resik*) and "sacred" (*suci*). To attain "purity and peace" (*hening*), it is necessary to know how to master oneself, suppress all dissociated will, and eliminate "desires" (*nepsu*). The most important one of all is the attitude of "remission" (*pasrah*) with respect to the Creator (Sang Maha Pencipta).

To paraphrase, the Merpati Putih student is enjoined to:

- search with all one's heart;
- develop precision and balance behavior;
- strive for humility and wisdom.

Overall, the student is required to respect the profound truths associated with the art and develop mastery over the senses and spiritual serenity.

We see here that the heart of the teaching is based on behavior and relationship with others. For Mas Pung, there is recognition, negatively, of what constitutes the characteristics of antisocial behaviors: indecision, unstable character, arrogance, turbulence, and so forth, in short, those characteristics that have adverse social consequences. The master emphasizes that it is not a simple view of mind, like in Western philosophy, but a relational principle in which the social, through the term *pusakané*, is tied to the cosmic harmony through the terms *titising hening*. The notion of remission is also important. It includes all activities and gestures, including thoughts. Remission is expressed simultaneously through the active social relationship of the subject and through the fact that one does not dissociate oneself from the natural environment.

Thus, we may notice that the statement's key, *Mersudi . . .*, is not used as a real *mantra*, that is, an efficient formula with ritual or religious purpose, but expresses a way of personal and social behavior in which Javanese roots can be continuously felt in the modern context where Merpati Putih operates. As asserted before, this aspect of the philosophy of the school, expressed by its founder Mas Pung, gives us keys to understanding the techniques aimed at reaching remote sensitive blind detection abilities that enable the apprehension of the proximal environment.

Tactile and Proprioceptive Senses to Detect Subtle Waves

According to Javanese experts, *getaran* (waves, vibrations) exist in themselves and everywhere, including in human beings. The techniques used

seek to sensitize the body to subtle vibratory frequencies. At Merpati Putih the training starts with the two breathing series mentioned earlier with reference to *tenaga dalam*, with which two complementary postures are associated. The type of breathing for these exercises—initially "hissing"—becomes so smooth that no sound is emitted while the breath is exhaled only slightly.[6]

Subsequently, breathing techniques called "cleaning respiration" (*nafas pembersi*) are practiced, also with the eyes closed. These are performed seated in half-lotus, a position that corresponds to a slower rate of breathing with four aspects: nasal inspiration, retention, oral expiry, and reverse breathing. This breathing aims at locating and eliminating the tensions from the body. Then, while breathing in the same way, the attention of the practitioner is directed toward the cosmos, then toward the ground, then it is again centered on the body proper of the practitioner. Each one of these four stages must have a length of time proportionally equal to that of the others to reach at least an hour in all.

It is specified that the practitioner must maintain a state of receptivity; as much as possible: he must close the "external senses" (smell, hearing, sight, taste), he must calm his emotions and thoughts, and his attention must be focused on internal feelings, the relation of interiority with externality—particularly on the skin but also through breathing frictions (the physical contact of the mucous membranes and the alveoli of the lungs filled with air) and proprioception. With the aid of these breathing exchanges and sensations, he increases his internal receptivity and his contact with the environment.

The basic application into which the practitioner is initiated is the detection of obstacles (fig. 5.5). The practical session lasts at least as long as the preparatory phase, both reaching three hours or more. The trainers draw up a course of obstacles made up of sticks approximately 1.6 meters long, of which the majority—equipped with a base—are vertical, and placed at a distance from each other of 50 to 80 centimeters; simultaneously some others are placed horizontally. Practitioners therefore train on a surface of, more or less, 5 to 10 square meters, according to the number of participants.

The exercise consists of having the eyes blindfolded while endeavoring to detect the obstacles in order to avoid them. The hands represent the principal tool for detection, but the instructors whom I met insist on the need for being accustomed to detect with the entire body. They also maintain the need to invest oneself in active movement, which is

supposed to support *getaran* perception, in order to drive out consequent fear caused by the loss of the visual stimuli, as well as to stimulate self-confidence. The students then undergo an extended and monotonous training of their sensations and the interpretation of these sensations to help them overcome their apprehension and to establish a cause and effect relationship between what they feel between skin perception and proprioception and the level of the material reality surrounding them.

Thereafter, the student combines *getaran* and *tenaga dalam*. For the grade exams from levels six to seven, the blindfolded student must go through some obstacles, then locate a terracotta pot suspended in the air at the level of his face and break it with a blow using the external edge of the hand. In *getaran* training alone, one of the tests from level seven to level eight consists in stopping a ball shooting toward a goal, still blindfolded. Certain advanced groups play small football matches as an exercise of practical application. The most advanced specialists use knives or swords to cut objects, like vegetables, completely blindfolded.

Nevertheless, the grade of a pupil in the ranks of the school does not guarantee the quality of success in *getaran* applications. Experts who have reached a high level of detection insist on the fact that it did not come at once. Having begun the training of *getaran* on level six, they had to practice assiduously for at least three hours or more per day for at

Figure 5.5. *Getaran* detection during a National Day event in Jakarta.

least one year before certain mental blocks no longer arose, in particular the apprehension caused by the absence of visual support. This apprehension, according to them, pushes the practitioner to use analytical thought or his imagination to interpret his immediate environment. Thinking, however, far from being of any utility for this practice, is the principal obstacle to progress if it is not properly controlled and modulated by the "attention" (*perhatian*) on the *hati* (liver) as the physical center of feeling.

The difficulties that can discourage practitioners reside in several points including not only the investment of time and attention but frequently the strong physical investment required as well. This last point is particularly cogent for blind people. Since 1991, the techniques of *getaran* have been taught to blind men and women. After one conclusive experimental period carried out in Yogyakarta over a twelve-year period, other training centers have been created in Java (Jakarta and Semarang) and in Bali (Denpasar).[7] Visually handicapped people who are assiduous in training manage in a few months to perceive their close environment and thus manage to move around practically like sighted people.[8]

Not so long ago the practices of *getaran* were still shrouded in secrecy. They are now partially disunited from the traditional course of *pencak silat* and can be, in addition to blind people, transmitted to adults of more than thirty years of age within the framework of a health gymnastics course developed by the school. This became possible because the connections to local conceptions of time and space of the school transmission systems have been partially freed from Javanese ritual constraints. Conversely, the absence of such a background would probably not support the possibility of perennializing in a modern context this special tie to the natural environment related to particular social habits.

The various capacities to which *getaran* leads should not make us lose sight of the fact, however, that the techniques are supposed to make it possible first of all for the practitioners to learn how to know one's inner self, to control one's emotions, one's behavior, one's relations with others, and one's intimate relationship with the world. On several occasions I met with practitioners of the highest level in *getaran* who, after several years of advanced control of the techniques, expressed dissatisfaction and a sense that something was lacking. In order to compensate for these deep feelings, these experts consulted traditional Javanese masters and sometimes proceeded to follow their teachings; one of them has even founded his own school by reintroducing a religious orientation.

Therefore within the secular school, while pupils may develop abilities that resemble touch intensified to the extreme, practitioners marked by Javanese transmission systems—whereby an inner training evolves throughout the whole life—are not fully satisfied by the techniques alone.

Getaran and Cognitive Science

The further development of Merpati Putih's getaran raises the question of the objectivization of the techniques used. Certain cadres of the school had proposed to establish collaboration with the scientific circles of the neurosciences and kinetics in order to study the phenomenon before applying it in the public domain, but they were not heard. In spite of the efforts of rationalization and adaptation to the modern context, a certain empirical approach dominates in the development of the techniques. But this experimental approach, as we saw earlier with the training adapted to blind people, can take a long time before integration with the common course.

Nevertheless, when I speak about the phenomenon of remote blind detection to neurophysiologists, neuropsychologists, or psychophysicists it does not seem to astonish them. Because of their disciplines, they are well informed about the perceptive potential of the human body in all its richness and complexity and deplore the hegemony of works concerning visual perception in their respective fields. In particular, Alain Berthoz (1997: 58) concerning tactile sensitivity relates that: "Our skin contains many receptors sensitive to various aspects of contact with the external world. Some measure pressure . . . , others detect heat and cold and actually constitute a class of thermoreceptors" (36). It even appears that the sensitivity of these sensors is so subtle that they can carry out remote sensing, as in the case of the "facial vision of the blind": indeed "objects that are close to the face tend to provoke slight disturbances of the air as well as changes in heat radiation that could be detected by receptors on the face" (O'Regan 2001: 959).[9]

Consequently, various elements take part in the existence of a very elaborate perceptive apparatus ready to supplement the sense of sight.[10] It is theoretically not excluded that by using specific exercises this apparatus in which tactile capacities and other capacities related to balance and body motion may arise, intervene, and compensate for—or even replace—sight.

All the more so, says Berthoz, because tactile information seems to have access to the centers of the brain that process visual data (1997: 94–95). Moreover, the "attention" that is central in the practice of *getaran* exploits an important part of the sense of touch: "Tactile perception is not only in correspondence with vision, it is influenced by the active character of attention" (1997: 97).

Berthoz quotes the case of a several-years-long collaboration with two pedagogues during which he developed a set of exercises close to those of *getaran*. Berthoz states that: "These two teachers had succeeded, by a particular pedagogy of enriched environment, to teach partially sighted children to play the balloon, the ball, foil, etc. The more the movement was fast, the more the children seemed to succeed" (1997: 59).

Noting that "the fundamental problem is that of the unit of perception" and that "the neural bases of coherence are still badly understood" (1997: 103), Berthoz pleads for an approach that seeks to highlight the interdependence of the various cognitive potentials in order to restore the elements in their place within the whole. Because for him "there are more than five senses," it is also necessary to take into account "the vestibular sensors, the proprioceptors of the muscles, of the articulations, and for certain species, echolocation, the magnetic direction, etc." (Berthoz 1997: 287). He especially proposes to return to a classification of the senses that corresponds to "perceptive functions" and to add to the five senses those "of movement, space, balance, effort, self, decision, responsibility, initiative, etc." Jacques Ninio (1996: 36) draws up a list close to the preceding one, associating with the five senses those of "the vertical, the magnetic field, temperature, pressure, connection with time and with external movements," but also, for other species, echolocation and modification of the electric field.

Thus the Javanese concepts mentioned earlier present similarities with the observations developed by these authors in a way that insists on the need for taking into account proprioception, interpreted as the sense of internal touch or even the source of this sense or its prolongation according to the adopted prospect. One finds this taken into account in the Javanese conceptions that refer to one's "inner feeling," precisely including the sense of touch, and the complementary character of the senses, which in Java is expressed by the fact that the senses have the same source (the "central feeling") and are, in the original conceptions, activated by a common divine principle.

Another similarity that occurs between cognitivist observations and Javanese concepts is the latent possibility to accentuate one or more of the perceptive capacities and intensify their active role by concentrating one's attention on it, as found in the Javanese techniques of concentrating one's attention on a specific point of the body during the breakage technique or developing concentration to activate "inner feeling" or *getaran* perception during the deprivation of sight.

Alain Berthoz (2006), in collaboration with the philosopher Jean-Luc Petit, recently quoted further enquiries to underline the fact that the action of human beings is physiologically and sensitively directed toward an interaction with the world rather than toward a fundamental representation of the world preceding action (Berthoz and Petit 2006: 15, 163). Among others, I noticed a couple of these enquiries that can be related to the broader context of perception involved in *getaran*'s case that have to do with the completion of active imagination and perception on the one hand, and the construction of space through experience on the other.

We saw that the most skilled specialists of *getaran* have to train for more than three hours daily for a period of more than one year (in addition to several years of martial arts training and to twice or thrice weekly routine trainings) before starting to be able to enact remote sensitive blind detection. Their training involves repeated experience of continuously facing error and failing while practicing tentative motion detection. Concerning the difficulties of improving detection, the practitioners identified the interference of mind pushing them to think and rationalize. On this subject, Berthoz and Petit (2006: 167–168) explain that sensorial perception induces a nonsensorial component that they call *active imagination*, which compensates for what the senses cannot directly perceive. For instance, we imagine the back side of a ball as being the same as the side of the ball that we do see; in the same way, we imagine emptiness in a box of which we see the external part. The actual perception and this active imagination are thus continually intertwined to different degrees. In such conditions, it is not surprising if a genuine perception is hard to obtain and requires consistently good concentration and much training. It is all the harder to use without the sense of sight. Not using sight enables imagination to increase. Too much imagination, according to the authors, may provoke "empty perception" (almost the same words as those used by official coaches of MP school, meaning, in the case of *getaran* training, the inability to detect an obstacle).

Another aspect of the perceptive experience described by Berthoz and Petit (2006: 163) is that of neural activity for recognition of space. The somatosensorial motion maps of the cerebral cortex, for instance, are rapidly modified through experience. It means that the degree of adaptation of those motion maps to empirical perception activity is very high. We may suppose that frequent and prolonged blindfolded trainings such as those of MP play an important role in the configuration of the maps of those who are training, even if it is still hard to be precise without previous experimentation.

Therefore, when considering all these physiological capacities and abilities, it is essential to take into account that subtleties of the perceptive apparatus go well beyond the five senses. Old Javanese Sanskrit describes up to ten senses according to their respective body features: the ear, the skin, the eye, the tongue, the nose, the mouth [word], the hand [gripping action], the foot [mobility], the anus, the genitals (Zoetmulder 1995: 203). Subtleties of the perceptive apparatus also show through in the described techniques that empirically reveal senses substituting for sight. It is notable that all the ten bodily features listed here play an active part in the practice of *getaran* (for instance, muscles of the anus and the genitals are used at different phases of the breathing, the tongue is placed in a special way in the mouth, and so on).

The action is either internal—focusing attention on the sense of breathing as an internal sense of touch—or external. In both cases it is connected with Alain Berthoz's "sense of movement" that is activated every moment the body moves even slightly (through breathing activity, for instance) when engaged in intentional motion (2006: 206). *Getaran's* total perception, therefore, utilizes both internal and external orientations in a complementary way.

Observations on Corporal Training

Corporal trainings, or psycho-corporal trainings to be exact, are provided in the Far East with a particular valorization that has been comparatively illustrated by Jean-François Billeter (1984). Billeter opposed, through arguments and examples, the European valorization of contemplation with the Eastern concept of perfect action. However, in the analysis I develop here, it appears that modern scientific thought makes it possible to give a theoretical account of empirical methods, including the Javanese

method of *getaran*, by suggesting that the human body is equipped with a perceptive potential highly sensitive to seemingly negligible external variations. The science of cognition has developed conceptual elements close to those of the Javanese empirical method. In fact, "our modern forms of thought do constitute the rediscovery of a fundamental aspect of the human experiment," says Varela in relation to original Buddhism (ibid: 173).

In social anthropology, Marcel Mauss (1993) concludes that corporal and breathing practices like Indian yogic and Chinese Taoist techniques teach us something about the "complete human being" (the social, psychic, and physical one). Indeed it appears that if India and China respectively developed traditions of writing, sciences, refined technology, and religious and political centralism, in certain points comparable to what one finds in Western nations, they—like Java and compared to the Westerners—preserved empirical experience and practices that testify to the constitutive vitality of their social relations and the oral transmission of their cognition systems. In these designs and through these practices, the body engages in its totality.

Very different is the case of industrial Europe where the use of external prostheses has become the common rule and enabled a technology of assistantship of body motion (bicycle, motorbike, car, train, plane, elevator, electronic apparatus), and a specialization of the perceptive activity (notably through the increasing number of mass media: books, newspapers, radio, TV, movie, computer, video games). This type of technology and communicational and educational media are likely to modify intrinsic characteristics of sensitive perception.

David Howes (1990) argues that the hierarchalization of the senses varies not only from one social context to another but also from one era to another. He evokes the example of European printing works increasing the sense of sight to the detriment of that of hearing (1990: 102). Still it should be noted that the process of using systematically printed works for individual private reading began in the 1700s and took place over several centuries. Previously the hegemony of the sense of sight was not like that known today, with numerous modern media focused on sight (to which we add street advertising to those cited previously). In this period, according to Nélia Dias in the previous period (2004: 304) (referring to Karl M. Figlio): "feeling was identified with sensitivity and sensitivity in its turn with the sense of tact."[11] Tact seems to have lasted into the beginning of the nineteenth century (Dias 2004: 304) and does not differ

radically from eighteenth-century interpretation. It is difficult to name this sense (which shares certain aspects with the term "proprioception") that is able to distinguish without direct contact "heat and cold, dryness and wet" and is described as an "invisible and spiritual dimension" or "diffuse feeling by which we feel what occurs in us." Proprioception here is compared to tact as the main source of senses of which taste, the senses of smell, hearing, and sight form nervous extensions, prolongations, or special forms. Tact, thus seen as a "passive touch," is not devalued as "active touch" because of its association with the hand and the connotation of manual work and sexual habits (Dias 2004: 60–61).

This categorization organizing our view around a central internal sense and four external peripheral senses connected to the internal brings us directly back to the Javanese conceptions and raises the question of whether, for example, a practice such as reading, popularized by the generalized diffusion of printed works, intervenes not only to the detriment of the auditory attention, as Howes suggests, but also to the loss of attention to proprioceptive faculties.[12] What is at stake today in the horizon of printed media is the emphasis on electronic media cited earlier and the effect this type of media has on the development of human perception and its attendant social, educational, and cognitive implications. Do we moderns prefer to relate to external media cognitive objects or do we also want to nurture our inner abilities?

In conclusion, no final answer can be given to the question of what differentiates a sense and a capacity as it appears here in the light of the Javanese, eighteenth-century European, and contemporary examples. According to the referent system of values, ritual, positivist, or layman, and according to projections of the dominant academic disciplines and their impact on society, classifications can change on a scale of time that is difficult to determine. Who knows if our own conceptions of the senses will not approach the Javanese ones with future scientific discoveries concerning perception?

Notes

1. The recognition of the existence of muscular receptors at the end of the nineteenth century leads the British physiologist Charles S. Sherrington to replace the term "muscular sense" (an "internal" sense and so different from the five "external" senses) with that of "proprioception," making it possible to distinguish between internal and external transformations of the body (Forest 2004:

23). This innovative concept, based on former works (Forest 2004: 12–17) was modeled on the characteristics of the sense of tact: pressure, resistance, developed energy, tiredness, and pain. In addition to indicating that various features of the body all possessed tact with similar sensitivity, this study revealed a greater capacity of discrimination of the "muscular sense," particularly in regard to spatial orientation. This notion has become central in the physiology of movement and perception and has been pointed out by various authors. Some of them insist that proprioception exists only in accord with the other senses and speak of visual proprioception or cutaneous proprioception (Forest 2004: 29).

2. For Arnold Van Gennep, ritual initiation is composed by a set of rites that facilitate young people in "becoming [a] man or woman" (1991: 96). In his view, this initiation is characterized by three steps: separation from the world of women and children, reclusion in a special place (forest, hut, and so forth), integration with the male or female adult group. He also notices several common characteristics, such as fasting and alimentary proscriptions, that we also find in Java. From the analysis of his data, he concludes that "the suppression of ordinary life rules is essential to transitional periods." The three steps described by Van Gennep have been explored further by Victor Turner (1969), who theorizes that the period of reclusion (*liminal* phase) is an anti-structure that dialectically interacts with and has a regenerative effect upon the existing social structure and social norms.

3. For a detailed description of Javanese esoteric conceptions, classification system and contiguous practices, see de Grave (2001a: 18–144). On the classification system, see also: Van Ossenbruggen (1977).

4. Certain schools, influenced by Islam, preserve a strong mystical orientation. On the *tenaga dalam*, see de Grave (2001a: 146–207). On the complementarity between formal education and informal education see de Grave (2001b, 2004, 2005).

5. One characteristic of anaerobic breathing, which is based on long phases of apnea at the end of the inspiration and sometimes of the expiry, is to intensify blood circulation. Combined with muscular tension, it produces an effective hardening of the muscles, which become denser and more resistant.

6. That's not without reminding one of the "Primordial One" of the pre-Hinduism Indian conceptions that appears as a "vital force that breathes without the air moving (Gonda 1979: 219).

7. The center in Jakarta was created in collaboration with a foundation of the Land Forces.

8. A statistical average from three to six months was established. Progress is thus much faster than in sighted people; this average reveals a higher potential aptitude.

9. For a presentation of *pencak silat* and a detailed description of the Merpati Putih school, see de Grave (2001a: 215–327) (on *pencak silat*, see also de Grave 1996, 2000).

10. Kevin O'Regan specifies that hearing may also play a role in this process.

11. Certain authors like O'Regan or Varela argue a character of quasi-reciprocity on the prospective subject-object. For instance, Varela (1993: 172–173) stipulates that the relation of perception does not emerge from the subject, but rises from the "emergence" born from the "contact" between what perceives and what is perceived.

12. Philosophers and naturalists (for example, Condillac, Diderot, and Buffon) held with this view according to which "sight is a variety, even a species of touch" (Dias 2004: 58).

13. Except, in particular, the fact that the Javanese "inner feeling"—equivalent of the "passive touch"—is in no case regarded as a passive one since it is possible to cultivate it.

References

Berthoz, Alain, 1997. *Le sens du mouvement.* Paris: Odile Jacob.

———, Petit Jean-Luc, 2006. *Phénoménologie et physiologie de l'action.* Paris: Odile Jacob.

Billeter Jean-François, 1984. "Pensée occidentale et pensée chinoise: le regard et l'acte." Pp. 25–51 in J.-C. Galey, ed., *Différences, valeurs, hiérarchie: Textes offerts à Louis Dumont.* Paris: EHESS.

de Grave Jean-Marc, 1996. "Une école catholique de *pencak silat*: Tunggal Hati Seminari." *Archipel* 52: 65–75.

———. 2000. "Un champion issu du palais royal: L'histoire de RM Harimurti." *Archipel* 60: 141–166.

———. 2001a. *Initiation rituelle et arts martiaux: Trois écoles de kanuragan javanais.* Paris: Archipel/L'Harmattan.

———. 2001b. "Hubungan pendidikan formal dan non-formal di Indonesia: *Pencak silat*, tari dan cita-cita para pendiri pendidikan di Indonesia." *Suluah* 1 (2): 7–10.

———. 2004. "Profil de l'éducation indonésienne: Pratiques corporelles et dimension non formelle de l'éducation." *Actes du 1er congrès du Réseau Asie* (CD). Paris: Réseau Asie.

———. 2005. "La souplesse et la rigueur: Conceptions javanaises croisées en matière d'éducation et de relation." *Actes du 2nd congrès du Réseau Asie, 28–30 septembre 2005,* Paris (http://www.reseau-asie.com).

Dias, Nélia, 2004. *La mesure des sens: Les anthropologues et le corps humain au XIXe siècle.* Paris: Aubier.

Forest, Denis. 2004. "Le concept de proprioception dans l'histoire de la sensibilité interne." *Revue d'Histoire des Sciences* 57 (1): 5–31.

Gonda, Jan. 1979. *Les religions de l'Inde—I: Védisme et hindouisme ancien.* Paris: Payot.

Howes, David. 1990. "Les techniques des sens." *Anthropologie et sociétés* 14 (2): 99–115.

Mauss, Marcel. 1993. "Les techniques du corps." *Sociologie et anthropologie* 363–386.

Ninio, Jacques. 1996. *L'empreinte des sens: Perception, mémoire, langage.* Paris: Odile Jacob.

O'Regan, Kevin. 2001. "A Sensorimotor Account of Vision and Visual Consciousness." *Behavioral and Brain Sciences* 24 (5): 939–973.

Turner, Victor W. 1969. *The Ritual Process: Structure and Anti-Structure.* Berlin: Aldine.

Van Gennep, Arnold. 1991 [1909]. *Les rites de passage.* Paris: Picard.

Van Ossenbruggen, F.D.E. 1977 [1916]. "Java's Manca-pat: Origins of a Primitive Classification System." Pp. 30–60 in ed. Patrick Edward de Josselin de Jong, *Structural Anthropology in the Netherlands.* The Hague: Martinus Nijhoff.

Varela, Francisco, Evan Thompson, and Eleanor Rosch. 1993. *L'inscription corporelle de l'esprit: Sciences cognitives et expérience humaine.* Paris: Seuil.

Zoetmulder, Petrus Josephus. 1995. *Kamus Jawa kuno-Indonesia: Jilid I dan II.* Jakarta: Gramedia.

6

Thai Boxing

Networking of a Polymorphous Clinch

Stéphane Rennesson

Thai Boxing or Muay Thai is among the biggest and most important cultural industries in contemporary Thailand.[1] Our question here regards the "professional practice" (*muaj achi:p*, lit., professional boxing) of Muay Thai that encompasses close to all of the boxers in the kingdom of Thailand, except for a few amateur clubs where the upper class practices a traditional local form of self-defense. The modern sport of Muay Thai, heir to a long martial tradition, is largely a matter of prize fighting since pugilists going into the ring, even beginners from six years old on, are paid a sum of money, referred to as *kha: tua* (price of the body).[2]

Muay Thai is organized around networks of boxing camps or gyms, *khrüa khaj* (group of descent), that are structured according the evolution of mutual and reciprocal relations between camp owners and competition promoters. These networks are mainly oriented from rural areas toward the capital and thus reproduce the typical spatial hierarchy of Thai territory favoring Bangkok as the single valorized center. Every camp owner at the regional level is linked to local ones in the countryside through privileged relationships. The same system prevails between gym owners in the capital and in the main towns of the province. The whole organization is headed by important promoters in Bangkok who maintain connections with a clientele of camp owners in the capital and rural areas.

145

The world of professional Thai boxing is highly integrative since it links together many of Thai society's hierarchical stratums. The peasantry supplies the majority of the professional fighters, nearly half of whom are from the Northeast. While most rural camp owners are civil servants, chiefly teachers, the greatest gyms and stadiums both in the rural areas and big cities are headed by top military and police officers, businessmen and politicians, who are predominantly of Chinese descent.

In addressing the circulation of ideas that goes together with the geographical movements of Muay Thai boxers in Thailand, we shall principally consider Thai professional prize fighters coming from the Northeastern part of the country (Pha:k Isa:n).[3] Thai fighters have been traveling all over the country at least since the late nineteenth century. During this period of time the process whereby Muay Thai was becoming a competitive sport accelerated. The circulation of boxers is designed to facilitate their confrontations in the ring and relates to two types of boxers' movements. First the boxers travel with some members of their gym from their training place to the stadiums in order to fight with boxers from different networks. Locality and membership in a network tend to converge in order to underlie the principle of what can be called the "fighting exogamy": one cannot fight another boxer with whom one may be "intimate" (sa'nitkan), since this situation would result in a lack of fighting spirit from both sides. The application of this rule promotes a steady circulation of the camps' members to numerous sites of competition to look for suitable opponents. The second type of circulation of boxers concerns their exchanges within networks mainly from the numerous rural boxing camps to the big gyms and stadiums of Bangkok following their gradual acquisition of fighting skills. Once in the capital, they may be given a chance to face the best fighters of the country or be selected to represent their nation against foreign boxers. Thais refer to this kind of circulation by the expression doen sa:j, meaning to "walk along the line."

My key argument here involves questioning the pugilists' bodies as a convenient starting point from which to map the Thai social body, and by doing so, negotiate an outline of social groups. Bernard Formoso (1987 and 2001) has shown how the Thais, the Isans in particular, imagine social groups at every level following metaphors of the human body. This notion represents a useful tool of discrimination in the analysis of the boundaries of the social and cultural bodies. It should be emphasized that the Thais place great importance on the human body as a means to manage their relations to foreigners.[4] Following the boxers we shall

scrutinize their circulations and analyze their functioning as an instrument that enables the endless making and remaking of their bodies and of the nation at the same time.

Boxer or Fighter? Answering a Question to Appropriate a Pupil

When camp owners and their trainers welcome a new apprentice to the camp, the first weeks are dedicated to a kind of divinatory exercise in order to qualify the novice's aptitude to Muay Thai and identify his "boxing style" (*pra'phae:t muaj*) through practice.[5] This process is regarded as a test of a student's potential. A diagnosis is made when the parents of the newcomer first come to the camp to get the owner's approval to train their offspring. Remarkably, the trainers let the beginner exercise along with more experienced pugilists and they provide very little feedback. Without inciting the novice to surpass himself, they intend to test his resistance to effort and his will to endure the painful training required daily to prepare a boxer.

In the beginning an apprentice will only be explicitly asked to perform a "shadow boxing" (*muaj lom*) exercise for the trainer. The trainer will observe the novice closely to decipher what singular relation the boy can essentially nourish with the art of Muay Thai, that is to say, to figure out what is his personal style. The idea is to ascertain whether he is an "artist" (*muaj fi: mü:, muaj choeng*, or *boksoer*) or an "attacker" (*muaj buk, muay tho'ra'ö:t*, or *fajthoer*, from the English *fighter*) and so be able to personalize the training.[6] Two boxing methods are distinguished: on the one hand are pugilists who use counterattack, model their rhythm and tactics upon that of their opponent, fight smartly by dodging and side-stepping, and master the Muay Thai techniques with style; on the other hand are boxers who move unyieldingly forward, relying instead on their stamina and strength by enduring many blows, and whose technical register is more limited than those of the artists. The boxing stance of the "artists" refers to the notion of "art" (*sinla'pa'*) that underlines the civilized nature of Thai Boxing and its place within the national cultural heritage; the style of the "artists" belongs to the realm of beauty, and what is beautiful is virtuous, and what is virtuous from a Buddhist point of view is Thai. The "attacking" alternative makes sense as a less sophisticated practice of Muay Thai associated with the margins of the kingdom, at least according to the stereotypes used in the world of Thai

boxing, representations that should not be underestimated.[7] Significantly, the two boxing categories also refer to morphological types. The "artist" option is generally assigned to tall and slender boxers, while the "attacker" version applies to stocky fighters. In fact, the majority of the pugilists affirm this relationship between physiognomy and boxing styles through the tactical stance they favor during their fights. Since trainers don't have much information about the boxing qualities of newcomers, they try to connect the type of moves they see during early training sessions with morphological characteristics.

It is worth noting that corporal stereotypes, present especially in the mass media, nurture the image of the Isans (the economically and culturally marginalized population of the Northeast) as dark skinned with a stocky, muscular build. In the microsociology of daily interaction, discriminations are sustained by distinctions in physical appearance that refer to different ways of life.[8] Whiteness of the skin suggests less exposure to sunlight, indicating an occupation that does not relate to farming, building, or factory tasks. A pale complexion and a slender build bring to mind urban Chinese and Sino Thai populations, symbols of economic success that indicate a say in the consumption model that tends to impose itself upon Thai society.

The stereotype of the Isan body stands in opposition to the pale and slender aesthetic ideal. In the grammar of discrimination, the physical characteristics of the Isan peasant make him a suitable beast of burden for tiresome agrarian duties, unrewarding tasks in industry, and the boxing ring because the Isan body is molded by the hardships of life. Even though all Isan fighters do not correspond to this cliché, the recurrent identification of Northeastern boxers with the "attacking" boxing style seems to cultivate the negative *a priori* stereotype that Isans suffer in Thailand, where it is believed that because they are uneducated, they can derive benefit only from their body and physical strength. Muay Thai, through a reverse rhetoric, bestows an opportunity to turn the Isan body into a hero: the Isans' innate physical qualities, shaped by harsh conditions generation after generation, make these Northeastern peasants fearsome and wonderful boxers. Indeed they are much appreciated by promoters at large because of their presumed great stamina: the more spectacular and dramatic confrontations of these "attackers" are highly valued by spectators because of the exciting betting opportunities they afford. As such, Isan boxers represent a favored investment, since they are a reliable and profitable labor force that attracts a large popular audience.

As symbols of "attackers" Isan boxers embody in bold outline the moral values, such as courage, tenacity, and self-composure, that reflect the dominant, largely Buddhist, Thai ideology. These values, which constitute both goals and tools during the socialization process of the boxers in the camps, are closely linked to Buddhist ideals such as "detachment" (*khwa:m choej*), and the Buddhist spiritual goal of surpassing the self. From an empirical perspective, one cannot deny the fact that Muay Thai is indeed a violent sport: the whole body is engaged and can be used both as a weapon—gloved punches, elbows, knees, chins, and feet—or a target (except the head and the genitals, for which the only protection used is a groin guard).[9] In addition to exchanging blows, boxers can also wrestle with the upper part of their body. Throughout training sessions and while in the ring, boxers therefore must be "courageous" (*caj khla:*) and make no show of the suffering they endure so as not to "lose one's boxing form" (*sia ru:p muaj*), a specific criterion upon which decisions are made by referees. As much as such skills are required for every pugilist, the "attackers" symbolize them best.

The identification of the newcomer at the camp involves negotiating and mastering the neophyte's environment of origin. The whole process of inquiry, much debated between the camp members, is a way to acknowledge the new boxer as a whole person. Actually this is what parents seek when they entrust their child's education to a camp owner. Everybody hopes for a total reformation of the pugilist's person that is not strictly physical: the young boy should also be morally enhanced through hard training. The role of the "master of boxing" (*khru: muaj*), who is either the "trainer" (*phu: fük söm*) or the owner of the camp and often the same person in small rural institutions, like any master in Thailand, occupies a role ideologically closely linked to and legitimized by Buddhism. Considering the characteristics of Muay Thai, a boxing master exerts a peculiar moral influence. Trained and nurtured by a master, the boxers are thought to be shielded from becoming criminals. Boxers thus come within the scope of the lineage along which Muay Thai *savoir-faire* is transmitted. At the top of the legendary version of that lineage one finds Phra Narayana, the mythic founder of the national self-defense art and an avatar of Vishnu, followed in the late eighteenth century by two military figures linked to the protection of national freedom: Nai Khanom Tom, a fighter who restored the kingdom of Siam's honor by beating nine Burmese soldiers in a row at Muay Thai, and Phra Pichai Dap Hak, a famous soldier who helped General Taksin free the kingdom

of Siam from Burmese occupation. Thanks to what is widely considered in Thailand as its special martial skills, the Thai Nation (an anachronism before the beginning of the nineteenth century that means literally the "nation of freemen," *cha:t thaj*), has been able to keep at bay its foes and stay independent.

Moreover, from a synchronic perspective, the boxers are entangled in a web of moral obligations that oblige them not only toward their masters and parents but also toward the Buddha, the king, and the nation, the three pillars of the contemporary ideology that holds the whole population as one unit. This semiological stratigraphy is most visible during the "oath ceremony to the masters" (*waj khru:*), which is particularly represented by a "boxing dance" (*ra:m muaj*) that the pugilists perform in order to officialize the link with their master at the beginning of the transmission process and also as a prelude to each fight. The first oath ceremony generally signifies the confidence that the master puts in his pupil. The *ra:m muaj* ritual display shows that the boxer is fully in the grip of the master. Considerations of the neophyte's origin or style are then no longer pertinent, at least in the camp, unless a serious problem of performance occurs, like several punishing defeats in a row. Indeed, the fighter's results commit both the boxer and the camp owner toward the parents of the fighter who wait for their son's career to grant money and prestige. On the basis of an unproblematic functioning, the style of the boxer is therefore not a structuring debate to the socializing process of the camp. The polarization between "attacker" and "artist" tends then to be forgotten as boxers become known by their instructors and progress toward mastery of the basic combative moves and techniques. The polarizing schemata are almost unused in the camps since the staff have already identified the boxers and, consequently, appropriated them from a sporting point of view. As a matter of fact, if the results of a fighter are not subject to heavy criticism, the fighter is clearly bound to the master. The relation to their parents and their environment of origin will now show up in a different context, the contests.

The Sociobiologization of the
Boxers' Profiles: How to Dramatize the Fights

The style of the boxers materializes the bond between the spectators and the boxers. The conversation translates from the opposition in the

ring toward the feelings of belonging to social forms that are activated through the specialized terminology that we previously discussed. The use of polarization by the camps' training personnel and contest promoters is therefore essentially utilized in communicating a perspective in order to promote the boxers' image while they are circulating. The "attacker" and "artist" categories are often heard in three types of discourses: in discussions among members of the same network about fights and exchanges of their boxers; between boxing events' organizers and the boxers' managers when the negotiations to match fighters and to set up boxing programs are at their height; and the schematic distinction that finally appears when used by the events' speakers, especially as they announce before each fight the profile of the two opponents. What I would like to emphasize here is that Muay Thai contests embody oppositions between social groups through interpersonal challenge.

In small rural contests, the two sides competing behind the two fighters often don't belong to the same social background. The question here is of the many situations when a small rural camp owner challenges an important urban camp owner through his pupil. Even if the two sides don't differ that much, comments around the ring and back at the gym after the contest take shape as an opposition between rural and urban areas on a regular basis. I recall a rivalry between two camps situated in a single village at the time of a bout that brought together two of their boxers during a locally organized boxing contest. The fight was broadly discussed before it took place, throughout the contest, and long afterward. Some of the villagers reproached the owner of the second gym, a businesswoman of Vietnamese origin married to an influential member of the village's council, for having too roughly withdrawn her son from the first camp a few years ago. They said she didn't show enough respect to the owner of the first gym, the headmaster of the village's primary school, and broke the most elementary rules of courtesy by doing so. Her manners were of a businesswoman focused only on the sole perspective of fame for her son and she was careless of the local values that emphasize a strong and indestructible bond between a pupil and his master. Others, on the contrary, stated that the school's headmaster lacked ambition in the management of his boxing camp. He hadn't taken note of the trading dimension of present-day Muay Thai. The headmaster considered honoring tradition and having a good time around the ring as being of more importance than the cautious preparation of his boxers to achieve great victories in the famous stadiums of Bangkok. The atmosphere around

the ring during that specific fight was tremendously strained. The fervor ignited by the bout that night revealed a division of the local populace into two more or less porous sides.

Let us focus now on the conversations among intimates in the camps about the competitions in which the local boxers are involved. Before and after the fights, an amplification of the confrontation in the ring takes place through comments that seek to demonstrate the superiority of a certain social group as compared to others. According to Ajan Wichit (Master Wichit), the headmaster of a small rural Northeastern camp, for example, the "Isan body," sculpted generation after generation by the environment, is the best symbol of the local specificity that makes the inhabitants of the Northeast countryside a model to be followed by the whole Thai nation. Each victory of his boxers over pugilists from big city camps, "bred with jasmine rice and Chinese noodles," is an opportunity to celebrate with his boxers' parents a kind of "Isaness." Victory is thought to result from a harmonious relation to nature, or more precisely, as the consequence of one's adherence to nature's law, a notion that here refers to the Thai "natural order" (*thamma' cha:t*). *Thamma'* stands for "order or law" and *cha:t* for "what is": everything or the world by extension. *Cha:t* may also be used with a collective connotation to name a common origin from the point of view of an ethnic group's geopolitics.[10] Nature here opposes not culture but disorder. Drawing on an environmentalist discourse initially developed by urban and educated Thais who invested in NGOs favoring various grassroots contesting movements, Ajan Wichit states that the Isan nourish a relationship with their "natural environ-ment" (*singwaetlom*) and their "human environment" (*sangkhom*) that is characterized by a Buddhist morale of higher quality when compared to other Thai conceptions, especially that of the inner-city Sino Thai population. Through the consumption of goods offered by their local natural environment, the Isan would as such be more respectful of the natural environment than are the politics of successive governments that have not considered the basic needs of the peasants when they decide, for example, to install hydroelectric dams to exploit the natural resources and dramatically modify the rural way of life. Thus Ajan Wichit sees the Isan people, and Isan boxers in particular, as a marker for a Thailand trapped in a largely Westernized modernization process that he regards as a dramatic loss of the ethic nurtured traditionally in Buddhism.

Such a point of view looks quite similar to those of the organizers of Muay Thai training courses meant for clients who mainly come from

the big cities and belong to the well-to-do. All their clients share a kind of identity crisis and they seek the practice of a genuine Thai activity to shore up their "Thainess" (khwa:m pen thaj). The motto of these training courses lies actually in the reproduction of Thai peasants' ancestral gestures in their agrarian activities. According to the organizers, there is a natural relation between the timeless gestures of the peasants and the moves that characterize Muay Thai. The argumentation is based on a common acknowledgment of a specific Thai way of moving that "follows Thai people's nature" according to the local idiom (ta:m thamma'cha:t khon thaj). Such ideas are shared among numerous Thai people, beyond the restricted circle of the clients of these training courses. The notion of a Thai nation is naturalized and as such can be broadly used as an input medium through which to express reifying remarks.

Thus it becomes visible that through discourses and practice Muay Thai enables one to come within the scope of a specified "nature" (thamma'cha:t), Thai or Isan culture accordingly, and of a "national culture" (wa'ta'na'tham thaj or wa'ta'na'tham hae:ng cha:t). Nature and culture come into view as ways to rationalize one's relation to the world. Agricultural and martial techniques would then participate in the "Thai culture" while the gestures that materialize them would take part in the "Thai nature."

The reification of the two boxing styles undergoes a significant slide in the context of international boxing bouts, whether in Thai or English boxing, when Thai fighters meet foreigners. The local pugilists are either identified as "artists" who represent the entire skillfulness and elegance of the Thai aesthetic, or are identified as "attackers" who demonstrate the strength and martial potential of the Thai nation, or as both simultaneously. The situation is quite ambiguous when it comes to nominate the best representative for Thailand. Sorting out the different components of the population the borderlines are not only blurred, but there is a competition as to which would be the best compromise of the two styles to represent the Thai way of boxing. Finally, once the choice is made, everybody agrees on the fact that real pugilistic excellence depends upon a harmonious combination of the two styles. Such a symbiosis refers to the unity of the Thai people and marks the perfect boxer, whatever his regional origin, as an ideal representative for the country. The quintessence of Thai boxing cannot be achieved without the "attacker" face of the coin, provided by fighters originating from the Northeast of the country.

Every international boxing program in which Thai nationals are engaged is an opportunity to openly celebrate the Thai nation, all the

more so when the television presenters struggle with the classification of foreign opponents. Any hesitation or difficulty in identifying the fighter's style according to the traditional dichotomy may subsequently provide a comforting salve to soothe the possible disappointment accompanying the defeat of the local fighter.

Thanks to the travels of former famous Thai boxers around the world to teach their art and to the many foreigners, essentially "Westerners" (fa'rang), who since the 1970s have come to Thailand to study Muay Thai at its roots, the reification of an essential discrepancy between Thai boxers and foreign pugilists—through the comparison of their bodies, their athletic abilities, their fighting styles, and what kind of cultural orientation they embody—is not exclusively elaborated around the regularly organized mixed fights. Aside from a few cases when Westerners stay long enough in the country's camps to practice Muay Thai in a similar manner to their hosts, the difference of approach is such that it is possible to draw a clear boundary.

Every fight is indeed an opportunity to situate oneself in a social hierarchy that comes within the framework of the national territory. But one has to add that the boxing contests produce this kind of stereotyped opposition in a different way following each exact circumstance. Thanks to the gap that keeps apart the two fighters' sociological environment, fight observers indulge in tuning the distance between them, getting closer to some and moving away from others. This process is quite adaptable to each situation. Indeed, the feelings of distance and proximity produced during the fights take root in the handling of the stereotypes, which provide a convenient mechanism to mediate personal situations and to idealize large social units that are not often in the direct purview of the spectators' daily life experience.

The objectification operated through the polarization of the styles occurs at key events in the world of Muay Thai, essentially when the rationale is to reify the links that the fighters potentially personify. It is worth noting that the boxing aficionados are not fooled by their own simplifications. They admit to an awareness of the reifying effect proposed by the "artist/attacker" scheme as each of the two expressions refers to a corpus of sporting and physical characteristics wide enough so that it is almost impossible to acknowledge a single boxer who could meet purely one or the other type. As a matter of fact, every pugilist is an original mixed profile. All the more, in order to satisfy the circumstances of each single fight, or over the course of one's career, a fighter can be driven to develop skills against his own nature.

In the competitive context, the reifying sociobiologic connection established by these categories between physical characteristics, sporting behavior, and membership to groups embedded in natural and social environments serves to quite conveniently dramatize boxing events. It nourishes the events by extending the potential of meanings rooted in the boxers' action in the ring and indisputably rewards the investment of the spectators.

In conclusion, it is worth noting that the same boxer can be defined quite differently following the very context in which he is to fight. Considering the sociological situation of a given bout, a boxer can be classified under a category he is not used to, in the limits of his morphological and technical characteristics. Actually, what differs from one event to another is the way the manager, promoters, and journalists will promote the fighter in a program. The process begins with the negotiation of the bout to match up of a pair of boxers, followed by the weighing in session that results in the accentuation of the different characteristics of two boxers as a whole, in the perspective of an original clinch. The definition of the fighters' qualities is first subordinated to the imperatives of the promoters. The two boxers' profiles can be twisted a bit by the announcer during the contests and/or in the prognostics of the journalists before the fight to make the bout looking more exciting. First, whether they need to reify a style contrast or do the opposite and close the gap, the promoters exploit the qualities needed, omitting the others that don't match the plan. Second, and what may be even more important, is the fact that when one enters the details of the prognostics, one can notice that the characteristics of the fighters are not only constructed in mirror-like relation one to another, but also require a rich parallel description that stands out clearly from the simplifications of the boxing material through the use of the "attacker/artist" polarization. Once again, a journalist will pick up the qualities that enable him or her to draw two pugilistic portraits that can enhance boxing aficionados' appetite for exciting bouts. As was the case at the camp, the manipulation of stereotypes around the ring means more about organizing an original sociability around several pairs of fighters. The relevant unit of analysis is thus the clinch, definitely not the boxer, a statement that is ultimately backed by the vocabulary used to refer to boxers at training and during the contests. In both contexts, as a matter of fact, two opponents are called upon either individually (boxing partner) and together (boxing pair) with the same expression: *khu: muaj*, literary "boxing pair," as if a single fighter would mean nothing, and wouldn't be able to personify Muay Thai alone.[11]

Through their circulations within competitive networks, boxers are given the possibility to climb the ring's hierarchy and, through fighting, to

represent larger social units as they slide toward Bangkok. The feelings of belonging to the particular groups they embody is not the only variable according to the geographical context of each fight. We refer here to the very nature of the opposition that is proposed in every singular contest. And since the boxers are not merely isolated individuals but social agents holding a sociocultural background that can be discursively manipulated, it invites us to evade the boxer's body as a unit of meaning to invest the more dynamic heuristic perspective of the confrontation of two of them in a polymorphous clinch.

The so-called sporting criteria that define the two boxing styles are intimately intertwined with cultural, social, and environmental considerations that permeate the contemporary political discourse in Thailand. As such, they contribute through their circulations to bring into being shallow borders between different sociocultural and socioeconomic groups in the country and more sharp ones between a naturalized Thai nation and foreigners, especially Westerners. The question haunting boxing fans more or less openly is: to what degree is Muay Thai representative of "Thai" social identity. This uncertainty inflects each event, including such areas of signification as the boxer's physical appearance, the particular aspects of style, and many other aspects of the competitive bouts. Establishing the dynamic clinch as a heuristic concept in place of the single body, one can avoid several kinds of misunderstanding. An exploration of the specific circumstances of the boxers enables us to appreciate the broader sociological implications of the Muay Thai network. Pugilist's bodies, however imagistically striking, do not offer meanings that can be taken for granted—the boxer's body is a temporary state. Rather than reify the martial art, it will be more useful to study the patterns of adaptation.

Notes

1. Curiously, Muay Thai in its country of origin doesn't seem to arouse anthropologists' interest that much, apart from studies carried out by Catherine Choron-Baix (1995) and Peter Vail (1998a, 1998b). I am indebted to their previous fine analyses.

2. The redaction in this article has been mainly enabled by the support of the Quai Branly Museum, which granted me a postdoctoral fellowship in 2007–2008.

3. The Isan boxers represent nearly half of the 70,000 or so professional fighters in Thailand. The vast majority of them come from impoverished peasant

families. This is one of the reasons why I chose to complete my fieldwork in the Northeast region during almost two years (three months in 1999, twelve in 2000, three in 2002 and 2003). Professional Thai boxing represents the overwhelming majority of the Thai boxing activity in the kingdom. The few hundred amateur boxers in the major cities contrast with the 70,000 professionals embedded in a modern sport-business system.

4. According to Peter Jackson (2003), we have to acknowledge the human body in the Thai context as marked by gender behavioral performative norms.

5. The camps where I completed my fieldwork host only men, like the very great majority of them. Only a few camps are specifically dedicated to the training of women. If girls are more numerous than before in the professional Muay Thai, the national martial art remains a masculine occupation.

6. The same binary classification of boxers exists in the world of English Boxing, where distinctions are made between stylists, boxers or counter-punchers, and brawlers. The Thai version has been analyzed anthropologically by Peter Vail (1998a) and Stéphane Rennesson (2005).

7. Concerning the heuristic value of stereotypes see Michael Herzfeld's work (1992 and 2004, among others) or, in a Thai context, Bernard Formoso's analysis of Chinese and Thai relations in a small Isan town (2000).

8. Isans, Northeasterners, account for a third of the kingdom's inhabitants (67 million). Though the population has been under Siamese control for a couple of centuries, it is still culturally linked to the Lao of the eastern bank of the Mekong.

9. One should note that if a gum shield is chiefly used in the big events in Bangkok by confirmed pugilists it is rarely encountered in the numerous competitions organized in rural areas.

10. For example: an existence in the cycle of reincarnation (*cha:t*), an ethnicity (*cha:t wong*), a lineage (*cha:t phan*), a nation (*cha:t* or *pra'the :t cha:t*). According to Thongchai Winichakul's "geo-body" thesis (1994), the word *cha:t* has been used since the beginning of the twentieth century to refer to the idea of the nation. Combined with the notion of "territory" (*pra'the:t*) the word *cha:t* stands for the concept of *pra'the:tcha:t*, which means a people living within limits geographically defined.

11. Interestingly, the live comments and the reports after the contests leave less room for these kinds of rationalizations, which predominantly employ a narrative style in order to stick as much as possible to what is or has been going on between the ropes.

References

Choron-Baix, Catherine. 1995. *Le choc des mondes: Les amateurs de boxe thaïlandaise en France*. Paris: Kimé.

Formoso, Bernard. 1987. "Du corps humain à l'espace humanisé système de référence et représentation de l'espace dans deux villages du nord-est de la Thaïlande." *Etudes Rurales* 107–108: 137–170.

———. 2000. *Identités en regard: Destins chinois en milieu bouddhiste thaï.* Paris: CNRS éditions, éditions de la Maison des sciences de l'Homme.

———. 2001. "Corps étrangers: Tourisme et prostitution en Thaïlande." *Anthropologie et sociétés* 25 (2): 55–70.

Herzfeld, Michael. 1992. "The Creativity of Stereotypes." Pp. 71–97 in Michael Herzfeld, ed., *The Social Production of Indifference: Exploring the Symbolic Roots of Western Bureaucracy.* London: University of Chicago Press.

———. 1992. "La pratique des stéréotypes," *L'Homme* 32: 67–77.

———. 2004. *The Body Impolitic: Artisans and Artifice in the Global Hierarchy of Value.* Chicago: University of Chicago Press.

Jackson, Peter. "Performative Genders, Perverse Desires: A Bio-History of Thailand's Same-Sex and Transgender Cultures." *Intersetions: Gender, History and Culture in the Asian Context* Issue 9, August 2003. http://intersections.anu.edu.au/issue9/jackson.html (accessed 10 June 2011).

Rennesson, Stéphane. 2005. *Muay thai: Une ethnographie des filières de la boxe thaïlandaise en pays issane (Nord-Est thaïlandais).* PhD in Anthropology, University of Paris X-Nanterre.

———. 2007. "Violence et immunité: La boxe thaïlandaise promue en art de défense national." *L'Homme* 182: 163–186.

Sangsawan, Posawat. 1979. *Pattanakan kila muay thai* [Development of Thai Boxing]. MA of Physical Education, University of Chulalongkorn, Bangkok.

Vail, Peter Thomas. 1998a. *Violence and Control: Social and Cultural Dimensions of Boxing in Thailand.* PhD in Anthropology, Cornell University.

———. 1998b. "Modern Muay Thai Mythology." *Crossroads: An Interdisciplinary Journal of Southeast Asian Studies* 12 (2): 75–95.

Winichakul, Thongchai. 1994. *Siam Mapped: A History of the Geo-Body of a Nation.* Honolulu: University of Hawai'i Press.

Part III

Transnational Self-Construction

7

From Floor to Stage

Kalarippayattu Travels

Martin Welton

In *The Meaning of Truth* William James draws attention to significance of the relationship between the doer and the thing done in the accrual of value to either. "The relations between things, conjunctive as well as disjunctive," he suggests, "are just as much matters of direct particular experience, neither more, nor less so, than the things themselves" (1975: 7). The appeal to direct experience of relations as well as objects is of relevance to this discussion of the deployment of a martial arts practice within a variety of theatrical contexts for three principle reasons: first, it directs attention to processes of embodiment that might be shared across martial and performance practices; second, it suggests that understandings of the martial arts as a process of embodiment be made on the basis of comparing the differing contexts within which they are variously martial and/or artistic; and third, it demands that the perspective of those involved in these reckonings be brought into the account. A focus on the acts or processes of embodiment not only directs our attention to the centrality of the acts and the quotidian condition of their practice, over and above their ideal forms, but also to the significance of the context—or *habitus*—within which such activities take place. A contextual understanding of embodiment demands a consideration of how situatedness is both formative of embodiment and is in turn informed by it. Furthermore, an attention to the peculiarities of context draws our attention to the very

modality of practice as itself expressive or exploratory of meaning as well as to the objects and environments against and within which it occurs.

This chapter considers primarily the nonmartial practice of a martial art, in which the doer-done relationship is shifted from its original context, not only in consequence of the change in application, but also because this shift occurs across cultures. However, the chapter is not simply concerned with the "use" (or abuse) of the practices of one culture in and by another, but with the condition of movement by which this translation is both enacted and made manifest. The essay thus seeks to explore both the kind/s of bodies that might be articulated or enculturated by this movement, and also how movement itself carries with it and develops certain conditions of knowledge, even as it travels across contexts and across cultures. Indeed, the significance of "travel" here is that it not only draws attention to the fact of movement—that culture/s as well as people travel—but that it identifies movement as the meeting point of body and culture (Rojek and Urry 1997: 10).

As suggested, this chapter concerns the nonmartial practice of a martial art, and does so in conditions of cross-cultural application. Specifically, it considers three recent contexts and examples in which British, or British-based, theater makers have made use of the South Indian martial art *kalarippayattu*. While these three examples are by no means exhaustive of the uptake of *kalarippayattu* by practitioners of the performing arts, rather than martial arts, they do allow for rather different illustrations of the extent to which the practice is caught up in global flows of travel—from India to Great Britain for example. They also allow for some discussion of the practice as itself bound up in a process of travel(ing).

The use of *kalarippayattu* by non-Indian performing artists raises a number of anxieties, centered around the authenticity (or otherwise) of the manner and usage of this borrowing. Leaving those concerned with the postcolonial encounter in an era of globalization to one side, several of these can be seen to be connected to the validity of the use of a martial art in a theatrical context. These concerns pass in both directions, for both the integrity of the form itself, and also for an authenticity or integrity that it might lend to theatrical performance.

Readers with interests in the martial arts might well be familiar with *kalarippayattu* from the ethnographic writings of Phillip Zarrilli, not least of which is *When the Body Becomes All Eyes*, by far the most comprehensive work on the subject written in English. Those who have

studied his writings in detail might be aware that Zarrilli is also a theater director and actor trainer of some considerable repute, not least for his adaptation of *kalarippayattu* training as a preparation for performance. I do not address his theater work directly here, not least because he has written so extensively and effectively on it himself, but also out of a wish to identify and consider the manner in which a range of other theater directors and performers are making use of the practice. It may be the case that Zarrilli's work and writings have led the practitioners of the work discussed here, whether directly or not, to look to *kalarippayattu* to form or inform their work. While some would probably wish to acknowledge this, it seems important to look to the manner and terms of their own taking up of the martial art into performance. In his own writings, and in his teaching, Zarrilli has himself been keen to acknowledge that the majority of his study has centered on the practice of CVN-style *kalarippayattu* under the tutelage of Gurukkal Govindankutty Nayar (C. V. Narayanan Nayar). Much of this training took place in the late 1970s and 1980s. There are many forms of *kalarippayattu*, and while Zarrilli usefully identifies three major style groupings—northern, central, and southern—within these styles, and even within different schools or *sanghams* themselves, one finds many differences of form and inflection. Most of the theater practitioners discussed in this chapter can broadly be described as deploying a "northern" style, or a variant of it.

The contexts in which contemporary practitioners encounter *kalarippayattu* must be seen as differing considerably from Zarrilli's, not only because they do not do so for the most part in the course (and against the background) of ethnographic fieldwork, but also because to be doing so in the contemporary sociocultural milieu carries some quite particular resonances. Zarrilli's work and writing also recounts the passage of an Indian cultural practice into a Western context. While there are historical and contemporary examples of *kalarippayattu* being employed in performing arts in India, the upsurge of interest in the West, and in Great Britain in particular, is of interest here, not least because of the considerable shifts in terms of relationship between the two countries in economic and sociocultural terms since Zarrilli's work began in the late 1970s.[1] My own interest in *kalarippayattu* is borne out of this context, looking outside my own cultural and practical milieu initially as a student of Zarrilli in the United Kingdom, and then as an academic and theater maker, traveling to India on a regular basis for training and study.

Genuinely Inauthentic

In his study *The Antitheatrical Prejudice*, which uncovers not only the longevity, but also cultural breadth of social and philosophical opposition to the theater and its exponents, Jonas Barish suggests that:

> The fact that the disapproval of the theatre is capable of persisting through so many transformations of culture, so many dislocations of time and place, suggests a permanent kernel of distrust waiting to be activated by the more superficial irritants. The durability of the prejudice would seem to reflect a basic attitude toward the lives of men in society. (1981: 2)

That basic attitude, Barish writes, is informed by a philosophical tradition that is concerned with the possibilities and potential of an authentic account of the "natural" state of things. The theater, in which appearance seems to be all, represents not only the antithesis of this account, but also actively undermines its moral purpose. In Western cultures, at least since Plato, the actor's ability to convince others that he is that which he is not has been the basis of suspicion, persecution, and ridicule. This state of affairs does not only pertain to those cultures that find their roots in ancient Greece however. Since antiquity in India and China, as Barish again points out, actors have belonged to despised or lower castes, occupying the fringes of the social order.

By way of opposition, practices and practitioners of martial arts have often been used as exemplars of authentic action. In the *Bhagavad Gita* Krishna advises his devotee Arjuna that in the heat of battle he should act without doubt, in other words, authentic to his role as warrior he should be "true" to the moment and not trouble himself with thoughts as to its consequence: "Therefore, without attachment, always do whatever action has to be done; for it is through acting without attachment that man attains the highest [moral/spiritual purpose]" (Johnson 1994: 16). Similarly, the psychophysical discipline in meditation of the sage Bodhidharma is central to the legends of martial practice originating from China's Shaolin temple (Broughton 1999).[2]

However, despite the apparent inauthenticity of the theater, the problem of "being true to the moment" is also a common question in its practice. Central in this is the figure of Constantin Stanislavski. Perhaps the most significant figure in twentieth-century theater, Stanislavski was

not only responsible for accelerating the theater's drift toward respectability, which had begun with the *philosophes* of the Enlightenment such as Diderot, but also, (importantly in the contexts of this discussion) for subjecting the authenticity of the actor's performance to sustained investigation in both theory and practice. Not only did Stanislavski begin to systematize an approach to actor training to meet the demands of his preferred aesthetic (which might perhaps be broadly described as "naturalistic"), but he attempted to do so with an understanding of action and its motivation that was based in the physical reality being revealed by contemporary science.[3]

As the theater historian Joseph Roach (1985) demonstrates, Stanislavski drew heavily on the developing science of reflex psychology in his efforts to develop an approach to actor training. Although resisting a singular or overarching description, the various techniques bracketed together as the "Stanislavski system" attempted to offer actors sufficient control over their psychophysical makeup such that, not only was an illusion of spontaneity in action achieved, but the problematic of illusion itself was overcome. Without wishing to elide spontaneity with authenticity unduly, their linking in Stanislavski's work fits into his project of developing a style and method of acting that was "based on the laws of nature" (Stanislavski 1986: 287). Since it was based on the laws of nature, it would itself *be* nature, would be true, sincere, and unencumbered by artifice.

The earlier part of Stanislavski's career saw him attempt to resolve the problem of the actor's inauthenticity by developing a psychologically based process in which the actor attempts to find corresponding personal circumstances to those of their character, as a means of bringing about a personal response. While this account involves an inevitable degree of generalization, it was this idea that was broadly developed by the founders of the American Method approach to theater acting. Subsequently popularized by its uptake by a clique of Hollywood's most serious performers, the rigorous attempts to self-identify with character that this approach has engendered has been, it might be argued, largely responsible for forming popular notions of what acting entails. Stanislavski himself rejected this approach, not only for the pomposity it fostered, and the threat it posed to the actor's mental health, but also because, lost in the depths of mnemonic recall and identification, actors were often prone to inaction, to say nothing of the loss of fidelity to narrative and *mise-en-scène* brought about by fidelity to the "truth" of impulses brought about by the technique.

The "method of physical actions" that Stanislavski was to develop toward the end of his life not only reversed the psychophysical relationship between action and impulse that his earlier work had entailed, but also laid the grounds for a raft of approaches to actor and performer trainings, against the backdrop of which this discussion takes place. Whereas Stanislavski's earlier work had attempted to make acting authentic by attending to a rigorous psychological process invoking real memories and feelings, the method of physical actions paid attention to the construction of detailed physical actions in order to stimulate an authentic, and even spontaneous, response, in spite of the repetition that nightly theatrical performance entails: "It rests on the now familiar principle that every thought and feeling is connected to a physical action, that mind is merely the subjective aspect of an objective process called body" (Roach 1985: 213). While the tenability of this position has troubled many theater theorists in the years since Stanislavski's death, both the emphasis on action and the realization of the material basis of the performer's authenticity remain important not only to the formulation of appropriate trainings, but also to an understanding of theater's place in relation to the world, its efficacy, and value.

Authenticity and Myth

In his 2005 film *The Myth*, Jackie Chan plays an archaeologist who stumbles across a mythical sword, and, in parallel an alter ego in a past life, a Qin dynasty general. The plot of the film is somewhat convoluted, but of significance to this discussion is the sword's initial location in India, where Chan and his counterpart Tony Leung battle a variety of opponents in a manner somewhat reminiscent of "platform" video games. In these encounters, several of the warriors Chan encounters are *kalarippayattu* fighters. Seen against the Southeast Asian martial arts and urban settings most often used in Chan's films, the movements, weapons, dress, and ethnicity of his opponents are exotically different to his.

Chan's use of *kalarippayattu* practitioners in the film created a great deal of excitement in the Indian media. Not only does the film perpetuate an enduring and popular myth about *kalarippayattu*'s legendary origins, as I will discuss, but Chan's recognition and use of it as a "star" was seen as legitimizing a connected and chauvinistic claim to the *Indian* origins of a historically pan-Asian system of martial practices. Never mind that

the film cast the *kalarippayattu* practitioners as both exotic and "ancient," and the practice as belonging to an "other" past as much as Chan's is of the present, the recognition of the form by a "celebrity" martial artist was seen as endowing *kalarippayattu* with an important prestige:

> Jackie Chan is aware that the roots of Shaolin Kung Fu can be traced to Kalarippayattu, Kerala's ancient martial arts [sic.] Far away in Hampi, outside a stone temple, Chan patiently went through a dozen takes of intricate kalari movements for his latest film. "We've adapted the basics of Kalarippayattu and improvised on them," says the action maestro, who makes no bones about his fascination for India. (Nayar 2004)

The presumed connection of *kalarippayattu*'s tradition to antiquity mentioned in this quote enables a popular chauvinism in which India is the birthplace of all "Asian" martial arts, helpfully shrouded by the mists (and mysticism) of time. However, as the media interest around Chan's use of *kalarippayattu* in *The Myth* attests, there is a tension between the need to advocate for the martial art as a particularly Indian or Malayali tradition with semi-mystical origins and a dynamic and evolving practice, of interest and relevance to the contemporary citizens of an increasingly cosmopolitan nation.[4]

The *kalarippayattu* practitioners used by Chan in the film were drawn from the CVN *kalaris* of Kozikhode and Thiruvananthapuram, many of whom were well used to "performing" the martial art.[5] Not only do filmmakers making documentaries about Kerala's culture regularly film at these two prestigious training centers, but teachers and advanced students regularly present demonstrations at cultural events in India and abroad, as well as finding themselves co-opted as performers in films and theatrical productions.[6] The CVN *kalari* in Thiruvananthapuram's East Fort is also listed in the *Lonely Planet* and other guidebooks as "something to see," and during my own visits there for training between 2000 and 2004, tourists regularly visited the early morning training sessions to watch, and take photographs and video recordings (both with, and without the permission of the Gurukkal).[7,8] While this *kalari* is perhaps a little different from forms found elsewhere in Kerala in being so regularly and unstintingly subject to the tourist gaze, nevertheless, *kalarippayattu* joins other "traditional" practices in being packaged as part of the tourist experience of "God's Own Country."[9]

It is hard, however, to point to a singular tradition of *kalarippayattu* within Kerala. Just as Joseph Alter (2004) has shown "yoga" in modern India (and subsequently in its export elsewhere) to be something of a contemporary construction drawing on a variety of practices and philosophies as historically diverse as they are related, so, too, is "*kalarippayattu*." Not only is it necessary to look to the relative modernity of Kerala as a sociocultural entity, with the state being founded in 1956, but it is also (as I shall later discuss) important to see the "tradition" encountered in *kalarippayattu* practice as a relatively recent construction. Furthermore, the rapid changes to which contemporary Indian society finds itself subject are undoubtedly shifting the manner and extent to which the training is carried out. During fieldwork at the CVN *kalari* in East Fort Thiruvananthapuram between 2000 and 2004, many of the young men I trained with found it difficult to balance a six-days-a-week schedule of early morning and/or evening trainings with the demands placed on them by their commitments to employers, education, or families. In 2002, enquiring after Shankar, one of the most advanced students I had worked with during my previous visit in 2000, I was told that having recently married and now having to work to support his family, he found it difficult to maintain a commitment to regular training, and I trained with him no more than three times during my ten-week visit. Indeed, on each of my four visits during this period, among the students training most regularly were a significant number of non-Indian "tourists" like myself. These non-Indian students were training for a variety of reasons ranging from straightforward cultural tourism to the academic, and a sizeable number were interested martial or performing artists. As "temporary" students (even though some had made several visits, often for periods of a year or more) the position of relative and bounded leisure from which they approached the training was in marked contrast to the Malayali students who, for the most part, had to incorporate the training within the weft of their daily life.

Similarly, the place occupied by *kalarippayattu* within Malayali social consciousness is also shifting, as McDonald (2003) describes, in response to changing social assumptions about the role and function of bodily disciplines, and in reaction to the influx of mediated images of martial arts in movies and on television in which the fighting milieu is the street in contrast to the aesthetic confines of a *kalari*. While speaking to students beginning training at CVN *kalari* about their reasons for the undertaking, a common response was "to lose fat." Certainly the notion of

the *kalari* as a place of health and healing as a well as martial training is perhaps significant in shaping this reasoning, but the impact on the social consciousness of young Malayalis of the toned male bodies present in the media should not be overlooked.[10] Not only are young men increasingly exposed to body images offered in other cultural representations such as American film and television (American TV wrestling was very popular among the CVN students during my visits), but also in more culturally proximate media, such as Bollywood movies.[11]

Kalarippayattu is a physically exacting training however, not only in the relative amount of exertion that one might put into its practice, but also in the demands placed on or required of its practitioner's physicality. Historically, boys began training at relatively young ages—around seven, reaching their "peak" at the close of their teenage years. This is perhaps not uncommon among other athletic pursuits, but in undergoing training during these crucial years young men actively develop a physicality capable of supporting the demands of the practice, as well as the necessary strength and flexibility. The wide turnout in the hips and the ankle and shoulder rotation necessary for the most advanced levels of practice are founded upon this early start to training.[12] For many students undertaking training in a twenty-first-century *kalari* that finds itself in competition for their attention with other social practices (including other martial arts), authentic modes of tradition and embodiment might appear to be quite literally unattainable. However, the promise of an authentic embodiment of martial and cultural practice remains important, not only to indigenous Malayalis, but also to the increasing numbers of temporary visitors to Kerala's *kalaris* from both India and the rest of the world. Indeed *kalarippayattu* is used both within Kerala and elsewhere as a marker of a distinctively Keralan experience.[13]

As much as *kalarippayattu* may offer access to the authentic however, the increased exposure of this very promise seems to render it ever more elusive, not only locating it relative to an ever retreating "tradition," but also removing its practice from the sphere of the quotidian—the authentic is always somewhere or sometime else. This paradoxical relationship to the authentic is often used to mark out the difference between the tourist's encounter with cultural sites and practices and those of the "local." Dean MacCannell (1973), writing of the touristic consciousness, suggests that it is the aspiration toward authentic experience (and the denial of it in consequence of that very aspiration) that marks the touristic as a particular condition of being. Importantly, it is the partly imagined nature

of both the location and experience of the authentic that sustains the touristic search for it beyond the terms of an everyday life. While this account of tourism and the authentic locates both beyond the realm of the quotidian, more recent theory has begun to consider the extent to which tourism, particularly within globalized or cosmopolitan contexts, is an indubitable part of everyday life (Edensor 2007; Urry 2007). Moreover the quotidian nature and content of tourist encounters is all too easily overlooked if tourism is understood only through an ocularcentric privileging of sightseeing as the *sine qua non* of its experience, or a focus on radical differences between the tourist and the local.

Tourism, Tim Edensor suggests, is a practice of everyday life as often as it is an encounter with, or staging of, the spectacular: "tourists carry quotidian habits and responses with them; they are part of their baggage" (2007: 61). One need not even consider all tourists to be engaged within practices of "leisure." As Urry suggests (2007) global or transcultural mobilities often involve a blurring between travels given over to work and those in pursuit of pleasure or personal interest, in which those traveling for work find themselves sometimes at leisure. Without wanting to label the use of *kalarippayattu* by the non-Malayali practitioners described here in pejorative terms as "mere" tourists, in each of the three case studies described, efforts to engage or sustain a problematic notion of authenticity are inevitably encountered and (re)imagined somatically in the process of movement and travel, and it is this that leads me to invoke the "touristic."

"Tourism," Urry suggests, "always involves *corporeal* movement and forms of pleasure and these must be central in any sociology of diverse tourisms" (2002: 152). To describe a practice in terms of tourism is thus both to raise questions of bodily agency, and also to signal an effort toward understandings of other places, persons, or practices that are at least in part somatically engaged. Any question of authenticity must subsequently be considered with regard to its kinesthetic appreciation in motion.

Bodily Travels

The theater practitioners in the three case studies presented here have principally turned to *kalarippayattu* as a source of aesthetic inspiration. However, all have also found a deepening of their relationship to their own practice by then pursuing a relationship to the martial art beyond

this initial concern. Subsequently, in my presentation of them, while necessarily paying attention to the manner in which their appropriation of the martial art has been deployed in the service of theatrical representation, key in the discussion is the process of embodiment subsequently engendered.

Trestle Theatre Company's 2006–2007 production *Little India* is an adaptation of the classical Sanskrit drama *Shakuntala*, developed in collaboration with the Bangalore-based company Little Jasmine. The production had its genesis in a visit by Trestle's artistic director Emily Gray to the CVN *kalari* in Thiruvananthapuram in 2002. While this *kalari* has been the seed bed for a variety of excursions into the martial arts by theater makers, for Gray, it was as part of the pleasure of a tourist visit to Kerala that she found her interest piqued. Gray, whose background is contemporary dance as well as theater, recognized the possibility for choreography in the sequences and routines around which *kalarippayattu* training is structured and the "harmony" that is experienced between practitioners, even when engaged in acts of (potential) violence. Following this encounter Gray contacted Kirtana Kumar, director of Little Jasmine, to discuss the basis of a collaboration that might draw on *kalarippayattu* as part of its aesthetic.[14]

Gray's initial approach to Little Jasmine in early 2006 was a proposal that they (Trestle) commission the Indian company to develop the framework for a possible performance synthesizing *kalarippayattu* with storytelling and music. This work formed the basis for a ten-day residency at Trestle Arts Base, the company's headquarters in St. Albans, with the Indian company leading a group of performers (actors and dancers), directors, designers, and musicians through a process involving *kalarippayattu* training, improvisations based on elements of the form, and workshops on music and storytelling drawn from the earlier work on *Shakuntala* in Bangalore.[15] For many of the workshop participants—and then the company—the work with *kalarippayattu* provided a window onto a new set of possibilities for making performance. As one of the performers reported in a company feedback sheet following the residency: "the physical gesture and martial arts movements that I have learnt [sic], serves to create aesthetic forms onstage, and also 'physical stepping stones' for the devising process."[16]

For Gray, the initial interest in *kalarippayattu* was in the possibilities that the sequences of movements in its training routines presented for performance. Like many visitors to Kerala's *kalaris*, Gray was and is impressed by the supple finesse of the martial arts movements, especially

their "dance-like" qualities. Before returning to consider the trope of tour-
ism, and the travels made by the form from dirt floors in Southern India
to the sprung floors of European stages, it is worth resting a moment to
ponder the application of the description "dance-like" to *kalarippayattu*.
We are, after all, discussing a practice that, in several of its manifestations,
is both a violent undertaking and one that ultimately seeks pragmatic
rather than aesthetic applications.

Dance-like Fighting

For the dance theorist Sondra Horton Fraleigh, to identify human move-
ment as "dance" is to not only perceive it aesthetically, but to note an
intentional aestheticism in the undertaking itself:

> Dance is movement set apart from life; that is, movement
> seen for itself, most particularly its aesthetic qualities. Thus
> when I dance my attention must be lifted out of my use-
> ful body-of-tasks, my body of habituated movement, bodily
> awareness—my awareness of myself (and my-body-as-myself)
> changes. (1987: 30)

To describe martial practice in these terms is to note a body that performs,
in Victor Turner's sense, its own awareness of doing so. Turner describes
performance as an "involved process," rather than the simple manifestation
of *form* (1982: 191). This autotelic awareness also informs *kalarippayattu*,
at least insofar as it is represented by the CVN-style, which variously
connects the three examples of performance given here. The *sangham*
(school or style), established by C. V. Narayanan Nayar and which bears
his name, not only played an important role in the reemergence of the
martial art as a vibrant and culturally viable form after its suppression
under British rule, but led a tradition of public demonstrations of the
martial art.

As Zarrilli describes, together with his teacher Kottakkal Kanaran
Gurukkal, Nayar drew together the teachings of several masters of differ-
ent styles and lineages to create a new, composite style of *kalarippayattu*
(1998: 51–53).[17] Seen against the backdrop of a growing rediscovery of
indigenous cultural practices as part of a growing nationalism in the
1920s, these public demonstrations of martial practice played an important

role in the formation of a specifically Keralite identity, no easy thing in India, where linguistic and caste differences both precede, and frequently exceed, state structures and boundaries. Furthermore, it might be argued, the development of the CVN style as a *demonstrable* form of physical prowess, alongside the focus given in its synthesis to its efficiency as a fighting practice, has led to a conscious attention to form in practice.

Certainly, the attention to form in the CVN style is often concerned with biomechanical efficiency (the twisting of the body to create torque for a kick for example), balance or somatospatial awareness.[18] However, there is also a pleasure in the achievement of line, spring, or strike, which is reinforced by the attention drawn to the detail of their embodiment during teaching. In watching CVN training then, in which students and teachers alike are thus focused on form, *expression* by and through the body is not so much concerned with an aesthetic ideal, as a pleasure-in-form—in the practice of it—which the epithet "dance-like" begins to describe. Rather than an instance of an antitheatrical prejudice, describing the martial art as "dance-like" might be said to thus perceive its practitioners as in Horton Fraleigh words, "alive in the moment of their best utterance and action" (1987: xvii).

Still today, CVN teachers and students regularly travel within India and overseas to give demonstrations, as indeed do practitioners from many of Kerala's other *sanghams*. Quite apart from *kalarippayattu*'s historical connections to the performing arts, this has also seen the martial art quite deliberately presented for the stage, as in the International Workshop Festival's The Performer's Energy series in 1995 at London's Queen Elizabeth Hall. Under the heading "Dance Rites" it was shown alongside capoeira as a form that might not only be co-opted into theatrical practice, but was interesting in its own right as a practice for the stage.

Despite such efforts, and disregarding the significance of its demonstration or performance to its recent history and subsequent contemporary articulation, fears over the diminution of *kalarippayattu* as a necessarily *martial* art remain. Ian McDonald notes the challenge that globalization poses to *kalarippayattu* as an "indigenous discipline" through "the impact of different consumerist imperatives associated with tourism and the commodification of Asian martial arts" (2003: 1572). Among these pressures is the use of *kalarippayattu* in stage demonstrations. On a visit to an unnamed Thiruvananthapuram *kalari* he reports that: "the *Gurukkal* expressed concern over the pressure to emphasize the dance elements in kalarippayattu [sic] as a way of training students for stage

demonstrations" (1573). Although McDonald appears to overlook the role
played by performers (and, as suggested, *performance* itself) in the recent
development of the martial art, desires to keep the form unadulterated
by their contagion speak not only to the ongoing intercultural reach of
the antitheatrical prejudice identified by Barish nearly thirty years ago,
but also to the belief in an authentic mode of practice.

Following their ten-day residency, Trestle selected a group of actors
who would work on adapting Little Jasmine's workshop performance for a
UK tour. Taking their place alongside Gray and Trestle's own production
team were the composer Konarak Reddy and Anmol Mothi, the *kalarip-
payattu* practitioner and former Kerala state champion who had taught
the form to both Little Jasmine and the participants in the residency.
What Mothi offered the company was an opportunity not only to copy or
reproduce the appearance of the Indian martial art, but, in his presence
among the company as an "authentic" *kalarippayattu* master, to seek an
extension between their stage performance and training on the beaten
red-dirt floors of Kerala's *kalaris*.

The Quotidian Authentic

"Our body," Merleau-Ponty wrote, "is not primarily *in* space: it is of it"
(1994: 148). The implication in this instance is that space is not simply
supportive or locative of practice, nor even that which circumscribes it
(as in the sense of social space), but that movements through space are
coextensive with it. In taking Mothi's practice as the benchmark for their
own process of embodiment, Trestle sought to ground their deployment
on the authentic *kalari* floor upon which his was founded and furthermore
to extend with the wider body and history of the martial art's practice.
Little India staged demonstrably spectacular aspects of *kalarippayattu*—sword
play, stick fighting, and *meippayattu* (body-preparation sequences) car-
ried out at high-speed. However, it might be argued that in presenting
the martial art as a display of virtuosity, these polished displays mask
the mistakes, the effort, the very mundanity of quotidian practice. It is
at this mundane level, in which "other cultural" practices are not only
encountered but also to some extent comprehended, where perhaps we
might begin to locate their authenticity.

As Thomas Csordas suggests, discussing cross-cultural practice in
terms of embodiment "means not that cultures have the same structure as

bodily experience, but that embodied experience is the starting point for analyzing human participation in a cultural world" (1993: 1). Thus while interest in the use of the martial arts in performance practice might at first seem to be predicated on the spectacular possibilities of their display or their cultural "otherness," there is an extent to which engagement with practice as a function of the mundane or quotidian routine of "doing" shapes knowledge both of culture and self. This is especially so, when considered from an embodied, rather than spectatorial perspective. To undertake an "other" cultural practice in this respect is less to assume the role of participantethnographer than to "subvert," in Joseph Alter's terms, the condition of one's existing embodiment. "Any culture," suggests Alter, "is necessarily partial, and when juxtaposed to another culture it is at least partially subversive" (1997: 20).

As much as companies like Trestle draw on *kalarippayattu* as an authentically Indian practice in order to sustain and illustrate intercultural projects like *Little India*, there is also an extent to which performance makers in Britain are drawing, subversively, on the martial art in and of itself. In this respect, the practice does not necessarily rise to the surface *as* performance, but, in becoming assimilated into a performer's movement range and repertoire it *informs* it. For the dancer and choreographer Liz Lea, this relationship to *kalarippayattu* is important. While she has choreographed work that draws directly on *kalarippayattu* as movement material for dance, it is the extent to which its training—sustained over the long term—that shapes an attitude toward and an awareness of performance. For example, in *Eros~Eris* shown in May 2007 at the Royal Opera House's Linbury Studio, and in which Lea herself performed, although *kalarippayattu* itself did not enter the choreography, the awareness of body in performance that Lea has taken from the martial art nevertheless informed the piece.

Where does this leave the aesthetic then? The point is perhaps that in traveling from stage to floor, so to speak, and engaging with the training *qua* training (rather than as material from which something else will be made), the martial art comes to underpin theatrical performance as a mode of attention to the unfolding here and now. Zarrilli has suggested that this is "an observably real characteristic of consummate martial and theatrical artists" (1984: 192). Not all artists—martial or performing—rise to this level of mastery. The movement toward the most complete form of understanding is at least as important as an arrival at the ultimate state of complete realization. British-based artists taking up the martial

art experience this journey, traveling both toward mastery and, in the opposite direction, from floor to stage). The most complete form of the journey would require a long-term engagement with the form that asks more than a student who is involved "just for kicks" might expect. As Lea herself explained, "dancers take the shape [of the form] quite easily, but understanding the form is vital and while we may not fully get there it is vital to train and try to" (personal email correspondence, 13 July 2007). The physical facility gained elsewhere by the contemporary dancer may lend her body more readily to the architecture of the form than her stiffer compatriots, but clearly, for Lea at least, it is not enough simply to arrive at the point: "along the way [of long-term training] you learn so much and a different way of moving develops and is informed."

For the British theater director Tim Supple, this quality of attention became a central motif in his production of Shakespeare's A *Midsummer Night's Dream* for Dash Arts, with an inter-Indian cast. The production included a floor of red earth, and a ceremonial *lingam* at the front of the stage.[19] It clearly intended to locate the fantasy of the play within a recognizably "Indian" cosmology, and Supple's initial interest in *kalarippayattu* seems in keeping with this. For director and cast alike however, the martial art his shifted from being simply another aspect of the representation of an "Indian" universe occupied by the play to become a means of performance in its own right.

After performances in Mumbai, Delhi, Kolkata, and Chennai earlier that year, the production received its British premier at the Royal Shakespeare Theatre in Stratford upon Avon in June 2006. Still touring at the time of writing, it was developed by Supple and Dash Arts in collaboration with a large cast of actors, musicians, and designers, drawn from across India and Sri Lanka. What excited British critics in particular was not only the sensuousness of the acting, the ravishing set design, and musical score that accompanied the acting, but that Supple chose to retain many of the languages spoken by the cast. Shakespeare's language was cast therefore in several Indian tongues: Tamil, Malayalam, Hindi, Sinhala, Bengali, Marathi—and English.[20]

Having traveled widely in India and Sri Lanka in 2004 after an approach from the British Council to create a performance with Indian performers and musicians, Supple then invited sixty people to Mumbai for a week-long process of workshops and auditions. Like Gray, Supple's engagement with India might be thought of as initially "touristic" even if he wasn't himself a tourist in this respect. Indeed it seems necessary

to begin to remove the negativity connected with the appellation from theater practitioners like Supple or Gray who seek to extend the cultural boundaries of their work. Where an earlier generation of "intercultural" theater makers in the West were condemned both for the "ambivalent ethics" of their cultural tourism and their lack of an appropriate historicity (Bharucha 1990), both the world (now, significantly, a globe) and tourism itself have moved on. As Tim Edensor, notes: "Like other areas of life, which the effects of globalization increasingly penetrate, tourism provides an occasion for coming across and meeting with dimensions of cultural difference" (2007: 212). Furthermore, for Edensor, "The conventional habits through which tourism is performed can be confounded by those who perform tourism differently" (213). Like Gray, Supple's travels within India cannot readily be dismissed as "mere sightseeing." They represent a desire to participate and understand, sensitive to cultural difference. Similarly, while Supple sought to engage with *kalarippayattu* as source material for his own performance and to bring the expertise of its practitioners to bear on this borrowing, he found through a process of unfolding discovery a "use" for it beyond the spectacular.

Following the workshop in Mumbai, in early 2006, a group of twenty-two performers were taken to the ashram of the Adishakti Theatre Company just outside Pondicherry in Tamil Nadu where they rehearsed together for seven weeks. Among the performers making up this group was D. "Pappan" Padmakumar. A Malayali, with training in both *bharatanatyam* classical dance and *kalarippayattu*, Padmakumar performed as the fairy Mustard Seed as well as choreographing fight scenes and dances. As well as lending his particular skills to the performance itself, Padmakumar's *kalarippayattu* training became intrinsic to the process of its development, as he led the cast—and not only those involved in fight sequences—through a daily class. This process has continued throughout the performance's ongoing development on tour with the cast attending at least two classes a week, as well as making use of it as part of their nightly warm-up. For Supple, *kalarippayattu* offers a basis for theatrical action, lending performers a heightened sense of balance, alignment, and dynamism, as well as physical fitness and flexibility. Indeed on this basis he has suggested in an interview that it forms an excellent foundation for theatrical action in general.[21] For the actors themselves, working within such a linguistically complex environment and across a range of performance traditions, *kalarippayattu* became a kind of *lingua franca*, a physical grounding from which a shared understanding of *how* to perform

was developed. As Padmakumar told the *Hindu* newspaper: "It's one rhythm, one body language" (Muthalaly 2006). For Susanne Greenhalgh, writing of the Stratford performances in the *Shakespeare Bulletin*, the physical expertise enabled for the whole cast by their *kalarippayattu* training "both created a strong sense of ensemble playing, and enabled unimpeded communication between the performers, and crucially, with the audience" (2006: 67).

Quite how Greenhalgh can so directly attribute these phenomenal qualities to *kalarippayattu* is unclear, but they do seem to suggest the vibrancy of the performances by the entire company, as well as the "harmony" in its practice noted earlier by Emily Gray. The connection itself might be better considered through a further observation made by Padmakumar in the *Hindu* interview, where he suggests of his colleagues: "I can't believe how good they are. They're doing it just like the professionals, one or two are much better than me . . . they've learned to use hand gesture to connect with the eyes" (Muthalaly 2006). This connection of movement and vision as a means of being in, or occupying, space, offers a further understanding of *kalarippayattu*'s operation in the context of performance, irrespective of performance per se. Certainly in the CVN style in which Padmakumar trained, a connection is often made in teaching between movement and the directed use of visual focus. In training with weapons like the *cerruvadi*, or short stick, the student is encouraged to retain a focus on the teacher's eyes throughout sequences, trying to absorb the teacher's intention, rather than second guess the movement.

As a "seeing flow" (Babb 1981: 396) that unfolds during and as part of a broader movement practice, looking in *kalarippayattu* can be considered as not only the means by which the practice is learned or embodied, but as a part of the condition of its embodiment per se. For Zarrilli, the relationship between an active process of looking and the physical form is central to the manifestation of the "power" of the martial art. Taking the title of his ethnography *When the Body Becomes All Eyes* from a popular Malayalam folk expression (*meyyu kannakuka*), which suggests "an optimal state of awareness and readiness" (1998: 19), Zarrilli draws attention to the cultivation and development of a quality of attention at least as important as the physical action that it supports. Movement within space becomes a means of paying attention with a clarity akin to vision. In Dash Arts' *Dream* the clear use of hand gestures by the cast seemed to support Padmakumar's suggestion that his colleagues had begun to find a connection between hand and eye in this respect, with

critics commenting frequently on the "visceral" or "sensual" qualities of the performance.[22]

Conclusion

To return, in conclusion, to William James: if the relations between things (or in this case, practices) are at least as important as the things themselves, then those relations must be viewed not as lines between static points or nodes, but as movements—ongoing processes of unfolding, and (re)engagement. In all three of the examples discussed here, it is the development of a means of paying attention *with* one's body that describes a movement from the martial to the performing arts. This movement is itself predicated upon processes of travel in which real and imagined locations overlap. In the case of *Little India* and *A Midsummer Night's Dream*, the movements of *kalarippayattu* were used to represent or give a sense of India as an onstage location. In both cases however, the performers found themselves increasingly drawn to an engagement with the practice itself beyond the terms of its onstage representation, furthering a traveling imaginary in which their onstage representations seemed to be brought closer to the authentic sites of their originary practice. Traveling to India in their creative imaginations as well as in more straightforwardly touristic journeys there, both Gray and Supple and the performers working with them seem to have located an authenticity within the practice itself as movement rather than in its location in any particular site. Certainly this is predicated on at least a genealogical link to figures like C. V. Narayan Nayar and Kottakal Karnan Gurukkal, but insofar as their theatrical uses of *kalarippayattu* finds an authenticity, it is in "off-stage" and often quite personal uses of it, as Liz Lea and Pappan Padmakumar suggest.

Transferring from floor to stage, not only has the martial art moved from India to Britain, or from Malayali to non-Malayali bodies, but it has also found, despite an apparent shift from the quotidian to the spectacular, a necessary movement back to the quotidian in the manner by which it finds meaning for its practitioners. Even for those members of Trestle Theatre Company who, unlike Gray, did not actually travel to Kerala to experience *kalarippayattu*, there is a sense in which this process is touristic. Another place and an "other" practice of moving or doing is initially experienced on a spectacular level, but then bodily assimilated

back into the quotidian, as a mode of attention useful to—or meaningful within—theatrical production.

Notes

1. Warriors from Nayar and related castes were recruited by the originators of Kerala's *kathakali* dance dramas as performers with the requisite physical skill and dexterity to meet the demands of the emergent theatrical form. Vestiges of the martial art's form can be seen in some of *kathakali*'s basic choreography (see Zarrilli 1999). More recently, the Chennai-based choreographer Chandralekha drew on the martial art in dance works such as *Angika* (1983) and in her aesthetic theory of Indian dance (1985).

2. In popular legend, Bodhidharma, presumed to be the son of a warrior king, is selected by his master Prajñātāra to take the "true Dharma" to China and is also often accredited with passing on his martial practice (*kalarippayattu*) to the monks at Shaolin.

3. Note that this signals its proximity to movements towards a representation of the 'natural' rather than naturalism per se.

4. The ethno-linguistic identity of most Keralans, as speakers of Malayalam.

5. *Kalari*, meaning literally "place of training," is the generic title given to both the buildings and the individual organizations within which *kalarippayattu* training takes place.

6. On my last visit to the CVN *kalari* in Trivandrum in 2004, a large poster in the gallery area just above the pit of the *kalari* itself advertised the presence of CVN *kalari* artists at a festival of South Indian arts and culture in Vienna the previous year. Two advanced students had also recently returned from working in France with a Franco-Indian *Bharatanatyam* dancer.

7. The *kalari* in Thiruvananthapuram is affiliated to the larger CVN organization, or *sangham*, made up of other *kalaris* across the state of Kerala whose trainings share stylistic and pedagogical similarities and denote a shared lineage.

8. The honorific Gurukkal, although given to individual masters, is a plural of *guru* referring not only to the individual, but also to the embodiment of a lineage of teachers.

9. See for example the website of the Kerala state tourist board, www.keralatourism.org. The appellation "God's Own Country" is frequently used in tourist advertising throughout Kerala itself.

10. Advanced practitioners are frequently also trained in *kalari chiklitsa*, a system of complementary medicine. See Zarrilli (1999) and (1998) for an indepth discussion.

11. It is worth noting, however, that while popular in Kerala, the largely Hindi-language cinema of Bollywood is in competition with more immediately

recognizable Malayalam- and Tamil-language film industries in which the heroes are often rather more rotund.

12. The seasonal *uzhiccil* massage (a whole-body treatment administered through the soles of the feet) given by the Gurukkal to his students also plays a role in this, as Zarrilli describes (1989, 1994). The relative lack of response of my stiffer, adult body was pointed out to me by my teacher Sathyan, during *uzhiccil* in 2002, as something that could have been "corrected" by an earlier commencement to my practice, but which by the (then) age of twenty-nine was foreclosed to me.

13. For example, in Abi Ruchi, a Kerala restaurant in North London's trendy Stoke Newington, a miniature brass shield with cross-swords (an image widely associated with *kalarippayattu*) joins model Kathakali dancers and photographs of the state's famous backwaters as emblematic of Kerala's culture.

14. This word was used by Gray in an interview on 6 June 2007.

15. This residency also involved a further collaboration with storyteller Vayu Naidu and composer Konarak Reddy. Other participants were selected on the basis of a written application, expression of interest, and résumé.

16. Workshop evaluation form provided by Trestle Theatre Company.

17. For Nayar, Kottakkal Karnaran Gurukkal offered access to a more ancient tradition of *kalarippayattu*; the guru was already in his seventies when Nayar began his training: "Mr. Kanaran Gurukkal of Kottackal [sic] is one of the few surviving links with the past generations of illustrious fencing masters. He is now about 86 years old, but enjoys perfect health and is quite capable of overcoming any antagonist in fencing. He began his training in fencing when he was about 7 years of age, and has come out victorious in duels in a number of localities in British Malabar. It was 12 years ago that I learned the art from this guru" (1933: 347).

18. Writing in the papers of the Kerala Society in 1933, C. V. Narayanan Nayar himself noted "the perfect mastery over 'the eye, body, and feet' . . . acquired through systematic training" (347).

19. The phallic emblem of the god Siva, routinely found in temples and shrines dedicated to him.

20. See, for example, Michael Billington, "Indian Summer," *The Guardian*, 31 May 2006.

21. Personal interview, 3 November 2007.

22. See, for example, *Time Out* 5 November 2007.

References

Alter, Joseph. 1997. *The Wrestler's Body: Identity and Ideology in North India.* Berkeley: University of California Press.

————. 2004. *Yoga in Modern India: The Body Between Science and Philosophy*. Princeton, NJ, and Oxford: Princeton University Press.

Babb, Lawrence. 1981. "Glancing: Visual Interaction in Hinduism." *Journal of Anthropological Research* 37: 387–401.

Barish, Jonas. 1981. *The Antitheatrical Prejudice*. Los Angeles: University of California Press.

Bharucha, Rustom. 1990. *Theatre and World: Performance and the Politics of Culture*. London: Routledge.

Broughton, Jeffrey L. 1999. *The Bodhidharma Anthology: The Earliest Records of Zen*. Berkeley: University of California Press.

Chandralekha. 1985. "Militant Origins of Indian Dance." *Social Scientist* 9 (2/3): 80–85.

Csordas, Thomas J. 1993. "Somatic Modes of Attention." *Cultural Anthropology* 8 (2): 135–156.

Edensor, Tim. 1998. *Tourism at the Taj*. London: Routledge.

————. 2007. "Mundane Mobilities: Performance and Spaces of Tourism." *Social and Cultural Geography* 8 (2): 199–215.

Fraleigh, Sondra Horton. 1987. *Dance and the Lived Body: A Descriptive Aesthetics*. Pittsburgh: University of Pittsburgh Press.

Greenhalgh, Susanne. 2006. "*A Midsummer Night's Dream* (Review)." *The Shakespeare Bulletin* 24 (4): 65–69.

James, William. 1975. *The Meaning of Truth: The Works of William James*. Ed. Fredson Bowers. Cambridge: Harvard University Press.

Johnson, W. J., trans. 1994. *The Bhagavad Gita*. Oxford: Oxford University Press.

MacCannell, Dean. 1973. "Staged Authenticity: Arrangements of Social Space in Tourist Settings." *American Journal of Sociology* 79 (3): 589–603.

McDonald, Ian. 2003. "Hindu Nationalism, Cultural Spaces, and Bodily Practices in India." *American Behavioral Scientist* 46 (11): 1563–1576.

Merleau-Ponty, Maurice. 1994. *Phenomenology of Perception*. London: Routledge.

Nayar, C. V. Narayanan. 1933. "Fencing in Ancient Kerala." *Kerala Society Papers* 2 (11): 347–349.

Roach, Joseph. 1985. *The Player's Passion: Studies in the Science of Acting*. Ann Arbor: University of Michigan Press.

Rojek, Chris, and John Urry. 1997. *Touring Cultures: Transformations of Travel and Theory*. London: Routledge.

Stanislavski, Constantin. 1986. *Building a Character*. London: Methuen.

Turner, Victor. 1982. *From Ritual to Theatre: The Human Seriousness of Play*. New York: PAJ Publications.

Urry, John. 2002. *The Tourist Gaze*. London: Sage.

————. 2007. *Mobilities*. Cambridge: Polity.

Vijayakumar, K. 2000. *Kalarippayattu Keralathinte Sakthiyum Soundaryavum*. Thiruvananthapuram: Department of Cultural Relations, Government of Kerala.

Welton, Martin. 2006. "Just for Kicks? In Search of the Performative 'Something Else' in a South Asian Martial Art." *Contemporary Theatre Review* 16 (1): 153–158.

Zarrilli, Phillip B. 1984. "Doing the Exercise: The In-Body Transmission of Performance Knowledge in a Traditional Martial Art." *Asian Theatre Journal* 1 (2): 191–206.

———. 1989. "Three Bodies of Practice in a Traditional South Indian Martial Art." *Social Science and Medicine* 28 (12): 1289–1309.

———. 1994. "Actualizing Power(s) and Crafting a Self in *Kalarippayattu*: A South Indian Martial Art and the Yoga and Ayurvedic Paradigms." *Journal of Asian Martial Arts* 3 (3): 10–45.

———. 1998. *When the Body Becomes All Eyes: Paradigms, Discourses and Practices of Power in a South Indian Martial Art.* New Delhi: Oxford University Press.

———. 1999. *Kathakali Dance-Drama: Where Gods and Demons Come to Play.* London: Routledge.

Electronic Sources

Billington, Michael. 2006. "Indian Summer." *The Guardian*, 31 May. http://arts.guardian.co.uk/features/story/0,,1786492,00.html (accessed 14 November 2007).

Lea, Liz. 2007. "Re: Questions," 13 July, personal email (accessed 14 July 2007).

Muthalaly, Shonali. 2006. "The Making of the Dream." *The Hindu*, 19 April. http://www.thehindu.com/thehindu/mp/2006/04/19/stories/2006041900600100htm (accessed 7 June 2007).

Time Out. 2007. "A Midsummer Night's Dream (Review)." *Time Out*, 11 May. http://www.timeout.com/london/theatre/events/332967/a_midsummer_nights_dream.html (accessed 14 November 2007).

Film

The Myth. 2005. Dir. Stanley Tong. Emperor Pictures.

Other Sources

Trestle Theatre Company. From Bangalore to Britain, international workshop residency participant feedback forms.

8

The Oriental Martial Arts as Hybrid Totems, Together with Orientalized Avatars

Stephen Chan

The absorption of blows is rather easy. It depends more on those delivering the blows than the one receiving them. When I repeated this demonstration ten years later in 1994 at the University of Kent, the students laid in hard with long planks of 6x2 (timber 15 cm wide and 5 cm thick), and got it right. All I had to do was keep a rooted stance, control my breath, and relax my muscles. The point of the demonstration was the lack of tension. The harder the students swung the timber—and they did, revenge for years of hard tuition—the more certain the wood would break across my back. If it broke, it was an elementary law of physics that the shattering wood would absorb most of the impact. This is actually a cheat's demonstration.

Except that it also requires those swinging the timber to connect with the flat width of the plank. In 1984, in Zambia, Raymond came in hard with the edge. And not just the 5-cm-thick edge, but with the very edge where width and thickness met. That hurt, and the skin was cut and bled. It impressed the audience more than anything else. The master bled and did not change his expression! Actually, I was silently thinking of ways to impale Raymond, upward, with what was left of the shattered timber. But this sort of thing, a silly circus trick gone wrong, was the curiously right way to authenticate the oriental master. The oriental became Orientalized. Yes, he really can do some of the things we've seen in the movies.

And not just in Zambia. There, I had performed the flaming tiles demonstration. Now, this is even easier. All you have to do is douse the tiles with gasoline some minutes before they are lit. By the time you come to this part of the demonstration, the gasoline has soaked into the cement. When lit, the flames shoot up dramatically, but there are no flaming droplets of gasoline flying into your face and hair. If you're fast enough to break tiles without fire, you're fast enough to break them with fire. It's just cheating again. But at the University of Kent, Kam failed to douse the tiles in time. I had very long hair then—part of the mystique—and knew there had not been enough time—so I pulled my hair to one side and went through the tiles. But Kam had been assiduous in wanting spectacular flames, and had been liberal with the gasoline. So I came out of the tiles, my hand covered with gasoline and the gasoline covered with flames. I felt like someone out of the *Fantastic Four*! The audience gasped. He's on fire and he walks calmly to take his bow. Actually, it's the gasoline that's on fire, not the hand. Skin takes a while to ignite so, when the gasoline burned away, there would have been little damage. A suddenly apologetic Kam appeared nonetheless with water. And it all simply added to the show—and this is all that authentication in the minds of onlookers often is; and the "authentic" to which they are referred is often no more than what has been said in a badly researched, starry-eyed book, or seen in a hideously bad Hong Kong kung fu movie. If I had wanted to make my living doing this, rather than being an academic, I would have been a millionaire—but I have students around the world, and I have never charged any of them a fee.

This is to introduce the sort of hybrid essay that has marked much of my writing on international relations (e.g., Chan 1985)—the author as participant/observer who expresses his written observation within a scholarly framework. That framework is harder when there is very little writing on African martial arts, which is what this chapter is about, so that the intertextual discursivity of scholarship must yield to greater first-person narrative. I do not apologize for this. It seemed to me that there was a story worth telling here, and there was no other way to tell it. So, since this is a hybrid essay, it had better begin with an account of my own hybridity in the martial arts.

I have taught residentially in New Zealand, Zambia, and the United Kingdom, and have taught on a regular visiting basis in Zimbabwe, South Africa, and Norway; on an irregular but frequent basis in Slovenia, Ireland, Belgium, and Greece; and occasionally much elsewhere. I have

undergone training six times in Okinawa, and also in Tokyo, Hong Kong, Kaohsiung (Taiwan), and Beijing. My father and grandmother, refugees in New Zealand, were martial artists, but I was very determined to pursue my own training and, in any case, from the very beginning, it was clear that my grandmother herself authenticated the arts, not in the warlord era in China in which she had fought, but in the Chinese comics she would show me, and the 1950s Hong Kong films to which she would drag me. There was little by way of production values or skills in those pre–Bruce Lee days and, generally, I hated them. My very first formal karate teacher in New Zealand taught a hybrid Malaysian-Chinese and Japanese art, and he would perform the Maori *haka* (war dance) at the ceremonies that opened the international tournaments in which—in those days without gloves or weight categories—he would compete (and win). But, already, he was carrying five cultures (Japanese, Chinese, Malay, Maori, and white New Zealander) into international arenas where almost everyone else from the polyglot and multicultural South Pacific and Southeast Asia—all with their own "traditional" martial arts histories—mixed and matched, and authenticated themselves in creative and frankly knowing ways.

Much later, when I would visit Okinawa and Japan, I would learn how my teachers there had created themselves and created their styles, authenticating both against a tradition they knew was itself created and still within creation and which, in Okinawa with all its U.S. air bases, had been influenced in turn by the American airmen who had become devotees of the "Okinawan" way. One example is of my own colleague, Ron Nix (fig. 8.1), who has lived in Okinawa twenty years. Originally a U.S. airman, he married locally and has become a 7-dan in karate and almost a local cultural icon by his mastery of Okinawan *taiko* drumming and dance. But Ron's muscular approach to all arts has influenced a new generation of Okinawans. It might not be surprising then to anticipate how, in this chapter, the oriental martial arts have been recreated according to other cultural demands, or under other cultural opportunisms in Africa. Such demands and opportunisms, after all, were at work also in the Far East.

Japan and Okinawa

Previously, I have written about how, particularly in the postwar years, the mainland Japanese martial arts were modernized and "industrialized"—

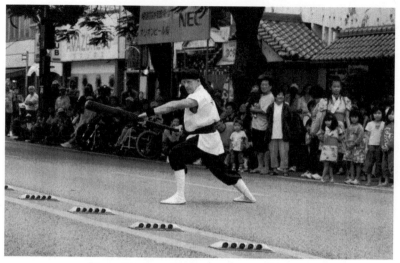

Figure 8.1. Ron Nix performing in Okinawa.

depicted within laws of physics and streamlined for athletic performance (Chan 2000). The Japanese sociologist Hiroshi Yoshioka has recounted how the Japanese reinvented themselves as samurai (Yoshioka 1995), not unlike how cowboys eventually were remodeled on John Wayne and, with lantern jaws, epitomized modern American men. Johann Arnason has extensively argued how the Japanese not only reinvented themselves, but reinvented the West with whom they deal and Western capitalism at which they excel (Arnason 1997). Within this carefully cultivated miscegenation, "traditional" culture, martial or otherwise, is never as it seems.

The case of Okinawa, the islands of southern Japan—once an independent kingdom (or kingdoms)—is less industrialized. It is almost folkloric in its history, but it is complex and mixed. John Sell has written the best of the imperfect books on Okinawan karate history (Sell 2000). They are imperfect because they take at face value the stories of the old masters and do not interrogate the differences between oral and written histories, about which Goody (1987) has famously written; and without interrogating the peculiar genres, aesthetics, biases for audience consumption, and ideologies of oral communication—not to mention its evanescence (Furniss 2004). The Sell book is the best because it depicts the political histories of the Okinawan arts, so that every genealogy is given certain preconditions, and the old masters are rendered neither miraculous inheritors nor magical avatars of a martial Heaven.

It was my fortune a quarter-century ago to fall in with karate teachers who were also self-proclaimed Okinawan nationalists. By an Okinawan nationalism they meant two key things: first, cultural autonomy from Japan, particularly in the martial arts; second, reference to a period of united Okinawan rule in the Sho dynasty. Before then, there had been a minimum of three kingdoms. One, centered at Nakajin castle, seemed to have been established by pirates with cosmopolitan backgrounds and an advanced sense of the rights of women. The second was centered on Nagasuku castle, and the rounded architecture of its walls seemed as much a spiritual expression as something designed for security. The third, which became the triumphant and unifying kingdom, was centered on Shurijo castle. This was completely destroyed in the war and restored painstakingly afterward.

A great many of the *ryu* with whom I trained over the years in Okinawa bore names prefixed with *Sei*, usually translated as "truthful." However, the character used for *Sei* is the same as that used for *Sho*. One day in 1999, walking around Shurijo castle with my most regular teacher, Sensei Shian Toma, a 10-dan black belt master of the *Seidokan*, I remarked upon the great wooden plaque hanging over the throne of King Sho. I mused about the plaque bearing the character *Sei*, but it was one of those moments of slow-motion realization that had formed before the sentence had finished. "Ah, *Sho*," I said. Sensei Toma just smiled, as if to say, "takes a really dumb student this long to figure it out." The inscription read, "In the Middle of the Mountain, (sits) only Sho." It was a plaque of recognition, gifted by the Chinese emperor to the Okinawan king.

This meant, of course, that all those *Sei* prefixes used the character that also represented cultural nationalism. Since I was a student of the *Seidokan*, I was understood (in Okinawa at least) to be an affiliate of this nationalism—a descendant, by adoption, of *Sho*. But, to have my own back on Sensei Toma, being a scholar also allowed me to make the following (silent) observations. The plaque was a gift from the Chinese emperor and hung over the Okinawan throne, so the Okinawan kingdom was a vassal or tributary kingdom. The inscription about "the middle of the mountain" was a play on the somewhat grander name of the Chinese empire—The Middle Kingdom, that is, the Central Kingdom (of the world). Not one mountain, but every mountain. The surrounding motifs were based on Chinese designs, almost deliberately not echoing the Japanese versions—so that Okinawan independence and culture, though with its own nativist impulses and oral claims, was a choice between competing affinities and,

during the Sho dynasty, the choice of affinity was to the Chinese who, in any case, reminded the Okinawans they could demand it anyway. There was a tension between the Chinese and Japanese over Okinawa as a sphere of influence until, one day in the eighteenth century, the Japanese Taira clan just invaded and conquered Okinawa. There they found the martial arts were corruptions and extensions of those in southern China. Even the original name for karate, *To de*, meant "China hand." It was the *To de* or karate arts that the mainland Japanese later recreated, first, to seem more "Japanese" and, second,, to operate in the competing currents and miscegenation of the postwar years. When I arrived in Africa in 1980, I already suspected all of this but, as soon as I began teaching karate, I was regarded as a purist (even if by default of my being oriental), just as Sensei Toma is regarded—and regards himself—as a purist and a pure cultural nationalist. I hasten to add that he is also a martial artist of uncommon power, even among masters, and great qualities of personal humility as well as Okinawan pride. But, provided he is able to be seen as non-Japanese, even he would not wish to be an avatar of something authenticated only in Okinawan autarky.

Zambia

Zambia became independent in 1964, led by Kenneth Kaunda, styled by many of his British Labour Party supporters as a "philosopher-king" (Hatch 1976) because of his espousal of Christianity and a socialism derived from his notion of African communalism—within a philosophy he called "humanism" (Kaunda 1966). He led a vigorous independence campaign (Kaunda 1962) and welded together a nation of about eighty "tribal groups," all with their own languages and customs—until he had incorporated the customs adopted under missionary influence, then colonial rule, and those that were an amalgam from the various "tribal groups," into a conservative cocktail that had no intrinsic logic except to hold the nation together, especially in the face of white settler rebellion to the south in Rhodesia, with huge economic consequences borne stoically by his people (Chan 1992); and this despite an erratic sense of foreign policy (Anglin 1994). I came to Zambia in 1980, months after Rhodesia finally gained majority-ruled independence as Zimbabwe, and stayed more than five years as Kaunda's popularity began to wane; then returned annually as the country moved beyond Kaunda to multiparty democracy and economic liberalization, and these moved quite rapidly

to corruption (which spawned an amazing satirical response beloved by citizens, collected in Clarke 2004), banking failures (Sardanis 2007), and a generalized ineptitude amid almost cynical *savoir faire* and *sangfroid* as the country lurched toward recovery, away again, and now toward again. The country became a victim of mass HIV infection, and a very large number of the karate students I taught have died. Those who lived undertook huge education campaigns against the pandemic, and one produced a book of extremely touching poems about deaths caused by AIDS (Mbazima 1997). In many ways, this mélange of a country is a favorite, but I have never been able to claim to understand it, and I look quizzically at those who say they do. Even though I had taught karate in New Zealand, it was Zambia that made me a karate teacher.

But what I found was a curiously officialized culture—Kaunda's culture—and, within it, all manner of competing survival tactics, even methodologies, but all claiming a Christian and Kaundaesque sanction. Then, because the country was impoverished, both because of the collapse of the international copper market and the cost of resisting Ian Smith's white Rhodesian settlers, the holding of office became a means not to do something, because little could be done, but to maintain a hierarchy and stop others doing things. Status became a valuable commodity within impoverishment, whether it provided financial rewards or not, or whether those financial rewards were modest or not. Zambia was a vast bureaucracy—or, more accurately, a country with two parallel bureaucracies, that of the governmental state and that of the single political party that dominated the state; and both bureaucracies were to do with policing rather than enabling. To appear, unannounced, as a karate teacher and upset the elaborate applecart of an established and modestly qualified national karate association was depicted as a threat not only to the karate status quo but the national status quo. How did this man appear in this country without official papers to teach karate? But, as it happened, I was in the country on diplomatic papers and, by very good fortune, the young Minister of Youth and Sport was a friend, whose birthday celebration I had orchestrated at a conference in Sri Lanka the year before. He ensured there were no national problems but, at the level of the national karate association, because my syllabus deviated from that previously known—it was the hybrid I had picked up in New Zealand and developed further by years of dojo-hopping all over London—it was declared heretical even if there was no choice that I, because of my rank, had somehow to be accommodated within the hierarchy. And being oriental helped—a lot. When, after a period of time, the fruits of my

teaching became clear, people flocked to the amazing oriental teacher at the University of Zambia dojo. But all I was doing was teaching karate as it was taught in London, and a lot of that at the hands of Sensei Enoeda of the Shotokan headquarters, whose staunch "traditionalism" I saw adapt and change as the years went by. I was simply taking a dated Zambian karate fifteen years into its future—by forced march because the future had arrived elsewhere. And, because I could then perform all the elaborate kung fu movie kicks—and no one else in Zambia could, by simple virtue of never having been taught how—the legend grew out of all proportion to my actual ability.

But it had been somewhat naïve on my part and it was certainly not planned. I was a teacher, with a hybrid background, of a hybrid art, landing square in the middle of a deliberately hybridized (eighty "tribal groups" forced through several condensed epochs leading to a form of modernity), ideologized (national unity under humanism), and officialized (twice over in parallel bureaucracies) nation in which all things were declared possible but all things were prevented by painstaking checks and procedures from becoming possible.

The University of Zambia

In 1980, the jewel of Zambia was its national university. Its landscaping was so attractive—lakes, lawns, and endless sprawling bougainvillea bushes—and its architecture so obviously cloned from Frank Lloyd Wright, though cloaked in ivy as if it had stood as a totem of modernity for a hundred Oxonian years, that wedding parties would come to the campus for their photos of a lifetime. The academic standard was high: all the professors and lecturers had been recently garlanded with American and British PhDs and the students were anxious to learn.

My office was adjacent to the campus, on the other side of a lake left as a nature reserve and where beautiful red Bishop birds would play in the reeds. One evening, shortly after my arrival in Zambia, I decided to take a walk across the campus. The sun was setting as I penetrated the campus further than before. I came to a huge windowless building, clearly a sports hall, and I was about to turn away since there was nothing beyond—when I heard the sound of *kiai*, the karate shout, coming from the hall. I went inside and there were some thirty variously kitted-out *karateka* going through a rough and antique version of *Shotokan* karate. I waited till the end, then asked them who their teacher was—but they

had no black belt teacher; they were a cooperative who taught themselves, with a single brown belt as group leader. "Would you like me to teach you?" This was a spontaneous and fateful question—and it all began from there, my nights being captured for years to come. And I did not endear myself to the local "purists" from the start, turning up in the Americanized satin *gi* (training uniform) and teaching Korean as well as Chinese movie kicks to which I hastily appended improvised Japanese names (which were later endorsed by Japanese friends—*katao geri* for axe kick and *sharin geri* for wheel kick, neither of which had been seen in the country before).

Of those who did not quit karate as adult careers and families asserted themselves, who did not become the casualties of HIV and violent crime, or who as soldiers were not incapacitated or killed on the famously underequipped Zambian peacekeeping missions, a solid handful are still active in karate more than a quarter-century later. The highest graded, Raymond Mbazima (figs. 8.2 and 8.3), who achieved 7

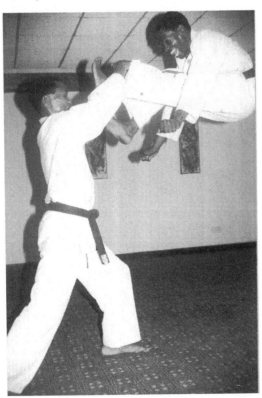

Figure 8.2. Raymond Mbazima performing a double-flying-front kick.

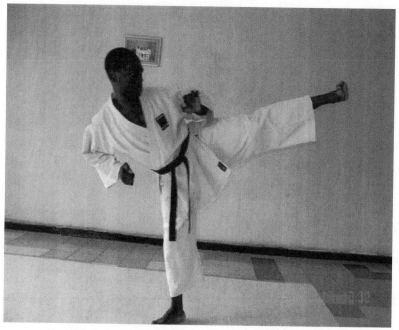

Figure 8.3. Raymond Mbazima performing a side-thrust kick.

dan at an international examination in Europe, was a callow devotee of the worst kung fu movies back in the early days—arriving for training notoriously, and inaccurately, swinging his *nunchaku*, the rice flails made infamous by Bruce Lee.

To where did all this eventually lead?

Other Southern African Countries

Three years later at the University of Zambia dojo, the floor nightly attended by more than one hundred students and with a "staff" of new black belts in attendance (the colored belts of that first night's accidental discovery), three Zimbabwean diplomats wearing black belts appeared for training. Their belts had been obtained in the United States, and it didn't take many physical moments to convince them that, as with many American belts then and even now, their qualifications had been inflated—probably by means of expensive commercial fees. Two never

came back, but one did and eventually requalified and, at the end of his diplomatic posting, returned home to Zimbabwe and, in the ethos then of the University of Zambia dojo, established not-for-profit outreach dojos in the poor townships of Harare. By this time I had returned to Britain, but would visit annually, usually being able to marry these visits with my research commitments, but sometimes doing it "cold."

The standard in Zimbabwe became higher than that in Zambia—which was high enough, given the athleticism and elevated pain barriers of so many of the students—together with photographic memories of the *kata*, the classical patterns, or choreography, by which the old and illiterate masters had handed down their teachings. But it was more than perfect mimesis. Whenever one of my African students is able to come to an international clinic, others are amazed by the prodigious command of every detail of the *kata* and the understanding of combat—based on having to do combat. Even the university students had often grown up in rough locations; many had served in the army or paramilitary, and even the very few women students in a largely male chauvinist society had completed military training. They understood immediately the combat applications and interpretations of *kata*. They understood also the Confucian sense of oriental manners and deference—but, of that, more later.

But to be a black belt in Zimbabwe was a triumph—if the holder was also black. Years of protracted white-minority rule (Horne 2001) had also meant a consignment of black *karateka* to substandard and largely segregated dojos. After majority-rule independence, the majority of the black belts were white and no one was teaching the African students to that standard. Certainly no one was teaching in the poor townships—where crime was meant to have its breeding place and unemployment certainly was rampant. Why empower the downtrodden and the criminals?

It was precisely to empower them—to employ the old "boxer rising from the ghetto" mantra—that this project was undertaken. Moreover, because of kung fu films, many self-declared township "masters" were operating often quite good dojos, if always with fanciful tuition, and a more "authentic" martial arts, even if in relative terms, required to be made available. By this time in any case, my own approach had veered back from satin Americanisms to a "pure-line" Okinawan form of teaching—albeit, as my teachers to this day complain, with Chinese flourishes unconsciously decorating the edges. The result, in a very few years, was that the ghetto boys (no girls—Zimbabwe seemed even more male chauvinist than Zambia) swept the national championships and eclipsed the largely

white clubs. The pleasure in the residual segregation that was karate was that no one knew from where and how they had suddenly sprung.

When, in 1992, I assumed a visiting appointment at what was then still called the University of Natal—Nelson Mandela having been released, but the apartheid minority government still in power pending the 1994 elections—I also discovered the university karate club, or rather clubs, one *Shotokan* and white and one *Kokyushinkai* and black. This reflected the historical sociology of South African karate. A singular white Cape Town *Kokyushinkai sensei* had opened his dojo to black students, but other *sensei* had not drawn back their doors with such a welcome. So I taught the black club—with misgivings, since the *Kokyushinkai* was notorious even in Japan for its rough-hewn ways; but I had stayed, in Tokyo, at the house of a friend of the style's founder, and I knew he would laugh at my hesitation. So I taught, but, being Oriental, I was the authentic bridge between the two segregated groups. By the time I left, the two clubs were preparing for their first *brai*, or barbeque, together. It was a curious progress, though wry to me. For years, as well-meaning but conservative white burghers began the slow project of integration, tentatively and with hesitation, they would invite their new, middle-class, black neighbors to backyard *brai*. This was both to make the effort at sociability and to postpone the final step of inviting them into their homes.

How Democracy and Neoliberalism Crowd Out the Idyll of the Avatar

When, in 1991, Kaunda fell in multiparty elections, the "democratic" era that was ushered in became, after the halcyon first hundred days of genuine idealism in government, a lust for leverage and access to wealth—led first by ministers, suddenly avaricious as they discerned how easy corruption could be, and then by a huge section of society as neoliberal economic reforms bit hard into already Spartan existences—turned the primitive social democracy of Kaunda into a relic of the toothless past.

Now, status and position, even in small institutions and organizations, meant not just petty status and petty control, but petty cash and plug-ins to cascading networks of government apparatus and the "civil society" of spawning NGOs. To be chairman of what was now the Zambia Karate Federation meant being chairman of a personal survival and enhancement mechanism—and the policing and control of others now meant a prevention of access or succession to this enhancement.

Similarly, in Zimbabwe, as the idealism of the early Mugabe years also broached into (at first minor) corruption and a growing determination never to cede political power, it coincided with government strictures brought about by IMF-style economic structural adjustment, and civil servants and diplomats could lose their jobs (Chan 2003). The now-former diplomat who had led the karate project in the townships turned to karate for his living. And this became a reversal of all that had been first intended. Now, his students and staff of black belt teachers facilitated *him*, when his original mission as a *sensei* had been to facilitate *them*. For this to continue, it became important that no one could challenge him in status, and those who might or could had to have their black belt gradings slowed down.

By this time, I was living in England, visiting annually but unable to monitor closely these changes in both countries. And I was heavily engaged in my "day job" as an academic and, in any case, having preached for years against neocolonialism, had grave doubts about even trying to impose centralized edicts from Canterbury, London, or Nottingham, or wherever my gypsy career took me. But something had to be done.

The slowly dawning shock was that I could no longer trade on my oriental appearance and demand oriental-style deference. In the constantly manipulated cultural changes that accompany development and uncertainty, "tradition" is used to justify exigent behavior. So it was that, in both countries, but particularly in Zimbabwe, senior *sensei* would declare themselves as operating within an "African tradition," that paralleled but, in an independent country, took precedence over "oriental tradition," and that the deference of all members of the dojo was owed not to the visiting senior instructor, but to the national head who in turn authenticated the students both as *karateka* (with gradings) and as good cultural citizens of Africa. It was a very neat trick because it was easy to affirm the symmetry of oriental and African deference, so nothing was being discarded, simply "nationalized," and then to assert ownership of African behavior since all concerned were African. I and my Orientalism were reduced finally to the substance of celluloid and video. What was given precedence was some hybrid of oriental appearance (vocabulary, costume, rituals) and African autonomy within African "customary" hierarchies—none of this was ever any more than fluidly customary (Iliffe 1987, 2005). The amalgam was held up as a totem that should not be defiled.

Added to this was the increasingly politicized and financially driven award of grades and belts. This interesting proposal had to do with value and choice. Driven to choose between obtaining money for subsistence

on the one hand, or merely receiving a token of esteem from members of an impoverished community on the other, extremely poor youngsters tended to choose the token of esteem. As times became harder and harder, this choice became more and more exploitative. I decided, finally, to break up the empire I had started, and I started over with those who wanted to come with me. In any case, the time had come, internationally, to impose and sustain a more uniform syllabus and higher overall standards—standards as well concerning ethics, even for dojos that chose to operate commercially. With great angst, the Zimbabwean project split in two. The Zambian project is much larger and more fraught, but it is staying together because many divisive chiefs cancel one another out; problematic teachers are currently being weeded out through internationalization of standards. There is nothing oriental any more. In this way karate, in my African experience, reflects the tensions and struggles within the globalization process—with its too-evident fault lines, benefits, losses, ironies, and contradictions. Whether Orientalized or internationalized, it is a form of paternalized control.

But at least I have given up my silly public demonstrations about the seeming oriental "magic" of the martial arts: no more fireworks, no more shattered lumber, no more invulnerable body.

One Grace Note and One Less Graceful Note

At the end of 2007 I received news that the Zimbabwean teacher who had begun so well, carrying forward the Zambian ideals of community service, but who had become an autarkic entrepreneur of karate, had died. It was not from HIV but from a scorpion bite, which, all the same, was not properly treated in the degenerated public hospitals of Robert Mugabe's Zimbabwe. Both those students who had stayed with him and those who came with me made the required displays of mourning. This much is both African and oriental. There was, at the request of his family, a karate demonstration at the funeral in his home village. For a brief moment there was miscegenation between two cultures. Behind the scenes overtures began as to whether and how the two groups could once again come together. But the black belts who had followed the deceased teacher had fallen behind in terms of syllabus and gradings. Their former colleagues had advanced beyond them. As once in Zambia, the hoarding of status in a society that had melted down became valuable

in itself. Better perhaps to remain independent of internationalism and its standards, and remain senior figures in their own grouping. From early Zambia to late Zimbabwe a circle had been spun, but much of this is also a reflection of the larger and stubbornly determined political isolations of the Zimbabwean regime. The world, never mind the Orient, can be left outside the borders of Africa.

By contrast, there is a very real—if not successful—effort on the part of many African countries to address the problems of other African countries; to look beyond borders and accept at least continental responsibilities. The African peacekeeping effort in Darfur is a case in point. There, hopelessly underequipped, out-gunned by rebel groups and Janjaweed militia alike, spread too thinly and in vulnerable positions, African soldiers are hunkering down to do what they can. Among them are Zambian peacekeepers, and among them my karate students. What they have learned from the martial arts about patience, fortitude, and mission is what has helped sustain them in their difficulties. Their letters and photos to me restore faith in the human project, no matter what its cultural origin.

The Avatar Looks East and Turns West

Increasingly I am traveling in the Far East and go out of my way on those travels to find teachers and take lessons. It doesn't matter what style they come from. There is always something to learn. But the style I teach remains firmly Okinawan. How I think as I dojo-hop, sample, make fusions in my head, is my own business of hybridity. How I now try to organize the various international groups I teach is straight out of management manuals published in the West. It's still more organic than most, there is much local autonomy, but there is much stricter quality control—and it takes an inordinate amount of time.

As the pandemic of HIV/AIDS ravages the martial arts community as much as any other African community, an increasing devotion to charitable projects has become part of the entire effort. Some of the very finest young masters, champions, and decent human beings have died. The bodies that looked so athletic in their prime, became first corroded from within and, in the sometimes breathlessly short endgames before death, can look so emaciated and uncontrollable that it is as if the death rattle were taking days rather than a final few seconds. When all that

is left of the body starts shaking incessantly, you can count down the time left with hideous precision. Iliffe has written about how hybridized contemporary African cultures still reserve a place for a peculiar dignity that drives individuality and inviolability to contest the Western protocols required for the administration of antiretrovirals (2006). It is not "denial" or perversity that prevents so many from enrolling on the ARV programs. It is the confessional nature of the enrollment, detailing sexual behavior and partners. The "silent unto death" determination that has marked out so much everyday dignity amid poverty, that has demarcated martial arts champions who triumphed without fuss against all odds, has also cut a swath through everything I have tried to do in Africa. It is a morbid nexus for a book about "embodied knowledge." And it is the final antiromanticism of the martial arts in practice. Finally, no Orientalism, no hybrid, no totem does anything but mourn.

Conclusion

Even the B and C movie circuit has waned in Africa. The carefully crafted artificiality of "art kung fu" movies such as *Crouching Tiger, Hidden Dragon* has meant a widespread knowledge of the cinematic techniques that render what was once "authentic" merely beautiful. And the Chinese have come to Africa in more visible and controversial ways—as high street merchants, undercutting local vendors with Chinese-made goods and often displaying crude forms of racism (Chan 2006), and amid huge international rumblings—so that there is no more premium value in being Chinese. Once, simply for the sake of "dares," I would walk in the most violent and crime-ridden of African streets to prove that no one would attack someone who looked like an escapee from a kung fu movie. I'm not sure I would have that invulnerability today. Internationalization has meant an end to naivete, a looking to one's own resources—even if dishonestly and exploitatively—and a looking to one's own sense of self-identification, both for the sake of identity in itself, and for the sake of mobilizing others around a national totem. The Orientalized avatar of the arts can no longer master and command the hybridity that must go into nations that have grown up—often tumultuously. The Orientalized avatar can still seek to impose a quality control to international standards but, finally, the memory of him as oriental means nothing anymore.

References

Anglin, Douglas. 1994. *Zambian Crisis Behaviour: Confronting Rhodesia's Unilateral Declaration of Independence*. Montreal and Kingston: McGill-Queen's University Press.

Arnason, Johann. 1997. *Social Theory and Japanese Experience: The Dual Civilization*. London: Kegan Paul.

Chan, Stephen. 1985. *The Commonwealth Observer Group in Zimbabwe: A Personal Memoir*. Gweru, Zimbabwe: Mambo Press.

———. 1992. *Kaunda and Southern Africa: Image and Reality in Foreign Policy*. London: I.B. Tauris.

———. 2000. "The Construction and Export of Culture as Artefact: The Case of Japanese Martial Arts." *Body and Society* 6 (1): 69–74.

———. 2003. *Robert Mugabe: A Life of Power and Violence*. Ann Arbor: University of Michigan Press.

———. 2006. "Scramble for China," *Prospect* (September): 16.

Clarke, Roy. 2004. *The Worst of Kalaki*. Lusaka, Zambia: Bookworld.

Furniss, Graham. 2004. *Orality: The Power of the Spoken Word*. Basingstoke: Palgrave Macmillan.

Goody, Jack. 1987. *The Interface Between the Written and the Oral*. Cambridge: Cambridge University Press.

Hatch, John. 1976. *Two African Statesmen*. London: Secker and Warburg.

Horne, Gerald. 2001. *From the Barrel of a Gun: The United States and the War against Zimbabwe, 1965–1980*. Chapel Hill: University of North Carolina Press. Iliffe, John. 1987. *The African Poor: A History*. Cambridge: Cambridge University Press.

———. 2005. *Honour in African History*. Cambridge: Cambridge University Press.

———. 2006. *The African AIDS Epidemic: A History*. Oxford: James Currey.

Kaunda, Kenneth. 1962. *Zambia Shall Be Free*. London: Heinemann.

———. 1966. *A Humanist in Africa: Letters to Colin Morris*. London: Longman.

Mbazima, Raymond. 1997. *Tears Too Soon: Inspirational Poems on AIDS*. Ndola, Zambia: Mission Press.

Sardanis, Andrew. 2007. *A Venture in Africa: The Challenges of African Business*. London: I.B. Tauris.

Sell, John. 2000. *Unante: The Secrets of Karate*. Hollywood: W. M. Hawley.

Yoshioka, Hiroshi 1995. "Samurai and Self-Colonization in Japan." Pp. 99–112 in Jan Nederveen Pieterse and Bhiku Parekh, eds., *The Decolonization of Imagination*. London: Zed.

9

Coffee-Shop Gods

Chinese Martial Arts of the Singapore Diaspora

D. S. Farrer

This chapter outlines the embodied practice of Chinese martial arts, with special reference to kung fu in Singapore.[1] Overseas Chinese martial arts exist as a vast reservoir of Chinese cultural capital, and some kung fu masters (*sifu*) remember over a hundred long sets of movements.[2] Consequently a particular question that has underpinned my research is how do the kung fu masters remember so many routines?[3] Such feats of social memory are not merely technical questions of interest only to practitioners, but raise issues concerning what special or unique cognitive/bodily powers may be attained through the study of kung fu, and broach questions concerning how such powers are attained, maintained, transmitted, or withheld. By "coffee-shop gods" I do not literally mean any "supernatural" powers attainable through the practice of kung fu, but refer here to the acquisition of embodied skills and cognitive abilities. Specifically, the question of memory and ability in Chinese martial arts is intertwined in the pedagogy, performance, and practice of kung fu. I learned that remembering the routines is intrinsic to the embodiment of particular experiences resulting in enhanced performative ability while studying kung fu systems originally derived from the Chin Woo Athletic Association and Choi Lai Fut in Singapore.[4]

Whereas informants consider performative abilities generated or demonstrated through the practice or performance of kung fu and lion dance to be profane pursuits rather than demonstrating tangible linkages

to the gods, such practices and performances are nonetheless enmeshed within a rich cultural milieu suffused with religious idols, sacred symbols, and ritual activity.[5] I found a key to understanding this complex tapestry was to practice kung fu myself and then sit and listen to the masters and their students as they talked in the coffee shop, where the simple activities of sitting, eating, drinking, and storytelling would reveal the social bonds, group practices, inherited stories, and the social, political, and religious beliefs of participants who are joined together as fictive kin.[6]

Many social theories have linked social and individual experience to the body, for example, character armor (Gell 1993; Reich [1945] 1990), embodiment (Csordas 1999, 2001, 2002), *hexis* (Bourdieu 1977: 87; 2002: 209; Jenkins 1991: 75), natural symbols (Douglas 1970), performance (Turner 1988; Schechner 1988, 1994), play (Caillois [1961] 2001; Huizinga 1950; Turner 1982), practical reason (Bourdieu 1998; Mauss 1979: 101), sensuous scholarship (Stoller 1997), somaesthetics (Shusterman 1997, 1999, 2000) and *technique du corps* (Mauss 1979: 107).[7] Nevertheless, building on Connerton's (1989) groundbreaking work, it may still be asserted with Kleinman and Kleinman (1994) that "the study of the processes that transform the bodily forms of social experience has yet to commence" (1994: 711).[8] We need to ask what are the actual processes involved in embodiment, where memories and the act of remembering link social tradition to individual, embodied experience, "because few social theorists have bothered to explore the methods of remembering that underwrite the incorporation of the social body into the physical body, the theoretical cartography that maps the processes that mediate (and transform) the nexus between the collective and the individual is underdeveloped to an alarming degree. The map is almost empty" (Kleinman and Kleinman 1994: 708). Although the "social body" is merely a figure of speech, I accept Kleinman and Kleinman's (1994) point that the processes of embodied memory have been neglected, and will demonstrate how martial arts enable, externalize, construct, and manifest social being through the individual body of the practitioner.

To begin to fill in the contours of their "theoretical cartography," Kleinman and Kleinman (1994) develop the notion of *sociosomatics*, through which they locate "domination and resistance" to the "deep memories" of terror and trauma suffered as a consequence of the Cultural Revolution (1966–1976) in China. Working from trauma-induced bodily symptoms including dizziness, vertigo, exhaustion, fatigue, and devitalization, and general bodily pain, such as backaches, cramps, and

headaches, Kleinman and Kleinman specify that "bodies transformed by political process not only *represent* those processes, they *experience* them as the lived memory of transformed worlds. . . . sedimented in gait, posture [and] movement" (1994: 715–717; Scott 1990). The extension beyond "representation" is crucial, otherwise, from the aforementioned formula it could appear that sociosomatics is merely a reformulation of Reich's ([1945] 1990) "character armor," where for Reich the stresses and strains of unconscious life (derived primarily from not copulating frequently or freely enough) are manifested in bearing, poise, and gait. But, applying Occam's razor, Kleinman and Kleinman (1994) note that useful explanations for nervous symptoms are to be found outside of the unconscious and in the realm of social and individual experience.

Thomas Ots (1994) shows how Chinese people alleviated accumulated stress and anxiety resulting in adverse bodily symptoms arising from the Chinese Cultural Revolution by using breathing exercises long associated with Chinese martial arts. Ots published a chapter in *Embodiment and Experience* concerning the embodied symptoms of stress caused by the Chinese Cultural Revolution, that are worked out through the spontaneous bodily movements demonstrated by members of the banned Falun Gong Association.[9] Ots argues that the *"qigong* craze" in China concerns people expressing and releasing their pent-up emotions in a highly structured social environment. People used *qigong* (exercises focusing on breathing) to release emotions, to deal with traumatic experiences from the Cultural Revolution, and that "[i]t is against this background of restoration of communist rule and failed hopes for major political change that the *qigong* movement came into existence in 1979/1980." For Ots *qigong* in China, seen here as spontaneous bodily movements rather than the prescribed patterns of martial *qigong*, served as an alternative means of self-expression at a time when "it was virtually impossible to voice one's political ideas" (1994: 130). Ots (1994: 132) argues that the lessening of the control of mind over the body, allowing the body to do its own thing, is a new form of *communitas*, and is associated with mystical power and magical experience (Turner 1969: 113; 1982: 45, 48). Ots is clearly working in the same paradigm as Kleinman and Kleinman, with a similar notion of deep traumatic memories that manifest themselves through nervous symptoms expressed and purged through the deep-breathing methods and vibrating limbs of spontaneous *qigong*.

The present study of Chinese martial arts in Singapore endeavors to add to the contours of the Kleinmans' "theoretical cartography" through

an inquiry into the realm of individual experience via the life histories and personal narratives of Singaporean Chinese kung fu masters and their followers (Langness 1965; Waterson 2007). Building upon Kleinman and Kleinman (1994) and Ots (1994), the practice of kung fu may to some extent be considered as a strategy of resistance employed to counter the negative effects of the socioeconomic order upon the human body. Indeed kung fu may help people to address the problem of ageing, as correct practice should help to ensure high levels of physical fitness where prevention of disease is considered as better than cure. Specifically, in modern Singaporean society, which demonstrates a pronounced degree of social engineering, the practice of kung fu and other martial arts may be considered to stave off the processes of bodily emasculation resulting from too much time spent at work.

Kleinman and Kleinman (1994: 717) report that ruinous experience ruins lives. By extension, injurious experiences result for the great mass of people from the daily grind for survival. Modern psychotherapy exists on the premises that ruinous experience will not necessarily ruin lives if individuals undergo a course of treatment. Similarly, in modern Singapore some informants regard the practice of kung fu as a form of embodied therapy wherein people, through their lives, tend to their bodies with specialist exercises to counter the repetitive strain injuries of work, and of old age, both of which insidiously destroy the youthful body.

If Falun Gong is a response to specific acute trauma in China, in modern Singapore, kung fu, especially the "soft" or "internal" styles such as T'ai Chi Ch'uan (taijiquan), baguazhang, and even the predominantly "external" Chin Woo, with "[i]ts formula of enlightened martial arts and clean modern living" are understood as an antidote to general chronic trauma (Morris 2000: 53).[10] Compared to the spontaneous bodily movements of Falun Gong, the prescribed patterns followed in kung fu may have existed for hundreds of years; such forms of practice are long tried and tested, unlike random or spontaneous movements that may eventually damage the body rather than heal it. However, it should be remembered that the primary reason for the development and maintenance of kung fu styles was for the purposes of battle and fighting. Some styles of kung fu may take the idea of fighting to extremes. In a book about the Shaolin Monastery, shown to me by my teacher Chow laoshi one day in the coffee shop, the "fighting monk" Shi Yanwu is pictured performing iron-crotch exercise (tiedanggong), which is "compulsory in the training for free-sparring" where he "heft[s] a 25-odd-kg stone block attached to his

testes with [a] rope" (Yan 1995: 60–61). In another picture the same man is seen pulling a 250 kg roller along with his testes (Yan 1995: 60–61). Fortunately, I was not expected to learn this exercise. These examples indicate that there is no necessary correlation between kung fu and good health; nevertheless many elderly kung fu masters attribute their enhanced levels of energy, vitality, and fitness to a lifetime of kung fu practice.

Whereas the practice of kung fu may help the aged maintain supple, flexible, and youthful-looking bodies, it does not follow that the practitioners will invariably age gracefully or build beautiful bodies in "the national interest" (Brownell 1995). For some, the healing properties of kung fu may extend the ability of older people to long continue with vices such as "womanizing" or the consumption of copious amounts of alcohol. For example, a famous ninety-year-old Hong Kong master who died recently had five girlfriends simultaneously; one was in her mid-thirties. Of course this sort of example serves as proof *to the practitioners* of the efficacy of kung fu in maintaining virility well into old age. Here I must shift from theoretical material to a brief consideration of method, prior to detailed discussion of the embodied social memory incorporated in kung fu that is disseminated as much within the coffee shop as within the training ground.

A Performance Ethnography of Kung Fu in Singapore

The anthropology of experience encourages anthropologists to become more open about their personal fieldwork experiences and not relegate their private lives solely to diaries (Turner 1985; E. Turner et al. 1992; Turner and Bruner 1986). The experiential approach demands a reflexive and occasionally autobiographical style. This chapter results from a performance ethnography of kung fu that took place predominantly over two-and-a-half years from 2005 to 2007, conducted primarily in Singapore, but also in Hong Kong, Malaysia, Thailand, and China.[11] Martial arts performance ethnography involves the researcher actively joining in and learning martial arts.[12] In my case this was the only way to become a full participant in the group's activities. Using the method of "snowball sampling," I gathered a set of informants from Chin Woo, who also encouraged me to participate in classes for Choi Lai Fut, *baguazhang* (Eight Trigram Palm), and *xingyiquan* (Form and Intent Boxing) and to attend many kung fu dinners, functions, and performances.[13]

My informants' conversations rapidly alternated between different Chinese "dialects" in a dazzling display of insight and humor. Such linguistic virtuosity reflects the Hokkien, Teochew, Cantonese, Hakka, Hainanese, Mandarin, and Peranakan composition of the Chinese ethnic component of Singapore, where, according to government statistics, the Chinese comprise 78 percent of the Singaporean population.[14] By focusing on kung fu in Singapore it may appear that I examine the margin rather than the center; the center of the kung fu world supposedly being somewhere in China. However, it is common knowledge that kung fu was crushed in China during the Cultural Revolution, and Western martial arts experts have long recommended looking outside of China toward Taiwan or Hong Kong to find "traditional" or "real" kung fu (Smith [1974] 1990: xi). Once the Cultural Revolution had all but eliminated kung fu in China, it was resurrected as *wushu*, a practice that informants regard as an ersatz reinvention of kung fu, liberally seasoned with ballet (a favorite of Chairman Mao's wife) and stripped of agonistic functions.[15] In 2007 I visited Guangzhou, China, and asked a local Chin Woo representative what they practiced. His answer was "freestyle boxing," to which I questioned if they also practiced the ten basic sets of Chin Woo, including *jie quan* (Intercepting Fist).[16] The Chin Woo representative looked confused. "They have lost everything," a Singaporean rapped. "Here *jie qian* just means borrow money" (substituting *quan* for *qian*, "borrow money," which sounds reasonably similar). However, during less cynical moments, Singaporeans do recognize that genuine kung fu skills still exist in China, albeit densely buried under a mountain of national and now increasingly commercial reinvention.

The Singapore Context

The Republic of Singapore is a mighty economic mini-metropolis, an island nation of 4.5 million people controlled by a regime that has remained in power since Singapore was ejected from the Malayan Federation in 1965. During this time Singapore has changed from a set of *kampungs* (villages) to a nation-state where more than half of the island is covered in concrete, and where for Chua (1994), the *kampung* exists now solely as a form of nostalgia.

The continuously changing Singaporean architectural, social, and economic environment may be a cause of anxiety to Singaporeans who witness the sites of their cherished memories permanently erased, but

whether or not this process undermines their sense of identity remains open to question. Here, despite muted public protest, many aesthetic, historical, and much-loved architectural structures have been effaced for the sake of state planned economic expediency or have been gutted, leaving facades meant to create flattering images of ethnic identity or economically productive tourist areas such as "Chinatown," "Little India," and the "Malay Village." Singapore is a city of permanent amelioration, a cityscape undergoing continuous reinvention where the old is effaced in continuous social reconstruction via political fiat. Yet, to paraphrase Igarashi, the memories of loss and colonialism remain to haunt the metropolis (2000: 114). Accordingly, when memories can no longer be attached to place, then other types of "landmarks" such as rites of passage, rituals, and performances become more pronounced (Halbwachs 1992: 222).

Andrew Morris (2004; 2000: 52), a historian of Chinese sport, has argued that *wushu* provides a platform through which to inculcate a sense of "Greater China" (Chinese identity beyond the Republic) among overseas Chinese people long cut off from the mainland. Integral to his account is the rapid development of "The Pure Martial Arts Association" (Chin Woo) from the 1920s, which today is more prevalent in Southeast Asia than in China. Morris notes that Chin Woo created cultural and trade bridges between the overseas Chinese population and China, and served as a vehicle of Chinese nationalism to foster a sense of modern "pure" Chinese identity among the overseas Chinese. Morris (2000: 48 n1) approaches Chin Woo (*jingwu*) primarily from the viewpoint of China (hence his adoption of the term *Huaqiao* for overseas Chinese, a term only used by mainland Chinese to refer to the overseas Chinese, and not by the overseas Chinese in self-reference), whereas my purpose is to broach Chinese martial arts and social memory from the Singaporean context. In contemporary Singapore, kung fu functions as a vehicle of Chinese cultural pride beyond the nation of China, and acts as a memory bank, preserving the soul of routines they claim no longer exist in China. In my view, the commonly touted local idea that the overseas Chinese anxiously regard themselves as lacking in some essential ethnic attributes of Chinese identity is a red herring. Quite the contrary; kung fu masters believe they embody the soul of a greater Chinese identity through their preservation of authentic kung fu sets long since forgotten in China. Hence Singaporean masters refer to themselves as "The Dagger Society" a label that refers to their use of swords, and harks back to a classical Chinese martial arts song.[17]

The Dagger Society

Training in Chin Woo kung fu in Singapore takes place once a week in a basketball court or in a circular concrete parade ground in a park on Sunday mornings from 7:00 a.m. to 9:00 a.m. Lessons are free; no payment is required or accepted, although students contribute S$20 to the club kitty annually. Chow *sifu*, respectfully referred to as *laoshi* (teacher), aged seventy, is the oldest and most experienced instructor. He travels frequently to teach kung fu overseas. Aged sixty-four, Ng *sifu*, is referred to as *sifu*. He is a diligent practitioner and the keystone of the group due to his unfailing presence. Mr. Tan, *shizhang* (teacher), the third instructor, has followed Ng *sifu* for forty years, and at fifty-three remains remarkably lean and fit. A coffee-shop supervisor, Mr. Tan's severe countenance inversely reflects Ng *sifu*'s playful *joie de vivre*. The masters have trained together since they were teenagers learning kung fu in Kampung Glam, formerly a village in Singapore. They say it takes ten years of hard training to become a *sifu* in Chin Woo.

To collect the complete life history of any individual is impossible. At best the anthropologist can string together a set of fragments into a narrative that is coherent and acceptable to the informants. Here I can only offer glimpses of the lives of Singaporean Chinese kung fu practitioners, filtered through my narrative that should suffice to demonstrate the way the fabric of their lives are imbricated with kung fu. Chow *laoshi* and Ng *sifu* are both self-contained and modest men, and it proved difficult to derive anything as systematic as a curriculum vitae. With occasional exceptions the other Singaporean practitioners were equally cagey. The word "cagey" comes close, but does not quite render the sense of a private home space the Chinese in Singapore enjoy. Sustained long-term access to Chinese Singaporean familial day-to-day home living is out of the question unless one is born into a Chinese Singaporean family, or one marries into one and lives with the in-laws. Chinese Singaporeans generally do not entertain visitors at home, but more frequently entertain their friends, guests, and business associates outside at the restaurant or coffee shop.

Chow *laoshi* was a young boy during World War II and survived the Japanese invasion and occupation of Singapore. His mother died when he was five years of age and his father died when he was ten, leaving him to be brought up by an aunt. During his childhood the war prevented him from gaining much formal schooling, so he put himself through night

school as a young adult, learning first to read and write Chinese, then English, followed by Japanese. After night school he would attend Chin Woo practice, five nights a week. Months of daily practice were punctuated by occasional stage performances for the martial arts community. Chow *laoshi* and Ng *sifu* specialized in performing the two-person fighting set Spear vs. Three-Section Staff, which they still perform together on special occasions (fig. 9.1). Chow *laoshi*'s first job was at a dry cleaner pressing the jackets of British soldiers serving the postwar colonial regime. Chow *laoshi* related that the jackets could not come out looking shiny, or else the cleaners would have to pay for a new jacket, which was very expensive. Mastering kung fu provided Chow *laoshi* a way to manage his definition of self beyond his demeaning work situation. His dry cleaning apprenticeship lasted three years and then he worked for another four as a master of the dry cleaning trade, understudied by his own apprentices.

During this time he married, and after the dry cleaning job became a bus driver for a Japanese tour company. In the 1980s Chow *laoshi* worked for over twenty years as a tour guide for Japanese tourists visiting Singapore and Southeast Asia. The reader will note that this timeline leaves over thirty years unaccounted for. There is no point to press *laoshi* further; it's his right to keep the details of his life to himself. As Igarashi

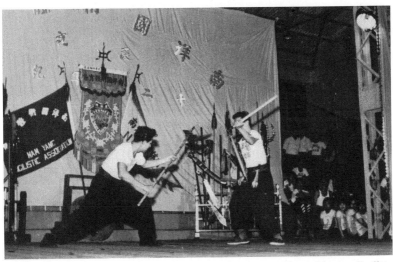

Figure 9.1. Chow *laoshi* and Ng *sifu* perform Spear vs. Three-Section Staff in the late 1950s.

consoles, "the reassembled fragments of the past inevitably reveal cracks and missing pieces; and the cracks and missing pieces are central to understandings of the past" (2000: 6).

Chow *laoshi* specializes in teaching weapons and sets from Shaolin kung fu, and is also active as a lion dance instructor. When he was a young man Chow *laoshi* was compact and wiry; now that he is old he has become rather stout, yet for his age and size he is surprisingly fast and nimble, especially with a broadsword in hand. Among the students he is nicknamed "The Walking Library" because of his repertoire of kung fu forms spanning the entire spectrum of Northern Chinese kung fu and lion dance. In this way Chow *laoshi* has compensated admirably for his lack of early formal education.

Among the wider community Chow *laoshi* is known for his polite geniality, as someone who is never vulgar or raises his voice. "He is a real gentleman," an elder woman from another kung fu school once told me. Chow *laoshi* does not openly criticize others. He teaches a notion of *tse chang* (habitual), meaning "some things cannot be changed." Such things include body postures where the mind says do something, but the body does not want to follow. This is especially noticeable when a student is shown a move and tries to execute it only to freeze and become immobile, or when a student has ingrained habits incorporated from another martial art that may suddenly appear in the place of the moves taught. "This happens to some people some of the time," says Chow *laoshi*, but not all people suffer from this "blockage" (my term, which he agreed was appropriate). This philosophy emerges from the practice of kung fu, and it affords the teachers an air of quiet resignation, despite their determination, patience, and perseverance to impart their teachings. When teaching the forms, Chow *laoshi* abbreviates moves like jumping spinning kicks by merely turning on the spot; the student must have already mastered the basic techniques before they can access, learn, and appreciate the embodied kung fu remembered by Chow *laoshi*.

About fourteen years ago Ng *sifu*, a former taxi driver, struck first prize in the local lottery ("4D") and promptly retired.[18] He attributes his good fortune to ritual practices he performs in Thai Buddhist temples. The exact figures were never revealed, but Ng *sifu* occasionally wears heavy gold chains and Rolex watches studded in diamonds. Fit, and surprisingly young looking, Ng *sifu* possesses the lean muscular legs of a twenty-year-old athlete. The first time I observed him in the park he leapt over three feet up into the air with both heels striking his buttocks one after the

other—a feat that is more difficult than it sounds. Ng *sifu*, affectionately known as "Old Eagle," specializes in teaching Eagle Claw kung fu (fig. 9.2). He also teaches *liuhebafaquan* (Six Harmonies Eight Methods), said to be a fusion—or the origin—of *taijiquan, baguazhang,* and *xingyiquan.*

Roughly three groups attended the lessons, and classes usually comprised between five and twenty-five pupils, with a gender divide of four males to one female. Practitioners included youngsters and teenagers, whose attendance was sporadic due to the pressures of schooling. When they rehearsed their forms youngsters and experts were fascinating to watch as they dropped from high to very low stances with effortless speed and fluidity, only to rise back up again like martial dancers. The bulk of practitioners were aged thirty to fifty-five and were reasonably dedicated as shown by the fact they would turn up on rainy days during the monsoon. Some of the practitioners in their fifties appeared remarkably fit and young. This contrasts to Mr. Teo, supervisor of AMK125 coffee shop, who complained that he was exhausted from twelve-hour shifts with only two days off per month. He wanted to retire at fifty-five, only now the government has pushed the retirement age up to sixty-

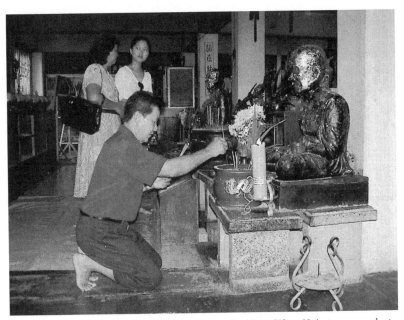

Figure 9.2. Ng *sifu* offers joss sticks to Luang Pu Tuat (Phra Ko), in a temple in Hat Yai, Thailand.

five. There was also a group of elderly practitioners, such as Mr. Tan who died aged eighty-eight. At his funeral Mr. Tan's beloved books on t'ai chi, decorated with scores of additional pictures and magazine cuttings of kung fu pasted throughout, were prominently displayed. There is a counterculture of elderly Singaporeans who resist low-paid jobs in McDonald's after being fired at fifty-five, but prefer to share their embodied knowledge, their social memory of kung fu, free of charge, to the fictive kin of their kung fu family.

The training sessions were not particularly formal, and Ng *sifu* would occasionally wander over and say to me "what do you want [to learn] next?" In years gone by classes were strict and behavior more severe, with more regimented group work and less individual instruction. Yong Feng pointed out that the teachers have mellowed with age. In the past, students would move through the basic sets in tandem to the piercing screech of a whistle, like soldiers on parade before a sergeant major. And previously, during individual instruction, the *sifus* would show only three to five moves of a set and make the students "practice until perfect" before moving on. However, on day one of learning a new form, Ng *sifu* once showed me twenty-seven moves from *fuhuqunyanggun* (jokingly nicknamed the "goat-bashing pole form"). Once I had completed the set and had a rough idea of the moves, Ng *sifu* spent months minutely correcting and refining my postures, some of which I was not able to perform with the first lesson anyway because I lacked the required flexibility and knee strength, and that only developed gradually after about twelve months of daily practice. It is a case of getting the basics down, and then a process of fine-tuning (*chiu chan*) to eliminate errors and acquire speed and power in the techniques over months and years. It is as if the student is wood, the teacher is a master carver, and the forms are the tools. The forms are designs for rebuilding the body, architectures of ability, where the goal is to attain and maintain agility. In a city constantly changing through processes of bland urban renewal, kung fu serves to transmit and maintain character, character that is intrinsically linked to a sense of Chinese cultural continuity.

During class the kung fu master would sometimes bring out a set of miniature photographs that showed every posture within a set, or use a pamphlet from the enormous stock of Chinese pamphlets that document kung fu forms. Pamphlets are more detailed than photographs alone as they contain captions and often have dotted lines drawn upon the diagrams to indicate the direction of the movements.[19] Digital cameras,

often situated in expensive mobile phones, also facilitated remembering the moves. Younger practitioners regularly emailed kung fu footage to each other, and burned it to DVD for the *sifus*. Although my group did not post their films on YouTube, many check out kung fu footage on the web. The postgraduate engineers among us quickly figured out a way to download directly from YouTube and burn the results to DVD. Such DVDs were routinely watched in the coffee shop on mini-DVD players or laptop computers, where the moves can be paused in mid-flight, to be examined, praised, or criticized.

The kung fu adept's life revolves around kung fu, where they must awake each day to arrive at the session by daybreak (7:00 a.m. in Singapore). In younger days they trained for three hours in the morning and for an hour at night, or vice versa, depending on work commitments. Our group normally met four or five times per week, usually at daybreak for about two hours training. After training, an hour or two was spent in the coffee shop, and on weekends these sessions continued for up to three hours. Some of the group spent occasional evenings drinking beer in the coffee shop owned by Yong Feng, and sometimes they took brief trips abroad to visit other kung fu teachers and temples in China, Malaysia, and Thailand. These trips involved meeting friends of the *sifus*', kung fu masters who would transmit their skills as fast as the students could absorb them. Voyaging together cements the group's social bonds and results in considerable sharing of knowledge, advice, and experience, helping the students quickly understand and acquire the myriad complex skills being transmitted.

Attending competitions, dinners, kung fu demonstrations, lion dance performances, and shopping for kung fu equipment, including clothes, DVDs, footwear, and weapons, alongside visiting other friendly teachers, can easily consume more than a hundred evenings and as many days per year. As Tonkin (1992) points out, "memory makes us, we make memory." Just as the lives of the kung fu practitioners are lived through kung fu, kung fu lives through the practitioners. The masters must have suitable students who are willing and able to remember their teachings, or their teachings will disappear into the dustbin of kung fu history. In my own case kung fu has been a lifelong hobby (some would say obsession), and I was always eager to learn new forms and techniques to the point where it became a competition between the instructors to see how much of their teachings I could absorb. Eventually, after months of intense daily tuition, they slowed down so that I would not "burst." Learning kung

fu in Southeast Asia is not simply about learning and repeating forms or exercises, but involves participating in the lives of the fictive kinship group.[20] And in Singapore much of life is spent in the coffee shop.

Enter the Coffee Shop

The Singaporean coffee shop (*kopitiam*) has come a long way since the 1970s. Except for the smooth concrete path that runs down the middle, most coffee shops are tiled from floor to ceiling. Some of the upgraded coffee shops now have both wall and ceiling fans and cable vision beamed through flat-screen high-definition television sets. Meanwhile digital cameras keep surveillance. Chinese-owned coffee shops usually have at least one shrine, and many are frequented by elderly customers who to the outsider may just look like low-income old people with nothing to do. Such people, however, may possess high status to the people around them. The coffee shop AMK125 is a typical Singaporean coffee shop and is located close to the park where kung fu training occurs (fig. 9.3). In England people give directions to strangers using pubs and churches as landmarks; in Singapore people navigate using the abbreviated area code (AMK is short for Ang Mo Kio) and the number of the street or block (125).[21] Singaporeans, many of whom eat out for breakfast, lunch, and dinner, are well aware of the best coffee shops in their locale and know where to find their favorite treats in other areas.

Immediately before the front entrance to the AMK125 coffee shop, on the right-hand side from the inside looking out, the Hokkien clientele, many of whom participate in periodic *tang-ki* rituals, provide offerings of cigarettes, coffee, beer, and joss sticks to the ghost-hunter deity that stands upon a shelf about five-foot high (fig. 9.4). The mysterious King of Ghosts (Da Shi Ye) adopts a kung fu pose with the left hand in "sword-fingers" (*jian zi*) as the right lifts what appears to be a scepter overhead.[22]

The martial pose shows the deity as protector of the living for beneath his left foot he overpowers a ghost who would otherwise cause mischief among mortals. Behind Da Shi Ye are the two hell deities Da Er Ye Bo (Elder and Second Grandpa deities).[23] The two work for the King of Hell, Yen Lo Wang. Da Ye Bo has a lolling tongue. He is in charge of keeping watch on the time when a person is to die, when he sends Er Ye Bo to fetch the soul in chains to hell. At the center of the coffee shop is a gold statue of the late Thai monk Luang Pu Tuat or

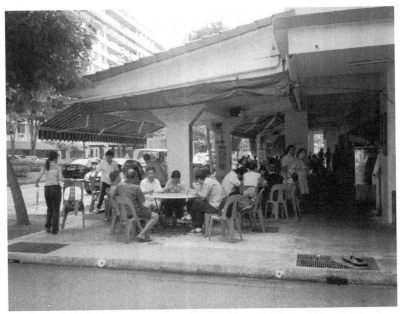

Figure 9.3. AMK125 coffee shop, Singapore.

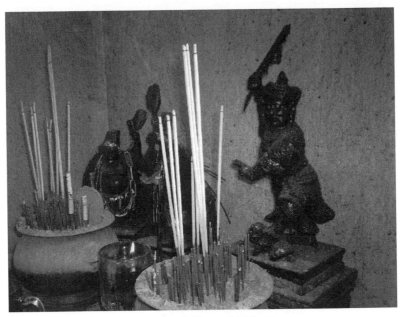

Figure 9.4. King of Ghosts (*right*), Singapore.

Phra Ko, encircled by neat piles of oranges in a high altar made from an open-faced yellow box.

On the left, just across the road, sits a large statue of Buddha, Guan Gong, and several other Chinese deities. The coffee shop was rumored to have been purchased in 2007 for the sum of four million Singapore dollars. Prior to the takeover of the coffee shop, now under new management, the god Dabogong was present, situated on the floor.[24] Although the deities on either side of the coffee shop survived the takeover, the shift in patron deity for the coffee shop, alongside the upgrade, coincided with a dramatic resurgence of business. To the locals these are not merely hollow idols, but bodies inhabited by souls; the gods are transubstantial with the material substance they are composed from and directly relate to the success of the business.

Stalls in the AMK125 coffee shop include Auntie's local delicacies of *rojak* and *popiah*, the Ming Kitchen Seafood Restaurant, Tim Sum (*dim sum*), Indian curry and *prata*, a vegetarian stall, Fishball Noodle, Chicken Rice, Wanton Noodle, Fried Prawn Mee, Malay Food, Western Food, Beverages, and Economic Mixed Rice and Vegetables. There are forty tables and enough seats for two hundred people. Others have written about food and "racial" hybridity in the Singapore context (Chua and Rajah 2001). It may seem to the outsider that Singaporeans, especially the Singaporean government, are even more obsessed with "race" than they are with food, to the point that there is really no such thing as a "Singaporean," a collective national identity apparently being absent or suppressed by the state discourse on race (Chua 1998). Those labeled "Malays" or "Indians" on their compulsory government-issued identity cards also frequent the coffee shop and by and large they eat from the Malay, Indian, or Western stalls. However, unless there is an international football match being aired, the television sets are invariably switched to the Chinese channels.[25]

Some Chinese Singaporeans feel that their oasis of safety is surrounded by potentially hostile Muslim countries (Indonesia and Malaysia) that would prefer a sermon from Osama bin Laden to a plate of Guinness pork ribs. Perhaps in some ways a siege mentality is justified. Singapore is a heavily fortified overseas Chinese bank, encircled by countries in which overseas Chinese capitalists make up a tiny minority of the population and yet control a vastly disproportionate share of the wealth.[26] However, at night, the coffee shop transforms into something resembling a Hokkien

pub, where Chinese taxi drivers and even minority Indian and Malay Muslim men partake of the one-liter bottles of Tiger, Heineken, Becks, and Carlsberg stacked in red ice buckets on many of the tables. Here nobody fears the religious persecution suffered in neighboring Malaysia, where Muslims caught drinking alcohol are fined, jailed, and paraded around the streets in trucks. Minority Singaporeans sit discreetly aside and separate from their Chinese "countrymen," yet one feels there may indeed be a case for Gordon Allport's "contact hypothesis," where close proximity breeds trust and respect based upon mutual knowledge and understanding (Allport 1954).[27]

Bringing the Lions, Heroes, and Gods to Life

The way martial myths, legends, stories, rituals, and traditions are remembered plays an important role in the embodied practice, maintenance, and transmission of kung fu, which serves to bring the lions, heroes, and gods to life. Alongside Bodhidharma, the putative founder of Shaolin martial arts, traditional styles of kung fu revere Guan Gong, the god of war, who usually is depicted carrying a halberd (fig. 9.5). Kung fu forms depicting battle techniques attributed to Lord Guan appear in many styles of kung fu and, here, we can see the sword-finger (*jian zi*) posture adopted by the figure's left hand, a posture that is adopted by kung fu practitioners whenever they practice the straight double-edged sword or the halberd, and which functions in combat as a piercing weapon aimed at the opponent's vital points.

When depicted holding a book Guan Gong is also known as the god of literature. In addition, as the god of business he is the most popular effigy displayed in coffee shops and other Chinese businesses in Singapore. Hence Guan Gong bridges the status gaps between the educated aristocrat, the scholar, the merchant, and the lower-class fighter; where mastery in any of these fields brings great prestige and collapses the status boundaries between them. Guan Gong represents honor, loyalty, and fidelity. Immensely popular in Southern China and Singapore, Guan Gong appears inside Hong Kong police stations and simultaneously functions as "the god of the blood-oaths taken by secret societies" (Elliot 1998: 160). Guan Gong is the deification of a mortal, Guan Yu (162–220), the mighty general of Shu whose exploits are mythologized in the classic

novel *The Romance of the Three Kingdoms.* Guan Yu served under Liu Bei in the civil war that usurped power from the Han dynasty, replaced by the Kingdom of Shu under the new emperor Liu Bei.

As Elliot (1998: 160) correctly notes, the triads have not forgotten the blood oath of brotherhood sworn in the peach garden between Guan Yu, Zhang Fei, and their "Eldest Brother" Liu Bei. The blood oath of Guan Yu provides an apt analogy for the imagined family operating in Chinese business, triad, police, and kung fu circles (Anderson 1991). In kung fu, Lord Guan (Guan Yu) is commonly said to be the historical founder of Eagle Claw kung fu and *baguazhang*. Although such "lineage myth[s]" cannot withstand modern standards of historical scholarship, questions of historical accuracy to "distinguish real or fake" fail to address the continued symbolic importance of such origin myths (Kennedy and Guo 2005: 45).

While the founding myths of kung fu styles are different in content, they tend to exhibit the same basic structure. Such myths, for

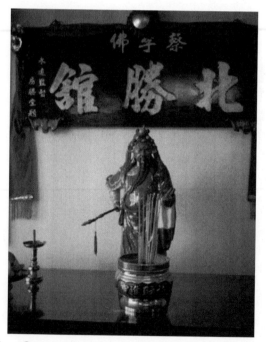

Figure 9.5. Guan Gong, at the entrance of Choi Lee Fat Kwoon (school), Guangzhou, China.

example, include the origin of the (Tibetan) White Crane School (*bai he pai*), where a Lama kung fu expert developed a style of kung fu after observing a black gibbon in combat with a white crane. Another origin myth is provided by Southern Praying Mantis kung fu (*nan pai tanglang*), where a monk watched a praying mantis defeat a bird and reported his observations to the abbot, who then consolidated a set of strengthening and conditioning exercises hitherto scattered among the various Shaolin styles of the Fukien temple into one style (Whitrod 2004). Here we see a predominantly long-range Northern style featuring expansive arm and leg movements, sharing a structurally similar mythopoetic origin account with a short-range Southern style specializing in the phoenix-fist one-inch-punch.

The myth remains the same, only the art is inverted, and this raises a question: if the arts were the same, would the origin myths differ?[28] It is tempting to apply the model, but the answer is complicated because, whereas several schools of Southern Praying Mantis kung fu trace their origins to a fight between a bird and an insect, in a displacement of the origin "myth" the supposed "real" lineage is altered to different founders, and therefore different, competing lineages come into play. Furthermore, such an answer does not account for Northern schools of Praying Mantis kung fu with similar origin myths yet different stylistic foundations (long range rather than short, and utilizing different striking surfaces of the hand). Precisely because of such difficulties it is better to undertake particular in-depth studies to build up a data set rather than impose questions based upon abstract theoretical formulae. Therefore I adopt an approach that addresses Chinese martial arts within the social structures of the "outer environment," vis-à-vis fictive kinship, ritual corporations, and the coffee shop.

The importance of (changes in) origin myths makes it apparent that the mythic forms, structures, symbols, and representations are functional and not merely ornamental. The stylized "movements" of kung fu contained within the sets provide a rich vein of symbolic representation, and may be based on the movements of animals, outlaws, heroes, assassins, immortals, and deities. Such movements proceed frame by frame and when combined form combat scenarios, which, to employ Goffman's (1974: 10) "frame analysis," rehearse a series of "strips" of combative behavior and premeditated responses (Farrer 2006: 30; Goffman 1974). During instruction the movements are frozen in space and individually named as different positions or "stances." Adopting the language of the anthropology of art,

these stances, or frozen artistic forms, provide specific "motifs" (Gell 1998: 171–190). Significantly, there is a common set of recurrent motifs operating throughout the different styles. These frozen singularities are connected into various sequences in different ways depending on the design and purpose of the form. It is partly through understanding the latent potential of the motifs, in isolation and combination, that the exponent learns how to apply them in combat and to strengthen the body. However, the necessity to embody the movement points beyond the individual stances or postures, because the styles differ in the method by which the practitioner slips from one position to another, whether moving gracefully like t'ai chi or in the violent staccato phrases of (Northern) Seven Star Praying Mantis Fist (qi xing tanglang quan).

Stylistic differences are not simply ornamental; neither do they solely function for combative training. Students of a particular style must be able to remember the forms properly and be able to demonstrate the specific moves in the correct sequence; otherwise they may be accused of heresy against the teacher, the school, and its traditions. In Singapore the Chinese martial arts considered "traditional" are those styles prevalent during the early part of the twentieth century, including Choi Lai Fut, Jow-Ga, Fujian White Crane, Tibetan White Crane, and Chin Woo.[29] These tend to operate from established premises, most of which are situated in Geylang, Singapore's red light district. The fervid part of Geylang consists of about forty streets (lorong) that fishbone out from either side of the main road. Stacked with brothels, bars, and coffee shops, Geylang boasts over a hundred lion dance associations and kung fu schools. Geylang is an area with lower-cost rents than other parts of Singapore, and the architecture consists of prewar properties with steep staircases leading into narrow three-story houses adorned with colorful Chinese signs and red lanterns. Hordes of men, mainly from the laboring classes, wander around throughout the night to eyeball the sex workers (some of whom are transvestites). During almost a decade spent in Singapore (1998–2007), Geylang proved to be the best place to observe police raids, triad gangsters, and street fights. Vibrant coffee shops are open twenty-four hours and many Singaporeans will visit Geylang just to get a bite to eat or drink a beer in the middle of the night.

To some extent styles considered "traditional" in Singapore refer to those that continue archaic ritual practices such as adopting disciples (tu di), where the student commits to "wear one shirt," meaning they

follow one style of kung fu and pledge lifelong obedience to the sect. The rituals associated with discipleship may include the sacrifice of a pig and chickens for a feast, and swearing thirty-six oaths of allegiance while kneeling before the master (cf. Elliot 1998: 164–165). Disciples are sworn to maintain the secrets of the society that are passed down from generations of masters. Such practices seem to have little appeal to martial arts oriented Singaporeans who prefer to cross-train several martial arts and pay for lessons than offer sole allegiance to one organization. Hence, Chia *sifu* says that Hong Shen Choi Lai Fut in Singapore is fast dying out because modern Singaporeans lack the necessary commitment. This contrasts with masters living in Western countries that fly with their followers across the globe to swearing-in ceremonies staged in Asia. At an event I attended in Guangzhou, China, in November 2007, the penultimate feast featured elaborate kung fu demonstrations set in a hotel ballroom attended by several hundred people. Western students who relished the "exotic and oriental" aspects of kung fu, and who posed tough in tight muscle T-shirts and kung fu attire as they holidayed in the safety of their little gangs dominated the onstage performances. Somehow they seem to miss the point: "disciples accepted—by direct debit," a Singaporean informant quipped, whose own master charges nothing and does not stand out in the crowd, but who, in traditional style keeps his kung fu cards close to his chest.

At first glance it may seem contradictory that in Singapore the "traditional" category also applies to the intentionally modern style of Chin Woo. Unlike Cantonese styles such as Choi Lai Fut, Chin Woo does not encourage a system of "discipleship," and traditional rituals such as feasting on General Guan's birthday are dispensed with. Originally Chin Woo masters would not even accept the term "*sifu*," but insisted upon being addressed with the more egalitarian title of "Mr." Compared to the other traditional kung fu styles in Singapore, Chin Woo is exceptional because it is an athletic association and not a sect. Unlike most traditional styles of kung fu, Chin Woo masters say "there are no secrets." Athleticism, ability, and agility are emphasized over arcane esoteric knowledge, and for aches and pains masters are more likely to recommend pills from the pharmacy than tinctures from traditional Chinese medicine. Nonetheless, the Chin Woo practitioners I trained with in Singapore are highly regarded by the other kung fu schools because of their preservation of "traditional" kung fu. Albeit many Chin Woo practitioners eschew ritual

and institutionalized organization (in favor of the park), they form group bonds lasting decades and operate as a type of imagined family precisely in the same way as the other "traditional" schools.

Occasionally when paying for drinks in the coffee shop, some of the Chin Woo practitioners would show off a picture of Huo Yuanjia, proudly mounted in the display panes of their wallets. Huo Yuanjia (1867?–1910) cofounded the Chin Woo Athletic Association in 1910 in Shanghai and was reputed to be one of the foremost fighters in China at the turn of the century, famous for challenging Western wrestlers, boxers, and Japanese judo experts in bouts of empty-hand combat. To counter Japanese (or Western) proclamations that the Chinese were "the sick men of Asia," the Chin Woo Athletic Association combined "the best" of Chinese martial arts under the umbrella of a friendly association (see Kennedy and Guo 2010. This association promoted anti-Japanese sentiment in China and supported nationalism and Dr. Sun Yat Sen. In retaliation, as the story told in the coffee shop goes, Huo Yuanjia was murdered by an evil Japanese doctor who deliberately prescribed him the wrong medicine for tuberculosis.[30] Jet Li plays Huo Yuanjia in the film released as *Huo Yuanjia* in 2006, which the *sifus* watched on DVD as soon as it was released. In the film Huo Yuanjia is in the midst of a battle with a Japanese fighter, and when they take a break to drink, Huo Yuanjia's tea has been poisoned by a dishonorable Japanese officer with a high stake in the betting. The Singaporean *sifus* dismiss the film as hopelessly inaccurate. Their version is that Huo Yuanjia had unfortunately befriended a Japanese doctor who was really a Japanese spy/assassin.[31] Singaporeans have not forgotten that Japanese spies posed as innocent professionals and merchants all across the Malay Peninsula for several years prior to the fall of British colonial Singapore to Japanese soldiers on bicycles in 1942.

Remembering the moves is a social activity, one that takes place as much inside the coffee shop as within the class. However, as with all social activities, problems occur when people disagree with how the routines should be remembered. In Chin Woo, as practiced in the park, I saw three different versions of the same form taught by three instructors claiming that their routine was the correct one. Previously, to forestall criticism, students learned several versions of the same set. Later the teachers convened and eventually settled upon an "official version." However, not all disputes are settled so collegially. During my fieldwork on Hong Shen Choi Lai Fut one instructor misremembered the steps and taught the wrong combination to his students. Subsequently, he was said to have

gone against Chia *sifu*, the tradition, and the school: branded a traitor, he was expelled from the organization. Similarly, among the Chin Woo practitioners it is considered essential to know and transmit the correct version of the forms, albeit that some "poetic license" may be granted as dictated by individual somatotype (where, for example, someone may be too fat, old, or weak to perform a move correctly).

Because of such crises of misremembering great difficulties assail those who would learn more forms than they can accurately remember. Problems of remembering are pronounced in Chin Woo, because it is an amalgamation of several different kung fu styles. Chin Woo ultimately dispenses with the root, tree, and branch metaphor of kung fu techniques/knowledge, for a rhizomic formula (Deleuze and Guattari 2002). Chin Woo advises the student to specialize in one style or another after learning the basic Chin Woo Ten Routines.[32] By developing a mastery of the shared basic stances and movements, Chin Woo teaches the fundamentals of Northern kung fu and prepares the student to specialize in other styles, including Eagle Claw (*yingzhaoquan*), Northern Shaolin, Northern Praying Mantis, and the subtle internal systems such as Wu Style *taijiquan*, *xingyiquan*, *baguazhang*, and Water Boxing, or liuhebafa.[33]

Most of the Chin Woo routines require considerable effort to master and consist of a long series of movements composed into various strips strung together into a coherent whole (Goffman 1974). The first step on the road to mastery is to remember all the moves. One informant suggested that: "The way Chinese are brought up is different from Westerners. They have to learn the characters by rote; otherwise they don't know how to read. So from young they have to memorize the characters (from field notes)." He was implying that the same process occurs with kung fu, where the memorization of Chinese characters spills over into the rote learning of routines one step at a time. However, learning is just the first step to remembering a routine. This stage is followed by years of relentless practice to develop the fine motor skills needed to perfect the form, during which time the master will impart the special properties of the routine as related to the development of *techniques du combat*. Ultimately, the practitioner will be in a position to demonstrate and pass on the routine in turn. Each step offers its own set of challenges, each of which lead to the development of an increasingly subtle understanding. One way the masters remember is through associations made to gods, immortals, outlaws, heroes, and heroines as they appear in myths, legends, and stories. Remembering is more than recollecting

historical references; it involves revealing patterns located in written language, embodied practices, and kung fu.

Chow *laoshi* remembers the moves partly because he recorded in written lists the names for each technique when learning the routines. Chinese names exist for every single move, known and understood within a "specialized ethnosemantic lexicon."[34] Such minute documentation is tedious when attempted in English, because it lacks the poetry of the Chinese phrases, where one may conventionally "wield a saber like a fierce tiger" (*dao ru men hu*) or "brandish the sword like a swimming dragon" (*jian ru you long*). Many of the forms and moves are named after the exploits of the 108 heroes of Liang Shan Po, as recounted in *Outlaws of the Marsh*; others stem from classics such as *The Romance of the Three Kingdoms*. Chow *laoshi* invited me to watch his collection of DVDs concerning the 108 heroes of Liang Shan Po, and subsequently we would discuss the moves associated with the outlaws as he taught me in the park. Similarly, I was told to read the book and watch the DVDs for *The Romance of the Three Kingdoms*. Chow *laoshi* taught the moves demonstrated on the screen performed by the actors, locating them back into their kung fu sets.

In the coffee shop, Chow *laoshi* especially liked to recount the legend of Wu Song, one of the 108 heroes (see Shi and Guanzhong [1980] 2007: 348). *Laoshi* related the tale as follows: Wu Song enters a tavern with the sign "Three bowls and you can't cross the ridge" (or "drink three bowls; then pass out" in his words) and then imbibes an entire barrel of the house brew. Afterward, while crossing the mountain ridge, Wu Song chances upon a man-eating tiger and kills it with his bare hands, a feat that earns him a hero's welcome and reward in the nearby village. Returning home, Wu Song kills his sister-in-law and her lover with his broadsword after they cuckold, poison, and murder his malformed brother. He is tried, branded on the face, and sentenced to exile. During the long journey to the prison, rather than escort him properly to jail, his guards attempt to murder him. Despite being locked in heavy shackles binding his hands and neck, Wu Song kills both the guards and then continues to the jail unescorted. Settling into the prison, Wu Song is mysteriously given comfortable quarters and feasted upon good wine and meat. The prison governor formerly had a lucrative pub business, until a powerful gangster protected by a murderous fighter took over his establishments. Wu Song agrees to take care of matters, with the proviso that he must first stop at every pub along the way for a drink. Suitably intoxicated,

Wu Song kills the warrior. Leaving the prison, he subsequently finds lodging at a lord's house. There, Wu Song is framed as a thief by the lord. But when it was revealed that this treacherous lord masterminded the pub takeover, Wu Song takes his broadsword and slays the entire household, including the lord, some male guests, the women, children, and all the servants.

Such stories are introduced to kung fu practitioners early in their practice. Kung fu demonstrates how culture infolds into the body and how bodily practices reciprocally outfold into social space (Kleinman and Kleinman 1994: 710–711). For example, in the form called "Wu Song Kills the Tiger," taught by Chow *laoshi*, the kung fu practitioner does the first third of the set with his or her arms held together at the wrists as if wearing manacles, with the left hand clamped firmly over the right wrist. The "manacles" are cracked upon the raised right knee as the right fist springs open. The left knee then springs up and the back of the left hand strikes the raised left thigh. With the hands now free the practitioner dodges to the left placing the right foot behind the left knee and crossing the arms in front, then darts to the right into the horse riding stance (*ma bu*) with a both fists striking out on either side. A whirling jumping kick (*shen fong*) combines with a great circling of the hands in front of the body, after which the performer lands in a low crouching stance, to conclude this series of moves. The upheld right palm shudders aloft as if from intoxication—"lack of beer," as *laoshi* would joke—and then a broadsword is picked up and whirled about in a demanding strip of precise moves lasting several minutes.

The theatrical embodiment of themes from classical Chinese literature into kung fu should not be understood as merely a modern phenomenon dependent upon new technology, film, and DVD to transmit popular versions of the classics to the supposedly uneducated lower-class kung fu masters. Rather, all Chinese know such stories. The practice of kung fu contains many elements of symbolic representation concerning the antics of Chinese heroes and gods and enacts centuries-old cultural traditions. The techniques of Chin Woo transmit to successive generations of kung fu students in the Singapore coffee shop the classic stories of the 108 heroes, General Guan, and other gods, outlaws, and heroes not merely as a representation, but as an embodiment through continuous martial training. As the movements of kung fu are performed, these stories, legends, places, names, even the political choice associated with General Guan are "remembered" and unify diverse practices such as martial arts,

rituals of affiliation, and religious worship, bringing Chinese folklore to life through the channel of the secular body. Active remembering produces martial arts culture at its richest and makes for remembrance that is simultaneously enacted and immanent. Like an external memory, the overseas Chinese martial arts exist as a vast reservoir of Chinese cultural capital, one that has the potential to be reinvested back into China.

Notes

1. Specifically I outline findings of my research into Chin Woo (examining a group who originally derived from the Chin Woo Athletic Association) supplemented with findings from the Singapore Hong Shen Koon Chinese Kootow and Lion Dance Society, simply known as Choi Lai Fut (which I intend to document more thoroughly at a later date). Chin Woo, or *jingwu*, a modern association of predominantly Northern Chinese styles, including Eagle Claw, Praying Mantis, Northern Shaolin, and the so-called internal styles such as T'ai Chi Ch'uan, was introduced into Southeast Asia from China in the 1920s (for detailed historical accounts see Morris 2004: 2000). Choi Lai Fut developed originally in Foshan, Guangdong Province, in Southern China during the peasant conflict and warlordism of the 1800s.

Yong Feng, Ellis Finkelstein, Roxana Waterson, and Julainah Johari read through drafts of this article and made useful suggestions. I must especially thank John Whalen-Bridge and Margaret Chan, who gave sage advice, corrections, and additions.

2. For the purposes of this chapter I have transliterated using both the Wade-Giles and Hanyu Pinyin systems. A nuanced approach is important for validity, and better reflects the ethnographic materials. For example, Singaporean kung fu masters do not refer to themselves as *shifu*, but as *sifu*. For my informants the distinction is important, because the term *shifu* is used by them to refer to masters from mainland China, and is usually not employed to refer to Chinese masters hailing from Singapore. This is merely a general distinction and is context dependent because Cantonese masters from Guangzhou or Hong Kong are also referred to as *sifu*.

3. "Routine," "form," and "set" are interchangeable concepts that refer to specific choreographed sets of movements passed down within various styles of kung fu. A *style* of kung fu refers to a type of kung fu, such as Praying Mantis or Eagle Claw, that is constituted of sets of movements alongside other specific exercises. A "school" of kung fu is a social organization of one or more styles.

4. In self-reference Singaporean and Malaysian Chinese informants refer to the "Chin Woo Athletic Association" or "Chin Woo" using the Wade-Giles

system of transliteration, in preference to "Jingwu" (Pinyin). Complications arise where some informants sometimes use Chin Woo and Jingwu interchangeably; or may use Chin Woo to refer to Singaporean or Malaysian versions of Jingwu, reserving Jingwu to refer more properly to the martial art in China. Generally my informants refer to their martial art in English as "Chin Woo" and not "Jingwu" (Pinyin) so I have adhered to their preference throughout.

5. Lion dance is an activity restricted to kung fu practitioners. In Singapore, to find hidden kung fu schools, or ones that do not directly advertise, simply look for lion dance associations. In terms of practical kung fu skills, lion dance teaches footwork, balance, timing, and rhythm.

6. The coffee shop in Singapore society is quite different from Starbucks or Coffee-Bean, and more like the coffee houses of seventeenth- and eighteenth-century London and Paris.

7. Halliburton (2002) provides a useful survey of the literature and notes the difference between the anthropology of the body and embodiment: "Csordas distinguished between the anthropology of the body, which considers the body as an external object of analysis and that tends to focus on *concepts* of the body or bodily metaphors, and studies of embodiment, which consider the actual lived experience of being in the body or 'being in the world (1999)'" (2002: 1124).

8. Kleinman and Kleinman recognize Bourdieu's (1977) contribution to the marriage of social structure and quotidian experience through *habitus*, but they fail to mention his concept of *hexis*, which Bourdieu considered *the embodiment of habitus* (Bourdieu 1977: 87; 2002: 209; Jenkins 1992: 75). Foreshadowing Bourdieu's notion of *hexis*, Mauss (1979: 101) employed *habitus* to refer to acquired abilities and faculties; to "practical reason" manifested in individual and collective techniques and works, distributed unevenly across a population, and not to the soul, or individual memory, and its repetitive faculties, habits, and customs. More recently, Richard Shusterman (1997, 1999, 2000) develops "pragmatist aesthetics" to extend Bourdieu's notion of *hexis*; and develops the notion of *somaesthetics*, to encapsulate the embodiment of aesthetics. Although Bourdieu, Mauss, and Shusterman formulate positions relating individual experience to the embodiment of social or cultural structures, the domain of memory, as Kleinman and Kleinman (1994) pointed out, remains largely outside of these equations. Even Paul Ricoeur (2005) in his monumental *Memory, History and Forgetting* neglects a discussion of embodiment.

9. Falun Gong literally means "Practice of the Wheel of the Dharma" (Margaret Chan, personal correspondence 2008).

10. Chinese martial arts can be divided into *neijia* (internal family) or *wàijiā* (external family) styles. The so-called soft or internal arts include *baguazhang*, *xingyiquan*, and *taijiquan*. *Baguazhang*, based on the *I Ching* or *Book of Changes*, and to a lesser extent *taijiquan*, emphasizes "spiraling energy" in the performance of movement. In *taijiquan* the stance remains well grounded and the power of the

movement is generated through the movement of the whole body, particularly the hips and the waist. In *baguazhang* the "coiling energy" is combined with circling footwork, and this style emphasizes continually shifting footwork through a practice known as "walking the circle." *Xingyiquan* (Hsing I) is based on twelve animals and the five elements and is the "hardest" and most linear of the "soft" or "internal" styles (Frantzis 1998; Liang, Yang, and Wu 1994).

11. Theater director and performance theorist Phillip Zarrilli (1998) found that the Indian martial art *kalarippayattu* provided the basis for actor training in *kathkali* theater in Kerala. Zarrilli set out to learn *kalarippayattu*, and he calls the full immersion of the researcher into the performance genre "performance ethnography" (Farrer 2006, 2007, 2009: 16–17; Zarrilli 1998: 255 n6).

12. Previously I attained a Chow Gar Praying Mantis Kung Fu black belt from training three to five hours a day with Paul Whitrod, *sifu* from 1988 to 1996. See http://www.chowgarsouthernmantis.com/instructuk.php.

13. To attain "native ability" in such a complicated linguistic field would take the best part of a lifetime. As it was, I put an average of fifty hours every week into learning Chinese martial arts. I conversed with Chow *sifu* primarily in English, and with Ng *sifu* in Malay (which I learned to speak during my studies of the Malay martial art *silat* in Malaysia [Farrer 2006; 2008; 2009]), the local patois "Singlish," mixed together with Mandarin and Cantonese. I had the generous assistance of Mr. Yong Feng BSc, MSc, owner of two coffee shops and a member of Ng *sifu*'s group for more than thirty-five years, who acted as my translator where necessary. Only because of my sincere attempts to learn kung fu did the Singaporean masters open up to me. To join Choi Lai Fut, a closed-door school, required a formal introduction from Chow *sifu*. In a tense atmosphere I had to spar with Chia *sifu*, and later face off against seven of his ferocious students, one after the other. For this effort I was awarded an honorary black belt.

14. In Singapore the Peranakan Chinese, also known as the Baba-Nonya or Straits Chinese, are terms used to refer to the descendants of Chinese settlers who originally intermarried with the indigenous Malay population in fifteenth-century Melaka. According to the Singapore Peranakan Association, "[t]he word Peranakan means 'local born' in Malay [and] refers to the Peranakan Chinese as well as other Peranakan communities which developed in South-east Asia. These include the Chitty Melaka (Indian), Kristang (Eurasian) and the Jawi Peranakans" (http://www.peranakan.org.sg/).

15. Historians, such as Brownell (1995), through a discussion of "body culture," and Morris (2004; 2000) who details "body cultivation" or *tiyu*, read changes in Chinese martial arts through the project of nation-building in modern China. For Morris (2004: 185–245) the "Pure Martial School" (the Jingwu Association) began the process of repackaging Chinese martial culture in a modern, scientific, and nationalist wrapping, paving the way for Chinese martial arts to

be stripped of their agonistic elements and become supplementary contenders in the development of modern Olympic sports. Chinese martial arts apparently moved through four phases of development, from the first stage of village militia and military application (pre-Republican era), to the Pure Martial era, 1920–27, to the State *Guoshu* project, 1927–37, culminating in the People's Republic of China *Wushu* phase (from 1959–present) (Kennedy and Guo 2007: 50–51; Morris 2004: 185–229).

16. Singaporean Chin Woo experts assert that Bruce Lee learned *jie quan*, a form that contains all of the essential principles of kicking, such as flying kicks, kicking and punching simultaneously, 360-degree whirling kicks, and low 360-degree sweeps, and claim that this form influenced Lee to name his own martial style Jeet Kune Do (Way of the Intercepting Fist).

17. "The Dagger Society" Suite, Xia, Fei-Yun/Shanghai China.

18. In Singapore most taxi drivers do not own their taxis, but must rent them on a daily basis. Similarly, in the past most "rickshaw coolies" did not own their own vehicles (Warren 2003a: 317). Financial independence through hard work is thus an unlikely event, which perhaps explains the popularity of the "4D" daily number bet among Singapore taxi drivers.

19. For a discussion of Chinese martial art training manuals, see Kennedy and Guo (2005).

20. Where the *sifus* appear like older and younger brothers, surrogate parents to the group of older uncles and aunts, and younger nieces and nephews (younger in the sense of newer to the organization).

21. This is not the actual location. Names have been altered to protect the privacy of the informants.

22. Taoist priest Master Jave Wu (Taoist name: Zheng Yi Long Shan Men Xiao Hua Jun) explained that Da Shi Ye is one of the manifestations of the compassionate Goddess of Mercy Guan Yin. Despite his fearsome appearance, he does not cause pain, even to ghosts. Traditionally he carries not a weapon but rather a banner that reads *jie ying xi fan* (leading to the Western Paradise) or *pu do sheng zhong* (salvation from sufferings). Margaret Chan (personal communication 2008) explains that Da Er Ye Bo are worshiped as gods of fortune. Da Ye Bo wears a tall hat on which is written *yi jian da ji* (fortune at one glance), and Da Shi Ye, the protector of people, is often depicted in a martial pose so he may crush underfoot the evil spirits that cause misfortune, ill health, or other problems. See also Chan (2006); Sutton (2003).

23. The title "Grandpa deities" is a familial term popular with worshipers; the pair are properly addressed as General Xie (Da Ye Bo) and General Fan (Er Ye Bo).

24. God statues are usually placed on altars or shelves in the front room or hall of homes and shops. The spatial protocol is that the patron deity (favored by the worshiper) is located at the central, most important location. To the right

(when facing the altar) is the place of second importance, on the left is the place of third importance. On the floor are placed the gods of the earth or locality (Margaret Chan, personal communication 2008).

25. Singaporeans seem obsessed with English League football, especially Manchester United Football Club. In this sense Singaporean Chinese identity straddles Great Britain, the former colonial power, and China, the home of their forebears.

26. Point supplied by intelligence expert Dr. Philip Davis (personal communication, 1999).

27. In Singapore 85 percent of the population live in government Housing Development Board flats, which enforce a policy of "racial" quotas to ensure that the "races" are evenly spread.

28. The question here is based upon a formula developed by Lévi-Strauss (1982) in *The Way of the Masks*, wherein the plastic form remains the same when the myth is inverted, or the myth is inverted where the plastic form remains the same.

29. Hong Quan kung fu (Hung Gar in Cantonese) is widely found in Singapore. Emphasizing low solid stances and powerful strikes, this style mimics the movements of five animals, namely, the tiger, crane, leopard, snake, and dragon. Although Hong Quan has existed in Singapore for many decades and practices the system of discipleship, for some unknown reason, *sifus* from different schools do not regard it as a "traditional" style in Singapore.

30. Morris (2004), who has devoted a chapter documenting the transformation of martial arts to national skills in modern China, and other martial art historians such as Kennedy and Guo (2005; 2010), point out that this foundation myth deserves to be taken with a pinch of salt.

31. Bruce Lee played Huo Yuanjia's embittered student who seeks revenge for his master's death in the 1972 film *Fist of Fury* (Thomas 1994: 133–156).

32. These ten routines are some of the very best routines of Northern Chinese kung fu, namely, *tantui, gongliquan, jiequan, shangdazhan, xiadazhan, baguadao* (saber), *fuhuqunyanggun* (staff), *wuhuqiang* (spear), *dandao chuan qiang* (saber vs. spear), *jietantui* (a two-person fighting form), and *taoquan* (another two-person fighting form). Each division can be further subdivided, where Shaolin includes dozens of sophisticated routines, and the internal arts include a myriad of routines said to derive from Wudang Mountain. From the Singapore official syllabus it can be seen that there exist at least six two-man fighting forms, eighty-six Yellow River weapons forms, and seventy-five Yellow River unarmed forms. The Yellow River styles refer to those supposedly derived from or developed within the Fukien Shaolin Temple that was burned down in 1674 by Qing forces trying to suppress a hotbed of Ming resistance (Elliot 1998: 165–166). There are also twelve weapons routines and nine open-hand routines from Chu Chuang Gwangzhou, and from Chen Jiang there are nineteen weapon forms and thirty-two unarmed

forms. Chow *laoshi* showed at least sixty routines, of which forty-two appear on the syllabus. Each routine is comprised of dozens of individual movements.

33. Chin Woo's four divisions include the "external arts" of Eagle Claw derived from Master Chen Zizheng, Northern Praying Mantis from Master Luo Guangyu, Northern Shaolin and the "internal arts" including *xingyiquan* from Master Zhao Lianhe, and Wu Style Taijiquan taught by the founder of this style, Wu Jianquan.

34. See *A Chinese-English and English-Chinese Glossary of Wushu and Qigong Terminology* (Hong Kong: Hai Feng Publishing Co., 1991).

References

Allport, Gordon W. 1954. *The Nature of Prejudice*. Cambridge, MA: Addison-Wesley.

Anderson, Benedict. R. O'G. 1991. *Imagined Communities: Reflections on the Origin and Spread of Nationalism*. Rev. ed. London: Verso.

Bourdieu, Pierre. 1977. *Outline of a Theory of Practice*. Cambridge: Cambridge University Press.

———. 1990. *In Other Words: Essays Towards a Reflexive Sociology*. Stanford: Stanford University Press.

———. 1998. *Practical Reason: On the Theory of Action*. Stanford: Stanford University Press.

———. 2002. Response to Throop, C. Jason, and Keith M. Murphy. "Bourdieu and Phenomenology: A Critical Assessment." *Anthropological Theory* 2 (2): 185–209.

Brownell, Susan. 1995. *Training the Body for China: Sports in the Moral Order of the People's Republic*. Chicago: University of Chicago Press.

Caillois, Roger. [1961] 2001. *Man, Play and Games*. Trans. Meyer Barash. Urbana and Chicago: University of Illinois Press.

Chan, Margaret. 2006. *Theatre Is Ritual, Ritual Is Theatre; Tang-ki: Chinese Spirit Medium Worship*. Singapore: Singapore Management University and SNP.

Chua, Beng Huat. 1994. "That Imagined Space: Nostalgia for the Kampung in Singapore." Working Papers Series No. 122. Dept. of Sociology, National University of Singapore.

———. 1998. "Racial Singaporeans: Absence after the Hyphen." Pp. 28–50 in Joel S. Kahn, ed., *Southeast Asian Identities: Culture and the Politics of Representation in Indonesia, Malaysia, Singapore and Thailand*. London: I.B. Tauris; Singapore: Institute of Southeast Asian Studies.

Chua, Beng Huat, and Ananda Rajah. 2001. "Hybridity, Ethnicity and Food in Singapore." Pp. 161–200 in David Y. H. Wu and Tan Chee-Beng, eds., *Changing Chinese Foodways in Asia*. Hong Kong: Chinese University Press.

Connerton, Paul. 1989. *How Societies Remember*. Cambridge: Cambridge University Press.

Csordas, Thomas J. 1999. "The Body's Career in Anthropology." Pp. 172–205 in Henrietta L. Moore, ed., *Anthropological Theory Today*. Cambridge: Polity.

———. 2001. *Charisma, Language and Legitimacy: Ritual Life in the Catholic Charismatic Renewal*. New York: Palgrave.

———. 2002. *Body/Meaning/Healing*. Basingstoke, Hampshire: Palgrave.

Elliot, Paul. 1998. "The Boxers: The Fists of Righteous Harmony." Pp. 155–183 in *Warrior Cults: A History of Magical, Mystical and Murderous Organizations*. London: Blandford.

Deleuze, Giles, and Félix Guattari. 2002. *A Thousand Plateaus: Capitalism and Schizophrenia*. Trans. Brian Massumi. Reprint. London: Continuum. Original edition *Mille Plateax*, Vol. 2 of *Capitalisme et Schizophréne*, Les Editions de Minuit, Paris, 1980.

Douglas, Mary. 1970. *Natural Symbols: Explorations in Cosmology*. London: Barry and Rockcliff.

Farrer, D. S. 2006. "Deathscapes of the Malay Martial Artist." *Social Analysis: The International Journal of Cultural and Social Practice*. Special edition on Noble Death 50 (1): 25–50.

———. 2007. "The Perils and Pitfalls of Performance Ethnography." *International Sociological Association E-Bulletin*.

———. 2008. "The Healing Arts of the Malay Mystic." *Visual Anthropology Review* 24 (1): 29–46.

———. 2009. *Shadows of the Prophet: Martial Arts and Sufi Mysticism*. Netherlands: Springer.

Frantzis, Bruce Kumar. 1998. *The Power of Internal Martial Arts: Combat Secrets of Ba Gua, Tai Chi and Hsing-I*. Berkeley: North Atlantic Books and Energy Arts.

Gell, Alfred. 1993. *Wrapping in Images: Tattooing in Polynesia*. Oxford: Clarendon.

———. 1998. *Art and Agency*. Oxford: Oxford University Press.

Goffman, Erving. 1974. *Frame Analysis: An Essay on the Organization of Experience*. Boston: Northeastern University Press.

Halbwachs, Maurice. 1992. *On Collective Memory*. Trans. Lewis A. Coser. Chicago: University of Chicago Press.

Hallander, Jane. 1985. *The Complete Guide to Kung Fu Fighting Styles*. Burbank: Unique Publications.

Halliburton, Murphy. 2002. "Rethinking Anthropological Studies of the Body: Manas and Bōdham in Kerala." *American Anthropologist* 104 (4): 1123–1134.

Hobsbawm, Eric J., and Terence Ranger. 1983. *The Invention of Tradition*. Cambridge: Cambridge University Press.

Hsu, Adam. 1997. "The Myth of Shaolin Kung Fu." Pp. 59–65 in *The Sword Polisher's Record: The Way of Kung Fu*. Boston: Tuttle.

Huizinga, Johan. 1950. *Homo Ludens: A Study of the Play Element in Culture.* London: Beacon Press.

Igarashi, Yoshikuni. 2000. *Bodies of Memory: Narratives of War in Postwar Japanese Culture, 1945–1970.* Princeton and Oxford: Princeton University Press.

Jenkins, Richard. 1992. *Pierre Bourdieu.* London: Routledge.

Kalra, Virinder S., Raminder Kaur, and John Hutnyk. 2005. *Diaspora and Hybridity.* London: Sage.

Kennedy, Bryan L., and Elizabeth Guo. 2005. *Chinese Martial Arts Training Manuals: A Historical Survey.* Berkeley: North Atlantic Books.

———. 2010. *Jingwu: The School That Transformed Kung Fu.* Berkeley: Blue Snake Books.

———. 2007. "The Jing Wu Association." *Classical Fighting Arts* 2 (12): 48–55.

Kleinman, Arthur, and Jane Kleinman. 1994. "How Bodies Remember: Social Memory and Body Experience of Criticism, Resistance, and Delegitimation Following China's Cultural Revolution." *New Literary History* 25: 707–723.

Kong, Bucksam, and Eugene Ho. 1973. *Hung Gar Kung-Fu: Chinese Art of Self-Defense.* Los Angeles: Ohara Publications.

Langness, L. L. 1965. *The Life History in Anthropological Science.* New York: Holt, Rinehart and Winston.

Lévi-Strauss, Claude. 1982. *The Way of the Masks.* Trans. Sylvia Modelski. Seattle: University of Washington Press.

Liang, Shou-Yu, Jwing Ming Yang, Wen Ching Wu. *Baguazhang (Emei Baguazhang): Theory and Applications.* Boston: YMAA.

Mauss, Marcel. 1979. *Sociology and Psychology: Essays.* Trans. Ben Brewster. London: Routledge and Kegan Paul.

Morris, Andrew D. 2000. "Native Songs and Dances: Southeast Asia in a Greater Chinese Sporting Community, 1920–1948." *Journal of Southeast Asian Studies* 31 (1): 48–69.

———. 2004. "From Martial Arts to National Skills: The Construction of a Modern Indigenous Physical Culture." Pp. 185–229 in *Marrow of the Nation: A History of Sport and Physical Culture in Republican China.* Berkeley: University of California Press.

Ots, Thomas. 1994. "The Silenced Body-The Expressive *Lieb*: On the Dialectic of Mind and Life in Chinese Cathartic Healing." Pp. 116–138 in Thomas Csordas, ed., *Embodiment and Experience: The Existential Ground of Culture and Self.* Cambridge: Cambridge University Press.

Reich, Wilhelm. [1945] 1990. *Character Analysis.* Trans. Vincent R. Carfagno. 3d ed. New York: Noonday Press.

Ricoeur, Paul. *Memory, History and Forgetting.* Trans. Kathleen Blamey and Davis Pellauer. Chicago and London: University of Chicago Press.

Schechner, Richard. 1988. *Performance Theory.* Rev. ed. New York: Routledge.

————. 1994. "Ritual and Performance." Pp. 613–647 in Tim Ingold, ed., *The Companion Encyclopedia of Anthropology: Humanity, Culture and Social Life*. Reprint, 2000. London: Routledge.

Scott, James C. 1990. *Domination and the Arts of Resistance: Hidden Transcripts*. New Haven and London: Yale University Press. Cited in Kleinman, Arthur, and Jane Kleinman. 1994. "How Bodies Remember: Social Memory and Body Experience of Criticism, Resistance, and Delegitimation Following China's Cultural Revolution." *New Literary History* 25: 707–723.

Shi, Nai'An, and Luo Guanzhong. [1980] 2007. *Outlaws of the Marsh*. Trans. Sidney Shapiro. 3 vols. Beijing: Foreign Languages Press.

Shum, Leong. 2001. *The Secrets of Eagle Claw Kung Fu*. Reprint, 1980. Boston: Tuttle.

Shusterman, Richard. 1997. "Somaesthetics and the Body/Media Issue." *Body and Society* 3: 33–49.

————. 1999. "Somaesthetics: A Disciplinary Proposal." *Journal of Aesthetics and Art Criticism* 57: 299–313.

————. 2000. *Pragmatist Aesthetics: Living Beauty, Rethinking Art*. 2d ed. New York: Rowman and Littlefield.

Smith, Robert W. [1974] 1990. *Chinese Boxing: Masters and Methods*. Berkeley: North Atlantic Books.

Stoller, Paul. 1997. *Sensuous Scholarship*. Philadelphia: University of Pennsylvania Press.

Sutton, Donald S. 2003. *Steps of Perfection: Exorcistic Performers and Chinese Religion in Twentieth-Century Taiwan*. Cambridge (MA) and London: Harvard University Press.

Thomas, Bruce. 1994. *Bruce Lee: Fighting Spirit*. Berkeley: Frog.

Tonkin, Elizabeth. 1992. *Narrating Our Pasts: The Social Construction of Oral History*. Reprint, 1999. Cambridge: Cambridge University Press.

Turner, Edith L. B., William Blodgett, Singleton Kahona, and Fideli Benwa. 1992. *Experiencing Ritual: A New Interpretation of African Healing*. Philadelphia: University of Pennsylvania Press.

Turner, Victor W. 1969. *The Ritual Process: Structure and Anti-Structure*. New York: Aldine de Gruyter.

————. 1982. *From Ritual to Theatre: The Human Seriousness of Play*. New York: PAJ Pub.

————. 1985. *On the Edge of the Bush: Anthropology as Experience*. Ed. Edith L. B. Turner. Tucson: University of Arizona Press.

————. 1988. *The Anthropology of Performance*. New York: PAJ Pub.

Turner, Victor W., and Edward M. Bruner, ed. 1986. *The Anthropology of Experience*. Urbana: University of Illinois Press.

Warren, James Francis. 2003a. *Rickshaw Coolie: A People's History of Singapore 1880–1940*. Singapore: Singapore University Press. First edition Oxford University Press 1986.

————. 2003b. *Ah Ku and Karayuki-San: Prostitution in Singapore, 1870–1940*. Singapore: Singapore University Press. First edition Oxford University Press 1993.

Waterson, Roxana, ed. 2007. *Southeast Asian Lives: Personal Narratives and Historical Experience*. Singapore: National University of Singapore; Athens: Ohio University Press.

Whitrod, Paul. 2004. *Chow Gar Southern Praying Mantis Kung Fu*. N.p.

Yan, Xing, et al., eds. (1995). *Treasure of the Chinese Nation, the Best of Chinese Wushu: Shaolin Kungfu*. Chinese edition (in English). N.p.: China Books and Periodicals.

Yang, Jwing Ming, and Jeffrey A. Bolt. 1982. *Shaolin Long Fist Kung Fu*. Burbank: Unique Publications.

Zarrilli, Phillip B. 1998. *When the Body Becomes All Eyes: Paradigms, Discourses and Practices of Power in Kalarippayattu, a South Indian Martial Art*. Delhi: Oxford University Press.

Contributors

Paul Bowman teaches cultural studies at Cardiff University, United Kingdom. He is the author of *Post-Marxism versus Cultural Studies* (2007), *Deconstructing Popular Culture* (2008), *Theorizing Bruce Lee* (2010), and *Beyond Bruce Lee* (2011, forthcoming). He is editor of *Interrogating Cultural Studies* (2003), *The Truth of Žižek* (2007), and *The Rey Chow Reader* (2010), as well as issues of the journals *Parallax*, *Social Semiotics*, and *Postcolonial Studies*.

Stephen Chan OBE is Professor of International Relations at the University of London and was Foundation Dean of Law and Social Sciences at the School of Oriental and African Studies. A former international civil servant, he has lived and worked extensively in Africa. Winner of the 2010 International Studies Association Eminent Scholar in Global Development Award, Chan is the author of *The End of Certainty: Towards a New Internationalism* (2009), *Robert Mugabe: A Life of Power and Violence* (2003), and *Out of Evil: New International Politics and Old Doctrines of War* (2004).

D. S. Farrer is Assistant Professor of Cultural Anthropology and Anthropology Program Coordinator at the University of Guam. His ongoing research regarding Malay and Chinese martial arts has appeared in *Social Analysis* (2006) and *Visual Anthropology Review* (2008), and he was a contributing editor to *Martial Arts of the World: An Encyclopedia of History and Innovation* (2010). Farrer's book *Shadows of the Prophet: Martial Arts and Sufi Mysticism* (2009) is the first ethnographic account of Malay *silat* and of the Haqqani-Naqshbandi Sufi Order. He is currently editing a volume on war magic and warrior religion.

Jean-Marc de Grave is Assistant Professor at the Université de Versailles Saint-Quentin (France) where he teaches Javanese civilization, anthropology, and sociology. He is a member of the research institute Centre Asie du Sud-Est (Paris) and the author of a book on Javanese rituals, *Initiation rituelle et arts martiaux: Trois écoles de kanuragan javanais*, that was awarded the Jeanne Cuisinier Prize in 2000. He has written articles on education and martial arts in Indonesian education and Javanese dance and is working on a chapter for a forthcoming book on apprenticeship and education in Southeast Asia, India, and China.

Jie Lu is Professor of Chinese Studies and Film Studies at the University of the Pacific. She is the author of *Dismantling Time: Chinese Literature in the Age of Globalization* (2005) and has edited: *China's Literature and Cultural Scenes at the Turn of the 21st Century* (2008); "Writing against Spectacular Reality: Cultural Intervention in China and Taiwan," *Journal of Contemporary China* (2008); "New Literary and Culture Scene in Contemporary China," *Journal of Contemporary China* (2003 and 2004); and "Chinese Literature in Post-Mao China," *American Journal of Chinese Studies* (1998).

Stéphane Rennesson was a Postdoctoral Fellow at Quai Branly Museum and an Assistant Professor of Anthropology at University of Versailles Saint Quentin before becoming a researcher at the Laboratoire d'Anthropologie Urbaine (Institut Interdisciplinaire d'Anthropologie du Contemporain, EHESS-CNRS). His work has been published in French journals such as *L'Homme, Ethnologie Française*, and *Actes de la Recherche en Sciences Sociales*. He is devoted to the study of competitive games and sports in Thailand.

Martin Welton earned his PhD from the University of Surrey and is a lecturer in the Drama Department of Queen Mary, University of London. Welton's research centers on questions of phenomenology and embodiment with regard to the senses in performance—in particular the condition of "feeling" in the theater. Welton (2006) has published on South Asian Martial Arts in *Contemporary Theatre Review*.

John Whalen-Bridge is Associate Professor of English at the National University of Singapore. He has written *Political Fiction and the American Self* (1998) and has published articles on American literature in relation to

Buddhism, Orientalism, the Cold War, and pragmatism. He has coedited *Democracy as Culture: Deweyan Pragmatism in a Globalizing World* (2007), *Emergence of Buddhist American Literature* (2009), and *American Buddhism as a Way of Life* (2010). He is currently working on a book-length study of "Engaged Aesthetics" in Buddhist American literature.

Index